MAKING THEM MOVE
Mechanics, Control, and Animation of Articulated Figures

The Morgan Kaufmann Series in Computer Graphics and Geometric Modeling

Series Editor, Brian A. Barsky (University of California, Berkeley)

Richard H. Bartels, John C. Beatty, and Brian A. Barsky,
An Introduction to Splines for Use in Computer Graphics and Geometric Modeling (1987)

Christoph M. Hoffmann,
Geometric and Solid Modeling: An Introduction (1989)

Norman I. Badler, Brian A. Barsky, and David Zeltzer,
Making Them Move: Mechanics, Control, and Animation of Articulated Figures (1991, book and videotape)

Andrew S. Glassner,
Ray Tracing: Theory and Practice (1992)

MAKING THEM MOVE

Mechanics, Control, and Animation of Articulated Figures

Contributors

Norman I. Badler
Alan H. Barr
Rodney A. Brooks
Tom Calvert
Jeffrey Esakov
Michael Girard
Mark Green
Peter H. Greene
Jugal Kalita
J. A. S. Kelso
Nadia Magnenat-Thalmann
Gavin Miller

A. S. Pandya
K. G. Pearson
Elliot Saltzman
Richard A. Schmidt
R. C. Schmidt
Dan Solomon
Daniel Thalmann
M. T. Turvey
Bonnie L. Webber
Jane Wilhelms
Douglas E. Young
David Zeltzer

Edited by

Norman I. Badler (University of Pennsylvania)
Brian A. Barsky (University of California, Berkeley)
David Zeltzer (Massachusetts Institute of Technology)

MORGAN KAUFMANN PUBLISHERS, INC.
San Mateo, California

Publisher and Editor *Michael Morgan*
Project Management *Jennifer Ballentine*
Copy Editor *Larry Olson*
Design and Composition *Ocean View Technical Publications*
Cover Designer *Terry Earlywine*

About the cover Front: Single frame from the computer-generated film *Eurhythmy*; © 1990, Michael Girard and Susan Amkraut, reprinted with permission. Back: Still from *Her Majesty's Secret Serpent*, Gavin Miller, Michael Kass, Lance Williams; © 1989, Apple Computer, Inc., reprinted with permission. Still from *Grinning Evil Death*, Bob Sabiston and Mike McKenna; © 1990, MIT, reprinted with permission.

The publisher gratefully acknowledges permission to reproduce the following material:
Chapter 4, "A Robot that Walks: Emergent Behaviors from a Carefully Evolved Network" was originally published in *Neural Computation* 1(2):253–262; © 1989, Massachusetts Institute of Technolgy, reprinted with permission. **Figure 1.5** from M. Travers, "Animal Construction Kits," in *Artificial Life*, C. Langton (ed.); © 1988, Addison-Wesley Publishing Company, reprinted with permission. **Figures 6.4–6.7** from D. Young and R.A. Schmidt, "Units of Motor Behavior: Modifications with Practice and Feedback," in *Attention and Performance XIII*, M. Jeannerod (ed.); © 1990, Lawrence Erlbaum Associates, Inc., reprinted with permission. **Figure 8.1** was produced with the Peak Performance Technologies (Englewood, Colorado) motion analysis system, reprinted with permission. **Figure 8.2** from H. Haken, J.A.S. Kelso, and H. Bunz, "A Theoretical Model of Phase Transitions in Human Hand Movements," *Biological Cybernetics*, 51, pp. 347–356; © 1985, Springer-Verlag, reprinted with permission. **Figure 8.3** from G. Schöner, W. Jiang, and J.A.S. Kelso, "A Synergetic Theory of Quadrupedal Gaits and Gait Transitions," *Journal of Theoretical Biology*, 142, pp. 359–391; © 1990, Academic Press, Ltd., London, reprinted with permission.

Library of Congress Cataloging-in-Publication Data
Making them move : mechanics, control, and animation of articulated
 figures / edited by Norman I. Badler, Brian A. Barsky, David
 Zeltzer.
 p. cm. — (The Morgan Kaufmann series in computer graphics
 and geometric modeling, ISSN 1046-235X)
 Includes bibliographic references and index.
 ISBN 1-55860-106-6
 1. Computer animation. I. Badler, Norman I. II. Barsky, Brian
 A., 1954– . III. Zeltzer, David. IV. Series.
TR897.5.M35 1991
006.6—dc20 90-41087
 CIP

Morgan Kaufmann Publishers, Inc.
Editorial Office *Orders*
2929 Campus Drive, Suite 260 P.O. Box 50490
San Mateo, CA 94403 Palo Alto, CA 94303

Preface

The genesis of this book can be traced to a conversation between David Zeltzer and Norman Badler during the closing days of the 1985 ACM SIGGRAPH Computer Graphics Conference. Zeltzer noted the lack of a forum in which computer graphics researchers interested in the animation of human figures could meet and share ideas, problems, and successes. While computer-based modeling of three-dimensional figures was rather straightforward—and the rendering of realistic images was, for the most part, well understood—making the figures *move* realistically remained a difficult and challenging task. Badler agreed that a meeting would be an excellent idea and offered to help determine if financial support might be obtained from the National Science Foundation (NSF). Even though initial contacts with NSF were encouraging, the workshop idea languished as more immediate academic and research concerns occupied Zeltzer and Badler. Despite periodic chiding that the workshop ought to happen, their respective projects took first priority.

The catalyst turned out to be Mike Morgan of Morgan Kaufmann Publishers, who arranged a meeting between Brian Barsky and Norman Badler at the 1988 ACM SIGGRAPH meeting in Atlanta. Interested in soliciting manuscripts in the rapidly growing field of computer graphics, Morgan also noted that Morgan Kaufmann was beginning to publish work from meetings more specialized than SIGGRAPH. Badler suggested that a book compiling state-of-the-art research efforts in figure animation would be unique and suggested that Zeltzer's dormant workshop idea be the vehicle for soliciting and organizing a set of papers. Barsky agreed to help, adding his editorial experience from previous collaborations with Morgan Kaufmann.

Now the wheels began to turn. Badler and Zeltzer reviewed the Morgan Kaufmann offer. Zeltzer drafted a proposal to NSF for a small, invitation-only workshop, of approximately 20 leading researchers in graphics, psychology,

physiology, robotics, and mechanical engineering. Such a multidisciplinary meeting, it was thought, would allow researchers to become familiar with results and methodologies across disciplines, provide for an open exchange of ideas in an area of growing interest, and perhaps most significantly, provide the basis for what could become fruitful collaborations in the future. Researchers contacted expressed encouraging support for both the workshop and the book, and most agreed to the request to submit a paper covering a broader view—accessible to researchers in other fields—of their research rather than more narrowly focused articles on recent results.

The workshop was funded, by NSF as well as with enthusiastic additional support from the MIT Media Lab. The authors were invited, and the interdisciplinary meeting was underway. During the *Workshop on the Mechanics, Control, and Animation of Articulated Figures*, April 6–7, 1989, held at the MIT Media Lab, there were unique opportunities for interaction and understanding among researchers from disparate disciplines, who would not normally have had the opportunity to attend each other's technical conferences.

The 15 chapters in this volume are a subset of the invited papers distributed to the participants at the meeting. They have been selected by the editors, and produced specifically to emphasize the global as well as the particular problems of the field. Not only does this volume explore how computer graphics can be used to graphically simulate human or animal figures—"making them move" in a natural, physically realistic, or perhaps aesthetically effective manner—but it describes corresponding and contrasting explanations for "real" organisms as well as for robots.

More than half of the chapters here are by experts in computer graphics. For someone familiar with graphics technology but a newcomer to figure animation, this book will serve both as a broad introduction to the field as well as a focused probe into some of the difficult areas. For the researcher in animation and simulation, this volume will be a useful reference and a source of information on techniques at the forefront, including the very different perspectives of researchers in other fields—psychologists, physiologists, and other students of motor behavior have a great deal of insight and empirical knowledge that can profitably be shared with the computational community. In addition, researchers in robotics, mechanical engineering, and the life sciences will, through this book, become aware of the growing potential—and pitfalls—of graphically sophisticated, computational models of human, animal, and robot agents. We believe that all readers will find new ideas here, and especially new perspectives on deceptively familiar issues.

Organization of the Book

This book has been organized into four major parts: "Interacting with Articulated Figures," "Artificial and Biological Mechanisms for Motor Control," "Motion Control Algorithms," and "Computing the Dynamics of Motion."

Part I Interacting with Articulated Figures

The three chapters in Part I provide complementary perspectives on the requirements, design, and implementation of computer systems for simulating and displaying human figures. In *Task-level Graphical Simulation: Abstraction, Representation, and Control,* Zeltzer takes an overall look at the kinds of abstractions needed for defining, editing, and controlling computational models. He then considers the available interaction paradigms, and describes the kinds of access to the abstraction classes each interaction paradigm provides. By enumerating these interfaces—that vary both in level of detail, from *machine-level* to *task-level* access to computational models, as well as in the demands placed on the user—the resulting taxonomy can serve as a conceptual blueprint to guide the development of interactive, graphical simulation systems.

Tom Calvert, in *Composition of Realistic Animation Sequences for Multiple Human Figures,* also begins with a discussion of an abstraction hierarchy. In this case, however, it is an attempt to capture essential stages in the "creative process involved in composition or design," in order to understand the requirements of a system that can generate expressive, realistic animation of multiple human figures. Various approaches to specifying the movements of human figures are discussed, including examples of recent and ongoing work on figure animation at Simon Fraser University.

Suppose we wanted to use computer animation to *instruct* someone—human or robotic—in the performance of a task. How can we specify the task and the motions required to carry out the task? In *Animation from Instructions,* Badler, with Bonnie Webber, Jugal Kalita, and Jeffrey Esakov, argues that natural language provides a common representation for driving both animation and narration. This chapter examines the nature of instructions and plans, and the ways in which these constructs can influence an agent's behavior. Finally, the major components under development for a system that can generate animation from instructions are described, including a natural language processor, an incremental planner, and a graphical simulator that can portray multiple, anthropometrically scaled human figures performing a task in a work environment.

Part II Artificial and Biological Mechanisms for Motor Control

In Part II, the focus shifts from computer graphics to robotics, physiology, and psychology, as we take a look at existing physical motor control systems, both artificial and biological. This part is further subdivided into three subparts: "Artificial Motor Programs," "Biological Motor Programs" and "Learning Motor Programs."

Artificial Motor Programs The first subpart consists of the single chapter by Rodney Brooks, *A Robot that Walks: Emergent Behaviors from a Carefully Evolved Network.* It is an account of his "subsumption architecture" for repre-

senting and controlling the perception-driven behavior of autonomous robots. In particular, Brooks and his colleagues have built a a six-legged walking machine that can prowl about in a cluttered environment, avoiding obstacles. It can even follow warm, moving targets—such as slowly walking humans—with its infra-red sensors. These behaviors are robust and controlled by a decentralized set of rather simple networks that can be extended incrementally to improve the robot's performance.

Biological Motor Programs The four chapters in the second subpart present a range of thinking on the control systems that biological organisms have evolved to coordinate motor activity, by researchers well known for their contributions to the study of motor behavior. Interesting in their own right, these chapters can also offer insight into the close coupling among dynamics, physically based modeling, and motion control; as well as the design and organization of computer programs for controlling figure motion.

"A prevailing view in motor physiology for the past two decades," as K. G. Pearson points out in Chapter 5, "has been that the timing of repetitive motor activity is established by central neuronal circuits," and Pearson's research in the 1970s on these pattern-generating mechanisms in the control of insect locomotion is still widely cited. Recent work, however, has questioned the primacy of these central rhythm generators, and in *Sensory Elements in Pattern-Generating Networks,* Pearson presents the main results of a detailed analysis of the flight system of the locust, and in the process, elucidates the role of sensory feedback in the generation of rhythmic motor output.

Douglas Young and Richard A. Schmidt, in *Motor Programs as Units of Movement Control,* first recount the theoretical and experimental background of the "generalized motor program." They go on to describe experiments that investigate how such motor programs are affected by practice, in particular, in the coordination of voluntary movements that involve multiple motions to follow a moving target. Their chapter closes with some suggestions for behavior modeling and animation.

The final two chapters in this subpart attempt to provide unified accounts of perception and action, intentions and dynamic systems. In *Dynamics and Task-specific Coordinations,* M. T. Turvey, Elliot Saltzman and R. C. Schmidt discuss, from the perspectives of physical biology and ecological psychology, how task-oriented behaviors are expressed as emergent properties of dynamical systems. In *Dynamic Pattern Generation and Recognition,* J. A. S. Kelso and A. S. Pandya "use the language of nonlinear dynamical systems" to suggest that patterned motor behavior emerges from the dynamic interaction of oscillatory components of biological motor systems, rather than explicit neural motor scores.

Learning Motor Programs The third subpart consists of a single chapter, *A Computer System for Movement Schemas,* by Peter Greene and Dan Solomon.

They begin by describing their notion of a "motor schema," and relate it the stages of motor development proposed by Jean Piaget. They describe a computer system, MOOSE, intended to model these ideas and close with a discussion of the implications of these ideas for connectionist models of sensorimotor behavior and "higher motor and mental functions."

Part III Motion Control Algorithms

In Part III, we return to the problems of computer simulation and animation of figure motion, and consider three systems in some detail.

In *Constrained Optimization of Articulated Animal Movement in Computer Animation,* Michael Girard presents a new algorithm for obtaining smooth limb movement. Based on optimization methods, he shows how dynamic programming can be used to compute the optimal velocity distribution for a linkage moving through some path in joint-space, providing animators with a new tool for achieving expressive and natural limb motion. At the same time, he points out the shortcomings of the method for achieving coordinated, multilimb motion, and suggests some useful approaches for future research.

How can we simulate the motion of animals *without* limbs? Crawling is of interest because it is the primary means of getting around for a large number of species, exhibiting great taxonomic diversity, and all of which represent successful adaptations to a particular ecological niche. The chapter by Gavin Miller, *Goal-directed Animation of Tubular Articulated Figures or How Snakes Play Golf,* shows how to simulate terrestrial locomotion of legless figures—snakes and worms. Using mass-spring systems, and suitable models of friction and "concertina progression," he demonstrates the automatic animation of creatures that use a very different method of locomotion from that of most vertebrates.

Whether or not a figure has legs, its motion is generated by the contraction of muscles, and the shape of the figure is continually changing as joints rotate, and as soft tissue is compressed and displaced. We close the section with *Human Body Deformations Using Joint-dependent Local Operators and Finite Element Theory,* by Nadia Magnenat-Thalmann and Daniel Thalmann, who describe a representation and algorithms for modeling surface deformations of the human figure in motion. These techniques are part of their HUMAN FACTORY system for 3-D character animation.

Part IV Computing the Dyanamics of Motion

Finally, in Part IV, we take a close look at the issues involved in computing the dyanamics of motion—in particular, the mathematics, the numerical techniques, and the special interface and control problems that arise.

In *Dynamic Experiences,* Jane Wilhelms reviews her research in computing the dynamics for animating rigid and flexible bodies, including a discussion of her implementation of constraints and collision detection. She also describes her work on the interactive manipulation of articulated figures.

Mark Green, in *Using Dynamics in Computer Animation: Control and Solution Issues,* pays particular attention to the ways in which dynamics simulation and motion control techniques interact to affect the numerical stability and stiffness of the relevant differential equations. Following a detailed discussion of solution techniques, he presents the results of an experimental comparison of four of these numerical methods, run on a test suite of linear and nonlinear second-order differential equations.

We close the volume with a discussion of abstractions for computer animation, from the perspective of a researcher who has spent considerable effort extending the notion of "solid modeling." In *Teleological Modeling,* Alan Barr presents a new approach for modeling objects that encompasses forces and torques, internal stresses, energy and other physical properties, in addition to the usual geometric descriptions. Barr describes a hierarchy of abstractions for defining objects at multiple levels of representation, and argues for a new "graphics pipeline" that can accept descriptions of events, constraints and physical forces acting on objects; compute the 3-D "kinematic primitives" by solving the resulting equations of motion; and finally, generate the 2-D pictorial primitives by rendering the geometric models. These techniques, he suggests, "have the potential to extend the scientific foundation for computer graphics."

Appendices

Appendix A provides notes and commentary on the videotape produced to accompany *Making Them Move.* The videotape features eight selected animation sequences that illustrate techniques discussed in this book (ordering information can be found opposite the Contents). *Appendix B* provides brief biographical information on the editors and contributors.

Acknowledgments

The editors wish to thank numerous individuals for their assistance and cooperation in making the workshop and this volume a reality. In particular, thanks go to all the authors who generated the chapters. Thanks also go to the MIT Media Lab staff and students for the workshop arrangements. Special thanks go to Janette Noss, whose organizational skills and patience were indispensable to the success of the workshop and the compilation of this volume. Nicholas Negroponte, cofounder (with Jerome Wiesner) and director of the Media Lab, provided per-

sonal encouragement and necessary additional funding for the workshop. Thanks also to Mike Morgan of Morgan Kaufmann Publishers, a pleasure to work with, as always, who provided the final impetus to "get the ball rolling." Finally, thanks to Jennifer Ballentine of Ocean View Technical Publications for her patience and the many early morning hours spent putting this volume together. The workshop was supported in part by National Science Foundation Grant No. IRI-8822415.

Norman I. Badler, Philadelphia, Pennsylvania
Brian Barsky, Berkeley, California
David Zeltzer, Cambridge, Massachusetts

MAKING THEM MOVE: Mechanics, Control, and Animation of Articulated Figures VIDEOTAPE

A one-hour videotape featuring selected animation sequences that illustrate techniques discussed in this book is available from Morgan Kaufmann Publishers. Appendix A of this volume, entitled *Video Notes* (beginning on page 323), includes commentary on many of the selections.

Selections

- David Zeltzer and others (MIT Media Lab), *The BOLIO Virtual Environment System*
- Norman Badler and others (University of Pennsylvania), *Strength-guided Motion* and *Task Animation from Natural Language*
- Tom Calvert and others (Simon Fraser University), *COMPOSE* and *Goal-directed Dynamic Animation of Human Walking*
- Rodney Brooks and others (MIT), *Genghis: A Six-Legged Walking Robot*
- Michael Girard and Susan Amkraut (Stichting Computeranimatie), *Eurhythmy*
- Gavin Miller (Apple Computer), *How Snakes Play Golf* and *Her Majesty's Secret Serpent*
- Nadia Magnenat-Thalmann (University of Geneva) and David Thalmann (Swiss Federal Institute of Technology), *Galaxy Sweetheart*
- Jane Wilhelms (University of California, Santa Cruz) and David Forsey (University of Waterloo), *Interactive Dynamics*

Videotape only: ISBN 1-55860-**154-6**, **$29.95** (U.S. & Canada shipping and handling, $3.50; international, $6.50)

Book/Video package: ISBN 1-55860-**155-4**, **$69.95** (U.S. & Canada shipping and handling, $6.00; international, $10.00)

For information and prices for video formats other than NTSC VHS, contact the Morgan Kaufmann marketing department at (415) 578-9911. Prices will be honored until December 31, 1990; thereafter, contact us for current pricing.

To order, send check or VISA/MasterCard information to: Morgan Kaufmann Publishers, 2929 Campus Drive, Suite 260, San Mateo, CA 94403. Phone (415) 578-9911, Fax (415) 578-0672.

Contents

I

INTERACTING WITH ARTICULATED FIGURES

1

Task-level Graphical Simulation: Abstraction, Representation, and Control

David Zeltzer
Computer Graphics and Animation Group
The Media Laboratory
Massachusetts Institute of Technology
Cambridge, Massachusetts

ABSTRACT

What are the major design elements for developing reconfigurable graphical simulation systems? What tools should we provide the user for defining and interacting with objects and agents in virtual environments at varying levels of complexity? I describe a set of abstraction categories—*structural, procedural, functional*, and *agent* abstractions—needed for representing and controlling simulated objects and agents, and I discuss how programming, and direct manipulation or *guiding* techniques, can be used to afford interactive access to graphical simulations at appropriate levels of abstraction. The lowest layer of abstraction is represented by objects and structures with no procedural attachment, and is called the *machine level*. At the other extreme, the *task level*, guiding and programming tools interact with agents through their repertoire of behaviors. Task level interaction *emerges* when guiding and programming techniques are applied at higher layers of abstraction. I describe how programming and guiding can be used with each of the four classes of abstraction—as control instruments or as definition and editing tools. This analysis is illustrated with examples from previous and current graphical simulation systems, and provides a conceptual blueprint for the design and implementation of graphical simulation systems for a variety of applications.

1.1 *Representing and Controlling Virtual Worlds*

Continued investigation of the virtual environment as a telepresence instrument, and as a research and development tool—in robotics, simulation and training, mechanical design, and a host of other areas—is urgent and timely. Moreover, developments in interactive interface technologies—e.g., devices for measuring hand motion—require a careful study of the ways in which we can define and interact with artificial agents and processes.

For example, mobile robots with multiple manipulator arms will be used to perform maintenance and repair on the space station in low earth orbit (Engelberger, 1989). Yet for the foreseeable future, robots will not be intelligent enough to operate with complete independence, but will require operator intervention to perform tasks in changing or unanticipated circumstances. What are the telerobotic interface requirements for interacting with quasi-autonomous agents, with many degrees of freedom (DOFs) and at varying levels of abstraction—ranging from direct manipulation to task-level interaction? How can a human operator safely and effectively control multiple manipulators and multiple cameras to effect a task that the robot is unable to perform on its own? What is the role of gestural, kinematic input? What is the role of force output? Is there a synergistic effect when multiple sensory channels—e.g., audio, visual, and tactile feedback—are combined? A virtual environment can serve as a laboratory to study these and other issues, as well as providing a simulation platform for designing robotic devices and their operator interfaces, and for training the operators who will use them.

The representation and display of virtual 3-D worlds has been the subject of much recent research (Badler et al., 1985; Brett et al., 1987; Brooks, 1986; Fisher et al., 1956; Zeltzer, 1985). A number of workers are investigating mechanisms for simulating particular aspects of the behaviors of agents and objects, e.g., physically based modeling of nonrigid objects (Platt and Barr, 1988; Terzopoulos and Fleisher, 1988), simulation of the dynamics of rigid, possibly articulated, bodies (Barzel and Barr, 1988; Hahn, 1988; Wilhelms, 1987), collision detection and response (Moore and Wilhelms, 1988), and modeling of complex behaviors (Girard and Maciejewski, 1985; Haumann and Parent, 1988).

With few exceptions, however—see the thoughtful commentary of Brooks (1988)—discussions of "virtual environments," "synthetic worlds" and "artificial realities" in the current computer graphics literature reflect a rather *ad hoc* and piecemeal approach.

What are the major design elements for developing reconfigurable graphical simulation systems? What tools should we provide the user for defining and interacting with objects and agents in virtual environments at varying levels of complexity? In earlier work (Zeltzer, 1985) I defined a set of abstraction mecha-

nisms appropriate for virtual world construction—in particular, with respect to simulating human and other autonomous agents—and I argued that there are three modes for interacting with these simulations. Here, I want to reexamine these ideas in the light of our recent experience with graphical simulation and virtual environments: I review briefly the set of abstraction mechanisms appropriate for virtual-world simulation, then consider the relations among interaction modes and the abstraction mechanisms. I will illustrate this discussion with examples from existing graphical simulation systems—including a prototype *integrated graphical simulation platform* (IGSP) we call BOLIO, under development in our laboratory at MIT (Zeltzer et al., 1989). Finally, I will indicate where development remains to be done.

1.2 *Managing Complexity: Simplification, Interaction, and Insight*

Understanding the appropriate simplifications to make is critical for problems that involve grappling with complex systems. The importance of abstraction for hiding irrelevant detail—thus allowing one to focus on generalizations, concepts, and terms appropriate to the task at hand—has been long recognized in computing (Wasserman, 1981). This is certainly true if we want to model nontrivial environments and agents with varying levels of autonomy. At the very least, we need to enumerate the physical processes to be simulated for a given application, and the levels of detail at which they will be simulated—e.g., do we need to model friction, and if so, what simplifying assumptions about objects and surfaces must we make? This will allow us to match the complexity of the simulation to the application in a principled way. It will also allow us to follow a stepwise path for increasing simulator complexity as processing power increases, and as our understanding of the processes to be modeled grows in sophistication.

We also need to identify levels of detail in order to give the user appropriate access to computational models. For example, the human figure has over 200 DOFs, yet providing the user with 200 knobs for interactively controlling joint rotation doesn't seem to be the answer! Simply put, the control task becomes unmanageable if we try to interact with the model at the wrong level of detail.

Finally, abstractions are an important tool for learning and problem solving; for gaining *insight* into the objects and processes we wish to model. The casual or novice user, unfamiliar with the details of the underlying structure, may observe and interact with a simulation, while the sophisticated user will be able to analyze the simulation to find which factors gave rise to a given phenomenon. Providing the means to move smoothly between levels of complexity can allow the novice to become expert as she gains confidence in understanding a computational model at each layer of complexity.

1.3 *Abstraction Mechanisms for Graphical Simulation*

1.3.1 *Related Work*

Abstraction mechanisms for reasoning about objects and physical systems have been discussed for some time in the AI literature. Moorthy and Chandrasekaran (1983) describe the representation of the functioning of devices for troubleshooting and diagnostic reasoning. Chandrasekaran (1985) discusses the importance of encoding knowledge at appropriate levels of abstraction for knowledge-based reasoning using generic reasoning tasks. Falkenhainer and Forbus (1988) describe the use of simplifying assumptions for managing complexity in qualitative physics. Bond and Soetarman (1988) discuss issues and mechanisms regarding system abstraction for knowledge-based simulation, including levels of abstraction along different *abstraction dimensions*. Fishwick (1988) constructed a knowledge-based graphical simulation system in which processes were expressed as distinct sets of production rules that could be interfaced to each other at different levels of abstraction; he showed how to move between levels of process abstraction as needed. Forbus (1988) describes requirements, including levels of abstraction for describing physical systems and their behavior, for an *intelligent computer-aided engineering* workstation.

Much of this work in AI is concerned with the ability to make inferences about the behavior of processes and devices, given some initial description and current state information. In our context, we are not so much concerned with making inferences and predictions about behavior, as we are with specifying and controlling behavior. The major difficulty is what has been called the *degrees of freedom* problem (Turvey et al., 1982). Simply put, biological (and some artificial) motor systems possess far too many individual pieces to be regulated separately—motor control requires some means of "chunking" behavior into manageable subsystems.

In the following sections, I describe four kinds of abstractions for graphical simulation. The first two, structure and procedure, are analogous to the data and procedural abstractions of programming languages, although here they are specialized to allow us to describe the objects and processes in a graphical simulation. Two other kinds of abstraction are needed for "chunking" motor behavior into functional motor units, and for organizing these motor units into the behavioral repertoire of a synthetic *agent*.

1.3.2 *Structure*

A *structural abstraction* mechanism must be provided for describing the kinematic structure of objects, such as a transformation hierarchy for a jointed figure, and for defining physical attributes of objects, like mass and stiffness.

Conventionally, tree structures have been used to represent articulated figures, and these are adequate for representing objects composed of *open* kinematic chains, in which one end—the *base*—is fixed and the other—the *tip* or *end-effector*—is free to move. However, kinematic structures often change over the time-course of a simulation, as when a walking biped plants one foot and then the other on the ground, forming a series of alternating base frames; or when a human clasps both hands together, forming a closed linkage from one shoulder, through the clasped hands, to the other shoulder. Thus, transformation trees must be extended in order to account for changing kinematic structures (Sims and Zeltzer, 1988). Finally, a structural definition should provide a data structure with no embedded functional specifications for *how* an object should move, since that would only serve to limit the possible motions of kinematically complex and redundant linkages, such as the human arm.

Most animation and simulation systems provide straightforward structural definition mechanisms for rigid-body linkages, e.g., Blinn's ARTIC language (Blinn, 1982), the Builder subsystem to the UNC Walkthrough architecture simulator (Brooks, 1986) and Sims's *figure editor* front-end for an automatic gait simulator (Sims, 1987). We will see that such facilities need to be extended to handle objects of increasing mechanical complexity.

1.3.3 *Procedure*

Procedural abstractions are a mechanism for defining processes that control rigid and nonrigid object motion, such as collision detection, inverse kinematics, forward dynamics or elastic deformation, *independent* of the structure of the agent or object.

Such procedures are often provided for the user as built-ins (e.g., automatic collision detection), but may be constructed by the user in systems embedded in high-level programming languages, e.g., ASAS (Reynolds, 1982).

Recognizing procedural elements as an abstract category does not in itself enforce the proper selection of levels of abstraction during implementation. However, it can serve to focus our attention on the following issues:

* Which procedures should be provided as built-ins?
* Should there be programming access to the simulation at all?
* If so, which procedures can the user modify?
* What tools should be supplied to the user for constructing and modifying procedures? Should they be interactive, graphical tools, or simply access to a text editor for coding in the implementation language?
* Should there be a family of procedures, of varying complexity, for a given simulated phenomenon? How can the simulation user select among them?

We will deal with many of these questions in the next sections. Some of the answers, however, depend on the particular application domain.

1.3.4 *Function*

Functional abstractions are the means with which we associate procedures with objects and object subassemblies, for the purpose of defining meaningful behaviors. This is motivated by studies of biological systems: A large body of evidence suggests that natural movement systems have evolved into hierarchical control structures coordinating largely autonomous subsystems (Greene, 1972; Grillner, 1975; Pearson, 1976). In all but the simplest organisms, behavior cannot be controlled and coordinated by direct innervation of muscle fibers, which would, in sheer number, overwhelm any hypothesized central motor control unit. Instead, there are intervening layers of organization between the brain and the motor periphery. These subsystems appear to be organized as modules consisting of a set of muscles and joints that can effect a particular class of motions, each module under the control of a set of *motor programs* (Gelfand et al., 1971).

The control of motor behavior remains an area of intense investigation by many workers, but however the motor units may be implemented in living systems, the hierarchical organization of motor control is widely accepted. This allows complex, largely unmanageable systems with many DOFs—like the human figure, with over 200 DOFs—to be decomposed into a set of small, constrained, and manageable subsystems, each with only a few DOFs. For example, we can define a grasping and reaching behavior by controlling the motion of kinematic chains representing the arm and hand of a figure using inverse kinematic procedures. Since we know the operation to be performed, we can, in effect, apply functional constraints so that the arm and hand linkage—with nearly three dozen kinematic DOFs—can be controlled with far fewer parameters—say, the Cartesian coordinates of the object to be grasped, and strength and velocity parameters. We have used these ideas to construct systems, composed in part of sets of such functional units, for coordinating walking and other behaviors in simulated humans and animals (Zeltzer, 1982; McKenna et al., 1990).

1.3.5 *Agents and Computational Ethology*

Animals as well as human beings rely on routine, perception-driven behaviors to act in the physical world efficiently, in the face of changing conditions, apparently without conscious intervention. *Ethology* is the study of animal behavior in nature; *computational ethology*, then, is the study of the representation and logical organization of perception and motor behavior to effect the goal-driven actions of synthetic *agents*.

An *agent* consists of a structural definition, a set of functional units that defines the behavior repertoire of that entity, and some means for selecting and sequencing (possibly concurrent) behaviors.

Agents of course vary greatly in complexity. We can consider a simple, rigid, monolithic object in a dynamic simulation to be a primitive agent, consisting of a simple structural definition—e.g., a single node in a transformation

hierarchy, and a number indicating its mass. Its behavior repertoire is the suite of procedures for simulating Newtonian mechanics, which are invoked whenever a force acts on the object.

The other extreme is typified by an agent representing a simulated human. Its structural definition may be arbitrarily complex, say, depending on the level of detail at which its motion is being simulated: joints abstracted as rotary joints, or more realistically, as complex structures actuated by opposing muscles. Its behavior repertoire may consist of a set of functional units such as walking, running, standing, sitting, grasping, reaching, and so on.

The mechanism for selecting and sequencing motor skills to generate routine behaviors must link *action* with *perception*. I have discussed the architecture of such an adaptive controller, based on an *skill lattice*, in which motor skills are nodes in a network where the arcs represent inhibitory and excitatory connections, and traversal of the network depends on the current motor goal and sensory input (Zeltzer, 1983; 1987). Recent work in robotics has developed in similar directions (Brooks, 1989; Connell, 1989; Maes, 1989). The nature of this so-called *situated* or *reactive* planning is far from completely understood, and remains an active area of research.

We have looked at four abstraction types for constructing synthetic agents and objects: *structural abstractions* for specifying kinematic and dynamic attributes; *procedural abstractions* for controlling structure-independent behavior; *functional abstractions* for associating structures with controlling processes; and *agents*, composed of suites of motor skills and a mechanism for selecting and sequencing these motor units. In the following sections, I discuss modes of interaction with these four classes of abstraction.

1.4 *Guiding and Programming*

In earlier work three modes of specifying and controlling behavior were identified: *guiding, programming* and *task level* interaction (Zeltzer, 1985), defined roughly as follows:

- *Guiding:* The explicit specification of objects and behavior by the user. Guiding systems—e.g., TWIXT (Gomez, 1984) and BBOP (Williams, 1982)—are typified by the interactive specification of key transformations using various graphical input devices, usually accompanied by built-in procedural support (e.g., linear and cubic interpolation) for automatic in-betweening.

- *Programming:* The specification of objects and behavior in some programming notation, possibly a special-purpose animation language, e.g., ASAS (Reynolds, 1981), or MIRA (Maganet-Thalmann and Thalmann, 1983).

- *Task level:* The implicit specification of objects and behavior in terms of events, goals, and constraints.

The difficulty with this trichotomy, of course, is that a task-level description of some action to be performed—perhaps written in some constrained natural language—is also a *program* in a very real sense. This suggests that there really is no guiding, programming, and task-level trichotomy. Rather, guiding and programming may be applied at differing levels of abstraction. Task-level interaction *emerges* when guiding and programming techniques are applied at higher layers of abstraction, namely, to functional units and agents.

Guiding and programming seem to be at opposite ends of an axis which represents the means for specifying some action; others have recognized this guiding/programming dichotomy, especially in the user-interface research community (Boies et al., 1989). Guiding requires the user to supply all the details, as in leading a robot through some series of motions with a teaching pendant, or designing key-frames with graphical input tools. Programming implies that objects and their behavior are specified algorithmically. See Figure 1.1.

The lowest layer of abstraction is represented by objects and structures with no procedural attachments and is called the *machine level*. At the other extreme, the *task level*, guiding and programming tools interact with agents through their repertoire of behaviors. That is to say, at the machine level the user interacts with the system in terms of the abstractions provided by the virtual *machine*, i.e., the graphical, procedural, and data primitives of the implementation language. At the task level, interaction is in terms of the virtual *world*, i.e., names and behaviors of simulated agents and objects, such as walking, grasping, or possibly complex goal-seeking activity. We would control a simulated human figure at the task level, for example, by telling it to "Walk to the door," rather than by writing a program describing the needed joint rotations in detail.

1.4.1 *Multiple Perspectives*

There are often many ways in which we want to view objects and their relationships in a virtual environment. For example, I have discussed structural abstraction as a means of describing seemingly fixed kinematic and dynamic attributes of some simulated physical object, which may be arbitrarily complex. However, we may wish to examine an object at varying levels of kinematic or dynamic complexity: as a monolithic entity, perhaps represented by its center of mass; as a collection of subparts, each of which may be viewed as a "black box"; or we may wish to examine each of the subparts themselves at varying levels of detail. In some cases, we may begin with only a rough structural description based on initial specifications and requirements. For a design task, for example, the objective would be to arrive at a detailed structural description through a process of refinement, modification, simulation, and validation. Or we may simply wish to view object states: as programmed data structures and procedures; as graphical objects; or as kinematic, geometric, or dynamic entities.

The four kinds of abstraction presented here are intended to serve as basic mechanisms for constructing and controlling objects in a virtual environment,

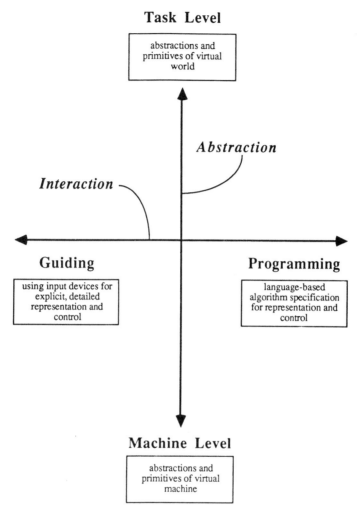

Figure 1.1 Interaction and Abstraction

and, in particular, for constructing autonomous agents. The two axes—*abstrac-tion* and *interaction*—represent only two of the ways we might wish to view virtual entities. But these are *necessary* perspectives; for particular tasks, we might wish to implement other tools for viewing and manipulating objects and processes built using these abstraction mechanisms.

1.4.2 *Representation and Control*

Guiding and programming tools have a dual nature: they can be used to construct and modify instances of any of the abstraction types; or they can be used at run

time as control instruments. This notion is familiar to any programmer who has used a keyboard to type in a program, and then has used the same keyboard to supply parameters to the program as it runs. Figures 1.2 and 1.3 schematically depict these two kinds of access—representation and control—respectively. Labels on the arcs represent either components of a graphical simulation environment, or systems that exemplify components that provide the indicated access to computational models. These will be discussed in detail in the following sections, where we examine the application of guiding and programming tools, both as construction and control instruments, at each level of abstraction.

1.5 *Guiding: Direct Manipulation of Virtual Objects and Agents*

Guiding requires the *user* to provide the parameters required by some program. Guiding is interactive and direct, and requires real-time or near-real-time system response (Sturman et al., 1989). Examples include the familiar operations of pointing with a mouse, sketching with a graphics tablet, entering values with sliders or knobs, or triggering state changes with buttons. Guiding is also common in industrial robotics, since operators often use teaching pendants to lead a manipulator arm through a series of motions, which are to be replicated later in a factory workcell.

A number of guiding devices are in the standard repertoire of most workstation and PC environments, including graphics tablets, dials, joysticks, and, of course, the ubiquitous mouse. With other kinds of devices and systems it is possible to measure movements of the user's body, and thus provide *gestural* input. For example, camera-based systems have been used to record human movement (Ginsberg and Maxwell, 1983) and more recently, several new devices have become commercially available for measuring hand motion—the DataGlove from VPL, Inc. (Zimmerman et al., 1987) and the Dexterous Hand Master from Exos, Inc. (Marcus and Churchill, 1988). Another device, the SpaceBall[1] provides six DOF force input along three translational axes and three rotational axes. This is not the place for an exhaustive listing of guiding devices, however. We will merely note that these and other devices are available in addition to the set of conventional graphical input devices.

In graphical simulations, guiding is useful as a means for specifying the details of some motion or process. However, since humans are not very good at attending to more than a few tasks at once (Kantowitz and Casper, 1988), the power of guiding tools diminishes rapidly as the number of simultaneous DOFs to be controlled increases—hence the importance of "chunking" by applying

1. Spatial Systems, Inc., 900 Middlesex Turnpike, Billerica, MA 01821

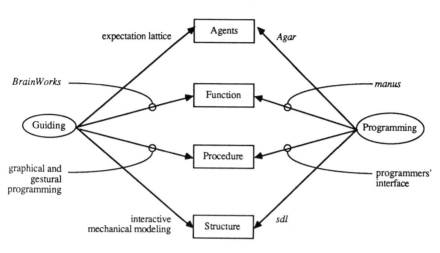

Figure 1.2 Representation and Abstraction. Labels on arcs represent interaction components, or examples of such components, which are discussed in the text.

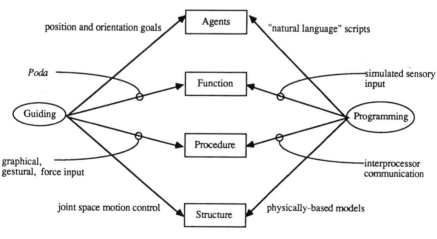

Figure 1.3 Control and Abstraction. Labels on arcs represent interaction components, or examples of such components, which are discussed in the text.

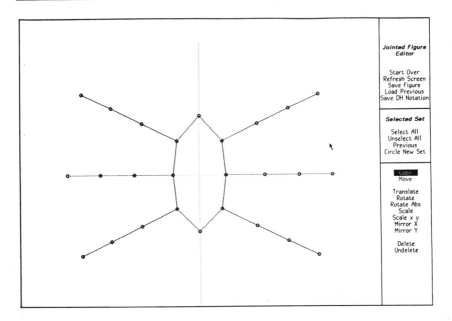

Jointed Figure
Editor

Start Over
Refresh Screen
Save Figure
Load Previous
Save DH Notation

Selected Set

Select All
Unselect All
Previous
Circle New Set

Copy
Move

Translate
Rotate
Rotate Abs
Scale
Scale x y
Mirror X
Mirror Y

Delete
Undelete

Figure 1.4 *Figure Editor* for designing articulated structures (Sims, 1987). Circles represent hinge joints; line segments stand for rigid links. Limbs are attached to the body by ball joints.

guiding techniques at the appropriate level of abstraction. In the following sections, we examine how guiding tools can be applied to each of the four abstraction classes.

1.5.1 *Guiding and Structure*

Representation. We can use guiding tools to graphically construct and modify the structure and mechanical properties of agents and objects. An example is Sims's *figure editor,* a visual tool for designing jointed figures (Sims, 1987). The figure editor provides a MacDraw-style interface to allow the drawing of 2-D schematics of 3-D, jointed figures. See Figure 1.4.

These 2-D representations are automatically transformed into three-dimensional, articulated figures—which can then be made to walk over uneven terrain using inverse kinematics and a gait sequencer.

Taking an alternative approach, Lowther (1985) built a graphical editor for defining transformation trees directly. Her system incorporated a *motion checking* stage, in which joint and link specifications—based on Denavit-Hartenberg notation (Denavit and Hartenberg, 1955)—could be interactively validated, by

pointing to a joint and observing the motion that resulted in the animated figure when joint values were changed with a slider.

As Brooks points out, model building remains perhaps the most time-consuming bottleneck in constructing virtual worlds (Brooks, 1986). This is especially true when models are deformable, or are to be simulated dynamically, since these techniques require the specification and validation of detailed information regarding physical properties, in addition to the usual kinematic attributes. Therefore, interactive tools for defining and editing mechanical specifications, i.e., for interactive *mechanical modeling*, are especially important when these techniques are employed in a virtual environment.

Control. Guiding tools have been used for some time for the direct control of figure motion in joint space—e.g., BBOP and TWIXT. In general, this is a tedious method of controlling more than a few objects, or jointed figures with more than a few DOFs. Moreover, tasks that seem trivial in the physical world may be difficult to perform in a virtual world. For example, we can reach and grasp an object in plain view without a moment's hesitation, yet positioning and orienting a virtual 3-D object is considerably more difficult. In large part, this is due to a lack of appropriate depth and motion cues—e.g., motion parallax and binocular vision—provided by most conventional graphics workstations. For some applications, for instance, simulated telerobotics, there is no reasonable alternative to implementing *telepresence* using head-tracking and head-mounted displays. In other applications, though, it may be more productive to make use of knowledge about the user's intentions by applying constraints on motion, e.g, forcing the motion of a 3-D cursor to remain on some chosen surface (Bier, 1990).

Nevertheless, in everyday life, humans are adept at placing and orienting objects with their hands. Thus, direct manipulation remains a powerful and appealing control metaphor for positioning virtual objects, and we provide users of the BOLIO system with direct gestural means—currently, via the Data-Glove—for accomplishing such tasks. Joint space control of figures is also useful when the number of DOFs is small, say from three to six. We are interested in investigating the use of multiple-DOF input devices—e.g., the DataGlove, the Dexterous Hand Master, and the SpaceBall—for direct manipulation involving many DOFs in simulated telerobotic tasks, with and without telepresence.

1.5.2 *Guiding and Procedures*

Control. It is now commonplace in graphics systems to use guiding tools to supply a stream of values as input to procedures that compute transformation matrices, which are subsequently applied to solid models or to the synthetic camera. For example, in the BOLIO, it is possible to attach input from the

SpaceBall or the DataGlove to the camera, and so control a moving point of view with hand gestures. This has also been true for some time in figure animation systems, where much research has focused on the problem of controlling end-effector motion in Cartesian space, using inverse kinematics (Girard, 1987) or constraints (Badler et al., 1987).

However, virtual environments are useful in other ways beyond simply displaying a world in motion. We are interested in giving users access to computational models of behavior, so that they can *explore* the input/output relationships of these models, *modify* the models to test their own understanding of the structures and processes involved, and *construct* and test new models, perhaps to validate some hypothesis about the physical world through simulation in the virtual world. Although we and others have attempted to build interactive graphical systems without a programming interface, it has become clear that creating and modifying computational models *requires* programming. This means that when one designs a graphical simulation platform, the interface for defining, composing, and manipulating procedural abstractions must be considered at the outset.

Representation. In particular, we can think of guiding tools as instruments for constructing representations of algorithms and procedures and not just an instrument for controlling behavior. In large part, this is the motivation behind visual or graphical programming systems, in which visual representations of programming abstractions can be manipulated directly, on screen, to compose larger program elements. This is in fact an area of active research in software technology (Chang et al., 1986; Haeberli, 1988; Meyers et al., 1989).

It is ironic to encounter a researcher using some set of interesting and powerful guiding devices to interact with virtual objects in a simulation—yet when the code needs debugging or revision, these direct manipulation tools lay idly by (with the possible exception of a mouse used for cutting and pasting or menu selection) as she or he types intently at the keyboard. I argue two points here:

- Interacting with procedural elements should be considered as much an integral part of graphical simulation as controlling the synthetic camera. We need to provide access to the procedural elements as part of the debugging and development process, part of applications building, or as part of a process of experimentation and exploration of computational models by scientists, engineers, or other end users.

- These programming interfaces should take advantage of the available guiding devices, incorporated either in prototype or commercially available graphical programming environments. Moreover, graphical programming tools should be extended to include force and kinesthetic input, such as hand gestures.

1.5.3 *Guiding and Functional Units*

Representation. Recall that functional abstractions enable us to associate procedural elements with structural elements, for the purpose of defining meaningful behaviors. In this context, guiding tools can be applied, again, in a graphical and gestural programming paradigm. Here however, rather than interacting with machine-level (i.e., graphical and programming language) primitives, the objects and processes represent entities of the virtual *world*—e.g., a linkage that is part of some jointed figure and a procedure for computing inverse kinematics.

Interest in graphical programming is clearly increasing, and this paradigm is of particular importance for allowing users to interact directly, and in a nontrivial way, with the processes and behaviors of interest in virtual environments. This is exemplified by the work of Levitt (1986) on a graphical programming system known as HOOKUP, which has been used to rapidly prototype behavior modules in a simplified 2-D animation application. Travers has built a graphical "wiring system" for constructing mobile agents capable of a few goal-driven behaviors, using cybernetic networks of neurons, motors and sensors, after Braitenberg (Travers, 1988; Braitenberg, 1984). See Figure 1.5.

In another example, Rodney Brooks has constructed legged robots controlled by networks of augmented finite-state machines (see *A Robot that Walks: Emergent Behaviors from a Carefully Evolved Network*—Chapter 4, this volume). In earlier work, it was shown that finite-state machines could be used to control locomotion of multilegged robots (McGhee, 1976) as well as a kinematic simulation of human walking (Zeltzer, 1982). Brooks has independently generalized and formalized this technique, which could serve as the basis of a graphical language for defining and interconnecting functional units.

Control. At this level, we wish to input control parameters directly to executing functional units, i.e., named behavioral modules and their components. Girard has implemented such a tool for controlling stepping motion in his PODA system for simulating human and animal locomotion (Girard, 1987). This interface allows users to specify end-effector trajectories much like a guiding interface for an industrial robot: the linkage representing one leg is displayed on the screen; users can "grab" the "foot" and move it through some desired trajectory. Then, during a gait cycle, whenever the gait sequencer triggers a leg to step, the foot is made to follow this trajectory using inverse kinematics.

A number of functional units of our gait and vehicle simulations are also controlled interactively in the BOLIO IGSP. For example, a suite of functional modules makes up the behavior repertoire for a kinematically simulated insect, and control parameters for most of these can be input using an X-window panel with sliders, including the frequencies of the gait oscillators we use for coordi-

Figure 1.5 View of the "Turtle-Wiring" Window from BrainWorks, a graphical interface for building cybernetic agents (Travers, 1988)

nating stepping motions, the turning radius used by the steering servomechanism, and the rate of overall "metabolism" of the insect (McKenna et al., 1990).

More sophisticated agents, or *virtual actors*, will be constructed by composing larger, and more complex, adaptive behavior suites. There is no reason to believe that such an engineering task is any less daunting than writing and debugging large programs: This means that appropriate guiding tools and graphical interfaces will be essential for *debugging* the behavior of virtual actors, and for later exploring their performance in varying environmental situations.

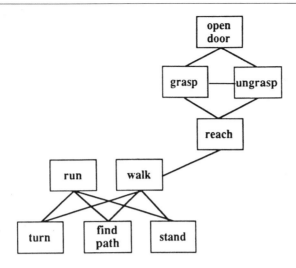

Figure 1.6 A simplified example *skill lattice* of motor skills for a simulated human agent. Arcs represent goal/subgoal relations among motor skills based on preconditions that must be true in order for a motor skill to execute. For example, to *open door*, one has to *grasp* the door- knob, *reach*ing for it if necessary. But if the doorknob is not within reach, one must *walk* toward the door. The *walk* motor skill, in turn, has a similar similar set of preconditions.

1.5.4 *Guiding Agents*

Representation. In Section 1.3.5 I briefly discussed a reactive planning mechanism for controlling agents, based on the *skill lattice* architecture for perception-driven action. Just as we can apply guiding tools to construct procedural and functional abstractions, we can employ these same tools for constructing higher level suites of motor skills. For example, using a heterarchical data-flow layout of skills, we could graphically "hook up" various motor behavior units in an skill lattice (see Figure 1.6). This is a research effort currently underway in our laboratory, intended to validate and extend the concept; many unanswered questions remain regarding its implementation. Nevertheless, we can expect that interactive, graphical representations of behavior suites will expedite the development and prototyping of robust reactive planners and will provide a powerful and convenient means for specifying the behavior repertoires of agents in future systems.

Control. In this context, one can think of direct manipulation tools as supplying task-level position and orientation goals for agents. For example, one can use

Table 1.1 Hand Motion Taxonomy (Sturman et al., 1989)

Hand Position & Orientation	Finger Joint Angles		
	Don't care	**Static fingers**	**Moving fingers**
Don't care	X	**Finger posture** (choice) e.g., *fist*	**Finger gesture** (valuator)
Static hand	**Hand posture** (locator)	**Oriented posture** e.g., *thumbs up/down*	**Oriented gesture** e.g., *bye-bye* vs. *come here*
Moving hand	**Hand gesture** (stroke)	**Moving posture** e.g., *banging fist*	**Moving gesture** e.g., *strong come here* or a *salute*

a 3-D locator to indicate a target object to be grasped by a simulated robot arm, or to point out a target location for a mobile agent (McKenna et al., 1990).

Using hand-motion measurement devices, we are currently investigating task-level gestural interaction with objects and agents. In this work we have developed a taxonomy of hand motions useful for guiding in virtual environments (Sturman et al., 1989). In this taxonomy we distinguish between *postures* and *gestures*, such that postures represent *stationary positions* of the hand or fingers, while gestures represent hand or finger *motions*. See Table 1.1.

The first row and column of the table, in which only one of finger joint angles or hand motion are important, suggests one mapping of postures and gestures to the familiar logical input devices *choice, valuator, locator*, and *stroke*. The *pick* device can easily be implemented as a combination of devices, e.g., *locator* and *choice*. The lower right 2 × 2 submatrix represents more complex, composite movements familiar from everyday social interactions. These do not readily correspond to conventional input metaphors, and reflect the richness of whole-hand interaction. A gestural language, of course, could be used to implement a *string* device, but this is a nontrivial task (Poizner et al., 1983), which may be better accomplished—at least, in part—by currently available voice-recognition systems.

1.6 *Programming: Algorithmic Description and Control*

The right-hand sides of Figures 1.2 and 1.3 represent interaction with the abstraction classes using mostly notation-based paradigms.

```
begin body
     begin pelvis
          [r_hip r_femur r_knee begin r_ankle
               [r_balloffoot r_toe]
               [r_heel] end]
          [l_hip l_femur l_knee begin l_ankle
               [l_balloffoot l_toe]
               [l_heel] end]
          [spine begin spine2
               [r_clav r_shldr r_uparm r_elbow r_forearm
                  begin r_wrist
                    [r_thumb2 r_thumb3]
                    [r_palm r_mid r_tip r_tip2] end]
               [l_clav l_shldr l_uparm l_elbow l_forearm
                  begin l_wrist
                    [l_thumb2 l_thumb3]
                    [l_palm l_mid l_tip l_tip2] end]
               [skull jaw]
          end] /* spine2 */
     end /* pelvis */ end /* body */
```

Figure 1.7 A textual description of a simplified human figure, using the skeleton description language, SDL (Zeltzer, 1982)

1.6.1 *Programming and Structure*

Representation. It is certainly possible to generate structural descriptions pro-cedurally, and this is an option provided in Sims's figure editor—one can use LISP code to directly generate joint and link structures, e.g., screw joints or anthropometrically scaled links, not readily obtained using the built-in kinematic primitives (Sims, 1987). It is also not uncommon to "hard code" structural descriptions in special-purpose simulation software. The more general approach, however, is to provide text-based structural descriptions that can be input at run time. Figure 1.7 shows the description of a simplified human figure using the skeleton description language, SDL (Zeltzer, 1982). This description is input and parsed by the jointed-figure animation system, SA, and a transformation tree corresponding to the specified kinematic structure is generated (Zeltzer, 1984). Open chains are enclosed in brackets ('[', ']'), and the construct **begin** joint name... **end** indicates a joint where multiple chains attach. E.g., r_hip, l_hip and spine all connect at pelvis.

Guiding and programming tools for building structural definitions are com-plementary. ASCII text files are often useful as intermediate forms for communi-cating among programs and host processors and should be provided as an output

option for graphical structure editors. Moreover, text-based descriptions are easily created and modified with conventional text editors, and this is adequate for defining simple structures "by hand," or for modifying more complex structures created with a gestural or graphical interface.

Control. What has recently come to be known as *physically based modeling* provides a convenient characterization for the notion of procedures that operate directly on structures. Examples include elastic deformations of solid models, collision detection and response, and forward dynamics.

In general, the computational cost of such methods is high, and developing efficient algorithms and implementations remains an area of active research. Nevertheless, such procedural support is a necessary element of graphical simulation. For this reason, in the BOLIO IGSP we have provided:

- low-cost collision detection and dynamic simulation of monolithic objects as built-ins;
- a programmers' interface, which facilitates incorporating new procedural elements, e.g., forward dynamic simulation with endpoint constraints (Schröder and Zeltzer, 1990); and
- a mechanism for associating procedural elements with objects, the MANUS constraint network, which is discussed below.

In the next section, I examine the issue of providing programming tools for constructing and controlling procedural elements.

1.6.2 *Programming and Procedures*

Representation. Graphical simulation can be a key element of a transparent computing environment to support and enhance a wide range of creative tasks, including simulation, design, and learning. Some users may be content to interact with predefined objects and behaviors, e.g., users of vehicle simulators for training purposes. Others—engineering and scientific users—may want to program their own models of objects and processes, and subsequently modify the programs based on performance of the models in the virtual environment. For these users, as I have stressed, programming tools should be available to define the behaviors of objects, processes, mechanisms, and agents, which can then be incorporated in the simulation environment. While some of these programming tools may be graphical or gestural, it is clear that such tools will not replace text-based programming, at least in the near term.

For these reasons, and because the BOLIO system serves as a development test bed in our own lab, we have developed a modular and consistent programmers' interface, which includes a global object database; a mechanism

```
; start up sa on remote workstation tigger
manipulator sa -c "remsh tigger source /u/dz/wsa.start" -off
; read in the sa startup script
manipulator sa -a "/snaggle/u/dz/graphics/Skeleton/get-sa-world"
; tell bolio to update the display
manipulator sa -f "echo display"
; tell bolio to start listening to sa
manipulator sa -on
; set up the synthetic camera
vp_read_view /cga/bolio/views/d-view3
; tell sa to read in a file describing a walking task
manipulator sa -s "task /snaggle/u/dz/graphics/Scripts/Walk2"
; setup DataGlove stuff
#include setup_gl2
; include a script describing a DataGlove posture command
#include r_setup_follow
; use the "gl" hand posture
#include setup_obj4
; give bolio the list of graphic objects in the figure that SA
    will manipulate
make_world sa_world l_uparm l_forearm l_hand r_uparm ...
```

Figure 1.8 Excerpt from a BOLIO startup script, showing the use of the *manipulator* command for interprocess communication

for passing messages among distributed processes; and a function library for access to the primitive operations for kinematics, dynamics, and the constraint definition and satisfaction tools that BOLIO provides. These have been used to incorporate a number of disparate applications into the virtual environment, including biped and hexapod locomotion simulators (Zeltzer et al., 1989; Mckenna et al., 1990), a facial tissue modeling system (Pieper, 1989), a system for interactively studying the aerodynamics of simple airfoils, and a teleoperator interface for controlling a robot arm in a remote location by directly manipulating its graphical simulation.

Control. The use of procedures—as well as typed or spoken input—to supply run time data to other procedures is a conventional programming paradigm. However, since real-time or near-real-time response is crucial, the BOLIO IGSP provides a mechanism for interprocessor communication, so that computationally expensive processes, e.g., forward dynamics, can be off-loaded to other hosts. By associating logical I/O channels, i.e., UNIX pipes and sockets, with

command streams issued by off-host processes, distributed processes can communicate with the BOLIO process running on the workstation on which the virtual environment is being displayed. This is specified with the *manipulator* command—so-called because it allows distributed processes to "manipulate" BOLIO entities—which can be entered at the keyboard or included in the usual startup scripts. Figure 1.8 shows a start-up script which invokes the SA system on the remote processor *Tigger*.

1.6.3 *Programming and Functional Units*

Representation. Recall that a functional unit represents the association of one or more procedural elements with one or more structural elements. The BOLIO IGSP provides two methods for accomplishing this (Zeltzer et al., 1989; Sturman et al., 1989):

- The MANUS system provides a built-in language and processor for associating objects and processes—by means of a *constraint network*—to define behaviors. Objects in the constraint network are connected by instances of constraints, and each such instance points to a procedural element necessary to process the constraint. This is quite general, and can be used, for example, to link inverse kinematics routines to a linkage, or to define the events that are triggered when a guiding device, such as the DataGlove, contacts a virtual object. That is, MANUS allows us to define a variety of "behaviors" involving objects at all levels of abstraction, from machine-level physical input devices to task-level virtual agents.

- Application modules, such as SA, may have their own internal functional abstraction mechanisms, and can be easily incorporated into BOLIO. In SA, functional abstraction is largely accomplished by a structure known as the *movement table*, which maps motor skills (procedures) directly to functional elements (Zeltzer, 1984). Users can interact with jointed figures at the task level through the behaviors implemented and controlled by SA. SA, in turn, communicates with BOLIO at the machine level by sending a stream of graphical object names and transformation matrices, so that figures can be properly updated by BOLIO at each time step. BOLIO, and other simulation processes, communicate with SA through the MANUS constraint network. This is used to specify which objects are controlled by SA so that SA can generate an appropriate response when these objects undergo some state change.

Control. The control task involves supplying appropriate parameter values to functional units at run time. In addition to using guiding controls, discussed above, this can be done procedurally and can be characterized as providing simulated sensory data to synthetic behavior modules—i.e., agents can use a

suite of simulated sensors to modulate their behavior. Both SA and Sims's loco-motion simulator use a fast collision-detection algorithm (based on preprocessing the terrain database) to "sense" contact between the ground surface and the feet. Similar facilities are implemented in BOLIO by message passing among pro-cesses (McKenna et al., 1990). The construction of interesting virtual environ-ments that can support nontrivial sensory interaction is a difficult problem, how-ever, which will be discussed further in Section 1.7.

1.6.4 *Programming Agents: Computational Ethology*

Representation. The relationship among language, graphics, and gestures as media for describing behavior is an interesting open question. We know from our everyday experience that it is sometimes difficult to describe an action—riding a bicycle, for example—solely with words. As Badler et al., argue, however, there are kinds of information, especially *intentions*, that are best communicated ver-bally (see *Animation from Instructions*—Chapter 3, this volume). Thus, in addi-tion to using graphical programming tools to define and modify behavior repre-sentations—e.g., the *skill lattice*—languages for describing behavior are also under development. For example, Travers has developed such a language, AGAR (Travers, 1988), based in part on ethological ideas, (Lorenz, 1981; Tinbergen, 1969), and on Minsky's "society of mind" theories (Minsky, 1975).

Control. Programs for controlling the behavior of agents take the form of con-strained natural language scripts. In order to interpret goal-oriented motion descriptions, however, a great deal of real-world knowledge is needed. There have been a few attempts to implement task-level input using knowledge base technology. Drewery and Tsotsos describe a prototype task-level system that used a frame-based approach (Minsky, 1975) to execute simple goals and direc-tions based on English motion commands (Drewery and Tsotsos, 1986) and Ridsdale et al. developed a rule-based system—the *Director's Apprentice*—that could handle certain theatrical concepts (Ridsdale et al., 1986). Badler et al. developed a task-level system for translating NASA task protocols into animated sequences showing astronauts executing tasks in a space station work environ-ment (Badler et al., 1985). Recent work involves the exploration of natural language as a means of controlling the behavior of graphically simulated agents, including a study of the mapping between action verbs and the kinematic and dynamic primitives of the motion simulator (see *Animation from Instructions*, Chapter 3—this volume). In addition to mapping action descriptions onto an appropriate sequence of simulation behaviors, we need some mechanism to han-dle task-level descriptions of objects. In a complementary investigation, Schafer conducted a pilot study aimed at understanding how humans communicate infor-mation about geometric objects (Schafer, 1989).

1.7 *Future Work*

Simulating the richness of detail of an ever-changing physical world remains an elusive goal and a major stumbling block in the implementation of virtual environments. Behavior modeling systems require a simulated environment with which agents can interact (Brooks, 1989).[2] Travers found it most difficult to define and simulate environments of adequate complexity for nontrivial agents (Travers, 1988). To implement such simulated environments we require:

- *Efficient and expressive model building tools for specifying complex objects, composed from a set of rigid and nonrigid parts, perhaps with movable joints.* The interface for these tools should be graphical and interactive. This is not strictly a solid modeling task: We are interested in designing objects, agents and mechanical assemblies with physical attributes. Once an initial design has been entered, the structural description will need to be validated—recall the *motion checking* stage for confirming joint specification in Lowther's system, described in Section 1.5.1. Thus, in addition, appropriate guiding tools for interacting directly with structural descriptions for testing purposes should be available.

- *Rapid prototyping of procedural elements (e.g., collision detection and response) and functional elements (e.g., motor skills for locomotion and navigation).* To support the necessary programming activity, the BOLIO IGSP currently provides:

 - a programmers' interface for accessing the library of core procedures (e.g., graphical operations and inverse kinematics);

 - an easy-to-configure X-based menu system;

 - simple access to the available guiding devices, e.g., the DataGlove;

 - and, for associating procedures with events and objects, the MANUS subsystem.

Some of these mechanisms currently require the programmer to write sometimes lengthy start-up scripts. In particular, a gestural and graphical front-end to MANUS would speed up the processes of "wiring in" new application modules and specifying complicated object/event dependencies. While I have given examples of graphical programming tools for such tasks, they are not a panacea—graphical programming has its own limitations, and remains an emerging

2. Rodney Brooks argues that, for robotics at least, it is undesirable to maintain models of the environment at all, because such models are inherently simplifications of a complex and dynamically changing physical environment. Thus, robots that are well behaved using simple models of static environments may fail when they encounter the complexity of the physical world (Brooks, 1989). Nevertheless, while Brooks's mobile robots can roam about in the real world with no symbolic representation of their surroundings—because their actions are driven by perception of physical objects—such a representationless paradigm is not open to us in graphical simulation.

Table 1.2 Interaction components that result when applying guiding and programming tools as instruments for defining and editing instances of the four abstraction classes

Interaction Paradigm	Representation Abstraction Class			
	Structure	Procedure	Function	Agents
Guiding	Interactive mechanical modeling	Graphical and gestural programming	Graphical and gestural behavior modeling	Rapid prototyping of behavior suites and reactive planners
Programming	Text-based descriptions of kinematic and dynamic attributes	Programmers' application interface	Dependency network for linking objects and processes, applications and devices	High-level languages for describing behavior

field (Shu, 1986). Nevertheless, the usefulness of these tools in graphical simulation and behavior modeling is apparent, in addition to the need for relatively "seamless" interfaces for more conventional styles of program editing and debugging.

1.8 *Conclusion*

I have presented a conceptual framework for constructing and interacting with virtual objects and agents. We have looked at four abstraction mechanisms—*structural, procedural, functional*, and *agent* abstractions—and we have seen how the two interaction paradigms—*guiding* and *programming*—provide differing access for both *representation* and *control* at varying levels of abstraction. This analysis has allowed us to identify the kinds of access we require for defining and controlling computational models in virtual environments at varying levels of abstraction, ranging from the definition and joint space control of articulated structures, to task-level interaction with autonomous agents. These access components are summarized in Tables 1.2 and 1.3, which list the kinds of interaction that arise from applying guiding and programming tools for definition and editing, and for run time control, respectively.

By providing means to add, modify and create simulation components, virtual environments become easily reconfigurable. This has enabled us to readily adapt the BOLIO system for a variety of research applications, including investigations of task-level interaction with synthetic agents (McKenna et al., 1990), dynamic simulation of jointed figures (Schröder and Zeltzer, 1990), the perfor-

Table 1.3. Interaction components that result when applying guiding and programming tools as instruments for the run time control of instances of the four abstraction classes

Interaction Paradigm	Control			
		Abstraction Class		
	Structure	Procedure	Function	Agents
Guiding	Interactive Cartesian or joint-space motion control	Interactive parameter input at run time	Direct manipulation of motor units	Interactive specification of an agent's task goals and parameters
Programming	Physically based modeling	Typed, spoken, or computed run time input; Interprocessor communication	Simulated sensors for motion units	Natural language scripts

mance of various graphical and gestural input devices (Sturman et al., 1989), and the modeling of human facial tissue (Pieper, 1989). Ongoing work includes the design and implementation of a telerobotic interface for a remote maniupulator, and a terrain and flight path viewing system for aircraft mission planning.

Clearly, not every application requires all access modes—for example, a flight simulator or other simulation and training system need not provide a programmer's interface for end users. But given an application, one can ask which of the interaction components will be required. This framework has served us in the design and implementation of the BOLIO IGSP, and it will continue to guide system development as we enrich the simulated environment, and enhance the behavioral competence of the synthetic agents.

Acknowledgments

This work was supported in part by NHK (Japan Broadcasting Corp.), National Science Foundation Grant IRI-8712772, and an equipment grant from Hewlett-Packard, Inc.

References

Badler, N.L., Korein, J.D., Korein, J.U., Radack, G., and Shapiro Brotman, L. 1985. Positioning and animating human figures in a task-oriented environment. *The Visual Computer* 1(4): 212–220.

Badler, N.I., Manoochehri, K.H., and Walters, G. 1987. Articulated figure positioning by multiple constraints. *IEEE Computer Graphics and Animation* 7(6):28–38.

Barzel, R. and Barr, A.H. 1988. A modeling system based on dynamic constraints. *Proc. ACM SIGGRAPH, Computer Graphics* 22(4):179–188.

Bier, E. 1990. Snap-dragging in three dimensions. *Proc. 1990 Symposium on Interactive 3D Graphics*, March 25–28, Snowbird, Utah, pp. 193–204.

Blinn, J.F. 1982. Systems aspects of computer image synthesis. *Course Notes, Seminar on Three Dimensional Computer Animation*, ACM SIGGRAPH, Boston, Mass.

Boies, S., Green, M., Hudson, S., and Meyers, B. 1989. Panel: Direct manipulation or programming: How should we design user interfaces? *Proc. ACM SIGGRAPH Symposium on User Interface Software and Technology*, Nov. 13–15, Williamsburg, Virginia, pp. 124–126.

Bond, A.H. and Soetarman, B. 1988. Multiple abstraction in knowledge-based simulation. *Proc. Society for Computer Simulation Multiconference on Artificial Intelligence and Simulation*, Feb. 3–5, 1988, San Diego, Calif., pp. 61–65.

Braitenberg, V. 1984. *Vehicles: Experiments in Synthetic Psychology*. Cambridge, Mass.: MIT Press.

Brett, C., Pieper, S., and Zeltzer, D. 1987. Putting it all together: An integrated package for viewing and editing 3D microworlds. *Proc. 4th Usenix Computer Graphics Workshop*, October, Cambridge, Mass., pp. 2–12.

Brooks, C.P., Jr. 1986. Walkthrough—A dynamic graphics system for simulating virtual buildings. *Proc. 1986 ACM Workshop on Interactive 3D Graphics*, October 23–24, Chapel Hill, No. Carolina, pp. 9–21.

Brooks, C.P., Jr. 1988. Grasping reality through illusion—Interactive graphics serving science. *Proc. CHI '88*, May 15–19, Washington, D.C., pp. 1–11.

Brooks, R.A. 1989. The whole iguana. *Robotic Science*, ed. M. Brady. Cambridge, Mass.: MIT Press, pp. 432–456.

Chandrasekaran, B. 1985. Generic tasks in knowledge-based reasoning: Characterizing and designing expert systems at the "right" level of abstraction. *Proc. Second IEEE Conf. on Artificial Intelligence Applications*, December 11–13, Miami Beach, Florida, pp. 294–300.

Chang, S., Ichikawa, T., and Ligomenides, P.A. (eds.). 1986. *Visual Languages*. New York: Plenum.

Connell, J.H. 1989. A colony architecture for an artificial creature. A.I. Technical Report TR-1151. Cambridge, Mass.: Massachusetts Institute of Technology.

Denavit, J. and Hartenberg, R.B. 1955. A kinematic notation for lower-pair mechanisms based on matrices. *Journal of Applied Mechanics*, vol. 23, June, pp. 215–221.

Drewery, K. and Tsotsos, J. 1986. Goal directed animation using English motion commands. *Proc. Graphics Interface '86*, May 26–30, Vancouver, Canada, pp. 131–135.

Engelberger, J.F. 1989. *Robotics in Service*, Cambridge, Mass.: MIT Press.

Falkenhainer, B. and Forbus, K.D. 1988. Setting up large-scale qualitative models. *Proc. AAAI-88*, August 21–26, St. Paul, Minn., pp. 301–306.

Fisher, S.S., McGreevy, M., Humphries, J., and Robinett, W. 1986. Virtual environment display system. *Proc. 1986 ACM Workshop on Interactive Graphics*, October 23–24, Chapel Hill, No. Carolina, pp. 77–87.

Fishwick, P.A. 1988. The role of process abstraction in simulation. *IEEE Trans. Systems, Man, and Cybernetics*, 18(1):18–39.

Forbus, K.D. 1988. Intelligent computer-aided engineering. *AI Magazine* 9(3):23–26.

Gelfand, I.M., Gurfinkel, V.S., Tsetlin, M.L., and Shik, M.L. 1971. *Models of the Structural-Functional Organization of Certain Biological Systems*. Cambridge, Mass.: MIT Press.

Ginsberg, C. and Maxwell, D. 1983. Graphical marionette. *Proc. ACM SIGGRAPH/SIGART Workshop on Motion*, April, Toronto, Canada, pp. 172–179.

Girard, M. and Maciejewski, A.A. 1985. Computational modeling for the computer animation of legged figures. *Proc. ACM SIGGRAPH, Computer Graphics* 19(3):263–270.

Gomez, J.E. 1984. Twixt: A 3-D Animation System. *Proc. Eurographics '84*. Amsterdam: North-Holland.

Greene, P.H. 1972. Problems of organization of motor systems. *Progress in Theoretical Biology*, vol. 2. New York: Academic Press, pp. 303–338.

Grillner, S. 1975. Locomotion in vertebrates. Central mechanisms and reflex interaction. *Physiological Reviews* 55(2).

Haeberli, P.E. 1988. ConMan: A visual programming language for interactive graphics. *Proc. ACM SIGGRAPH, Computer Graphics* 22(4):103–111.

Hahn, J.K. 1988. Realistic animation of rigid bodies. *Proc. ACM SIGGRAPH, Computer Graphics* 22(4):299–308.

Haumann, D.R. and Parent, R.E. 1988. The behavioral test-bed: Obtaining complex behavior from simple rules. *The Visual Computer* 4(6):332–347.

Kantowitz, B.H. and Casper, P.A. 1988. Human workload in aviation. *Human Factors in Aviation*, ed. E.L. Wiener and D.C. Nagel. San Diego: Academic Press, pp. 157–187.

Levitt, D. 1986. HookUp: An iconic programming language for entertainment. *Proc. COMPSAC Conf. on Software and Applications*, October.

Lorenz, K.Z. 1981. *The Foundations of Ethology*. New York: Simon and Schuster.

Lowther, K. 1985. *Modelling Movement through Environments: Giving Characters a Sense of Where They Are*. MSVS Thesis. Cambridge, Mass.: Massachusetts Institute of Technology, August.

Maes, P. 1989. How to do the right thing. A.I. Memo 1180. Cambridge, Mass.: Massachusetts Institute of Technology, December.

Magnenat-Thalmann, N. and Thalmann, D. 1983. The use of high-level 3-D graphical types in the Mira animation system. *IEEE Computer Graphics and Applications* 3(9):9–16.

Marcus, B.A. and Churchill, P.J. 1988. Sensing human hand motions for controlling dexterous robots. *Proc. Second Annual NASA/USAF Space Operations Automation and Robotics Workshop*, July 20–23, Wright State University.

McGhee, R.B. 1976. Robot locomotion. *Neural Control of Locomotion*, ed. R. Herman. New York: Plenum, pp. 237–264.

McKenna, M., Pieper, S., Zeltzer, D. 1990. Control of a virtual actor: The Roach. *Proc. 1990 Symposium on Interactive 3D Graphics*, March 25–28, Snowbird, Utah, pp. 165–174.

Meyers, B.A., Vander Zanden, B., and Dannenberg, R.B. 1989. Creating graphical interactive application objects by demonstration. *Proc. ACM SIGGRAPH Symposium on User Interface Software and Technology*, Nov. 13–15, Williamsburg, Virginia, pp. 95–104.

Minsky, M. 1975. A framework for representing knowledge. *The Psychology of Computer Vision*, ed. P. Winston. New York: McGraw-Hill.

Minsky, M. 1987. *The Society of Mind*. New York: Simon and Schuster, 1987.

Moore, M. and Wilhelms, J. 1988. Collision detection and response for computer animation. *Proc. ACM SIGGRAPH, Computer Graphics* 22(4):289–288.

Moorthy, V.S and Chandrasekaran, B. 1983. A representation for the functioning of devices that support compilation of expert problem solving structures. *Proc. IEEE Medcomp '83*, September.

Pearson, K. 1976. The control of walking. *Scientific American* 235(6):72–86.

Pieper, S.D. 1989. *More than Skin Deep: Physical Modeling of Facial Tissue*. M.S. Thesis. Cambridge, Mass.: Massachusetts Institute of Technology, February.

Platt, J.C. and Barr, A.H. Constraint methods for flexible models. *Proc. ACM SIGGRAPH, Computer Graphics* 22(4):279– 288.

Poizner, H., Klima, E.S., Bellugi, U., and Livingston, R.B. 1983. Motion analysis of grammatical processes in a visual-gestural language. *Proc. ACM SIGGRAPH/SIGART Workshop on Motion*, April, Toronto, Canada, pp. 148–171.

Reynolds, C.W. 1981. Computer animation with scripts and actors. *Proc. ACM SIGGRAPH, Computer Graphics*, 16(3):289– 296.

Ridsdale, G., Hewitt, S., and Calvert, T.W. 1986. The interactive specification of human animation. *Proc. Graphics interface '86*, May 26–30, Vancouver, Canada.

Schafer, P. 1989. *Try to Describe This Over the Phone: An Investigation of the Communication of Shape*. M.S. Thesis. Cambridge, Mass.: Massachusetts Institute of Technology.

Schöner, P. and Zeltzer, D. 1990. The virtual erector set: Dynamic simulation with linear recursive constraint propagation. *Proc. 1990 Symposium on Interactive 3D Graphics*, March 25–28, Snowbird, Utah, pp. 23–31.

Shu, N.C. 1986. Visual programming languages: A perspective and dimensional analysis. *Visual Languages*, ed. S. Chang, R. Ichikawa, and P.A. Ligomenides. New York: Plenum, pp. 11– 34.

Sims, K. 1987. *Locomotion of Jointed Fingers Over Complex Terrain*. MSVS Thesis. Cambridge, Mass.: Massachusetts Institute of Technology.

Sims, K. and Zeltzer, D. 1988. A figure editor and gait controller for task level animation. *Course Notes, Synthetic Actors: The Impact of Robotics and Artificial Intelligence on Computer Animation*, ACM SIGGRAPH, August 2, Atlanta, Georgia.

Sturman, D., Zeltzer, D., and Pieper, S. 1989. Hands-on interaction with virtual environments. *Proc. ACM SIGGRAPH Symposium on User Interface Software and Technology*, November 13–15, Williamsburg, Virginia, pp. 19–24.

Sturman, D., Zeltzer, D., and Pieper, S. 1989. The use of constraints in the bolio system. *Course Notes, Implementing and Interacting with Realtime Microworlds*, ACM SIGGRAPH, July 31, Boston, Mass.

Terzopoulos, D. and Fleischer, K. 1988. Deformable models. *The Visual Computer* 4(6):306–331.

Tinbergen, N. 1969. *The Study of Instinct*. London: Oxford University Press.

Travers, M. 1988. Animal construction kits. *Artificial Life*, ed. C. Langton. Reading, Mass.: Addison-Wesley, pp. 421–442.

Turvey, M.T., Fitch, H.L., and Tuller, B. 1982. The problems of degrees of freedom and context-conditioned variability. *Human Motor Behavior*, ed. J.A.S. Kelso. Hillsdale, N.J.: Lawrence Erlbaum Associates.

Wasserman, A.I. 1981. Toward integrated software development environments. *Software Development Environments*, ed. A.I. Wasserman. New York: IEEE Computer Society, pp. 15–35.

Wilhelms, J. 1987. Using dynamic analysis for realistic animation of articulated bodies. *IEEE Computer Graphics and Applications* 7(6):12–27.

Williams, L. 1982. BBOP. *Course Notes, Seminar on Three-Dimensional Computer Animation*. ACM SIGGRAPH, July 27.

Zeltzer, D. 1982. Motor control techniques for figure animation. *IEEE Computer Graphics and Applications* 2(9):53–59.

Zeltzer, D. 1982. Representation of complex animated figures. *Proc. Graphics Interface '82*, May, Toronto, Canada, pp. 205–211.

Zeltzer, D. 1983. Knowledge-based animation. *Proc. ACM SIGGRAPH/SIGART Workshop on Motion*, April, Toronto, Canada, pp. 205–211.

Zeltzer, D. 1985. Towards an integrated view of 3-D computer animation. *The Visual Computer*, 1(4):249–259.

Zeltzer, D. 1987. Motor problem solving for three dimensional computer animation. *Proc. L'Imaginaire Numerique*, May 14–16, Saint-Etienne, France.

Zeltzer, D., Pieper, S., and Sturman, D. 1989. An integrated graphical simulation platform. *Proc. Graphics Interface '89*, June 19–23, London, Ontario.

Zimmerman, T.G., Lanier, J., Blanchard, C., Bryson, S., and Harvill, Y. 1987. A hand gesture interface device. *Proc. CHI+GI 1987*, April 5–9, Toronto, Canada, pp. 189–192.

2

Composition of Realistic Animation Sequences for Multiple Human Figures

Tom Calvert

Centre for Systems Science
Simon Fraser University
Burnaby, British Columbia

ABSTRACT

The two major problems that must be addressed in producing realistic animation of multiple human figures are the design of bodies (with clothing) and the specification of movement. This chapter discusses movement specification and the developments that are needed for animation to progress from kinematic methods to an ideal intelligent system that interfaces with the creative process of the animator and provides multiple knowledge bases to relieve the animator of tedious detail work. The new system will incorporate knowledge of the personal and physical characteristics of the figures to be animated as well as strategies to carry out specific tasks. The system will produce feasible movement patterns from very general high-level inputs. In addition to the general discussion, several projects at Simon Fraser University that address various aspects of the movement specification problem are described.

2.1 *Introduction*

The animation of a few solid objects is challenging, but the realistic animation of human figures is so difficult that it is rarely attempted in production animation. The two major difficulties are the design of realistic body models and the speci-

fication of realistic movement. It is quite straightforward to produce reasonable movement on bodies that approximate the human form, but we are not very close to producing either bodies or movement that would fool an observer into thinking that they were real. One of the reasons this problem is so difficult is that body language is an important element of interpersonal communication, and we are all sensitized to observe the movement of others very carefully indeed.

Both in movement specification and body design, the best results have been obtained when an animator works for many hours to meticulously define the path or the shape by hand. Thus, it is not surprising that much of the current research concentrates on knowledge-based systems that take advantage of *a priori* knowledge about the problem to relieve the animator of tedious work. This chapter presents some ideas on an ideal system for realistic movement specification for multiple human figures; the issue of realistically rendering clothed bodies that maintain their realism as the bodies change shape will not be pursued. The ideal system depends on an understanding of the creative processes involved in composition of complex movement sequences as well as an understanding of the different ways in which knowledge about the physical, biological, psychological, and functional aspects of human movement can be built into an intelligent knowledge-based system for movement specification. The chapter will also briefly summarize several projects at Simon Fraser University that address various aspects of the problem.

2.2 An Abstraction of the Compositional Process

In order to design the ideal animation system, we first have to understand something about the creative process involved in composition or design. This process is poorly understood. Not only is the process different for each individual, but it changes from time to time for a given individual. However, some generalizations are possible (Simon, 1969).

2.2.1 The Hierarchy of Abstraction

Initially, there is a general outline of the composition or design; this can be a simple sketch or merely an idea in the mind of the artist. This is the highest-level conceptualization of the shape, energy flows, and timing of the composition. Because it is inherently an abstraction, this highest level is the most difficult to represent. The composition then becomes successively more concrete as details are added and the process moves to lower and lower levels of abstraction. The lowest level in the abstraction hierarchy is a complete realization of the composition as a fully rendered animation. An important element of the creative process is the need to move flexibly back and forth between levels. Successive refinement of the low-level details may reveal the need to change the high-level theme (Calvert, 1986).

2.2.2 *Alternate Views*

Since the human mind can handle only a limited number of independent variables at one time, it is important to be able to simplify the task and to study the composition of an animation from different points of view (Simon, 1969). For example, in composing an animation of multiple human figures, at any point in time the spatial interrelationships of the figures should be available for study and refinement. As well, a representation analogous to a musical score should allow the animator to review and edit developments over time. A third view should allow the movement paths of the figures on the stage to be specified and edited. All of these components of the final, fully rendered realization should be available for preview at any stage with minimal delay. It is important for the animator to have flexible access to these alternate views and to be able to move back and forth between them.

2.3 *The Ideal System*

Based on this discussion of the composition process, it is proposed that an ideal animation system for human figure animation should have the following general characteristics:

1. At the highest level, the system will accept natural language and graphical input with about the same information content and complexity as that found in the script for a film or a play. Presumably, the characters to be animated will be identified, and their special characteristics will be described, where these are considered to be important. There will be standard stage directions ("Bill enters stage left"). It is expected that from this input the system will generate a feasible animation. The general nature of such a high-level system was discussed in a recent paper (Calvert, 1986).

2. At a second, intermediate level, the high-level input will generate a detailed script. This script will provide the details of the movements for the figures in terms such as gait and style of gesture as well as the start times and durations for all movements. The important feature of this score is that it is readable by the animator and can be added to or edited. It is in this way that the animator can adjust the feasible animation generated by the system to what is really needed.

3. The third and lowest level comprises detailed movement instructions for each limb segment as a function of time, possibly implemented using hierarchical channel tables. These instructions are also accessible to the animator, but it is assumed that they are seldom changed, except for "fine tuning."

These characteristics imply that underlying the "ideal system" there will be a comprehensive intelligent structure incorporating multiple knowledge bases and a powerful reasoning capability. There will also have to be a strong computational capability to implement rendering algorithms, simulations for dynamically specified movement, and the like.

2.4 *Approaches to Movement Specification for Articulated Bodies*

The development of a comprehensive system for the realistic animation of multiple human figures will be based on a number of existing approaches. The reality of movement specification today is that we have some very well-developed kinematic methods and some research that points to new approaches using dynamic simulation and expert systems. In this section, key approaches are summarized and applied to the more comprehensive "ideal system."

2.4.1 *Kinematic Specification*

The animation of an articulated structure requires that a support position be defined in three dimensions and that three angles be specified for each body segment. Using kinematic methods, this can be obtained from live action, from notation, or by interactive graphical specification.

2.4.2 *Live Action in Kinematic Specification*

The difficulty in kinematic specification is to find ways to allow the animator to handle the complexity involved in the many (40–200) interacting parameters needed to specify the body. Thus it is not surprising that ways have been found to copy movement patterns from living human subjects. This can be done by "rotoscoping," that is, by recovering data from film or video, or by using some form of electronic instrumentation.

Rotoscoping involves digitizing the joint coordinates of all body segments from at least two orthogonal views recorded on film or video. This tedious approach is also important in biomechanics research, and there is a continuing interest in automating it, but the pattern recognition problems involved are quite difficult. An excellent example of this approach at its best can be seen in the Robert Able Associates SIGGRAPH video *The Making of Brilliance* (Able, 1985).

Live movement can also be captured in realtime with special instrumentation. Goniometers provide a relatively inexpensive method, and we have experimented with this approach (Calvert et al., 1980). The major disadvantage is that the measuring equipment inhibits the free movement of the subject. A subject can move more freely with lighter time-multiplexed light-emitting diodes

attached to the joints; the SELSPOT and WATSMART systems are commercial examples of this rather expensive approach. A promising approach that is currently under development involves a specially instrumented bodysuit that gives the computer real-time analog signals proportional to the angle of each joint. This is an extension of the use of goniometers and the VPL DataGlove.

Much of the commercial animation of human figures has used one of these approaches. The movement patterns digitized with any of these methods can be normalized for speed and body size and stored in a library of fundamental movement patterns. Although this specification approach is difficult to generalize, it does provide a method to capture the subtle movement patterns of an individual.

2.4.3 *Notation*

Movement patterns can also be specified with notation; this approach has been used for recording dance for many decades (Benesh and Benesh, 1956; Eshkol and Wachmann, 1958; Hutchinson, 1960). A number of computer-based systems have been developed to edit or interpret Labanotation (Badler and Smoliar, 1979; Calvert, Chapman and Patla, 1982), Benesh notation (Politis, 1987; Ryman et al., 1984), and Eshkol-Wachmann notation scores. Our own experience with Labanotation has shown that it provides a viable method to specify animation but that, even with the addition of a macro capability, it is extremely tedious. (Some might compare it with programming in assembly language, and even dancers do not find it easy to learn.) However, this approach has the great advantage that it relies on the animator's conceptualization of the movements required, and it certainly lends itself to the development of complicated scores. Other advantages of this approach are that the resulting score provides a method summarizing the development of the animation over time and that the score can be edited and changed.

2.4.4 *Interactive Specification*

A third approach is essentially three-dimensional keyframing. This involves the interactive specification of body positions in a 3-D graphics environment. The user is presented with a space-filling vector representation of the human body on the screen of a graphics workstation. The body can be viewed from any angle with a perspective projection under the control of a mouse or equivalent device. The body segments can be picked (again with a mouse or equivalent device), and the orientation of each segment is specified by the user. The end result is directly equivalent to the output from notation, but the user has direct visual feedback and finds the adjustments to be reasonably natural and intuitive.

In order to develop a sequence of animation on the computer, the animator performs four main steps: the design of a sequence of body positions, the interactive generation of the keyframes, the calculation of intermediate frames by

interpolation, and a motion test of the results. Examples of systems implementing this approach include those developed at New York Institute of Technology (Van Baerle, 1987) and Simon Fraser University (Ridsdale et al., 1986).

2.4.5 *Kinematic Animation of Multiple Figures*

The animation of a single figure involves a significant number of parameters for each keyframe (between 40 and 200 or more). With multiple figures, the problem becomes even more difficult for the human animator. In an attempt to study how scenes with multiple figures can be composed, we have been working with dance choreographers, Catherine Lee and Thecla Schiphorst. We have developed a prototype system, COMPOSE, for outlining a sequence for multiple figure animation, where the paradigm is parallel to that of the outline processors for text (Calvert et al., 1986, 1989; Lee, 1988).

The animator first sees a screen (Figure 2.1), which is divided into a number of windows. Down one side there is a menu of figures in standard stances; up to 18 figures in standing, lunging, sitting, kneeling, or lying positions can be displayed at any one time. The largest display provides a view of the stage, which the animator can continually adjust by using the mouse.

The animator starts by setting up an initial scene. Figures are chosen from the menu of stances and are placed on the floor plan using the mouse (note that additional figures can be defined and added to the stance menus at any time). Their facings are then individually adjusted. Different figures are identified with different colors or a label. When the initial scene is satisfactory, it is stored, and

Figure 2.1 The Stage Display with a Stance Menu from the Macintosh Version of COMPOSE

a second one is created; this is repeated for as many scenes as are needed to define this segment of the animation. These scenes are similar to the series of storyboard sketches used in planning a film, but the interactive 3-D workstation allows the animator to zoom in or zoom out from the stage and to view it from any angle.

In addition to the display of figures on the stage, a timeline display, somewhat analogous to a musical score, provides a summary of the body stances for each figure as they develop over time (Figure 2.2). This timeline display provides an alternative way to build up the animation, and it can be edited in much the same way as text on a word processor (cut, paste, and so forth). Since the timeline cannot show the paths followed by the figures in space, this is available in a path display, which can also be edited.

The COMPOSE system has been implemented on Silicon Graphics IRIS and Apple Macintosh computers. Initial experience shows that, although it is still a kinematic animation system, the use of stance menus of predefined figures and the use of timeline and path displays make it a viable tool for the animation of multiple figures.

2.4.6 *Physically Based Movement Specification*

An obvious approach to the specification of natural movement is to make use of our knowledge of the dynamic properties of physical objects, that is, they must obey Newton's laws of motion. Although the simulation of the movement of simple solids in frictionless space is straightforward, the dynamic simulation of

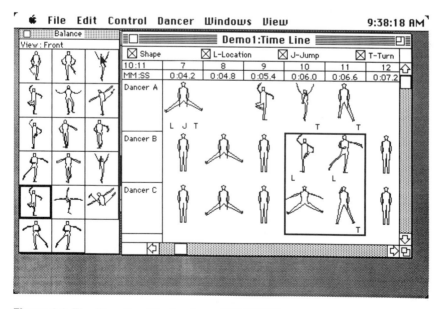

Figure 2.2 The Timeline Display from COMPOSE

an articulated structure with the complexity of the human body is less simple. Problems arise when estimating the dynamic parameters (such as moments of inertia, centers of mass, joint friction, and muscle and ligament elasticity), and solving a system of dynamic equations turns out to be computationally rather expensive. The biggest challenge with this approach, however, has been to find intuitive ways to specify and control motion since it requires knowledge of the joint torques and external reaction forces to solve the dynamic equations and produce animation. Joint torques are produced by the human muscles and are generally under voluntary control. For a moving human subject, these joint torques are, in a real sense, unknowable, although methods exist to estimate them. In spite of the fact that it is difficult to estimate parameters and torques, this approach is quite attractive since the kind of movement that is produced will have some "natural" qualities even if the estimates are inaccurate.

A number of groups are investigating this approach (Armstrong and Green, 1985; Badler, 1986; Bruderlin and Calvert, 1989; Wilhelms and Barsky, 1985). Human figure models have been produced that, for example, react in a natural way when pulled from a sitting to a standing position. It is not so clear, however, that a complete simulation approach will provide the best way to generate complex voluntary movement. It can be argued that the way in which many human movements are stored internally is more kinematic than kinetic. Nevertheless, since dynamic simulation guarantees physically realistic movement, it provides the best knowledge base for movements that are limited dynamically. Perhaps a "dynamic filter" can be developed to ensure that kinematically specified movement is more natural. An approach we have developed to use dynamic simulation to animate realistic human walking is next described briefly.

2.4.7 A Physically Based Approach to Human Locomotion

Certain types of movement, such as walking and running, are conceptually well understood, yet a complete dynamic simulation of such actions is infeasible because generating the proper torques for a locomotion cycle is complicated by such problems as balance and coordination of the legs. However, kinematic approaches are inflexible and typically produce a "weightless," unrealistic animation.

At Simon Fraser University, Armin Bruderlin has adopted a hybrid kinematic/dynamic approach (Bruderlin, 1988; Bruderlin and Calvert, 1989). Much like Zeltzer (1982), he incorporates knowledge of the locomotion cycle into a hierarchical motion control process. The key idea is that the system "knows" about certain classes of motion and provides the animator with a set of movement commands or parameters that completely control the figure. The animator no longer has to specify joint angles over time because the system, once initiated, is able to autonomously execute a desired motion. This approach parallels our understanding from neurophysiology of how complex articulated movements are controlled in mammals (see Figure 2.3).

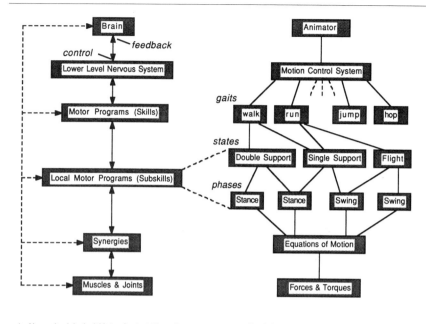

a) Neurophysiological Motor Control Hierarchy b) Animation of Legged Locomotion

Figure 2.3 Model of Articulated Motion Control

In order to animate bipedal locomotion, the animator takes over the tasks of the brain in the neurophysiological model. At the top level, the desired motion is initialized by specifying such parameters as step length, step frequency, or velocity. The lower level nervous system is represented by the motion control system, which contains knowledge about locomotion. Depending on the animator's specification, the control system selects a proper gait that is then decomposed by the (local) motor programs into its underlying components. Every gait (for example, walking) is made up of the different states (for example, a single support state, where one foot is off the ground). These states, in turn, are broken up into the individual leg phases (e.g., stance and swing phases). Thus, a gradual reduction in the number of degrees of freedom, along with a decrease in the levels of coordination, is achieved by the control system, which parallels that of its natural, biological counterpart. At the bottom level, knowledge is incorporated in the dynamic equations of motion for the legs. Like the synergies, these equations are tailored to perform a specific application. For example, a compound pendulum simulates the swing leg. The dynamics can be considered the low-level, executive parts of the control, which produce natural movements while guided and coordinated by higher levels.

Figure 2.4 Display of a Walking Figure

Our experience suggests that this hybrid of dynamic and goal-directed techniques provides a useful method of animating walking and running under a fairly wide range of conditions. The hierarchical decomposition of a task supports a convenient motion specification, and the dynamic equations of motion produce realistic locomotion patterns. A single frame taken from a typical walking sequence generated by this approach is illustrated in Figure 2.4.

2.4.8 AI-based Specification

The notion of using AI and expert systems approaches to capture the knowledge and skills of the animator is obvious, but the implementation is not. At one level, it is fairly straightforward to build up a knowledge base of movement characteristics for the body. These will include basic data on the individual being animated (such as physical dimensions and moments of inertia) and such constraints as the range of movement for specific joints. The knowledge base should also include typical movement patterns for locomotion, simple voluntary movements such as grooming habits or shaking hands, and characteristics of the individual that determine how the movements are carried out (brisk, lethargic, happy, sad, and so forth).

At the highest level, the system should be able to deduce feasible animation for goal-oriented tasks. This would include, for example, feasible movements for the three or four characters on stage in a television situation comedy or a feasible

animation for a crowd scene with a dozen people walking up and down a sidewalk. Note that people follow quite tight rituals for their body movements when they meet strangers, those known slightly, or close friends (Birdwhistell, 1970). This system can also build on work such as that of Reynolds (1987) on flocking and that of Wilhelms on complex behaviors of simple creatures (Wilhelms, 1990).

There has been some research in this direction (Zeltzer, 1983). Badler (1985) has used a constraint base to constrain his dynamic simulations, and Drewery and Tsotsos (1986) have studied a frame-based approach to goal-directed animation. The animation produced by the Human Factory system of Magnenat-Thalmann and Thalmann (1987) is impressive. Another approach to this problem has been taken by Gary Ridsdale. He has developed a system for human figure animation that finds feasible movement paths that take account of the feelings of the characters being animated as well as other environmental factors (Ridsdale, 1987).

2.4.9 *The Director's Apprentice*

Another problem that Ridsdale addressed in his Director's Apprentice system was the placement of figures in the scene. The rule base includes some of the standard rules of direction for the placement of actors on a stage and for their movement as the action proceeds. It also allows the animator to enter personal information about each character. This might take the form of "John hates Mary," "Mr. Jones is the boss of Mr. Smith," or "Bill irritates Simon." Then, as action proceeds, mainly through ongoing conversation between the characters, feasible movement patterns are predicted by the system. The system is driven by a script, which at this point is used only to indicate which character is speaking. Consideration of the meaning of each utterance is well beyond our current plans.

Not surprisingly, it has been found that the different rules of direction and the rules describing the characters are often in conflict. Thus, mechanisms must be developed to provide feasible solutions that in some sense minimize these conflicts; obviously, there will be no unique results, and the animator may wish to apply judgment to the weighting of different rules.

2.4.10 *Secondary Movement*

A rather different approach to the use of knowledge has been adopted by Claudia Morawetz at Simon Fraser University, who has developed the GESTURE system for animation of secondary movement (Morawetz, 1990). Although other approaches can provide the specification of correct movement patterns to achieve high-level goals, the movement will not be realistic unless it includes those subtle secondary gestures that humans add to their primary movement. Secondary movement involves much of the body language that is so crucial to subconscious nonverbal communication (Scheflen, 1972). Morawetz's system

Figure 2.5 Two Interacting Human Figures in the GESTURE System

allows the animator to define the specific *personality* of the individual actor (extrovert vs. introvert, cheerful vs. gloomy, assertive vs. passive, domineering vs. submissive) as well as the *moods* that affect the actor from time to time (boredom, nervousness, fatigue, impatience, fear). As implemented, the GESTURE system generates secondary movement for two characters walking toward each other (see Figure 2.5).

The rule base developed by Morawetz is only partially complete, and we have dubbed the system that uses it a "mock expert system" since it does not truly reason about the facts available. Considerable additional work is necessary to analyze the extensive literature on body language and to incorporate it into an expert system. Nevertheless, even this simple implementation has shown that interesting movement can be produced automatically.

One of the problems that Morawetz had to address in developing this system was the representation of gestures. Her approach is similar to Zeltzer's (1983). However, whereas Zeltzer uses frames to represent movement, she uses a graph in which the execution of a sequence of movements is equivalent to traversing the graph. Nodes in the graph contain joint angle values for a collection of joints. These can be looked upon as key positions for a set of joints in the body model. Arcs are labeled with the names of different movements and a number indicating the number of frames between key positions. This representation is very flexible

since a graph can encode results from arbitrary motion algorithms, such as from a dynamic simulation, as easily as from keyframe movement. This can be done by enhancing the graph with nodes representing the motion data and creating appropriate arcs connecting these nodes.

Since nodes in the graph correspond to body positions, the graph would become unmanageably large if all possible body positions were included in one graph. One way the number of nodes can be reduced is to take advantage of the fact that most gestures do not involve the whole body. Usually a gesture is performed by one arm, the head, the torso, or some simple combination, so to reduce the number of nodes and avoid repeating information, nodes are grouped into separate graphs, each graph pertaining to a unique set of joints that form one body part.

Secondary movement can be classified as "destination" movements, which terminate after a fixed period of time (such as placing a hand on the waist), and "action" movements, which continue until they are interrupted by another movement (such as rubbing an eye). Action movements are implemented by cycling through nodes in a graph. When an interruption occurs, the node is created. The joint angles of the interruption node are obtained by interpolating between the nodes at either end of the arc that was being traversed. When the graph traversal continues, the temporary node adopts the arcs from whichever of the two nodes was closer when the interruption occurred. This method of supporting interruptions allows new movements to begin at any specified time.

Our current goal is to build on the work of Ridsdale and Morawetz and to develop expert systems that incorporate the "text-book" rules of direction as well as specific information about individual characters in the action. With this information stored in rule bases, the expert system can provide the animator with an initial framework for the action; the animator would then experiment with a number of alternatives in arriving at one or more sequences.

2.5 *Toward an Ideal System*

The ideal characteristics outlined above are currently unachievable, but many of the components exist. Reasoning systems with multiple knowledge bases can take account of the personal and physical characteristics of the figures to be animated and can provide feasible movement patterns for specified tasks. Physically based simulation provides a particular source of the knowledge necessary for realistic movement. With a better understanding of the creative processes involved in the composition of animation sequences, more flexible user interface and visualization tools are being developed. However, some difficult problems remain. Probably the most difficult will be the animation of the human face. It was pointed out above that humans critically observe each other's movements as a means of communication, and the most critical observation is reserved for the face. At least for the meantime, however, we can look forward to very realistic animation of crowd scenes where the faces are indistinct.

Acknowledgments

The work described here was supported in part by grants from the Social Sciences and Humanities Research Council of Canada, the Natural Sciences and Engineering Research Council of Canada, and the Centre for Systems Science at Simon Fraser University. The author gratefully acknowledges the contributions of Severin Gaudet, Chris Welman, Catherine Lee, Armin Bruderlin, Claudia Morawetz, Gary Ridsdale, Thecla Schiphorst, and John Dill.

References

Able, R., et al. 1985. The making of BRILLIANCE, *SIGGRAPH Video Review*, Issue 20, ACM, New York.

Armstrong, W.W. and M. Green. 1985. The dynamics of articulated rigid bodies for purposes of animation. *Proc. Graphics Interface '85*, Canadian Information Processing Society, Toronto, Ontario, pp. 407–416.

Badler, N.I. 1986. Animating human figures: Perspectives and directions. *Proc. Graphics Interface '86*, Canadian Information Processing Society, Toronto, Ontario, pp. 115–120.

Badler, N.I., et al. 1985. Positioning and animating figures in a task oriented environment. *The Visual Computer*, pp. 212–220.

Badler, N.I., J. O'Rourke and H. Toltzis. 1979. A spherical representation of a human body for visualizing movement. *Proc. IEEE* 67:1397–1402.

Badler, N.I. and S.W. Smoliar. 1979. Digital representation of human movement. *Computing Surveys* 11:19–38.

Benesh, R. and J. Benesh. 1956. *An Introduction to Benesh Dance Notation*. A. C. Black, London.

Bergeron, P. 1985. Techniques for animating characters. *SIGGRAPH '85 Tutorial Notes*, ACM, New York.

Birdwhistell, R.L. 1970. *Kinesics and Context: Essays on Body Movement Communication*. Univ. of Pennsylvania Press, Philadelphia.

Bruderlin, A. 1988. *Goal Directed Animation of Bipedal Locomotion*. MSc Thesis, School of Computing Science, Simon Fraser University.

Bruderlin, A. and T.W. Calvert. 1989. Goal-directed dynamic animation of human walking, *Computer Graphics, Proc. SIGGRAPH '89* 23(3):233–242.

Calvert, T.W. 1986. Towards a language for human movement. *Computers and the Humanities* 20(2):35–43.

Calvert, T.W., J. Chapman, and A. Patla. 1982. Aspects of the kinematic simulation of human movement. *IEEE Computer Graphics and Applications* 2(9): 41–50.

Calvert, T.W., J. Chapman and A. Patla. 1980. The integration of subjective and objective data in animation of human movement. *Computer Graphics* 14(3): 198–203.

Calvert, T.W., C. Lee, G. Ridsdale, S. Hewitt, and V. Tso. 1986. The interactive composition of scores for dance. *Dance Notation Journal*.

Calvert, T.W., C. Welman, S. Gaudet, and C. Lee. 1989. Composition of multiple figure sequences for dance and animation. In R.A. Earnshaw and B. Wyvill (Eds), *New Advances in Computer Graphics, Proc. Computer Graphics International Conf.*, Tokyo, Springer-Verlag, pp. 245–255.

Drewery, K. and J. Tsotsos. 1986. Goal directed animation using English motion commands. *Proc. Graphics Interface '86*, Canadian Information Processing Society, Toronto, Ontario, pp. 131–135.

Eshkol, N. and A. Wachmann. 1958. *Movement Notation*. Weidenfeld and Nicholson, London.

Hutchinson, A. 1960. *Labanotation*. Theatre Arts Books, 2nd edition, New York.

Lee, C. 1988. A New Way to Make Dances. *Dance in/au Canada* 55:16–23.

Magnenat-Thalmann, N. and D. Thalmann. 1987. The direction of synthetic actors in the film *Rendez-vous à Montréal. IEEE Computer Graphics and Applications* 7(12):9–19.

Morawetz, C. 1990. A framework for goal-directed human animation with secondary movement. *Proc. Graphics Interface '90*, Canadian Information Processing Society, Toronto, Ontario, pp. 123–130.

Morawetz, C. 1989. *A High Level Approach to Animating Secondary Human Movement*. MSc Thesis, School of Computing Science, Simon Fraser University.

Politis, G. 1987. *A Computer Graphics Interpreter for Benesh Movement Notation*. PhD Thesis, Dept. of Computer Science, University of Sydney.

Reynolds, C. 1987. Flocks, herds and schools: a distributed behavioral model. *Proc. SIGGRAPH '87, Computer Graphics* 21(4):25–34.

Ridsdale, G. 1987. *The Director's Apprentice: Animating Figures in a Constrained Environment*. PhD Thesis, School of Computing Science, Simon Fraser University.

Ridsdale, G., S. Hewitt and T.W. Calvert. 1986. The interactive specification of human animation. *Proc. Graphics Interface '86*, Canadian Information Processing Society, Toronto, Ontario, pp. 121–130.

Ryman, R., A. Singh, J.C. Beatty, and K.S. Booth. 1984. A computerized editor for Benesh movement notation. *CORD Dance Research Journal* 16:27–34.

Scheflen, A.E. 1972. *Theory of Body Language and the Social Order*. Prentice Hall Inc., Englewood Cliffs, NJ.

Simon, H.A. 1969. *The Sciences of the Artificial*. MIT Press, Cambridge, MA.

Van Baerle, S. 1987. A case study of flexible figure animation. *SIGGRAPH '87 Tutorial Notes*, ACM, New York.

Wilhelms, J. and R. Skinner. 1990. A "notion" for interactive behavioral animation control. *IEEE Computer Graphics and Applications* 10(3):14–22.

Wilhelms, J. and B.A. Barsky. 1985. Using dynamic analysis to animate articulated bodies such as humans and robots. *Proc. Graphics Interface '85*, Canadian Information Processing Society, Toronto, Ontario, pp. 97–104.

Zeltzer, D. 1983. Knowledge based animation. *Proc. ACM SIGGRAPH/SIGART Workshop on Motion*, pp. 187–192.

Zeltzer, D. 1982. Motor control techniques for figure animation. *IEEE Computer Graphics and Applications* 2(9):53–59.

3

Animation from Instructions

Norman I. Badler, Bonnie L. Webber,
Jugal Kalita, and Jeffrey Esakov

Department of Computer and Information Science
University of Pennsylvania
Philadelphia, Pennsylvania

ABSTRACT

We believe that computer animation in the form of *narrated animated simulations* can provide an engaging, effective and flexible medium for instructing agents in the performance of tasks. However, we argue that the only way to achieve the kind of flexibility needed to instruct agents of varying capabilities to perform tasks with varying demands in work places of varying layout is to drive *both* animation and narration from a *common representation* that embodies the same conceptualization of tasks and actions as *natural language* itself. To this end, we are exploring the use of natural language *instructions* to drive animated simulations. In this chapter, we discuss the relationship between instructions and behavior that underlie our work and the overall structure of our system. We then describe in somewhat more detail three aspects of the system—the representation used by the *simulator*, the operation of the simulator and the *motion generators* used in the system.

3.1 *Introduction*

The enterprise we have embarked on rests on a two-part argument:

- *Narrated animations* are an engaging and extremely effective medium for instructing agents in task performance. Moreover, coupled with the emerg-

ing technology of *virtual reality* (Fisher et al., 1986), narrated animations can provide a low-cost way of giving learners "personal" trainers and "on-site" environments in which to train.

• The only way to create the kind of *flexible* narrated animations needed to instruct agents of varying capabilities to perform tasks with varying demands in work places of varying layout is to drive *both* animation and narration from a *common representation* that embodies the same conceptualization of tasks and actions as natural language itself.

Here we explain and elaborate this argument, before describing our own efforts towards creating narrated animations.

To argue the first point—that narrated animations are an engaging and extremely effective medium for instructing agents in task performance—we need to answer three questions:

1. Why narrated *animations*? Why not just *annotated* or *captioned still images*?

2. Why *narrated animations*? Why not just movies or videotapes of human agents carrying out the tasks?

3. Why *narrated* animations? Why not animation alone?

Annotated or captioned stills are clearly useful in grounding the referents of terms in instructions such as "the pipe and ball assembly" and "four blade flanges" (to take two examples from a ceiling fan installation manual) and in demonstrating *what* the end results of particular actions should look like. However, they cannot show the agent *how* to achieve those results. Narrated *animations* can do both. As to why animation should be preferred to live-action video-tapes, it is simply that graphics (and schematic renderings, in general) can abstract away (as well as visually "carve" away) what is *irrelevant*, demonstrating only what is *relevant* to the task at hand. As to why *narrated* animation is better than animation alone, researchers studying *plan inference* have shown just how hard it is to infer an agent's intentions from his or her observed actions alone (Cohen, 1981). To effectively instruct an agent to do a task, the communication of *intentions* is as important to effective performance as the communication of actions. Such intentions cannot be effectively communicated through images alone. For example, consider the following excerpt from instructions for installing a diverter spout on a bath tub faucet:

> Install new spout. When doing so, DO NOT use lift knob or hose connection for leverage. Damage may result! Tighten by hand only.

While red-slashed icons on warning signs may be effective in *reminding* people of what behavior is forbidden ("no smoking," "no wearing high-heeled shoes"), they cannot unambiguously convey the *reason* for forbidden or otherwise discouraged behavior. Communication of both the *hows* and the *whys* of task performance requires a union of both visual presentation and language.

The second part of our argument is that the only way to create the kind of *flexible* narrated animations needed to instruct agents of varying capabilities to perform tasks with varying demands in work places of varying layout is to drive *both* animation and narration from a *common representation* that embodies the same conceptualization of tasks and actions as natural language itself.

Of course, we are not claiming that animation can be driven *solely* from that common representation: Other types of knowledge are clearly needed as well—including knowledge of motor skills and other performance characteristics (see Section 3.7). Nor are we claiming that these types of knowledge could in any way be provided through natural language. That too is clearly false. For example, the gross underspecification of natural language communication comes out most strongly when attempting to describe motion: The relation between language and the world appears to be at its most tenuous where motion specification is concerned. Existing means of specifying motor skills such as direct manipulation, skill learning, and algorithmic determination are clearly more appropriate.

The second part of our argument raises the following further questions:

1. Why should animation and narration be driven from a common representation? Why not just create them separately—for example, through direct manipulation and text provided by some commentator?

2. Why should that representation embody the same conceptualization of tasks and actions (that is, reflect the same ontology) as natural language itself?

3. Where are we going to get that common representation?

The point of driving animation and narration together from a common representation is *flexibility* and *accuracy*. How an agent should carry out a task may depend on both his capabilities and features of the given workplace. Veridical narration must reflect both the agent's actions and the conditions motivating them. This can be provided by an outside commentator, but she will have to comment afresh (and in a consistent manner) for each "version" of the task simulation. Moreover any *changes* in the task (for example, those arising from minor model changes in the device whose use is being portrayed) are likely also to require fresh commentary in order to remain veridical. As we and others have argued regarding *explanation* of expert system behavior, it is desirable that the explanation *derive from* the same underlying specification as the system's reasoning, if that explanation is to truthfully represent *why* the system came to its conclusions.[1]

As to why that common representation should embody the same *ontology* of tasks and actions as natural language (including the range of causal and other-

1. This is not to say the reasoning and explanation must be *structurally* identical: Clarity and communicativeness often argue against such an isomorphism.

wise contingent relations between actions assumed by language), the *reasons* are separate for animation and narration, but the *conclusion* is the same. On one hand, if the representation is to drive the generation of natural language, the structure of the representation should be directly related to natural language semantics. On the other, since natural language semantics is directly related to natural cognition, it is likely that a representation that embodies it will be maximally helpful to (human) graphics systems designers developing and modifying the animation side of the system.

Finally, as to where we can get that common representation, we would like to argue *against* creating it by hand and *for* acquiring as much as possible through the medium most often used for conveying the whats and whys of actions and tasks—*natural language instructions*. The alternative of encoding the driving representation directly by hand has all the disadvantages that have pulled the programming language community in the direction of higher and higher level programming languages and the "smarter," more powerful compilers they demand.[2] That such higher level tools should include natural language instructions comes in part from the vast body of such data we have around and in part, what we can learn from them vis-à-vis the production of the narrative that accompanies animation (or even live instructional material) to clarify and explain the action.

This chapter describes some of our work to date on producing narrated animations from natural language instructions. Its structure is as follows:

- Section 3.2 briefly describes previous efforts to connect natural language instructions with computer graphics animations.

- Section 3.3 discusses instructions as given in natural language and characterizes computational models for understanding them.

- Section 3.4 outlines the structure and components of the system we are developing here at the University of Pennsylvania to study instructions and their animation by synthetic (human-like) agents.

- Section 3.5 elaborates the portion of the system between the planned actions and semantically valid primitives that may be characterized computationally.

- Section 3.6 describes the simulator and temporal constraint planner that organizes the primitives into a sequential stream of executable motions.

- Section 3.7 outlines the available motion generators.

- Section 3.8 summarizes agent performance issues that arise at various places in the system.

- Section 3.9 offers some observations and conclusions.

2. In the case of animation, higher level tools will widen the user community beyond current manually skilled (or programming-wise) animators; to include for example, human factors engineers with tasks to design or evaluate and trainers with new personnel to instruct.

3.2 *Background*

Because there has been so little substantive work published (or, to our knowledge, done) on controlling and augmenting animation with natural language (but see Esakov and Badler, 1990; Gangel, 1985; Green and Sun, 1988; Simmons and Bennet-Novak, 1975; Takashima et al., 1987), it is important to state clearly why we believe this route will prove successful. Several developments have occurred in animation technology that are enabling us to realize the "natural language connection."

Task-level specifications are one of the three levels of animation control described by Zeltzer in his insightful analysis (Zeltzer, 1985). He recognized the need for planning and the requirement that tasks be executable as **skills** known to the animated agent. In 1983 we outlined a system designed to translate task descriptions into animation (Badler et al., 1983) that has evolved into the structure presented here.

Previous attempts to animate natural language have been weakened by a limited or arbitrary set of motion control schemes available to implement task semantics. Prior to 1978, Badler et al. (Badler, 1978; Weber et al., 1978) tried to design a suitable architecture but were stymied during implementation by large numbers of particular animation process problems requiring clarification and solution (Badler et al., 1980). Later, problems of locomotion control, essential to action of a mobile agent, were addressed by others (Bruderlin and Calvert, 1989; Girard and Maciejewski, 1985; Zeltzer, 1982) yielding manageable models. Inverse kinematics for end-effector goal positioning were adopted from robotics or invented for biomechanical models (Badler et al., 1987; Girard and Maciejewski, 1985; Korein and Badler, 1982; Korein, 1985; Lee et al., 1990; Zhao and Badler, 1989).

More recently, dynamics simulations have allowed objects to move in physically correct motions (Armstrong et al., 1987; Hahn et al., 1988; Hoffman and Hopcroft, 1987; Isaacs and Cohen, 1987; Moore and Wilhelms, 1988; Wilhelms, 1986; Wilhelms, 1987), and geometric constraints resolved by kinematic, force, or energy considerations have freed animators from having to specify the details of object trajectories (Barzel and Barr, 1988; Brotman and Netravali, 1988; Gardin and Meltzer, 1989; Witkin et al., 1987; Witkin and Kass, 1988).

Zeltzer (1982), Reynolds (1987), and Ridsdale (Ridsdale et al., 1986) have explored behavioral models that tried to control the complexity of interaction between many individuals or parts of the same object. By putting together enough animation processes, the Thalmanns have even used "synthetic actors" to animate the personalities, expressions, and actions of lifelike figures of Marilyn Monroe and Humphrey Bogart (Magnenat-Thalmann and Thalmann, 1987).

Coming even closer to natural language-level instructions, high-level action descriptions have been compiled into simple animations based on a small number of predefined actions (Drewery and Tsotsos, 1986; Fishwick, 1986; Takashima et al., 1987) or motor skills (Morasso and Tagliasco, 1986; Zeltzer,

1990). Berk et al. (1982) have used English to specify colors for animation, and Becket (1990) has used English to select and modify texture map parameters, to make more realistic and "imperfect" pictures.

3.3 *Instructions*

The jumping-off point for our view of *instructions*—what they *are*, what it means to *understand* them and what it means to *use* them in the context of *animation from instructions*—is the view of *plans* we have adopted from the work of Pollack (1986; 1990), Suchman (1987), and Agre and Chapman (1989). This view of plans gives us a simple and uniform way to talk about instructions: It does not, by itself, solve the problem of fully linking understood instructions to agent *behavior*—the behavior we hope to demonstrate through our animated simulations. That linkage we are undertaking gradually, by considering instructions of increasing *richness*, in the sense described in Section 3.3.3.

3.3.1 *Plan as Data Structure*

In (Pollack, 1986), Pollack contrasts two views of plan: *plan as data structure* and *plan as mental phenomenon*. (The former appears to be the same view of plans that Agre and Chapman have called *plan as program*.) Plans produced by Sacerdoti's NOAH system (Sacerdoti, 1977) are a clear example of this *plan as data structure* view. Given a goal to achieve (that is, a partial state description), NOAH uses its knowledge of actions—their preconditions, the conditions they are able to achieve, and their elaborations in terms of (partially ordered) aggregates of other actions—to create a data structure (a directed acyclic graph) whose nodes represent goals or actions and whose arcs represent temporal ordering, elaboration, or entailment relations between nodes. This data structure represents NOAH's plan to achieve the given goal.

As Suchman points out, NOAH's original intent was to provide support for novice human agents in carrying out their tasks. Given a goal that an apprentice was tasked with achieving, NOAH was meant to form a plan and then use it to direct the apprentice in what to do next. To do this, it was meant to generate a natural language instruction corresponding to the action associated with the "current" node of the graph. If the apprentice indicated that he didn't understand the instruction or couldn't perform the prescribed action, NOAH was meant to "move down" the graph to direct the apprentice through the more basic actions whose performance would entail that of the original. The result is a sequence of instructions that corresponds directly to the sequence of nodes encountered on a particular graph traversal. This also shows why Agre and Chapman have labeled this the *plan as program* approach, since the plan effectively corresponds to a sequence of commands in the "instruction set" of the device (here, the human agent) intended to execute them.

To a great extent, this is the view of plans that has been taken by Mellish and Evans (1989), by Dale (1988) and by Feiner and McKeown (1989) in their respective work on generating natural language instructions from plans. Feiner and McKeown's COMET system uses schemata hand-encoded from radio repair instructions and produces coordinated graphics images and natural language texts to convey instructions that are demonstrably clearer and more understandable than either natural language or images alone ever could be. Although Mellish and Evans produce text based on (nonlinear) plans, the text structures they produce diverge from the structure of the corresponding plans, in order to cleanly separate a specification of what needs doing from a justification of why it needs doing in a particular way or a particular order. We will have more to say about Dale's system EPICURE in Section 3.3.3.

3.3.2 *Plan as Mental Phenomenon*

The alternative view of plans presented by Pollack (1986; 1990) is the *plan as mental phenomenon* view, which builds on earlier ideas about plans put forth by Bratman (1983). In this view, having a plan to do some action β corresponds roughly to

- a constellation of beliefs about actions and their relationships;

- beliefs that their performance, possibly in some constrained order, both entails the performance of β and plays some role in its performance;

- an *intention* on the part of the agent to act in accordance with those beliefs in order to perform β.

In order to describe the consequences of this approach for our view of instructions, we need to say more about such beliefs. Pollack draws a three-way distinction between *act-types*, *actions* (or acts) and *occurrences*. Act-types are, intuitively, types of actions like playing a chord, playing a D-major chord, playing a chord on a guitar, etc. Act-types, as these examples show, can be more or less abstract. Actions can be thought of as triples of act-types, agents, and times (relative or absolute intervals) like Mark playing a D-major chord last Sunday afternoon on his Epiphone. Because it is useful to distinguish an action from its occurrence in order to talk about intentions to act that may never be realized, Pollack introduces a separate ontological type occurrence that corresponds to the realization of an action. (Pollack represents an occurrence as OCCUR(β), where β is an action. Thus an occurrence inherits its time from the associated time of its argument.)

Agents can hold beliefs about entities of *any* of these three types:

- *Act-types:* An agent may believe that playing a D-major chord involves playing three notes (D, F#, and A) simultaneously, or that she does not know how to perform the act-type playing a D-major chord on a guitar, etc. Any or all of these beliefs can, of course, be wrong.

- *Actions:* An agent may believe that some action α_1 must be performed before some other action α_2 in order to do action β_1 or that α_2 must be performed before α_1 in order to do β_2. Here too, the agent's beliefs can be wrong. (It was to allow for such errors in beliefs and the natural language questions they could lead to that led Pollack to this *plan as mental phenomenon* approach.)

- *Occurrences:* An agent may believe that what put the cat to sleep last Sunday afternoon was an overdose of catnip. He may also have misconceptions about what has happened.

While Pollack does not discuss necessary or default relationships between beliefs about particular act-types or between particular act-types, actions and occurrences—for example, what beliefs about act-types are *inheritable* by more specific act-types or by the actions they participate in, this would seem a useful area to explore for its applicability to planning (Tenenberg, 1989), plan inference, and instruction understanding.

In contrast with the previous view of instructions as lexicalized graph traversals, the *plan as mental phenomenon* approach allows one to view instructions as being given to an agent in order that she develops appropriate beliefs,[3] which the agent may then draw upon in attempting to "do β." Depending on the evolving circumstances, different beliefs will become salient at different times. This appears to be involved in what Agre and Chapman and what Suchman mean by *using plans as a resource*. Beliefs are a resource an agent draws on in deciding what to do next.

3.3.3 *Behavior*

Given this view of *plan as mental phenomenon*, we can now consider possible relationships between instructions and an agent's *behavior*. At one extreme is a *direct* relationship, as in the game "Simon Says," where each command issued by the leader ("Simon says put your hands on your ears") is meant to lead directly to particular behavior on the part of the player. That is,

Instruction \Rightarrow Behavior

The fact that such instructions are given in natural language is almost (but not quite) irrelevant. That one can drive animated simulations from such instructions has been demonstrated by Esakov and Badler (1989). Key-frames from an animated simulation of two agents (John and Jane) at a control panel following an instruction sequence that begins

3. Since instructions may be presented as applicable *until* a particular event occurs ("Twist the blade until it clicks into place") or *after* a particular event has occurred ("After 1988, you have to depreciate X using revised schedule Y"), one might also assume they are meant to instill beliefs about particular occurrences as well.

John, look at switch twf-1.

John, turn twf-1 to state 4.

Jane, look at twf-3.

Jane, look at tglJ-1.

Jane, turn tglJ-1 on.

are shown in Figure 3.1.

In contrast, other common instruction sets (especially ones composed as texts rather than given incrementally "on-line") depart from this "Simon Says" model in many ways, including the following.

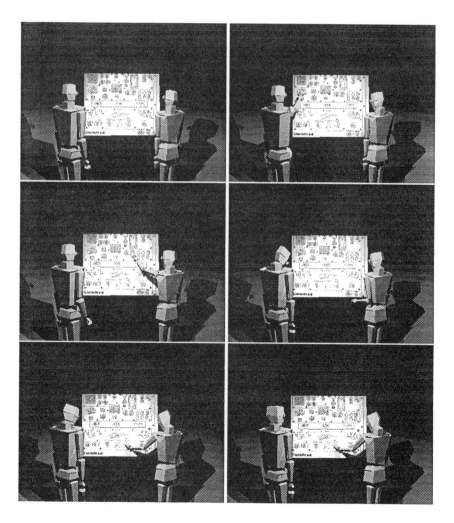

Figure 3.1 Control Panel Animation

1. The scope or manner of an action may become clear only through understanding several sentences in the instruction set. For example, the intended *culmination* of an action may not be intrinsic to that action, but only contingent on the start of the action prescribed next.[4] A simple example of this appears in the instructions that Agre and Chapman (1989) gave to several friends for getting to the Washington Street subway station.

> Left out the door, down to the end of the street, cross straight over Essex then left up the hill, take the first right, and it'll be on your left.

While the action description "[go] left up the hill" may have an intrinsic end point (that is, when the agent gets to the top of the hill), it is not the intended termination of the action in the context of these instructions. Its intended termination is the point at which the action of "taking the first right" commences—that is, when the agent recognizes that he has reached the first right.

The previous example illustrated the *scope* of an action provided by subsequent utterances. *Manner* can be specified as well—for example, where cautions or warnings in instructions provide information on how not to do an action, or what to avoid while doing it. For example, the following are part of instructions for installing a diverter spout on a bath tub faucet:

> Install new spout. When doing so, DO NOT use lift knob or hose connection for leverage. Damage may result! Tighten by hand only.

2. The instructions may describe a range of behavior appropriate under different circumstances. The agent is only meant to do that which she recognizes the situation as demanding during its performance. For example, the following are part of the same instructions for installing a diverter spout:

> Diverter spout is provided with insert for ½" pipe threads. If supply pipe is larger (¾"), unscrew insert and use spout without it.

In the above case, the relevant situational features can be determined prior to executing the instructions. In other cases, they may only be evident at the branch-point itself. For example, the following are part of instructions for filling holes in plaster over wood lath:

> If a third coat is necessary, use prepared joint compound from a hardware store.

Here, the agent will not know if a third coat is necessary until she sees whether the first two coats have produced a smooth level surface.

3. As in the *plan as data structure* model, instructions may delineate actions at several levels of detail or in several ways. For example, the following are part

4. This is not the case in "Simon Says" type instructions, where each action description contains an intrinsic culmination (Moens and Steedman, 1988).

of instructions for filling holes in plaster where the lath, as well as the plaster, has disintegrated:

> Clear away loose plaster. Make a new lath backing with metal lath, hardware cloth, or, for small holes, screen. Cut the mesh in a rectangle or square larger than the hole. Thread a 4- to 5-inch length of heavy twine through the center of the mesh. Knot the ends together. Slip the new lath patch into the hole…

Here the second utterance prescribes an action at a gross level, with subsequent utterances specifying it in more detail.

4. Some actions change significant features of objects; others result in their creation (or destruction). A referring term in an instruction often reflects the state of its referent at the point at which the instruction would be carried out. For example, in the following, the effect of the prescribed mixing action is to convert a powder into a paste.

> Mix plaster compound according to package directions. With a flexible putty knife or scraper, force the thick creamy plaster into the opening.

Recognizing coreference and other relationships between referring expressions is necessary for understanding instructions (or producing understandable ones (Dale, 1988)). Thus, there is a level at which action-describing utterances in instructions must be *modeled*, in order to understand them, prior to behaving in accordance with them. Dale's EPICURE system for generating natural language instructions contains such a "world model" (Dale, 1988).

5. *Instructions may only provide circumstantial constraints on behavior* but not specify *when* those circumstances will arise. For example, the following comes from instructions for installing wood paneling:

> When you have to cut a sheet [of paneling], try to produce as smooth an edge as possible. If you're using a handsaw, saw from the face side; if you're using a power saw, saw from the back side. Otherwise you'll produce ragged edges on the face because a handsaw cuts down, and a power saw cuts up.

Such cases as these illustrate an *indirect* relationship between instructions and behavior through the intermediary of an agent's beliefs and evolving plan. That is,

Instructions \Rightarrow Beliefs \Leftrightarrow Plan \Leftrightarrow Behavior

3.3.4 *Implementing These Ideas*

If we adopt this *plan as mental phenomenon* view in our animation from instructions work, then not only must we be able to derive from the natural language instructions an appropriate set of beliefs, but we must also have an account of the behavior that follows from an agent's beliefs and the intention of performing

some action β. The latter is the goal of much research in the *plan as mental phenomenon* paradigm. For the most part here, we hope to draw on advances made by others—for example, Pollack's work on inferring what she has called *simple plans*, ones whose actions are only linked by Goldman's *generation* relation (Goldman, 1970), from questions of the form

How do I do β. I want to do α.

At the natural language end of our animation from instructions work, we have begun to analyze several constructions commonly found in natural language instructions (Webber and Di Eugenio, 1990), in order to expand the range of instruction texts from which we can accurately derive appropriate agent beliefs about the actions involved and their relationships. These beliefs can then be used to drive our (incremental) simulator. Changes in the (simulated) environment resulting from (simulated) actions on the agent's part will then feed back through the agent's (simulated) perceptions, thereby possibly changing the set of beliefs informing the agent's decisions about subsequent actions.

In this way, we hope to produce veridical simulations of tasks performed in response to instructions, thereby enabling animation from instructions to be used more and more as a tool in task design and instruction. To this end, we will assume (at least initially) that the instructions cover all contingencies: If the simulator has to simulate an event that is impossible in the environment (because of unforeseen circumstances), the simulation will just stop, indicating why things cannot proceed. Not limiting ourselves in this way would require us to address the full scope of the AI planning problem, taking us away from a useful enterprise even with this limitation. For this reason, we will also be assuming there is only one *intentional agent*,[5] to avoid both the issues involved in achieving successful coordination (Grosz and Sidner, 1990) and the unforeseeable contingencies that can arise because of miscommunication, misunderstanding, and miscoordination among multiple, intentional agents.

3.3.5 *Summary*

So far, we have tried to make clear precisely what we mean when we use the term *instructions* and what we take to be the relationship between *instructions*, *plans*, and *behavior* embodied in our system design. In the next section, we will present this design, stressing the several architectural features that reflect this *plan as mental phenomenon* approach.

5. We distinguish three kinds of agents: *intentional* agents, *mechanistic* agents, and the world. Mechanistic agents, like washing machines and cars, can act and change the world, but only when acted on by an intentional agent or the world. The system we are developing assumes a single intentional agent, an independently changing world, and any number of mechanistic agents.

3.4 *System Design*

We have been working on the development of an animation from instructions system in the framework of the architecture shown in outline in Figure 3.2. Here we briefly describe the various components, with the representation produced by the *semantic mapper* discussed further in Section 3.5, the *simulator*, in Section 3.6, and the *motion generators* in Section 3.7. General human performance issues that cut across several of these components are highlighted in Section 3.8.

3.4.1 *System Overview*

In Figure 3.2, filled ovals represent data structures and boxes represent processes. The overall structure of the system is much like a pipeline in that natural language instructions enter at the top and complete animations emerge at the bottom. Unlike a pipeline, however, the system may be entered at any level and must be so designed for modularity, testing, and expansion. Portions of the system are used independent of the levels above. For example, the *display process* is a software base for direct graphical manipulation needed for real-time interactive task evaluation and geometric design, and the motion generators are the subject of ongoing algorithm development and refinement.

Various sorts of world and agent information are stored in *knowledge bases*; for diagrammatic simplicity we have omitted most of the specific connections and focused instead on general content categories such as the *object knowledge base*, the (geometric) *workplace specification*, the *agent specifications*, and so on. One exception is the explicit connection between natural language instructions and an *incremental planning* level, which involves the specific creation of *task-related actions* and *conditions* in the knowledge base. Note, however, that the diagram is not meant to imply that all knowledge is embedded in a single representation; rather, we have collected the different types to emphasize their presence and availability to all stages of the system.

The remainder of this section outlines the principal components of the system: the natural language processor, the incremental planner, the semantic mapper, the simulator, the motion generators, the display process, and the narrative planner and generator.

3.4.2 *Natural Language Processor*

When the natural language processor is complete, it will consist of a parser, semantic interpreter, and discourse processor (the latter to resolve—with respect to a discourse model of the instructions rather than the actual environment—the referring expressions used in the instructions). Up to now, we have been using a rather simple bottom-up parser called BUP in our language-to-animation research (Gangel, 1985). There seems to be value now in going to a much simpler, lexicalized system (one in which the lexicon essentially *is* the grammar)

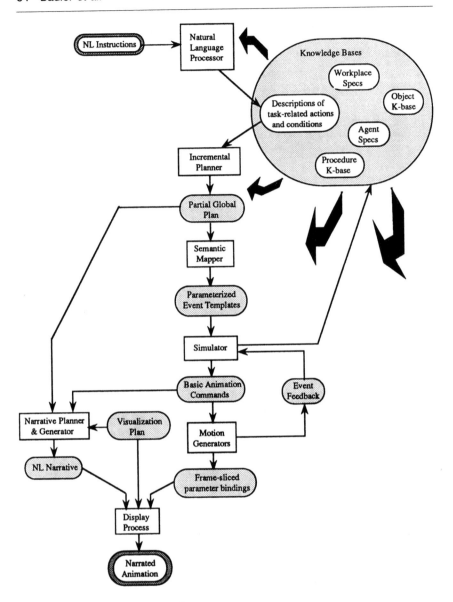

Figure 3.2 Design Framework

such as one based on lexicalized *tree adjunction grammars* (TAGs) (Abeille and Schabes, 1989; Schabes and Joshi, 1988) or *combinatory categorial grammars* (CCGs) (Pareschi and Steedman, 1987; Steedman, 1989).

The output of natural language processing will be a set of descriptions of actions involved in performing the task, relationships among those actions, and conditions/constraints on their performance. The descriptions can be viewed as

either the beliefs of the animated agent or the beliefs of the system, which controls the animated agent much like a marionette: The effect is the same. The language of these descriptions must combine features of procedural programming languages (including conditional, iterative, and while constructions), features of first-order logic representations, and features of frame/schema representations.

In developing appropriate descriptions of the intended relationships between actions, the discourse processor will make use of ideas about tense, aspect, and temporal and contingent modifiers presented in (Moens and Steedman, 1988; Passonneau, 1988; Webber, 1988), as well as information contained in the system's several knowledge bases.

3.4.3 *Incremental Planner*

At this point, the system must begin to make a connection between the action descriptions computed by the natural language processor and the behavior of its animated agent. Because, as has so often been noted, the world (here, the workplace) and even the agent's capabilities can change over time, independent of the agent's behavior and "intentions," we have chosen to use an incremental planner (see Figure 3.2) to develop a plan over time much like an Earley parser (Earley, 1970) develops a parse tree over time: It focuses its analysis on an initial window that gradually moves to the right. Just as, at an intermediate step, the analyses computed by an Earley parser are *global* in assuming an eventual full analysis as a sentence but only *partial* in having completely analysed only an initial substring, so the output of the incremental planner should be taken to be a *partial global plan*: It is *global* in reflecting the overall goal of "doing β," but only *partial* in having elaborated in detail the actions related to its upcoming behavior.

To this end, the incremental planner must be able to augment the set of beliefs about the actions whose performance is being considered next with:

- beliefs about other actions that may not have been made explicit in the instructions (because they were in some way "obvious"), and
- the expansion of all the action descriptions to a level of detail and vocabulary appropriate for the *semantic mapper*.

The information required to elaborate beliefs about actions in this way comes from the system's knowledge base, which includes information about actions, objects, the current state of the workspace, and the current state of the agent.

Before going on to describe briefly the properties and responsibilities of the semantic mapper, we must say a bit more about the way that incremental planning takes account of the current state of the "world" (here, the current state of the workplace and the agent). There is a two-step feedback loop from the motion generators to the simulator and from there, to the workplace specifications and agent specifications in the system's knowledge base, both of which are consulted during the planner's decisions about the next actions to consider. This enables

"actual" performance features to percolate up through higher levels of symbolic interpretation and affect decisions at more than one level.

For example, some events and situations can only be detected by the motion generators because they are tied to particular instantiated behaviors and coincidental relationships discovered during motion execution. For example, later in Section 3.6 we will show a "preening" event, which is precipitated solely by the agent's passing before a mirror. While not part of some overall plan, the interruption is as much a part of the animated behavior as the task that caused the agent to accidentally pass the mirror in the first place. Likewise, conditions that depend on changing workplace characteristics can affect the selection or completion of events. For example, "apply a quantity of patching compound" will affect both the decisions of the simulator and the incremental planner: The simulator must decide whether or not to send the motion generators another "apply a quantity of patching compound" action;[6] the incremental planner must monitor changes to the workplace specifications to determine the *need* for a third coat of patching, depending on whether the second coat has resulted in a smooth, level surface.

3.4.4 *The Semantic Mapper*

At any point, output from the incremental planner to the semantic mapper consists of the next elaborated actions from the *partial global plan*. As described in Section 3.5, the output of the semantic mapper is a set of *parameterized event templates*, which combine the temporal constraints, kinematic and dynamic features, and geometric constraints related to individual simulatable events. The mapper operates compositionally, building specifications of the features and constraints associated with the event description as a whole from those associated with its various parts (Kalita, 1990). A *parameterized event template* is therefore a specific *instance* of an event *class* (already known to the semantic mapper) where as much information as possible is filled in from the knowledge base and the given instructions in the partial global plan. The event classes known to the semantic mapper therefore define a unique lexicon that enables the meaning of an instruction to be expressed by animatable event primitives.

3.4.5 *The Simulator*

The simulator does several things: It solves a *temporal constraint satisfaction problem* (TCSP) among the current parameterized event templates, maintains an event queue, schedules the active events, and outputs basic animation commands, which are then interpreted by the motion generators.

6. Actions are of course specified to the *motion generators* as temporally ordered sequences of geometric, kinematic, and dynamic constraints that must be met—not as natural language utterances.

The temporal CSP involves both imposing consistency on the elements of the *temporal constraint set* (which may reference any nodes of the partial global plan) and conveying consistent relations down to the leaf nodes. The solution then is a partial linear ordering of the events that make up the leaves of the partial global plan. Our current TCSP solution methodology uses springlike constraints to model the temporal relations and an iterative numerical process to obtain a candidate partial ordering (Badler et al., 1988).

The simulator itself runs a conventional, discrete simulation cycle by maintaining an event queue, incrementing a discrete clock, and interpreting the currently active parameterized event templates. During event simulation, changes to the world model (geometry, resources, agent capability, etc.) may result in the activation of other event templates leading to contextually-dependent future actions. Feedback signals from the motion generators may also affect current events—for example, spatial difficulties (such as collisions) or agent capability failures (such as insufficient strength). Such features are mostly missing from other knowledge base simulation schemes (Hendrix, 1973).

3.4.6 *The Motion Generators*

A basic animation command provides sufficient data to execute one of the available motion generators (Section 3.7). The current animation command set includes motion paths (as key parameters), end effector goals, forces and torques, geometric constraints, simple locomotion, and facial muscle actions. Each command is executed by a corresponding motion generator: for example, forward kinematics by parametric interpolation; reach goals by inverse kinematics or a strength-guided reach; forces and torques by dynamics; geometric constraints by inverse kinematics; and facial muscles by a facial action model.

Since multiple animation commands may affect the same body part we use a merging method to maintain physical consistency in the object location database (Dadamo, 1988). The selection of the weighting parameters for this model has not been extensively studied, and more robust methods will be examined. We expect that the modifiers used in the original natural language instructions will be realized in the most appropriate terms in the semantic mapper, thereby limiting conflict between alternative specifications.

The actual performance (motion, timing, and success) of basic animation commands will vary according to:

- different physical characteristics and anthropometry of the agents (e.g., strength, speed, size, workload capacity, etc.)
- different environmental characteristics (e.g., actual scene geometry, object placement)
- prior event processing (posture resulting from previous task),
- immediate event contingencies (e.g., collision avoidance),

• external events in the world that bring about change independent of the agent, thereby undoing the needed effect of some action, eliminating the need for some action, or necessitating that a goal be achieved by some other procedure, if that procedure is contingent on some state holding in the world over its course.

The information for some of the performance models are stored within various knowledge bases (Section 3.8).

While executing a basic animation command, any of the unexpected occurences will feed back information to be considered by the simulator. The result may change the evaluation of the current parameterized event templates during subsequent simulation cycles.

3.4.7 *Display Process*

The display process is based on **Jack**, a powerful interactive graphics system for the manipulation and display of articulated figures (Phillips and Badler, 1988). **Jack** is used to define and execute a *visualization plan* (see Figure 3.2), which is the sequence of scenes, cuts, and camera views used to show the agent action. Currently this is totally under manual control of the animator, although we intend to (semi)automate its production based on the *agent plan* augmented with the intention and focus of the action (Ridsdale et al., 1986). Establishing an effective visualization plan is nontrivial, future effort, requiring cinematic knowledge, artistic design, and (ultimately) understanding of visual communication. Currently, default views may be manually defined based on an observer-agent who is in the scene but who may or may not be visible.[7] Establishing the line of view and the size of the viewed scene can be accomplished through spatial constraints. Knowledge of the intentions of the agents is necessary to form an appropriate view (Feiner, 1985). The observer may need to be positioned by a language-based description or manual methods. Preliminary study of cinematography terms indicates that language-based control of the camera is feasible.

3.4.8 *Narrative Planner and Generator*

Because of the important role that narration plays in complementing animation, the system as a whole is being designed with a *narrative planner and generator* component firmly in mind. There are two reasons for this:

7. When the observer is visible, the resulting views are of great importance in task analysis—they show the world as a real observer would see it; i.e., with self perception of other body parts. The typical movie, however, uses an "invisible" camera disembodied from any part of the environment. The camera may be attached to something moving, but is itself unseen.

- Without text explaining the *reasons* for observable actions, as researchers in plan recognition have noted (Cohen, 1981), such actions may be incomprehensible to observers. Exaggerating behavior to make it more communicative may have the adverse effect of making it less veridical.[8] Sharing the burden of communication between natural language and graphics, as Feiner and McKeown (1989) have noted, takes advantage of the best of both possible worlds.

- A frequent criticism leveled at automatic text generation is that it requires handcrafted representations as input: Even the increased customizability offered by text generation systems has not been accepted as an adequate counterargument to this criticism. Here, narration and animation are driven from common representations—a combination of the representations produced in the context of understanding the original instructions, plus the visualization plan used in producing the animation.

To satisfy the joint goals of providing an overall context in which to view the events on the "screen" and explaining the reasons for particular events that are happening, the narrative planner and generator require information from the *partial global plan* (for the "whys"), the basic animation commands (for particulars of what's happening "now") and the visualization plan (for what can the viewer see—in particular, what is centrally visible as opposed to being off-center or invisible, as the latter may have to be brought to the viewer's attention verbally, through the narration).

3.4.9 *Summary*

This overview has shown the connections and scope of each of the components of the system. In particular, we described the major "pipeline" of information from the language instructions through an incremental planner to a representational level, semantically interpreted and then simulated. The output of the simulator is a time-ordered sequence of explicit animation commands to be executed by various motion generators. Additional issues of information feedback to guide and control both the incremental planner and simulator were mentioned. A visualization plan and a narrative generator format the final presentation to the viewer.

3.5 *Between Action Descriptions and Actions*

Of fundamental importance to driving animation from natural language is an appropriate interface between natural language descriptions of actions and the

8. A situation inversely turned advantageous by the skilled cartoon animator (Thomas and Johnston, 1981).

primitive action elements that a simulator can animate. In English, action descriptions are not conveyed solely by the main verb but are distributed over the verb, its arguments, and its modifiers. The work here assumes that a description of the action can be built compositionally from features associated with its component elements. A more detailed description of this work is given in (Kalita, 1990).

3.5.1 *Relevant Features*

For a significant class of natural language verbs, it appears that their link to simulatable action elements can be based on an analysis of the movements they represent, taking into consideration physical attributes alone. The attributes we consider are: geometric constraints, aspectual features, and kinematic-dynamic distinctions.

3.5.1.1 *Geometric Constraints* Geometric constraints provide information regarding how one or more objects or subparts of objects relate to one another in terms of physical contact, absolute or relative location, inter-object distance, absolute and relative orientation, or path of motion.

Verbs dealing with geometric constraints may denote their *establishment* and *maintenance* (e.g., attach, hold, fix, grab, grasp, hook), their *elimination* (e.g., detach, disconnect, disengage, release) or their *modification* (e.g., loosen, tighten). These constraints may be positional or orientational.

1. *Positional constraints:* This refers to situations in which a 0-, 1-, 2- or 3-dimensional object is constrained to a 0-, 1-, 2- or 3-dimensional region of space. For example, in order to execute the command "Put the ball on the table," a point on the surface of the ball has to be brought in contact with (or constrained to) a point on the surface of the table. To execute the command "Put the block in the box," the volume occupied by the block must be constrained to the interior volume of the box.

2. *Orientational constraints:* The meaning of the preposition *across* in the sentence "Place the ruler across the table" requires, *inter alia*, that the longitudinal axis of the ruler and the longitudinal axis of the table top be perpendicular to each other.

3.5.1.2 *Aspectual Components* Aspect involves inherent semantic features of a lexical item pertaining to the temporal structure of the situation denoted by the lexical item, independent of context (Passonneau, 1988). These features include repetition and termination.

1. *Repetition:* Some verbs denote underlying motions that require repetitions of one or more submotions—for example, *roll, screw, scrub, shake, rock.* For other verbs, repetitions may or may not be performed (i.e., their performance depends on the object(s) involved, information gathered from linguistic input, etc.). Such verbs include *cut, fill, lace, load.*

2. *Termination conditions:* Some verbs denote underlying motions that have intrinsic terminal conditions reached in the normal course of events and beyond which the processes cannot continue. Some examples are: *align, assemble, attach, close, detach, drop, engage, fix, fill, place, release.*

Other verbs do not denote motions with intrinsic end conditions. The termination point may be determined by accompanying linguistic expressions, obtained through reasoning from commonsense knowledge or knowledge of the goal to be achieved, or defined by explicit feedback from simulation. Examples of such verbs are: *hold, press, scrub, shake.*

3.5.1.3 *Kinematic–Dynamic Characterization of Actions* Dynamics describes the force or effort influencing motion. Kinematics deals with direct path or goals, and motion specification. Often movements along the same spatial path and toward the same spatial goal may be represented by different verbs such as *touch, press*, and *punch*. These distinctions can be formulated in terms of dynamic specification.

1. *Kinematic:* These are verbs whose underlying motions can be expressed as a movement along an arbitrary path or at an arbitrary velocity. Some examples are *turn, roll, rotate.*

2. *Dynamic:* For a verb in this category, its underlying motion can be characterized by describing the force that causes it. Examples include: *push, shove, pull, drag, wring, hit, strike, punch, press.*

3. *Both kinematic and dynamic:* These are verbs that have strong path as well as force components: *swing, grip/grasp* (vs. *touch*), *twist.*

In practice, more control over the execution phase of the motion is obtained if the need for dynamics is converted into a strength requirement for the agent. This replaces the problem of absolute force specification with a relative specification as a fraction of the maximum performance rate (Section 3.8).

3.5.2 *Obtaining a Representation for the Verbs: Primitives*

The semantic mapper must output sets of parameterized event templates describing the actions to be simulated. These templates have slots for geometric relations and constraints, kinematics, and dynamics information.[9]

3.5.2.1 *Geometric Relations and Geometric Constraints* We specify geometric relations in terms of the following frame structure.

9. The dynamics case is not discussed here as it is currently being elaborated both in terms of classical physical forces and as agent strength requirements (Lee et al., 1990).

```
Geometric-relation:    spatial-type:
                       source-constraint-space:
                       destination-constraint-space:
                       selectional-restrictions:
```

Spatial-type refers to the type of the geometric relation specified. It may have one of two values: *positional* or *orientational*. The two slots called *source-constraint-space* and *destination-constraint-space* refer to one or more objects, parts or features thereof that need to be related. For example, in order to execute the command "Put the cup on the table," one normally brings the bottom surface of the cup into contact with the top surface of the table. The command "Put the ball on the table" requires bringing an arbitrary point on the surface of the ball in contact with the surface of the table top. Since the items being related may be arbitrary geometric entities (i.e., points, surfaces, volumes, etc.), we call them *spaces*; the first space is called the *source space* and the second the *destination space*. The slot *selectional-restrictions* refers to conditions (static, dynamic, global or object-specific) that need to be satisfied before the constraint can be executed.

Geometric constraints are geometric goals; they are specified as follows:

```
Geometric-constraint:    execution-type:
                         geometric-relation:
```

Geometric constraints are of four types, distinguished by the *execution-type* component. The execution class or type of a constraint may be *achieve*, *break*, *maintain*, or *modify*.

3.5.2.2 *Kinematics* The frame used for specifying the kinematic aspect of motion is the following:

```
Kinematics:    motion-type:
               source:
               destination:
               path-geometry:
               velocity:
               axis:
```

Motions are mainly of two types: *translational* and *rotational*. In order to describe a translational motion, we need to specify the source of the motion, its destination, the trajectory of the path, and the velocity of the motion. In the case of rotational motion, the path-geometry is always circular. The velocity, if specified, is angular. An axis of rotation should be specified; otherwise, it is inferred by consulting geometric knowledge about the object concerned.

3.5.2.3 *Temporals and Aspectuals* The central part of an object's motion consists of one or more components: *dynamics*, *kinematics*, and *geometric constraints*—along with control structures stating aspectual or other complexities

involved in the execution of an action. The constructs we use are: *repeat-arbitrary-times* and *concurrent*. The keyword *concurrent* is specified when two or more components need to be satisfied or achieved at the same time. The keyword *repeat-arbitrary-times* provides a means for specifying the repetitiveness property of certain verbs. A verb's semantic representation need not specify how many times a motion or submotion may need to be repeated. However, since every motion is presumed to end, the number of repetitions will have to be computed during the simulation (based on tests for some suitable termination conditions) or by inference, unless specified linguistically as in "Shake the block about 50 times." Other temporal information is carried along from the partial global plan.

3.5.2.4 *Representation of Verbal and Sentential Meaning* Since our meaning representation is verb based, the template for the representation of the meaning of a verb is also the frame for representation of meanings of sentences. The representation for a sentence has the following slots.

```
Verbal-representation: agent:
                       object:
                       kernel-actions:
                       selectional-restrictions:
```

Selectional restrictions may refer to dynamic or static properties of objects or the environment.

3.5.3 *An Example*

Here we show how individual representations of the verb *put* and a prepositional phrase headed by *on* combine to link the action description "Put the block on the table" with executable actions.

3.5.3.1 Put: *Establishing Positional Constraints* Webster's dictionary (Woolfe, 1981) defines one sense of the meaning of the verb *put* as "to place in a specified position or relationship." We consider only the positional aspect of the meaning to obtain a lexical definition. The lexical entry is

```
put (l-agent, l-object, l-locative)
                        ← agent: l-agent
                          object: l-object
                          kernel-action:
                             geometric-constraint:
                                 execution-type:achieve
                                 spatial-type: positional
                                 geometric-relation: l-locative
```

This representation tells us that *put* requires us to *achieve* a *positional* constraint between two objects, parts or features thereof. It does not indicate the type of positional relation to be achieved. The details of the geometric relation to be achieved have to be provided by the locative expression used, which may be in terms of prepositions such as *in, on,* or *across*.

3.5.3.2 On: *Support by a Physical Object* In our attempt to provide precise, implementable meanings of prepositions, we have been influenced by the definitions proposed by Badler (1975), Gangel (1985), and Herskovits (1986). They are currently limited in that they work with simple, solid, nondeformable geometric objects.

Among the senses of *on* defined by Herskovits (1986) is the one we are interested in here: *spatial entity supported by physical object*. Examples of its use are seen in sentences such as "Put the block on the table" and "Put the block on the box." One support situation that is commonplace is where the located object rests on a free, horizontal, upward-facing surface of the reference object. This need not be a top surface of the reference object, though it almost always is an *outer* surface (otherwise *in* is preferred). We describe this meaning of *on* as

```
on (X,Y)
    ←geometric-relation:
        destination-location: positional
        destination-constraint-space:
            any-of (supporter-surfaces-of (Y)))
        spatial-type: positional
        source-constraint-space:
            any-of (self-supporting-spaces-of (X))
        destination-constraint-space:
            any-of (supporter-surfaces-of (Y)))
    selectional-restrictions:
        horizontal (destination-constraint-space)
        equal ((direction-of
                (normal-to destination-constraint-space) "global-up")
        area-of (source-constraint-space) ≤ area-of
                                (destination-constraint-space)
        free-p (destination-constraint-space)
```

Given a geometric object, the geometrical function `self-supporting-spaces-of` obtains a list containing surfaces, lines or points on the object on which it can support itself. For example, a cube can support itself on any of its six faces, and a sphere on any point on its surface. The function `supporting-surfaces-of` finds out the surfaces of an object on which other objects can be supported. The functions `direction-of`, `normal-to`, and `area-of` are self-evident. The two directional constants `global-up` and `global-down` are defined with respect to a global reference frame.

3.5.3.3 *Composing Descriptions:* **Put the Block on the Table** The
sentence consists of the action verb *put*, a prepositional phrase headed by *on* and
a referent noun phrase. The meaning of the whole sentence, obtained by compos-
ing the meanings of its constituent parts, is as follows:

```
agent: "you"
object: block-1
kernel-action: geometric-constraint:
    execution-type:   achieve
    spatial-type: positional
    geometric-relation:
        destination-constraint-space: (area, area)
                spatial-type: positional
                source-constraint-space: any-of
                            (self-supporting-spaces-of (block-1))
                destination-constraint-space: any-of
                            (supporter-spaces-of (table-1)))
        selectional-restrictions:
                horizontal-p (destination-constraint-space)
                equal
                  (direction-of
                    (normal-to destination-constraint-space)
                      "global-up")
                area-of (source-constraint-space) ≤
                                area-of
                                    (destination-constraint-space)
                free-p (destination-constraint-space)
```

 In order to execute the action dictated by this sentence, the system looks at
the knowledge stored about the block to find a part or feature of the block on
which it can support itself. It can be supported on any one of its faces and no
face is more salient than any other for supporting purposes. A cube (the shape of
the block) has six faces, and one is chosen randomly as the support area.[10] The
program searches the knowledge stored about the table for a part or feature
which can be used to support other objects. It gathers that the table's function is
to support "small" objects on its top, which is also horizontal as required by a
selectional restriction. Finally, the system concludes that one of the sides of the
cube has to be brought in contact with the top of the table.

10. Of course, the program could select the face which is already in the most appropriate orientation.
It is therefore easy to see how modifiers such as *sideways* or *upside-down* could be interpreted as
variations from this default.

3.5.4 *Semantic Mapper Output*

The semantic mapper produces parameterized event templates, which are instances of event classes in a predefined hierarchy known to the semantic mapper and the simulator via the shared knowledge base. Thus the semantic mapper outputs instances of the event classes with certain kinematic, temporal, etc., constraints. We have seen that some constraints come from the knowledge base workplace model, some aspectuals provide temporal constraints from the partial global plan, and other slots are dependent on the class definition of the verb.

3.6 *The Simulator*

Input to the simulator consists of instantiated parameterized event templates, which represent the tasks known to it (Esakov and Badler, 1990; Esakov, 1990). *Instantiation* involves the creation of a specific template from the class definition, which may be done either by the semantic mapper or by predefinition in the knowledge base.

The simulator has two basic parts: an *event scheduler* and a *discrete event simulator*. The event scheduler is a temporal constraint satisfier that binds any constraints on start, stop, or duration times given in the templates to suitable clock times. Our implementation allows constraint specifications to include "fuzziness" terms such as *about, around, exactly*, and *preferred*, which places a weight on the relative importance of the constraint. This binding then results in a partial ordering of the instantiated events. The discrete event simulation employs symbolic and quantitative world knowledge to "execute" the partially ordered events by mapping them to "basic animation commands" that actually drive the motion generation process.

An important feature of the simulator is that the progress of the motion generators (which are invoked "outside" the simulator—see Section 3.7) can in fact affect the course of the simulation. This is done through the use of *daemons*, which examine the motion database, and through the support of *interrupts* and *continuations* within an event template. This separation of motion from event simulation permits more modular and efficient construction of the motion generators and focuses temporal control and exception handling in the simulator.

Event Scheduler[11] The event scheduler is governed by a clock, which represents the time within the simulated domain. Currently, the syntax used to represent time is based upon the 24-hour clock metaphor where a time is represented as a string of the form: HH:MM:SS.DDD (with as many decimal places as

11. For the sake of brevity, the examples do not represent the full functionality of the simulator, nor do they represent a semantically complete input set.

desired), or as a quoted LISP form: ′ (nid), where n is a number and, id is hr, min, sec representing hours, minutes, and seconds, respectively.

It is possible to indicate constraints on start, stop, and duration times of an event. These constraints can be to particular "clock" times or to the stop/start/duration times of another event. Furthermore, temporal adverbials (noted above) can be used to indicate the importance associated with achieving a particular temporal constraint.

The following two examples illustrate how temporal constraints (:time-constraints) in parameterized event templates (of some unspecified event class) are resolved to specific times and partially ordered by their start times. Only the relevant slots of the templates are shown here.

Example 1

```
(instantiate EVENT ()
             :instancename 'A
             :time-constraints ((start "10:00")
                                 (duration (about (5 min)))
                                 (end ((10 min) before (start b)))))
(instantiate EVENT ()
             :instancename 'B
             :time-constraints ((duration (1 hour))
                                 (end "11:00")))
```

The result of temporal constraint satisfaction here is:

Event	Start	Duration	End
A	09:56:16.121	00:04:55.522	10:01:11.641
B	10:07:27.762	00:56:16.119	11:03:43.879

Example 2

```
(instantiate EVENT ()
             :instancename 'A
             :time-constraints ((start "10:00")
                                 (duration (about (5 min)))
                                 (end ((10 min) before (start b)))))
(instantiate EVENT ()
             :instancename 'B
             :time-constraints ((duration (1 hour))
                                 (end (exactly "11:00"))))
```

The result of temporal constraint satisfaction is now:

Event	Start	Duration	End
A	09:55:02.184	00:04:54.044	09:59:56.227
B	10:04:58.410	00:55:02.184	11:00:00.594

As can be seen, the event scheduler resolves the constraints to specific times at which the events should begin and end. In the second example, the qualifier *exactly* caused a shifting so that the constraint that task B should end at 11:00 is given a higher priority.

3.6.2 *Discrete Event Simulation*

Once temporal constraints are satisfied, the simulator may begin the actual advancement of its time clock to execute scheduled events. The discrete event simulation algorithm is based on an event queue from which the current (active) events are selected at each clock tick, then converted into basic animation commands (Esakov, 1990). The event queue is "dynamic" in that (1) as events are finished, they are deleted, and (2) as new events are instantiated and scheduled (as output of the semantic mapper, based on the evolving partial global plan), they are added to the queue in the correct partial order. Interruptions (by message-passing) from an event or a feedback signal from a motion generator may also add (or delete) events. In addition, the simulator is responsible for managing available resources so that, for example, the agent's right arm is not given more than one task at a time.

Example 3 shows a single-direction information flow from the discrete event scheduler to basic animation commands. The task consists of generating the motion of the hands of a clock by changing orientation goals:

Example 3
```
(deftemplate show-time (start end)
  (default-duration (- end start))
  (precondition t)
  (runcondition t)
  (successcondition (= (send-message *clock* :real-clock) end))
  (on-success
   (progn
    (cancel-event-constraints)
    (instantiate yaps::show-time
                    ((send-message *clock* :real-clock)
                     (+ (send-message *clock* :real-clock) 60))
                 :instancename 'clock
                 :step '(60 sec)))))
```

```
(on-deletion
 (cancel-event-constraints))
(body
 (let ((minutehand (send-message *clock* :minute-hand-orientation))
       (hourhand (send-message *clock* :hour-hand-orientation)))
  (if (= minutehand 360) (setf minutehand 0))
  (if (= hourhand 360) (setf hourhand 0))
  (achieve-orientation (send-message *clock* :second-hand-referent)
                        360 :startvalue 0)
  (achieve-orientation (send-message *clock* :minute-hand-referent)
                        (+ minutehand 6) :startvalue minutehand)
  (achieve-orientation (send-message *clock* :hour-hand-referent)
                        (+ hourhand .5) :startvalue hourhand))))
```

This event template `show-time` has two parameters: start time and stop time. The default duration of an event is the difference between the two times. There is no precondition to firing this event and once fired, there is no condition that must be true during its duration (the "runcondition"). The definition of success of this event is that its simulation time equals its end time. Upon successful completion, the current animation command (`achieve-orientation`) constraints are cancelled and a new instantiation of the `show-time` template is created which will generate the motion for the next 60 seconds. The given time values are bound to the parameters upon instantiation, and temporal constraint satisfaction is trivially able to schedule this new instance of `show-time` for the next cycle.

The body of the template shows the `achieve-orientation` commands that are used to generate the motions for the second, minute, and hour hands of the clock. In a minute, the second hand will move 360 degrees, the minute hand 6 degrees and the hour hand a half of a degree. Were a digital clock to be used, a different set of animation commands would be used.

Example 4 demonstrates the interruption and continuation capabilities of the simulator, as well as a command for a more complex motion generator. Here a "walk" generator provides locomotion for an agent, and a daemon keeps track of when the agent passes in front of a mirror. When this occurs, an interrupt is generated temporarily blocking the "walk" event in favor of the "look in the mirror" event.

Example 4

```
(deftemplate preen-daemon (figure reflector)
  "Generate a series of preening commands for figure."
  (variables daemon-name)
  (precondition (not (in-front figure reflector)))
  (default-duration t)
```

```
(on-interruption
 ;; An interrupt, must be because figure is in front of a
   reflector
 (progn
  (send-to-event-class :locomotion :interrupt)
  (instantiate preen (figure reflector)
            :on-success
      (progn
       (send-to-event-class :locomotion :continue)
       (send-message self :continue)))))
(on-continuation
 (setf daemon-name (generate-daemon :front-of figure reflector
                                :interrupt-name :front)))
(on-deletion (delete-daemon daemon-name))
(body
 (setf daemon-name (generate-daemon :front-of figure reflector
                                :interrupt-name :front))))

(deftemplate walk (figure destination)
"Generate commands for figure to walk to destination. The hard
work is done in the walk motion generator."
 (event-class :locomotion)
 (precondition (not (at figure destination)))
 (on-interruption
   (progn
     (cancel-event-constraints)
     (send-message self :block)))
   (on-continuation (send-message self :unblock))
   (success-condition (at figure destination))
   (on-failure
     (send-to-parent self :failure :walk))
   (body
     (locomote figure (send-message destination
:full-geometric-reference))))
```

This example starts by defining[12] a preen-daemon event template that
monitors the motion database for a particular condition: front-of figure

12. In this case the event templates are being defined manually with the knowledge base. Eventually such templates will be generated via natural language and the semantic mapper from instructions such as "When John passes in front of a reflecting surface, he stops to preen himself."

`reflector`. If that condition occurs, the daemon will interrupt this event instance and delete itself so that it will not continually report the same condition.

The template `walk` is a member of the event class called `:locomotion`. When an interrupt (as generated by an instance of `preen-daemon`) is received by an instance of this `walk` template, the associated animation commands are cancelled and the event blocks. The `:block` message causes the interrupt to be applied to each of the parent events of a subevent. Conversely, when an event sends a continuation signal and unblocks, the message travels up to the parent events. When an event is continued, the body is reevaluated; however, it is not always necessary to reexecute an entire event hierarchy. The hierarchy tree is traversed (up toward the parents) and reexecuted from the event highest in the tree with a false precondition. Thus our agent may continue to walk, but not necessarily exactly on the same cycle, at the same pace, or even to the same target that was active on interruption.

The input to the simulator must fully specify how to handle interrupts. That is, each event within a simulation must explicitly define its interrupts and the corresponding handler. There are many different types of daemons that can be defined. Daemons such as *in front of*, *next to*, *to the left of*, *to the right of* are typical, and new daemons are being defined as needed. Presently our simulator restricts a given daemon to monitor only a single type of event with a single set of parameters. For example, while it is not possible to define a single daemon to monitor whether *any* agent passes in front of a mirror (as in the previous section), it is possible to define multiple daemons, each monitoring a single agent's relationship with a mirror.

When a condition occurs, the motion generator triggers an interrupt within the simulator. The interrupt is specific to the event in which the corresponding daemon was generated. One parameter to the interrupt is the interrupt name (as specified in the `(generate-daemon)` construct) which allows the event to distinguish between multiple types of interrupts and act accordingly. In particular, this event template should be modified so that an interruption will cause a graceful shutdown of the walk event and not an immediate freeze.

3.6.3 *Summary*

This section has described the process of converting parameterized event templates into sequences of basic animation commands. First a temporal constraint satisfaction method takes the current set of events and schedules them into a appropriate partial ordering. Then a discrete event simulator steps through the active event queue and outputs animation commands contained in the instantiated event templates. Exceptional conditions may be monitored by daemons whose outputs feed back to the simulator, potentially altering its active event queue and hence its execution trace.

3.7 *Motion Generators*

As the simulator schedules and executes the active events (in ignorance of the actual graphical frame times), it creates basic animation commands that invoke specific motion generators. Specifications that originally appeared as part of the body of the event template are passed through as a series of parameter values (for frame-to-frame interpolation), a force or torque, or a target location/orientation for an object. This information is processed by several motion generators. These tools can become quite sophisticated, generating and solving, for example, dynamics equations or constraint equations. Also, complex generation tools, such as a "walk" or a facial expression generator, could be used. In any case, however, the output of a motion generator is a complete binding of all the necessary object position, orientation, and shape parameters on a frame-by-frame basis. We have implemented six types of motion generators:

1. Forward kinematic-guided motion (key parameter interpolation),

2. Inverse kinematic-guided motion (constraint satisfaction),

3. Strength-guided motion,

4. Forward dynamics,

5. Walk,[13]

6. Facial expressions.

Forward kinematic-guided motion is used for the (create-dof-motion) simulator construct. This special case construct allows one to specify the end-time values to achieve for a parameter through the use of linear interpolation. The more general technique of specifying multiple value/time pairs is available as is the use of other interpolation algorithms (Steketee and Badler, 1985).

Inverse kinematic-guided motion uses a constraint solver to determine the configuration of a jointed chain of rigid segments given a goal position or orientation of the end-effector (Zhao and Badler, 1989). Positions may be specified as (sets of) points, lines, or planes, or surfaces of another object.

Strength-guided motion uses a strength model to determine the path that the end-effector will take to achieve a goal position (Lee et al., 1990). This algorithm is used whenever the end-effector (hand) is moving objects with mass. It makes use of parameters that define the "comfort" of a movement, mass of the object, and the strength of the end-effector chain (arm) (Grosso et al., 1989).

Forward dynamics applies the specified forces or torques to any object, the agent, or any of their parts (Wilhelms, 1987; Otani, 1989). Dynamics effects are primarily used to affect the workplace and agent as a whole, since the strength-

13. The walk generator is still under development.

guided motion is more controllable and efficient for task achievement. Typically task instructions do not specify forces directly; rather, motions result from internal *strength* and *joint limit* capabilities of the agent. The motions are much less like a marionette and much more like a real agent working with muscles against gravity. The dynamics simulation process is primarily used to move passive objects (for example, a thrown ball) or the entire agent, especially when such forces are the consequence of actions initiated by the agent. For example, executing a rapid turn while driving a car will cause centrifugal force to act on the body, altering its posture and, quite importantly, the direction of external forces which its strength model must resist.

The walk generator is based on Bruderlin and Calvert's dynamics and constraint model (Bruderlin and Calvert, 1989). In our current applications, it suffices to have limited point-to-point agent mobility. More complex locomotion tasks or sporting events have not been undertaken.

Facial expressions are executed based on a muscle model of the face derived from an extensive analysis of facial regions. Motion control is effected by the selection, modification, or removal of *action units* based on the Ekman and Friesen model (Platt, 1985).

These five generators yield a surprisingly versatile collection of *basic animatable tasks:*

- reach, touch, place, position [via inverse kinematics]
- orient, align [via inverse kinematics]
- attach, unattach, grasp, ungrasp [via topological connections in the underlying geometric database of objects]
- put, take [like reach, but with attached object]
- look at [via inverse kinematics using orientation]
- lift, push, pull [via strength-guided motion]
- stand up, sit down [via strength-guided motion]
- follow path [via forward kinematics]
- exert force or torque [via forward dynamics]
- walk along a path, walk to a goal point [via walk generator]
- produce facial expressions from speech intonation and emotion [implementation in progress (Pelachaud, 1990)]
- walk [implementation in progress based on (Bruderlin and Calvert, 1989)]

All of these constructs can be interrupted at any point throughout the motion. If that is done, the object maintains its current state, and the motion generator essentially "forgets" the animation command.

Each motion generator performs appropriate path planning for the basic animation commands it interprets. Of course, some path planning must occur at higher levels in the global planning process. The criteria for the division of path planning is that the work done at the discrete event simulation stage should not impact the planning of other events. For example, planning the navigation of a complex path is more appropriately performed within the global planner (Ridsdale et al., 1986). This is because different events may need to be planned during the traversal of the path, which in effect would divide the single event of navigation into a series of separable (yet linked) events. When the simulator executes the instantiation of some event template, the expected result is the normal completion of the subtask within the larger global plan.

The motion generators produce the required agent or object motion paths for each basic animation command for each frame. For example, lifting a weight onto a shelf may be given as one of the event templates within some globally defined task. The strength-guided motion generator is responsible for computing the arm motion and the actual path: It is not supposed to establish preconditions (holding the weight), but it is entrusted with computing reasonable arm and torso motions to actually move the end-effector holding the weight along a spatial path to the goal position. If something happens (such as failure or confounding obstacles) to interrupt this motion, then control is returned to the simulator to determine alternative strategies within the active event template. The interruptions are determined by explicit feedback from resident daemons watching for changes in the knowledge base or conveying error signals from the motion generators.

The collection of motion generators is meant to allow convenient simulation of the scope and variety of human movement. Our own efforts have focused on task execution rather than locomotion-dependent activities. Examination of numerous motion representation systems (Badler et al., 1979; Badler, 1989) has led to the current set of motion generators and the belief that they form a relatively complete set for instruction-directed movement synthesis.

3.8 Agent Performance Issues

Natural language instructions for a task rarely specify how long the task takes. Rather than "pick up the box in five seconds,"[14] one is more apt to hear "pick up the box [carefully, quickly]." That is, duration is left to the agent as a consequence of the agent's abilities. One of the most fundamental concepts underlying the entire simulation approach to executing the parameterized event templates is that agent structure, capability, and behavior dictate most of the actual motion parameters and should therefore yield natural movements and individual varia-

14. which, if heard, is usually interpreted inchoatively as "In five seconds, [begin to] pick up the box."

tions among different agents. We have already noted the roles of inverse kinematics, strength, and constraints in formulating a complete animation interface. These specifications alone, however, still require temporal duration information. The problem is that all of these specifications provide only some of the possible parameters of the agent motion. Performance models supply reasonable values for the remainder.

Several different kinds of performance models are accessible through various components of the knowledge bases:

Body segment size: Different length limbs and different sized bodies clearly affect the manner in which goals are reached, whether goals can be achieved without locomotion, whether an agent can fit into a space, etc.

Joint limits: Physical structure and clothing restrict motion, likewise affecting the manner of goal achievement and the postures available. In particular, joint limits force orientation goals to propagate rotations along the body linkage.[15]

Strength model: Different agents have remarkably different strengths, which clearly affects what tasks each *can* do. Strength also affects *how* tasks are done. Any force requirements imposed by a task must affect the positioning of the body joints for best use of available strength (subject to the *comfort model*). For example, the task "pick up the box" will result in radically different body postures and motions if the box weighs one pound or 100 pounds.

Comfort model: Just because an agent has sufficient strength to perform some task does not mean that it will be accomplished in a fashion requiring maximum exertion. The comfort model tries to distribute loads on body joints so that the overall force load minimizes the ratio of required to available torque at each joint.

Fatigue model: There is an energy penalty associated with any motion. By accumulating the energy and allowing for reasonable recovery times, a fatigue factor can be computed, which scales the available strength.

Task knowledge model: Part of the higher level agent capability model is a list of the parameterized events the agent "knows" how to execute. We have seen that this knowledge effects the extent of plan elaboration. Also, different agents can have different task models (one agent's "carry" may allow only one object, while another's allows any stable stack of objects) and different methods for executing tasks in the global plan (one agent might "paint" in careful linear strips while another uses randomly oriented strokes).

15. Imagine someone grasping your hand and then twisting it a full turn!

Task timing model: Fitts's Law (Fitts, 1954) gives some timing estimates for very simple reach and view events (Esakov and Badler, 1989). The strength-guided motion animation tool moves the end-effector at a rate consistent with the torque availability at the affected joints and therefore does not need a predetermined duration.[16] Such an event is finished when the goal has been achieved; a daemon can report the sucess (or failure) back to the simulator.

Resource allocation model: Each human agent has two hands, two feet, one direction of view, etc. During event execution, resources must be monitored and allocated to avoid contention, overload, or deadlock. Resource requirements must be noted for each task. Different agents can have different resources available, for example, a robot arm and a human differ in the number of end-effectors and their capacity.

Each of these models has been implemented in our animation system. Although animations to date have been primarily of the "Simon Says" variety, the methodology has shown the usefulness and even necessity of performance models in filling in essential information linking instructions to action.

3.9 *Conclusions*

We have presented a comprehensive framework for the interpretation of natural language instructions and their subsequent execution by a synthetic agent. The entire process is viewed as a pipeline with feedback, including a variety of knowledge bases to support planning, semantic mapping, agent capabilities, and workplace geometry.

Proceeding from natural language processing through an incremental planner that would produce partial global plans to carry out the required tasks, we saw that an incremental planning approach is necessary to handle the requisite task variability and environmental conditions. Components of the global plan are then expressed as parameterized event templates by a semantic mapper, which essentially builds operational (executable) definitions of motion verbs and their modifiers. These templates are simulated to produce basic animation commands, which in turn are directly executable by extant motion generators. The final frame-by-frame animation is viewed through a manually constructed visualization plan for manipulating the virtual camera so that animated images are displayed to the user on a Silicon Graphics 4D workstation.

We have many experiments to undertake and much more code to write, but our progress so far in integrating natural language instructions with the anima-

16. An interesting experiment, as yet untried, is to compute the action times of the simulated agent with a reasonable strength model and determine how close the results mirror known Fitts's Law data.

tion of a responsive humanlike agent has been very encouraging. Connections between these disparate fields are being made that promise to deeply affect them both.

Acknowledgments

This research is partially supported by Lockheed Engineering and Management Services (NASA Johnson Space Center), NASA Ames Grant NAG-2–426, FMC Corporation, Martin-Marietta Denver Aerospace, NSF CISE Grant CDA88–22719, and ARO Grant DAAL03–89-C-0031 including participation by the U.S. Army Human Engineering Laboratory. The authors would like to thank Mark Steedman for his comments and advice on earlier versions of this chapter.

References

Abeille, A. and Y. Schabes. 1989. Parsing idioms in lexicalized TAGs. *Proceedings of the 4th Meeting of the European Chapter of the Association for Computational Linguistics.* Manchester, England.

Agre, P. and D. Chapman. 1989. What are plans for? A.I. Memo 1050a, Artificial Intelligence Laboratory, MIT, Cambridge, MA.

Armstrong, W., M. Green, and R. Lake. 1987. Near-real-time control of human figure models. *IEEE Computer Graphics and Applications* 7(6):52–6.

Badler, N.I. 1975. Temporal scene analysis: Conceptual descriptions of object movements. University of Pennsylvania, Computer and Information Science, Technical Report MS-CIS-76–4. (Also PhD Dissertation, Department of Computer Science, University of Toronto, 1975.)

Badler, N.I. 1989. A representation for natural human movement. In *Dance Technology I*, J. Gray, (ed.). AAHPERD Publications, Reston, VA, pp. 23–44.

Badler, N.I. and S.W. Smoliar. 1979. Digital representations of human movement. *ACM Computing Surveys* 11(1):19–38.

Badler, N.I., S. Kushner, and J. Kalita. 1988. Constraint-based temporal planning. Technical Report, Dept. of Computer and Information Science, Univ. of Pennsylvania, Philadelphia, PA.

Badler, N.I., K. Manoochehri, and G. Walters. 1987. Articulated figure positioning by multiple constraints. *IEEE Computer Graphics and Applications* 7(6):28–38.

Badler, N.I., J. O'Rourke, and B. Kaufman. 1980. Special problems in human movement simulation. *Computer Graphics* 14(3):189–197.

Badler, N.I., J. O'Rourke, S. Smoliar, and L. Weber. 1978. The simulation of human movement by computer. Technical Report, Department of Computer and Information Science, University of Pennsylvania, PA.

Badler, N.I., J. O'Rourke, and H. Toltzis. 1979. A spherical representation of a human body for visualizing movement. *IEEE Proceedings* 67(10):1397–1403.

Badler, N.I., B.L. Webber, J.U. Korein, and J.D. Korein. 1983. TEMPUS, A system for the design and simulation of mobile agents in a workstation and task environment. *Proc. IEEE Trends and Applications Conference*, pp. 263–269.

Barzel, R. and A. Barr. 1988. A modeling system based on dynamic constraints. *Computer Graphics* 22(4):179–188.

Becket, W. and N.I. Badler. 1990. Imperfection for realistic image synthesis. Technical Report, Computer and Information Science Dept., University of Pennsylvania, Philadelphia, PA.

Berk, T., L. Brownston, and A. Kaufman. 1982. A new color-naming system for graphics languages. *IEEE Computer Graphics and Applications* 2(3):37–44.

Bratman, M. 1983. Taking plans seriously. *Social Theory and Practice* 9:271–287.

Brotman, L.S. and A.N. Netravali. 1988. Motion interpolation by optimal control. *Computer Graphics* 22(4):309–315.

Bruderlin, A. and T.W. Calvert. 1989. Goal-directed, dynamic animation of human walking. *Computer Graphics* 23(3):233–242.

Cohen, P. 1981. The need for referent identification as a planned action. *Proc. of International Joint Conference on Artificial Intelligence*, pp. 31–36.

Dadamo, D.T. 1988. Effective control of human motion animation, Technical Report MS-CIS-88–52, Dept. of Computer and Information Science, Univ. of Pennsylvania, Philadelphia, PA.

Dale, R. 1988. *Generating Referring Expressions in a Domain of Objects and Processes*. PhD Thesis, University of Edinburgh, Edinburgh, Scotland.

Drewery, K. and J. Tsotsos. 1986. Goal-directed animation using English motion commands. *Proc. Graphics Interface '86*, Vancouver, pp. 131–135.

Earley, J. 1970. An efficient context-free parsing algorithm. *Communications of the ACM* 13(2):94–102.

Esakov, J. 1990. *An Architecture for Human Task Performance Analysis*. PhD Thesis, Dept. of Computer and Information Science, University of Pennsylvania.

Esakov, J. and N.I. Badler. 1989. An architecture for human task animation control. *Knowledge-Based Simulation: Methodology and Applications*, P.A. Fishwick and R.S. Modjeski (eds.), Springer Verlag, New York.

Esakov, J., N.I. Badler, and M. Jung. 1989. An investigation of language input and performance timing for task animation. *Proc. Graphics Interface '89*, Waterloo, Canada, pp. 86–93.

Feiner, S. 1985. APEX: An experiment in the automated creation of pictorial explanations. *IEEE Computer Graphics and Applications* 5(11):29–37.

Feiner, S. and K. McKeown. 1989. Coordinating text and graphics in explanation generation. *Proc. DARPA Speech and Natural Language Workshop*, Morgan Kaufmann, San Mateo, CA, pp. 424–433.

Fisher, S.S., M. McGreevy, J. Humphries, and W. Robinett. 1986. Virtual environment display system. *Proc. 1986 Workshop on Interactive 3D Graphics*, Chapel Hill, NC, ACM Publications, New York.

Fishwick, P.A. 1986. *Hierarchical Reasoning: Simulating Complex Processes over Multiple Levels of Abstraction*. PhD Thesis, Dept. of Computer and Information Science, Univ. of Pennsylvania, Philadelphia, PA.

Fishwick, P.A. 1988. The role of process abstraction in simulation. *IEEE Trans. Systems, Man, and Cybernetics* 18(1):18–39.

Fitts, P. 1954. The information capacity of the human motor system in controlling the amplitude of movement. *Journal of Experimental Psychology* 47:381–391.

Gangel, J.S. 1985. *A Motion Verb Interface to a Task Animation System*. Master's Thesis, Dept. of Computer and Information Science, Univ. of Pennsylvania, Philadelphia, PA.

Gardin, F. and B. Meltzer. 1989. Analogical representations of naive physics. *Artificial Intelligence* 38(2):139–159.

Girard, M.l and A.A. Maciejewski. 1985. Computational modeling for the computer animation of legged figures. *Computer Graphics* 19(3):263–270.

Goldman, A.I. 1970. *A Theory of Human Action*. Princeton University Press, Princeton, NJ.

Green, M. and H. Sun. 1988. A language and system for procedural modeling and motion. *IEEE Computer Graphics and Applications* 8(6):52–64.

Grice, H.P. 1975. Logic and conversation. *Syntax and Semantics 3: Speech Acts*, Academic Press, New York.

Grosso, M.R., R.D. Quach, E. Otani, J. Zhao, S. Wei, P. Ho, J. Lu, and N.I. Badler. 1989. Anthropometry for computer graphics human figures. Technical Report No. MS-CIS-89-71, Dept. of Computer and Information Science, University of Pennsylvania, Philadelphia, PA.

Grosz, B. and C. Sidner. 1990. Plans for discourse. *Intentions in Communication*, P.R. Cohen, J.L. Morgan and M.E. Pollack (eds), MIT Press, Cambridge, MA.

Hahn, J.K. 1988. Realistic animation of rigid bodies. *Computer Graphics* 22(4):299–308.

Hendrix, G. 1973. Modeling simultaneous actions and continuous processes. *Artificial Intelligence* 4:145–180.

Herskovits, A. 1986. *Language and Spatial Cognition.* Cambridge University Press.

Hoffmann, C. and J. Hopcroft. 1987. Simulation of physical systems from geometric models. *IEEE Journal of Robotics and Automation* RA-3(3):194–206.

Isaacs, P.M. and M.F. Cohen. 1987. Controlling dynamic simulation with kinematic constraints, *Computer Graphics* 21(4):215–224.

Kalita, J.K. and N.I. Badler. 1989. Semantic analysis of action verbs based on animatable primitives. Technical Report, Dept. of Computer and Information Science, Univ. of Pennsylvania, Philadelphia, PA.

Kalita, J.K. 1990. *Analysis of Some Actions Verbs and Synthesis of Underlying Tasks in an Animation Environment.* PhD Thesis, Department of Computer and Information Science, University of Pennsylvania.

Karlin, R. 1987. *SEAFACT: A Semantic Analysis System for Task Animation of Cooking Operations.* Master's Thesis, Dept. of Computer and Information Science, Univ. of Pennsylvania, Philadelphia, PA.

Karlin, R. 1988. Defining the semantics of verbal modifiers in the domain of cooking tasks. *Proceedings of the 26st Annual Meeting of ACL*, pp. 61–67.

Korein, J.U. 1985. *A Geometric Investigation of Reach.* MIT Press, Cambridge, MA.

Korein, J.U. and N.I. Badler. 1982. Techniques for goal directed motion. *IEEE Computer Graphics and Applications* 2(9):71–81.

Lee, P. 1989. Kinematic paths from a strength and comfort model. PhD proposal, Dept. of Mechanical Engineering and Applied Mechanics, University of Pennsylvania.

Lee, P., S. Wei, J. Zhao, and N.I. Badler. 1990. Strength-guided motion. To appear, *Computer Graphics.*

Magnenat-Thalmann, N. and D. Thalmann. 1987. The direction of synthetic actors in the film *Rendez-vous à Montreal. IEEE Computer Graphics and Applications* 7(12):9–19.

Mellish, C. and R. Evans. 1989. Natural language generation from plans. *Computational Linguistics* 15(4):233–250.

Moens, M. and M. Steedman. 1988. Temporal ontology and temporal reference. *Computational Linguistics* 14(2):15–28.

Moore, M. and J. Wilhelms. 1988. Collision detection and response for computer animation. *Computer Graphics* 23(4):289–298.

Morasso, P. and V. Tagliasco (eds.). 1986. *Understanding Human Movement.* North-Holland, New York.

O'Rourke, J. and N.I. Badler. 1980. Model-based image analysis of human motion using constraint propagation. *IEEE Trans. PAMI* 2(6):522–536.

Otani, E. 1989. *Software Tools for Dynamic and Kinematic Modeling of Human Motion*. Master's Thesis, Department of Mechanical Engineering, University of Pennsylvania, Technical Report, MS-CIS-89–43, Philadephia, PA.

Pareschi, R. and M. Steedman. 1987. A lazy way to chart-parse with categorial grammars. *Proc. 25th Annual Meeting of the Association for Computational Linguistics*, Stanford, CA, pp. 81–88.

Passonneau, R.a. 1988. A computational model of the semantics of tense and aspect. *Computational Linguistics* 14(2):44–60.

Pelachaud, C.. 1990. *A 3D Animation System for Facial Expression, Emotion, and Intonation*. Forthcoming PhD Dissertation, Department of Computer and Information Science, University of Pennsylvania.

Phillips, C. and N.I. Badler. 1988. Jack: A toolkit for manipulating articulated figures. *ACM/SIGGRAPH Symposium on User Interface Software*, Banff, Canada.

Phillips, C., J. Zhao, and N.I. Badler. 1990. Interactive real-time articulated figure manipulation using multiple kinematic constraints. *Computer Graphics* 24(2):245–250.

Platt, S. 1985. *A Structural Model of the Human Face*. PhD Dissertation, Department of Computer and Information Science, University of Pennsylvania.

Pollack, M. 1986. *Inferring Domain Plans in Question-Answering*. PhD Thesis, Dept. of Computer and Information Science, University of Pennsylvania, Philadelphia, PA. (Available as Technical Report MS-CIS-86–40, University of Pennsylvania, May 1986.)

Pollack, M. 1990. Plans as complex mental attitudes. *Intentions in Communication*, J.M.P. Cohen and M. Pollack, (eds.), MIT Press, Cambridge, MA.

Reynolds, C.W. 1987. Flocks, herds, and schools: A distributed behavioral model. *Computer Graphics* 21(4):25–34.

Ridsdale, G., S. Hewitt and T.W. Calvert. 1986. The interactive specification of human animation. *Proc. Graphics Interface '86*, Vancouver, Canada, pp. 121–130.

Sacerdoti, E. 1977. *A Structure for Plans and Behavior*. Elsevier, New York.

Schabes, Y. and A. Joshi. 1988. An Earley-type parsing algorithm for tree adjunction grammars. *Proc. of the 26th Annual Meeting of the Association for Compuational Linguistics*, Buffalo, NY, pp. 258–269.

Simmons, R.F. and G. Bennett-Novak. 1975. Semantically analyzing an English subset for the clowns microworld. *American J. of Computational Linguistics*, Microfiche 18.

Steedman, M.J. 1989. Grammar, Interpretation, and processing from the lexicon. *Lexical Representation and Process*, W. Marslen-Wilson (ed.). MIT Press, Cambridge, MA.

Steketee, S. and N.I. Badler. 1985. Parametric keyframe interpolation incorporating kinetic adjustment and phrasing control. *Computer Graphics* 19(3):255–262.

Strawson, P.F. 1950. On referring. *Mind* 59:320–344.

Suchman, L. 1987. *Plans and Situated Actions: The Problem of Human-Machine Communication*. Cambridge University Press.

Takashima, Y., H. Shimazu, and M. Tomono. 1987. Story driven animation. *CHI+GI '87 Proceedings*, ACM SIGCHI, pp. 149–153 .

Tenenberg, J. 1989. Inheritance in automated planning. *Proc. First Int'l Workshop on Knowledge Representation and Reasoning,* Toronto, Canada, pp. 475–485.

Thomas, F. and O. Johnston. 1981. *Disney Animation: The Illusion of Life*. Abbeville Press, New York.

Vendler, Z. 1967. *Linguistics in Philosophy*. Cornell University Press, Ithaca, NY.

Weber, L., S. Smoliar, and N.I. Badler. 1978. An architecture for the simulation of human movement. *Proc. ACM National Conf.*, Washington, D.C., pp. 737–745.

Webber, B. 1987. The interpretation of tense in discourse. *Proc. 25th Annual Meeting of the ACL*, Stanford University, Stanford, CA, pp. 147–154.

Webber, B. 1988. Tense as discourse anaphor. *Computational Linguistics* 14(2): 61–73.

Webber, B. and B. Di Eugenio. 1990. Free adjuncts in natural language instructions. *Proc. of COLING-90*, University of Helsinki, Finland.

Wilhelms, J. 1986. Virya—A motion editor for kinematic and dynamic animation. *Proceedings Graphics Interface '86*, Vancouver, Canada, pp. 141–146.

Wilhelms, J. 1987. Using dynamic analysis for realistic animation of articulated bodies. *IEEE Computer Graphics and Applications* 7(6):12–27.

Witkin, A., K. Fleisher and A. Barr. 1987. Energy constraints on parameterized models. *Computer Graphics* 21(3):225–232.

Witkin, A. and M. Kass. 1988. Spacetime constraints. *Computer Graphics* 22(4):159–168.

Woolfe, H. (ed.). 1981. *Webster's New Collegiate Dictionary*. G.&C. Merriam Company, Springfield, MA.

Zeltzer, D. 1982. Motor control techniques for figure animation. *IEEE Computer Graphics and Applications* 2(9):53–59.

Zeltzer, D. 1985. Toward an integrated view of 3-D computer animation. *The Visual Computer: The International Journal of Computer Graphics* 1(4):249–259.

Zeltzer, D. 1990. Task-level graphical simulation: abstraction, representation and control. *Making Them Move: Mechanics, Control and Animation of Articulated Figures.* Morgan Kaufmann, San Mateo, CA.

Zhao, J. and N.I. Badler. 1989. Real time inverse kinematics with joint limits and spatial constraints. Technical Report MS-CIS-89–09, Department of Computer and Information Science, University of Pennsylvania, Philadelphia, PA.

II

ARTIFICIAL AND BIOLOGICAL MECHANISMS FOR MOTOR CONTROL

Artificial Motor Programs

4

A Robot that Walks: Emergent Behaviors from a Carefully Evolved Network

Rodney A. Brooks

MIT Artificial Intelligence Laboratory
Cambridge, Massachusetts

ABSTRACT

Most animals have significant behavioral expertise built in without having to explicitly learn it all from scratch. This expertise is a product of evolution of the organism; it can be viewed as a very long-term form of learning which provides a structured system within which individuals might learn more specialized skills or abilities. This suggests one possible mechanism for analogous robot evolution by describing a carefully designed series of networks, each one being a strict augmentation of the previous one, which control a six-legged walking machine capable of walking over rough terrain and following a person passively sensed in the infrared spectrum. As the completely decentralized networks are augmented, the robot's performance and behavior repertoire demonstrably improve. The rationale for such demonstrations is that they may provide a hint as to the requirements for automatically building massive networks to carry out complex sensory-motor tasks. The experiments with an actual robot ensure that an essence of reality is maintained and that no critical disabling problems have been ignored.

4.1 *Introduction*

In earlier work (Brooks, 1986; Brooks and Connell, 1986), we have demonstrated complex control systems for mobile robots built from completely distributed networks of augmented finite-state machines. In this paper we demonstrate that these techniques can be used to incrementally build complex systems integrating relatively large numbers of sensory inputs and large numbers of actuator outputs. Each step in the construction is purely incremental, but nevertheless along the way viable control systems are left at each step, before the next little piece of network is added. Additionally we demonstrate how complex behaviors, such as walking, can emerge from a network of rather simple reflexes with little central control. This contradicts vague hypotheses made to the contrary during the study of insect walking (for example, Bässler, 1983, p. 112).

4.2 *The Subsumption Architecture*

The subsumption architecture (Brooks, 1986) provides an incremental method for building robot control systems linking perception to action. A properly designed network of finite-state machines, augmented with internal timers, provides a robot with a certain level of performance, and a repertoire of behaviors. The architecture provides mechanisms to augment such networks in a purely incremental way to improve the robot's performance on tasks and to increase the range of tasks it can perform. At an architectural level, the robot's control system is expressed as a series of layers, each specifying a behavior pattern for the robot, and each implemented as a network of message passing augmented finite-state machines. The network can be thought of as an explicit wiring diagram connecting outputs of some machines to inputs of others with wires that can transmit messages. In the implementation of the architecture on the walking robot the messages are limited to 8 bits.

Each augmented finite-state machine (AFSM), Figure 4.1, has a set of registers and a set of timers, or alarm clocks, connected to a conventional finite-state machine which can control a combinatorial network fed by the registers. Registers can be written by attaching input wires to them and sending messages from other machines. The messages get written into them replacing any existing contents. The arrival of a message, or the expiration of a time, can trigger a change of state in the interior finite-state machine. Finite-state machines states can either wait on some event, conditionally dispatch to one of two other states based on some combinatorial predicate on the registers, or compute a combinatorial function of the registers directing the result either back to one of the registers or to an output of the augmented finite-state machine. Some AFSMs connect directly to robot hardware. Sensors deposit their values to certain registers, and certain outputs direct commands to actuators.

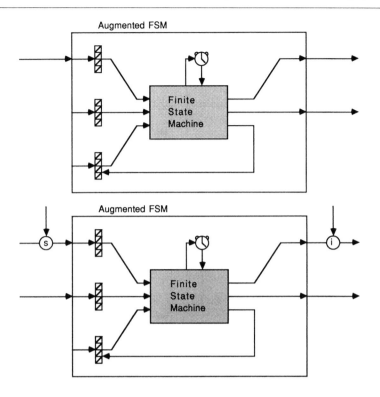

Figure 4.1 An Augmented Finite-State Machine consists of registers, alarm clocks, a combinatorial network and a regular finite state machine. Input messages are delivered to registers, and messages can be generated on output wires. AFSMs are wired together in networks of message passing wires. As new wires are added to a network, they can be connected to existing registers, they can inhibit outputs and they can suppress inputs.

A series of layers of such machines can be augmented by adding new machines and connecting them into the existing network in the ways shown in Figure 4.1. New inputs can be connected to existing registers, which might previously have contained a constant. New machines can inhibit existing outputs or suppress existing wires (Figure 4.1, circled 'i'). When a message arrives on an inhibitory side-tap no messages can travel along the existing wire for some short time period. To maintain inhibition there must be a continuous flow of messages along the new wire. (In previous versions of the subsumption architecture (Brooks, 1986) explicit, long, time periods had to be specified for inhibition or suppression with single shot messages. Recent work has suggested this better approach (Connell, 1988).) When a message arrives on a suppressing side-tap (Figure 4.1, circled 's'), again no messages are allowed to flow from the original

source for some small time period, but now the suppressing message is gated through and it masquerades as having come from the original source. Again, a continuous supply of suppressing messages is required to maintain control of a side-tapped wire. One last mechanism for merging two wires is called defaulting (indicated in wiring diagrams by a circled 'd'). This is just like the suppression case, except that the original wire, rather than the new side-tapping wire, is able to wrest control of messages sent to the destination.

All clocks in a subsumption system have approximately the same tick period (0.04 seconds on the walking robot), but neither they nor messages are synchronous. The fastest possible rate of sending messages along a wire is one per clock tick. The time periods used for both inhibition and suppression are two clock ticks. Thus, a side-tapping wire with messages being sent at the maximum rate can maintain control of its host wire.

4.3 *The Networks and Emergent Behaviors*

The six-legged robot is shown in Figure 4.2. We refer to the motors on each leg as an α motor (for *advance*) which swings the leg back and forth, and a β motor (for *balance*) which lifts the leg up and down.

Figure 4.3 shows a network of 57 augmented finite-state machines which was built incrementally and can be run incrementally by selectively deactivating later AFSMs. The AFSMs without bands on top are repeated six times, once for each leg. The AFSMs with solid bands are unique and comprise the only central control in making the robot walk, steer and follow targets. The AFSMs with striped bands are duplicated twice each and are specific to particular legs.

The complete network can be built incrementally by adding AFSMs to an existing network producing a number of viable robot control systems itemized below. All additions are strictly additive with no need to change any existing structure. Figure 4.4 shows a partially constructed version of the network.

1. Standup. The simplest level of competence for the robot is achieved with just two AFSMs per leg, *alpha pos* and *beta pos*. These two machines use a register to hold a set position for the α and β motors respectively and ensure that the motors are sent those positions. The initial values for the registers are such that on power up the robot assumes a stance position. The AFSMs also provide an output that reports the most recent commanded position for their motor.

2. Simple walk. A number of simple increments to this network results in one which lets the robot walk. First, a *leg down* machine for each leg is added which notices whenever the left is not in the down position and writes the appropriate *beta pos* register in order to set the leg down. Then, a single *alpha balance* machine is added which monitors the α position, or forward swing of all six legs, treating straight out as zero, forward as positive and backward as negative. It sums these six values and sends out a single identical message to all six

Figure 4.2 The six-legged robot is about 35cm long, has a leg span of 25cm, and weighs approximately 1 Kg. Each leg is rigid and is attached at a shoulder joint with two degrees of rotational freedom, driven by two orthogonally mounted model airplane position controllable servo motors. An error signal has been tapped from the internal servo circuitry to provide crude force measurements (5 bits, including sign) on each axis, when the leg is not in motion around that axis. Other sensors are two front whiskers, two four-bit inclinometers (pitch and roll), and six forward looking passive pyroelectric infrared sensors. The sensors have approximately 6 degrees angular resolution and are arranged over a 45 degree span. There are four onboard 8-bit microprocessors linked by a 62.5Kbaud token ring. The total memory usage of the robot is about 1Kbytes of RAM and 10Kbytes of EPROM. Three silver-zinc batteries fit between the legs to make the robot totally self-contained.

alpha pos machines, which, depending on the sign of the sum is either null, or an increment or decrement to the current α position of each leg. The *alpha balance* machine samples the leg positions at a relatively high rate. Thus if one leg happens to move forward for some reason, all legs will receive a series of messages to move backward slightly.

Next, the *alpha advance* AFSM is added for each leg. Whenever it notices that the leg is raised (by monitoring the output of the *beta pos* machine) it forces the leg forward by suppressing the signal coming from the global *alpha balance* machine. Thus, if a leg is raised for some reason it reflexively swings forward, and all other legs swing backward slightly to compensate (notice that the forward

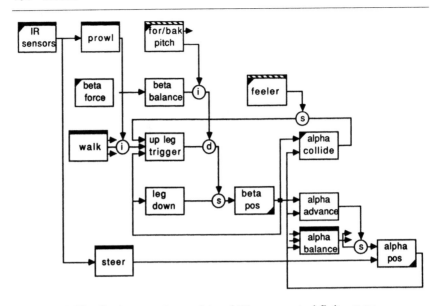

Figure 4.3 The final network consists of 57 augmented finite-state machines. The AFSMs without bands on top are repeated six times, once for each leg. The AFSMs with solid bands are unique and comprise the only central control in making the robot walk, steer and follow targets. The AFSMs with striped bands are duplicated twice each and are specific to particular legs. The AFSMs with a filled triangle in their bottom right corner control actuators. Those with a filled triangle in their upper left corner receive inputs from sensors.

swinging leg does not even receive the backward message due to the suppression of that signal). Now a fifth AFSM, *up-leg trigger* is added for each leg which can issue a command to lift a leg by suppressing the commands from the *leg down* machine. It has one register which monitors the current β position of the leg. When it is down, and a trigger message is received in a second register, it ensures that the contents of an initially constant third register are sent to the *beta pos* machine to lift the leg.

With this combination of local leg specific machines and a single machine trying to globally coordinate the sum of the α position of all legs, the robot can very nearly walk. If an *up-leg trigger* machine receives a trigger message it lifts its associated leg, which triggers a reflex to swing it forward, and then the appropriate *leg down* machine will pull the leg down. At the same time all the other legs still on the ground (those not busy moving forward) will swing backward, moving the robot forward.

The final piece of the puzzle is to add a single AFSM which sequences walking by sending trigger messages in some appropriate pattern to each of the

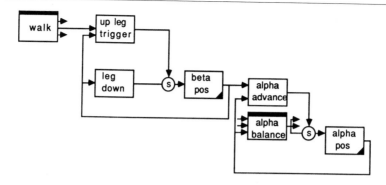

Figure 4.4 A strict subset of the full network enables the robot to walk without any feedback. It pitches and rolls significantly as it walks over rough terrain. This version of the network contains 32 AFSMs. Thirty of these comprise six identical copies, one for each leg, of a network of five AFSMs which are purely local in their interactions with a leg. The last two machines provide all the global coordination necessary to make the machine walk; one tries to drive the sum of the leg swing angles (α angles) to zero, and the other sequences lifting of individual legs.

six *up-leg trigger* machines. We have used two versions of this machine, both of which complete a gait cycle once every 2.4 seconds. One machine produces the well-known alternating tripod (Wilson, 1980), by sending simultaneous lift triggers to triples of legs every 1.2 seconds. The other produces the standard back to front ripple gait by sending a trigger message to a different leg every 0.4 seconds. Other gaits are possible by simple substitution of this machine. The machine walks with this network, but is insensitive to the terrain over which it is walking and tends to roll and pitch excessively as it walks over obstacles. The complete network for this simple type of walking is shown in Figure 4.4.

3. Force balancing. A simple minded way to compensate for rough terrain is to monitor the force on each leg as it is placed on the ground and back off if it rises beyond some threshold. The rationale is that if a leg is being placed down on an obstacle it will have to roll (or pitch) the body of the robot in order for the leg β angle to reach its preset value, increasing the load on the motor. For each leg a *beta force* machine is added which monitors the β motor forces, discarding high readings coming from servo errors during free space swinging, and a *beta balance* machine which sends out lift up messages whenever the force is too high. It includes a small deadband where it sends out zero move messages which trickle down through a defaulting switch on the *up-leg trigger* to eventually suppress the *leg-down* reflex. This is a form of active compliance which has a number of known problems on walking machines (Klein et al., 1983). On a standard obstacle course (a single 5 centimeter high obstacle on a plane) this new

machine reduced the standard deviation, over a 12 second period, of the readings from onboard 4 bit pitch and roll inclinometers (with approximately a 35 degree range), from 3.592 and 0.624 respectively to 2.325 and 0.451 respectively.

4. Leg lifting. There is a tradeoff between how high each leg is lifted and overall walking speed. But low leg lifts limit the height of obstacles which can be easily scaled. An eighth AFSM for each leg compensates for this by measuring the force on the forward swing (α) motor as it swings forward and writing the height register in the *up-leg trigger* at a higher value setting up for a higher lift of the leg on the next step cycle of that leg. The *up-leg trigger* resets this value after the next step.

5. Whiskers. In order to anticipate obstacles better, rather than waiting until the front legs are rammed against them, each of two whiskers is monitored by a *feeler* machine and the lift of the left and right front legs is appropriately upped for the next step cycle.

6. Pitch stabilization. The simple force balancing strategy above is by no means perfect. In particular, in high pitch situations the rear or front legs (depending on the direction of pitch) are heavily loaded and so tend to be lifted slightly causing the robot to sag and increase the pitch even more. Therefore one *forward pitch* and one *backward pitch* AFSM are added to monitor high pitch conditions on the pitch inclinometer and to inhibit the local *beta balance* machine output in the appropriate circumstances. The pitch standard deviation over the 12 second test reduces to 1.921 with this improvement while the roll standard deviation stays around the same at 0.458.

7. Prowling. Two additional AFSMs can be added so that the robot only bothers to walk when there is something moving nearby. The *IR sensors* machine monitors an array of six forward-looking pyro-electric infrared sensors and sends an activity message to the *prowl* machine when it detects motion. The *prowl* machine usually inhibits the leg lifting trigger messages from the *walk* machine except for a little while after infrared activity is noticed. Thus the robot sits still until a person, say, walks by, and then it moves forward a little.

8. Steered prowling. The single *steer* AFSM takes note of the predominant direction, if any, of the infrared activity and writes into a register in each *alpha pos* machine for legs on that side of the robot, specifying the rear swinging stop position of the leg. This gets reset on every stepping cycle of the leg, so the *steer* machine must constantly refresh it in order to reduce the leg's backswing and force the robot to turn in the direction of the activity. With this single additional machine the robot is able to follow moving objects such as a slow-walking person.

4.4 *Conclusion*

This exercise in synthetic neuro-ethology has successfully demonstrated a number of things, at least in the robot domain. All these demonstrations depend on the manner in which the networks were built incrementally from augmented finite-state machines.

Robust walking behaviors can be produced by a distributed system with very limited central coordination. In particular, much of the sensory-motor integration which goes on can happen within local asynchronous units. This has relevance, in the form of an existence proof, to the debate on the central versus peripheral control of motion (Bizzi, 1980) and in particular in the domain of insect walking (Bässler, 1983).

Higher level behaviors (such as following people) can be integrated into a system which controls lower level behaviors, such as leg lifting and force balancing, in a completely seamless way. There is no need to postulate qualitatively different sorts of structures for different levels of behaviors and no need to postulate unique forms of network interconnect to integrate higher level behaviors.

Coherent macro behaviors can arise from many independent micro behaviors. For instance, the robot following people works even though most effort is being done by independent circuits driving legs, and these circuits are getting only very indirect pieces of information from the higher levels, and none of this communication refers at all to the task in hand (or foot).

There is no need to postulate a central repository for sensor fusion to feed into. Conflict resolution tends to happen more at the motor command level, rather than the sensor or perception level.

Acknowledgments

Grinnell More did most of the mechanical design and fabrication of the robot. Colin Angle did much of the processor design and most of the electrical fabrication of the robot. Mike Ciholas, Jon Connell, Anita Flynn, Chris Foley, and Peter Ning provided valuable design and fabrication advice and help.

This report describes research done at the Artificial Intelligence Laboratory of the Massachusetts Institute of Technology. Support for the research is provided in part by the University Research Initiative under Office of Naval Research contract N00014–86-K-0685 and in part by the Advanced Research Projects Agency under Office of Naval Research contract N00014–85-K-0124.

References

Bässler, U. 1983. *Neural Basis of Elementary Behavior in Stick Insects.* Springer-Verlag, Heidelberg.

Bizzi, E. 1980. Central and peripheral mechanisms in motor control. *Tutorials in Motor Behavior,* G.E. Stelmach and J. Reguin, eds. North-Holland, Amsterdam.

Brooks, R.A. 1986. A robust layered control system for a mobile robot. *IEEE Journal of Robotics and Automation* RA-2, pp. 14–23.

Brooks, R.A. and J.H. Connell. 1986. Asynchronous distributed control system for a mobile robot. *Proceedings SPIE*, Cambridge, MA, pp. 77–84.

Connell, J.H. 1988. A behavior-based arm controller. MIT AI Memo. 1025.

Klein, C.A., K.W. Olson, and D.R. Pugh. 1983. Use of force and attitude sensors for locomotion of a legged vehicle. *International Journal of Robotics Research* 2(2):3–17.

Wilson, D.M. 1966. Insect walking. *Annual Review of Entomology*, II; reprinted in *The Organization of Action: A New Synthesis*, C.R. Gallistel, Lawrence Erlbaum, Hillsdale, NJ, 1980, pp. 115–142.

Biological Motor Programs

5

Sensory Elements in Pattern-Generating Networks

K. G. Pearson
Department of Physiology
University of Alberta
Edmonton, Alberta

ABSTRACT

A prevailing view in motor physiology for the past two decades has been that the timing of repetitive motor activity is established by central neuronal circuits. Recent studies on a number of locomotory systems have questioned this view. In some of these systems, it has been found that proprioceptive input establishes the timing of certain aspects of the motor pattern and is used in the generation of the rhythm. A basic problem is to determine how proprioceptive information is integrated into the central rhythmic networks for each of these systems. This problem has been analyzed in most detail in the flight system of the locust. The main results of this analysis are described in this chapter.

5.1 *Introduction*

The concept of central pattern generation became firmly established during the late 1960s and early 1970s with the discovery that virtually all rhythmic motor systems are capable of generating rhythmic activity in the absence of afferent input. By 1980, this phenomenon had been observed in over 50 motor systems (Delcomyn, 1980). Perhaps the most influential idea that arose from this discov-

ery was that the relative timing of motor activity in different muscles was established almost exclusively by central mechanisms. Indeed, Grillner (1981), in an extensive review of locomotion in vertebrates, stated that "no detail of the timing of EMG [electromagnetic] bursts has so far been shown to causally depend on phasic feedback" (p. 1196). Even so, it was well recognized that afferent feedback was essential for regulating the transitions between major phases of some rhythmic movements, such as the transition from stance to swing in the walking cat, and for stabilizing the centrally generated patterns of motor activity.

Since that time, the importance of afferent feedback in patterning motor activity has become even more apparent (Bässler, 1986; Pearson, 1985; 1987; Rossignol et al., 1988; Smith, 1986). Two major findings have been that proprioceptors can be elements in the network generating the basic rhythm (Bässler 1986; Horsmann and Wendler, 1985; Pearson et al., 1983; Sillar et al., 1986) and that in some systems phasic afferent signals are the causative events in establishing the timing of motor activity (Bässler, 1988; Smith, 1986; Wolf and Pearson, 1988). These findings have led to an increasing interest in the mechanisms by which sensory information is integrated into the central circuits to establish the normal motor pattern (see the excellent review by Rossignol et al., 1988, for a discussion of recent work on afferent control of rhythmic movements in vertebrates). Although some progress has been made toward understanding the mechanisms for sensory integration into central rhythmic networks, our current knowledge must be regarded as fragmentary. In no locomotory system have they been elucidated satisfactorily.

In this chapter, I summarize some of the results my colleagues and I have obtained on the role of proprioceptors in the patterning of motor activity for flight in the locust. In particular, I present some of the evidence that phasic signals from proprioceptors are involved in generating the basic rhythmicity and for establishing the timing of elevator activity.

5.2 *The Motor Pattern for Flight*

Flight in the locust is produced by two pairs of wings on the second and third thoracic segments. Wing movements are controlled by phasic contractions of 10 pairs of muscles/wing (four depressors and six elevators), with each muscle being innervated by from one to five motoneurons. During flight, the wing elevator and depressor muscles contract alternately at about 20 c/s. Contractions are phasic and are produced by one or two impulses in the innervating motoneurons. Our interest has centered on determining the mechanisms for the generation of the basic alternating pattern in elevator and depressor motoneurons. It should be noted, however, that the details of the timing of activity in individual muscles are complex and show subtle variations according to the behavior of the animal (Schmidt and Zarnack, 1987; Zarnack and Möhl, 1977).

5.3 *Sensory Elements in the Rhythm Generator*

The neural circuits for generating the basic flight pattern are localized within the thoracic segments. An important early discovery was that the isolated thoracic ganglia are still able to generate a rhythmic motor pattern in flight motoneurons (Wilson, 1961). This discovery led to the proposal that the flight rhythm was primarily generated by a centrally located neuronal oscillator. It was clear, however, that afferent input had some role to play because the frequency of the central oscillator was much lower than normal (12 c/s as compared with 20 c/s). The failure to observe any phasic influences of afferent input on this central oscillator (Wilson and Gettrup, 1963; Wilson and Wyman, 1965) gave rise to the idea that the main role of sensory input was to tonically increase the frequency of the oscillator but not to have any essential role in establishing the basic rhythm or pattern.

The first indication that the situation was more complex was Wendler's observation that moving the wings could entrain the flight rhythm (Wendler, 1974). This ability to entrain the rhythm implied that wing proprioceptors were elements in the rhythm-generating network in intact animals. Wendler did not identify the receptors involved in the entrainment phenomenon but amongst the likely candidates were the wing stretch receptors and the campaniform sensilla in the wing veins. Subsequently, it was found that selective stimulation of the forewing and hindwing stretch receptors could indeed reset and entrain the central oscillator (Möhl, 1985b; Pearson et al., 1983; Reye and Pearson, 1988) and that the flight rhythm could be entrained and reset by the campaniform sensilla (Horsmann and Wendler, 1985). A third group of receptors that has a strong effect on the central oscillator are the tegulae. These receptors are knoblike structures located near the anterior margin of the base of each wing (Figure 5.1A, B). Each tegula gives rise to about 80 afferents, and these discharge phasically during wing downstroke (Figure 5.1C; see Neumann, 1985). Brief stimulation of the hindwing tegula afferents results in a complete resetting of the central oscillator beginning with a burst of elevator activity (Figure 5.1D; see Wolf and Pearson, 1988). Removal of the tegulae reduces the wingbeat frequency from 20 c/s to about 15 c/s (unpublished; Kutsch, 1974; Pearson and Wolf, 1988).

These recent findings, together with early observations of the effects of receptor ablation (Kutsch, 1974; Wilson and Gettrup, 1963), have clearly demonstrated that wing proprioceptors fulfill all the usual criteria for elements in a rhythm-generating network, namely, they are phasically active, they reset the rhythm when stimulated, and their removal decreases the wingbeat frequency. Thus, one conclusion to be drawn from recent studies on the flight system of the locust is that the neural network for generating the basic rhythm for flight includes sensory elements (see also Altman, 1982; Wendler, 1982). The simple idea that afferent input functions only to tonically increase the frequency of a central oscillator must now be considered to be invalid.

Figure 5.1 Tegula afferents discharge phasically during flight, and their stimulation resets the central oscillator. Drawings A and B show the location of the forewing tegulae on the second thoracic segment. The hindwing tegulae are located in a homologous position on the third thoracic segment. (B) The tegulae are innervated by a branch (N1C1a) of nerve 1. (C) Phasic activity recorded from hindwing tegula afferents in a tethered flying animal. The top line indicates intracellular recording from elevator motoneurons in the metathoracic ganglion. The bottom line is extracellular record from nerve root 1 of the metathoracic ganglion. The brief burst of spikes labeled 'D' arise from activity in motor axons supplying the dorsal longitudinal (depressor) muscles. The long bursts of smaller spikes (onsets indicated by triangles) arise from tegula afferents (nerve root 1D was cut to eliminate input from the chordotonal organ and stretch receptor). Note that the onset of tegula activity just precedes the onset of the depolarization in the elevator motoneuron. (D) Stimulation of the hindwing tegula afferents in a deafferented preparation resets the central oscillator. The top line indicates intracellular record from a hindwing elevator motoneuron. The bottom line is an EMG from the dorsal longitudinal muscles. The tegula afferents were stimulated with a brief burst (indicated by the bar). This reset the rhythm by evoking an immediate depolarization of the elevator motoneurons. The arrows indicate the expected time of onset of depressor activity, had the stimulation not been given. (Parts A and B adapted from Neumann, 1985.)

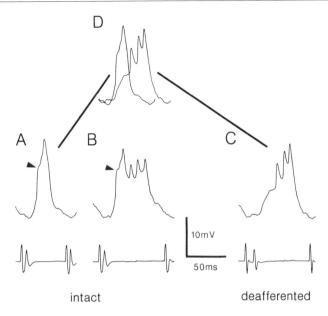

Figure 5.2 Profiles of synaptic potentials recorded intracellularly from a forewing elevator motoneuron in an intact tethered flying locust (A and B) and in a deafferented preparation (C). The arrowheads in A and B indicate the first elevator spike. Note the difference in the profiles recorded in the deafferented animal and in the intact animal at a similar cycle period (compare C and B). The rapid initial depolarization that always occurs in the intact animal never occurs in the deafferented preparation. Super-position of the profiles recorded in the intact animal at high wingbeat frequencies and in the deafferented preparation (D) yields a profile that resembles the potential at low wingbeat frequencies in the intact animal (compare D and B). (Adapted from Wolf and Pearson, 1988.)

5.4 *Sensory Input Times Elevator Activity*

Given that sensory feedback is involved in rhythm generation, an important problem is to determine the mechanisms by which proprioceptive information from the wings is integrated into central circuits. One approach that H. Wolf and I have used in an attempt to solve this problem is to make a detailed comparison of the activity patterns in motoneurons and interneurons in intact and deafferented animals (Pearson and Wolf, 1987; 1989; Wolf and Pearson, 1987; 1988; 1989). The most obvious effect of deafferentation, apart from the slowing of the rhythm, is a change in the characteristics of the synaptic input to the elevator motoneurons (Figure 5.2). In intact animals, the initial depolarization in elevator motoneurons is rapid in onset, and at wingbeat frequencies above 16 c/s

it is brief in duration, about 20 ms (Figure 5.2). As the wingbeat frequency falls below about 16 c/s, this discrete depolarization remains essentially unaltered, and a second distinct depolarization gradually appears as wingbeat frequency falls (Figure 5.2). Thus, at low wingbeat frequencies, there are two distinct components of the synaptic input to elevator motoneurons. By contrast, in deafferented preparations, the depolarizations are slow in onset and peak late in the interval between successive depressor bursts (Figure 5.2). This depolarization resembles the slow second depolarization seen in intact animals at low wingbeat frequencies (Figure 5.2). Hence the main effect of deafferentation is to completely abolish the initial rapid depolarization that occurs in elevator motoneurons in intact animals. As a consequence, the time of onset of elevator activity relative to the preceding depressor activity is delayed. EMGs from forewing muscles in tethered flying animals have shown that, following deafferentation, the interval between the onset of elevator activity and the preceding depressor activity increases from about 20 ms to about 50 ms, with a corresponding increase in the phase of elevator activity in the depressor cycle from about 0.4 to 0.6 (Pearson and Wolf, 1987; 1989). Deafferentation has only a minor effect on depressor motoneurons, in that it broadens but does not qualitatively alter the profile of synaptic input (Wolf and Pearson, 1987).

Intracellular recordings from elevator interneurons (those that depolarize in-phase with elevator activity) have revealed that the majority have a pattern of synaptic input similar to the elevator motoneurons. In other words, in intact animals they are rapidly depolarized and have their peak of activity early in the interval between successive depressor bursts, whereas in deafferented animals the depolarizations are slow in onset, and peak activity occurs at a relatively later time. An example is shown in Figure 5.3. Similar to the situation found in depressor motoneurons, the depolarizations in the majority of depressor interneurons (those depolarizing in-phase with depressor activity) remain relatively unaffected by deafferentation.

Two questions must be answered regarding the synaptic potentials occurring in elevator interneurons and motoneurons. The first is, what is the mechanism for generating the initial rapid depolarization? The second is, what causes the suppression of the second slower component of depolarization in animals flying at the normal wingbeat frequency of about 20 c/s?

5.4.1 *Generation of the Initial Component*

The fact that this component never occurs in deafferented preparations suggests that it is produced by an afferent signal. The signal we have identified is a phasic burst of activity in afferents arising from the tegulae. The main observations are as follows:

1. The tegulae discharge phasic bursts during flight, with the onset of afferent activity occurring just before the onset of the rapid elevator depolarization (Figure 5.1).

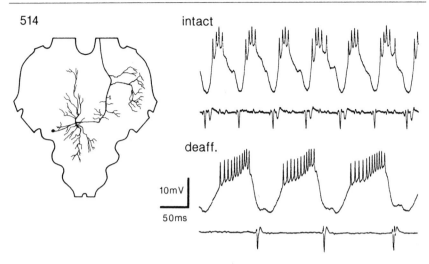

Figure 5.3 Deafferentation alters the profile of synaptic depolarization in interneuron 514. Interneuron 514 is located in the metathoracic ganglion (left) and makes excitatory connections to elevator motoneurons in the mesothoracic and metathoracic ganglia (Robertson and Pearson, 1985). In intact flying animals (records at top right) the depolarizations are rapid in onset, and peak activity occurs early within the depressor cycle. In deafferented preparations (records at bottom right), the depolarizations are slower in onset, and peak activity occurs late in the depressor cycle. The top lines are intracellular recordings from 514. The bottom lines are EMGs from depressor muscles. Note the qualitative similarity with the profiles of the synaptic depolarizations in the elevator motoneuron shown in Figures 5.2A and 5.2C. Similar changes in the profile of synaptic input occur in many other elevator motoneurons.

2. Removal of the tegulae abolishes the first component in the elevator depolarizations (Pearson and Wolf, 1988; Wolf and Pearson, 1988).

3. Phasic electrical stimulation of tegula afferents in animals in which the tegulae have been ablated restores the rapid early component in elevator depolarizations (Wolf and Pearson, 1988).

4. The pathways from tegula afferents to flight motoneurons are entirely appropriate for the generation of the rapid early component in the elevator motoneurons. (The organization of the pathways from the tegulae to elevator motoneurons is shown in Figure 5.4.)

A number of features should be noted. First, the tegula afferents make direct monosynaptic connections to elevator motoneurons in the ipsilateral hemiganglion and to elevator interneurons (Pearson and Wolf, 1988). Second, all the elevator interneurons we have examined in the metathoracic ganglion receive a pow-

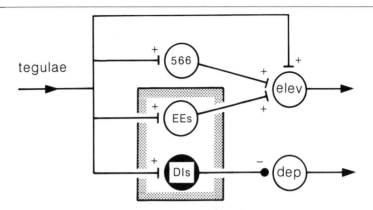

Figure 5.4 The organization of pathways from hindwing tegulae to flight motoneurons. EEs—elevator excitors; DIs—depressor inhibitors. The shaded box encloses interneurons in the central oscillator.

erful excitatory input from hindwing tegulae. Some of these interneurons (identified as 504 and 514) make direct excitatory connections to elevator motoneurons, whereas others (identified as 401, 511, and 515) monosynaptically inhibit depressor motoneurons.

Third, one pathway involves interneurons that are not elements in the central oscillator. An interneuron in this pathway is 566 (Figures 5.5 and 5.6). This interneuron makes very powerful excitatory connections to forewing elevator motoneurons (Figure 5.5) and receives large unitary excitatory postsynaptic potentials (EPSPs) from activity in all tegula afferents (Figure 5.5). What makes this pathway interesting is that, in the deafferented preparation, interneuron 566 is only weakly depolarized (Figure 5.6, deafferented) and probably contributes very little to the production of the deafferented motor pattern. In other words, it cannot be regarded as a significant element in the central oscillator. In the intact animal, by contrast, interneuron 566 is very strongly depolarized at the same time the tegula afferents are excited (Figure 5.6, intact) due to the direct connections it receives from these afferents. Because of its strong connection to elevator motoneurons, this burst of activity must contribute substantially to the depolarization of elevator motoneurons.

5.4.2 *Regulation of the Duration of Elevator Depolarizations*

It has been known since the early work of Wilson and his colleagues that input from the wing stretch receptors is essential for maintaining the normal wingbeat frequency of about 20 c/s. Selective removal of these receptors reduces the wingbeat frequency to about 12 c/s. Recently, we have observed that this decrease in the wingbeat frequency is associated with the appearance of a late depolarization in elevator motoneurons (similar to that shown in Figure 5.2) and

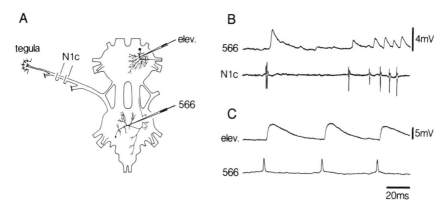

Figure 5.5 Hindwing tegula afferents make excitatory connection to interneuron 566 (see Figure 5.6 for structure), which in turn makes a powerful excitatory connection to forewing elevator motoneurons. (A) Diagram of experimental set-up. (B) Single spikes in tegula afferents recorded from nerve 1C (bottom trace) are followed 1:1 by unitary EPSPs in interneuron 566 (top trace). (C) Single spikes in interneuron 566 (bottom trace) are followed 1:1 by large EPSPs in a forewing elevator motoneuron (top trace). (Adapted from Pearson and Wolf, 1988.)

Figure 5.6 Strong rhythmic depolarizations are produced in elevator interneuron 566 in the intact flying animal (records at top right), but only weak, often subthreshold depolarizations are produced in a deafferented preparation (record at bottom left). Interneuron 566 is located in the metathoracic ganglion (left). Note that the strong depolarization that occurs in the intact animal began soon after the depressor activity (spike in EMG, bottom trace). By contrast, the depolarizations that occur in deafferented preparations have their onset much later relative to depressor activity (indicated by triangles). These late depolarizations are sometimes visible in the records made from 566 in the intact animal (arrow in top trace). (Deafferented record from Pearson and Wolf, 1988.)

that the slowing of the rhythm is almost entirely associated with the prolongation of elevator depolarizations (Wolf and Pearson, 1988).

The mechanisms by which stretch receptor input reduces the duration of these depolarizations have not been elucidated. There is no doubt, however, that they can do it. The most direct demonstration is that, in animals in which the stretch receptors have been removed (thus yielding prolonged elevator depolarizations), electrical stimulation of the forewing stretch receptors to mimic their normal input pattern can abolish the late depolarizations in elevators and so increase the wingbeat frequency (Wolf and Pearson, 1988). Thus it seems that, during normal flight, phasic signals from the forewing stretch receptors act to limit the duration of elevator depolarizations. An interesting aspect of this regulatory process is that the stretch receptor activity acts on the elevator depolarization immediately following the elevator burst that was responsible for exciting the stretch receptors. In other words, the stretch receptors do not act in a simple negative feedback loop to limit the amplitude of wing elevation (see Burrows, 1975, for a discussion of this idea).

5.5 *The Flight Pattern Generator*

Figure 5.7 summarizes the main features of the flight pattern generator that have been established by our recent studies. The central oscillator is depicted simply as reciprocal inhibition between two sets of interneurons, elevator interneurons (EINs) and depressor interneuron (DINs), although we know the situation to be much more complex (Robertson and Pearson, 1985). There is some evidence that each of these sets of interneurons is capable of generating brief bursts of activity in elevator and depressor motoneurons, respectively (Hedwig and Pearson, 1984; Wolf and Pearson, 1988). Currently, we know nothing about the cellular mechanisms for these burst generators. In the deafferented animal, we envisage that rhythmicity is generated by central switching between these burst generators.

Two major sensory systems are imposed onto this central network. The first is from the tegulae. These receptors are excited by wing depression, and their phasic activity acts to generate activity in elevator motoneurons. Three pathways are involved in the activation of elevators: excitation via direct monosynaptic connections, excitation via interneurons not in the central oscillator (for example, 566), and excitation via the interneurons that are elements in the central oscillator (for example, 504 and 514). One of the questions arising from these observations is, what is the contribution of the central oscillator to the production of elevator bursts? We know that numerous interneurons that are rhythmically active in the deafferented preparation (some of which can reset the rhythm) receive strong input from the tegulae. This input modifies their discharge pattern so that they are activated early in the interval between successive depressor spikes (Figure 5.3). If this input from the tegulae is primarily responsible for activating these elevator interneurons, then they would be functioning in a man-

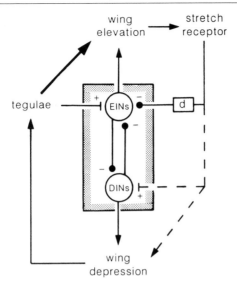

Figure 5.7 Schematic diagram summarizing the pattern-generating network for flight. The shaded box represents the central oscillator. EINs—elevator interneurons, DINs—depressor interneurons, d—delay. The tegulae are excited by wing depression, and they initiate elevator activity via a pathway that bypasses the oscillator (thick arrow) and via interneurons that are elements in the central oscillator. The stretch receptors are excited by wing elevation, and they regulate wingbeat frequency by controlling the duration of elevator activity on the next cycle (inhibitory pathway to EINs via the delay d). The stretch receptors also give excitatory input to depressor interneurons and motoneurons (dashed lines).

ner very similar to interneuron 566. This would mean that elevator bursts would be generated reflexly and perhaps independently of the mechanisms that generate these bursts in deafferented animals. Alternatively, tegula input may trigger whatever central mechanism operates in the deafferented preparation. In this case, normal elevator activity would be generated by a summation of central (from the elevator burst generator) and reflex (from the tegulae) signals. Regardless of the details of the mechanisms for the production of elevator bursts, it is clear that the timing of their onset depends on a phasic input from the tegulae.

Another important sensory system is that arising from the stretch receptors. These receptors are necessary for the maintenance of normal wingbeat frequencies. Our data indicate that they increase frequency by limiting the duration of elevator depolarizations. In Figure 5.7, this is depicted as an inhibition of elevator interneurons acting through a delay, d. By acting to limit the duration of elevator depolarization, the stretch receptors function to stabilize the wingbeat frequency. Suppose, for example, that for some intrinsic reason an elevator depo-

larization is prolonged, thus leading to a longer cycle period. Because of the delayed onset of depressor activity, the magnitude of wing elevation would increase and therefore increase the activity of the stretch receptors. This additional stretch receptor activity will then act to reduce the duration of the next elevator depolarization and so function to restore the normal cycle period. An interesting consequence of the delay in the stretch receptor feedback to elevators is that a characteristic instability often occurs in the flight pattern, namely, an alternation of long and short cycle periods (see Figure 14 in Wolf and Pearson, 1988). A short elevator depolarization produces a small burst of stretch receptor activity, which allows the next elevator depolarization to be prolonged. This then produces a large burst of stretch receptor activity, which shortens the next elevator depolarization, and so on.

Wendler (1982) has proposed that stretch receptor input maintains high wingbeat frequencies by promoting the generation of depressor activity. This is consistent with the findings that stretch receptor input is directed primarily to depressor interneurons and motoneurons; see the dashed lines in Figure 5.7 (Burrows, 1975; Reye and Pearson, 1987). It is also consistent with the finding that stimulation of stretch receptor afferents can advance the time of onset of depressor activity (Möhl, 1985b). A necessary condition for this mechanism to function is that the stretch receptor activity should precede the onset of depressor activity. At normal wingbeat frequencies (20 c/s), however, stretch receptor activity usually begins after the onset of depressor activity (unpublished; see also Figure 2 in Möhl, 1985a). Thus, under normal conditions, it seems unlikely that direct activation of depressor neurons by monosynaptic connections from the stretch receptors has a major role in regulating wingbeat frequency. At low frequency, however, this mechanism may be important.

The final aspect of the pattern generator to be considered is the mechanism for producing the transition from elevator to depressor activity. Since no sensory signals are known to occur at the time of the elevator to depressor transition, we conclude that this transition is established by a central mechanism similar to that functioning in deafferented animals, namely, that the termination of elevator activity removes inhibition from depressor interneurons, thus allowing the activation of the depressor burst generator. The timing of the onset of depressor activity relative to the termination of elevator activity is very similar in both intact and deafferented animals, as are the characteristics of the depressor depolarizations (Wolf and Pearson, 1987).

In summary, the generation of the flight motor pattern can be conceived as follows:

1. Wing depression excites the tegulae, which reflexively excites elevator motoneurons (directly and indirectly).

2. Wing elevator activity is terminated by removal of excitatory input from the tegulae and by the action of stretch receptor activity that precedes the elevator depolarization.

3. Termination of elevator activity leads by a removal of inhibition to the generation of a depressor burst to give wing depression, and so on.

Thus we see that both reflex and central mechanisms act in harmony to generate the motor pattern.

5.6 *Conclusions*

It has been recognized for some time that proprioceptors play an important role in the patterning of motor activity for flight in the locust (Wendler, 1974; 1982). However, only recently have we gained any detailed knowledge of the mechanisms by which sensory information is integrated into central circuits to establish the normal motor pattern. One of the major findings is that the timing of the onset of elevator activity is established by phasic afferent signals from the tegulae. These signals act via a number of parallel pathways to excite elevator motoneurons (Figure 5.4). Two of these pathways bypass the central oscillator and thus contribute a reflex component to the elevator excitation. The third pathway is via interneurons that are elements of the central oscillator. Of particular interest is that the activity patterns of these interneurons are modified by tegula input and they appear to function in a manner similar to those interneurons outside the oscillator. If this is the situation, then the entire elevator excitation would be produced reflexly in the intact animal.

The idea that phasic afferent signals are involved in establishing the timing of motor activity via reflexes has not been popular recently. This is because, in a large number of systems, motor patterns resembling the normal patterns can occur in deafferented preparations. But as we have seen in the flight system of the locust, the mere resemblance of motor patterns in intact and deafferented animals does not necessarily mean that the mechanisms generating the patterns are the same in both situations. It appears in this system that central processes can be radically modified by afferent input and that reflexes can establish some aspects of the motor pattern. Recent studies on walking systems in the cat (Smith, 1986), insects (Pearson 1985; Bässler, 1988), and crayfish (Sillar et al., 1986) have also indicated that reflexes produce some feature of the motor output. Moreover, we know that reflexes can function to compensate for external perturbations in the walking system of the cat (Rossignol et al., 1988) and that the reextension phase of the crayfish tailflip is reflexly generated (Reichert et al., 1981). Thus, it may be that for the past 20 years we have seriously underestimated the importance of reflex pathways in establishing the temporal pattern of activity for locomotion.

One aspect of timing that has clearly been shown to depend on phasic afferent input is the time of transition from one phase of the movement to the next. The clearest examples are in walking systems where the transition from stance to swing is initiated by afferent signals—in the cat (Grillner and Rossignol, 1978), insects (Bässler, 1988; Pearson and Duysens, 1976), and cray-

fish (Sillar et al., 1986). Similarly, in the flight system of the locust, the transition from wing depression to wing elevation is initiated by sensory signals (Pearson and Wolf, 1988; Wolf and Pearson, 1988), and in the respiratory and chewing systems of mammals afferent signals can function to terminate inspiration and jaw closing, respectively (Rossignol et al., 1988). These findings suggest that an important function of afferent input is to signal the attainment of a specific biomechanical state.

The reliance of afferent feedback to regulate phase transitions means that this state could be reached independent of minor external perturbations or changes in the properties of the musculoskeletal system. It is of interest that sensory regulation is most apparent in the transitions from what can be regarded as powerstroke to return stroke (stance to swing, wing depression to wing elevation, inspiration to expiration, jaw closing to jaw opening). Sensory regulation of this type of transition of presumably necessary to prevent the powerstroke from continuing beyond a point where it is no longer effective or is even counterproductive. These obvious examples of sensory input regulating the timing of motor activity indicate that the timing of more subtle aspects of motor patterns may be established by sensory signals generated during ongoing movements. Therefore it may be quite common for information about the biomechanical state of a system to be used to precisely time motor activity so that the subsequent movement is appropriate for that particular state.

If it is common for phasic afferent signals to time the occurrence of specific features of the motor pattern, then we must ask, what is the functional significance of the central oscillators (central pattern generators) that have been defined in most rhythmic motor systems? The broad issue is whether we can explain the generation of normal motor patterns by sensory modulation of the central oscillators (Grillner, 1985) or whether the incorporation of afferent input into these central circuits modifies their functioning so they can no longer be regarded as functional units (Pearson, 1985). A distinct possibility is that the central oscillators in many systems will be found to consist of a number of discrete subunits (unit burst generators) (Grillner, 1981; 1985; Smith, 1986). Some of these subunits will continue to function as elementary units in the intact animal (possibly triggered by afferent input), and others will be modified by afferent input and will not function in the same manner in the intact animal. This is the situation in the flight system of the locust, where the depressor burst generator functions at all times as an elementary unit and the elevator burst generator in the deafferented animal is modified in the intact animal by afferent input. The extent to which each central oscillator, or its associated unit burst generators, is modified by afferent input will undoubtedly vary from system to system. Present indications are that the largest effects of afferent input in reorganizing the functional properties of central circuits will be found in those systems in which the movements must adapt to a wide range of external conditions.

Acknowledgments

I thank Dr. J.M. Ramirez for his thoughtful comments on early drafts of this manuscript. Much of the research described in this chapter was done in collaboration with Dr. H. Wolf. I am grateful for having had such a talented colleague. The records shown in Figure 5.2 were obtained by Dr. Wolf. Research was supported by a grant from the Medical Research Council of Canada.

References

Altman, J. 1982. Sensory inputs and the generation of the locust flight motor pattern: From the past to the future. In: *Biona Report 2.* Edited by W. Nachtigall. Gustav Fischer, Stuttgart, pp. 127–136.

Bässler, U. 1986. On the definition of central pattern generator and its sensory control. *Biol. Cybern.* 54:65–69.

Bässler, U. 1988. Functional principles of pattern generation for walking movements of stick insect forelegs: The role of the femoral chordotonal organ afferences. *J. Exp. Biol.* 136:125–148.

Burrows, M. 1975. Monosynaptic connexions between wing stretch receptors and flight motoneurones of the locust. *J. Exp. Biol.* 62:189–219.

Delcomyn, F. 1980. Neural basis of rhythmic behavior in animals. *Science* 210:492–498.

Grillner, S. 1981. Control of locomotion in bipeds, tetrapods and fish. In: *Handbook of Physiology. Vol.III. Motor Control.* Edited by V.B. Brooks. American Physiological Society, Bethesda, pp. 1179–1236.

Grillner, S. 1985. Neurobiological bases of rhythmic motor acts in vertebrates. *Science* 228:143–149.

Grillner, S. and S. Rossignol. 1978. On the initiation of the swing phase of locomotion in chronic spinal cats. *Brain Research* 146:269–277

Hedwig, B. and Pearson, K.G. 1984. Patterns of synaptic input to identified flight motoneurons in the locust. *J. Comp. Physiol.* 154:745–760.

Horsmann, U. and Wendler, G. 1985. The role of a fast wing reflex in locust flight. In: *Insect Locomotion.* Edited by M. Gewecke and G. Wendler. Verlag Paul Parey, Berlin, pp. 157–166.

Kutsch, W. 1974. The influence of the wing sense organs on the flight motor pattern in maturing adult locusts. *J. Comp. Physiol.* 88:413–424.

Möhl, B. 1985a. The role of proprioception in locust flight. II. Information signalled by forewing stretch receptors during flight. *J. Comp. Physiol.* 156: 103–116.

Möhl, B. 1985b. The role of proprioception in locust flight. III. The influence of afferent stimulation of the stretch receptors nerve. *J. Comp. Physiol.* 156:281–292.

Neumann, L. 1985. Experiments on tegula function for flight coordination in the locust. In: *Insect Locomotion*. Edited by M. Gewecke and G. Wendler. Verlag Paul Parey, Berlin, pp. 149–156.

Pearson, K.G. 1985. Are there central pattern generators for walking and flight in insects? In: *Feedback and Motor Control in Invertebrates and Vertebrates*. Edited by W.J.P. Barnes and M. Gladden. Croom Helm, London, pp. 307–316.

Pearson, K.G. 1987. Central pattern generation: a concept under scrutiny. In: *Advances in Physiological Research*. Edited by H. McLennan, J.R. Ledsome, C.H.S. McIntosh and D.R. Jones. Plenum Press, New York, pp. 167–185.

Pearson, K.G. and Duysens, J.D. 1976. Function of segmental reflexes in the control of stepping in cockroaches and cats. In: *Neural Control of Locomotion*. Edited by R.M. Herman, S. Grillner, P.S.G. Stein and D.G. Stuart. Plenum Press, New York, pp. 519–538.

Pearson, K.G., Reye, and D.N., Robertson, R.M. 1983. Phase-dependent influences of wing stretch receptors on flight rhythm in the locust. *J. Neurophysiol.* 49:1168–1181.

Pearson, K.G. and Wolf, H. 1987. Comparison of motor patterns in the intact and deafferented flight system of the locust. 1. Electromyographic analysis. *J. Comp. Physiol.* 160:259–269.

Pearson, K.G. and Wolf, H. 1988. Connections of hindwing tegulae with flight neurones in the locust, *Locusta migratoria. J. Exp. Biol.* 135:381–409.

Pearson, K.G. and Wolf, H. 1989. Timing of activity in forewing elevator muscles during flight in the locust. *J. Comp. Physiol.* 165:217–227.

Reichert, H., Wine, J.J., and Hagiwara, G. 1981. Crayfish escape behavior: Neurobehavioral analysis of phasic extension reveals dual systems for motor control. *J. Comp. Physiol.* 142:281–294.

Reye, D.N. and Pearson, K.G. 1987. Projections of wing stretch receptors to central flight neurons in the locust. *J. Neurosci.* 7:2476–2487.

Reye, D.N. and Pearson, K.G. 1988. Entrainment of the locust central flight oscillator by wing stretch receptor stimulation. *J. Comp. Physiol.* 162:77–89.

Robertson, R.M. and Pearson, K.G. 1985. Neural circuits in the flight system of the locust. *J. Neurophysiol.* 53:110–128.

Rossignol, S., Lund, J.P., and Drew, T. 1988. The role of sensory inputs in regulating patterns of rhythmical movements in higher vertebrates. In: *Neural Control of Rhythmic Movements in Vertebrates*. Edited by A. Cohen, S. Rossignol, and S. Grillner. John Wiley and Sons, New York, pp. 201–283.

Schmidt, J. and Zarnack, W. 1987. The motor pattern of locusts during visually induced rolling in long-term flight. *Biol. Cybern.* 56:397–410.

Sillar, K.T., Skorupski, P., Elson, R.C., and Bush, B.M.H. 1986. Two identified afferent neurones entrain a central locomotor rhythm generator. *Nature* 323:440–443.

Smith, J.L. 1986. Hindlimb locomotion in the spinal cat: synergistic patterns, limb dynamics and novel blends. In: *Neurobiology of Vertebrate Locomotion.* Edited by S. Grillner, P.S. G. Stein, D.G. Stuart, H. Forssberg, and R.M. Herman. Plenum Press, New York, pp. 185–200.

Wendler, G. 1974. The influence of proprioceptive feedback on locust flight co-ordination. *J. Comp. Physiol.* 88:173–200.

Wendler, G. 1982. The locust flight system: functional aspects of sensory input and methods of investigation. In: *Biona Report 2.* Edited by W. Nachtigal, Gustav Fischer, Stuttgart, pp. 113–125.

Wilson, D.M. 1961. The central nervous control of flight in a locust. *J. Exp. Biol.* 38:471–490.

Wilson, D.M. and Gettrup, E. 1963. A stretch reflex controlling wingbeat frequency in grasshoppers. *J. Exp. Biol.* 40:171–185.

Wilson, D.M. and Wyman, R.J. 1965. Motor output patterns during random and rhythmic stimulation of locust thoracic ganglia. *Biophys. J.* 5:121–143.

Wolf, H. and Pearson, K.G. 1987. Comparison of motor patterns in the intact and deafferented flight system of the locust. 2. Intracellular recordings from flight motoneurons. *J. Comp. Physiol.* 160:269–279.

Wolf, H. and Pearson, K.G. 1988. Proprioceptive input patterns elevator activity in the locust flight system. *J. Neurophysiol.* 52:1831–1853.

Wolf, H. and Pearson, K.G. 1989. Comparison of motor patterns in the intact and deafferented flight system of the locust. 3. Intracellular recordings from interneurons. *J. Comp. Physiol.* 165:61–74.

Zarnack, W. and Möhl, B. 1977. Activity of the direct downstroke flight muscles in *Locusta migratoria* (L.) during steering behavior in flight. I. Patterns of time shift. *J. Comp. Physiol.* 118:215–233.

6

Motor Programs as Units of Movement Control

Douglas E. Young

Motor Behavior Laboratory
Department of Physical Education
California State University, Long Beach
Long Beach, California

Richard A. Schmidt

Motor Control Laboratory
Department of Psychology
University of California, Los Angeles
Los Angeles, California

ABSTRACT

Motor programs have been theorized to be the underlying representation for rapid movement since the early 1900s. More recently, a generalized motor program (Schmidt, 1975; 1985b) notion has been elaborated to account for the production of movements that have invariant characteristics within the structure of the movement pattern. Research that has examined rapid lever movements, typing, and locomotion has provided evidence in support of the generalized motor program as a structure that controls these behaviors. In this chapter, we extend this idea to a movement that requires a relatively complex pattern of action for goal achievement in a coincident-timing task, in which a moving target is intercepted by a lever controlled by a flexion-extension movement at the elbow joint. With analyses that allow the description of programmed units of behavior, we show that practice and feedback about the outcome (knowledge of results) resulted in a systematic reorganization in movement control. In early practice, subjects produced a single, preprogrammed bidirectional action. How-

ever, in later practice, subjects segmented this action into two sequentially controlled parts. This reorganization was characterized by a pause in movement after the backswing (flexion), a variable period in which subjects presumably processed visual feedback from the display, followed by a second program that controlled the forward swing (extension) movement to strike the target. Without knowledge about the outcome (KR), performance was less effective, and subjects did not learn the more effective two-unit action. The benefits of such a two-unit control mechanism are discussed, and implications for the modeling of behavior are examined.

6.1 *Introduction*

A fundamental idea in motor control is that (at least some) movements are controlled by an open-loop process, with a centrally "stored" structure (motor program) responsible for the grading, timing, and coordination of muscular activities necessary for skilled movement behavior. This motor program notion has had many forms and has been used to account for the production of a variety of different types of rapid movements (and specific types of long-duration movements). Schmidt (1975) extended the relatively simple concept into a more flexible generalized motor program that was proposed to control movements that have a common set of movement pattern characteristics (such as relative timing and relative force) but slightly different specific characteristics (such as overall time or overall force). With this generalized structure, many of the problems encountered with specific motor programs (such as storage and novelty) were minimized, resulting in a model for the production of movements that have similar movement pattern characteristics. One of the main assumptions of the generalized motor program concept is that the temporal structure of this control unit is essentially invariant across certain "surface" variations in the behavior. That is, the proportion of a movement's overall duration or relative time will remain constant regardless of superficial alterations in the absolute time of the overall behavior. In a number of experiments, a nearly invariant temporal structure has been found in a variety of movements ranging from rapid upper-limb movements (Armstrong, 1970; Shapiro, 1978) to relatively slow gait patterns in locomotion (Shapiro et al., 1981). It has been tempting to think that such generalized motor programs represent fundamental *units* of movement control. Of course, the discovery of such units has been of interest for decades, recent candidates for such units of behavior being the stress group as a programmed element in speech (Sternberg et al., 1978), whole words as units in typing (Terzuolo and Viviani, 1979; 1980), and portions of drawing movements during which certain relational invariants have been identified (Lacquaniti, Terzuolo, and Viviani, 1983; Viviani, 1986).

In our examination of how practice alters the kinematic patterns that describe relatively complicated movement control (Young and Schmidt, 1990),

one project addressed how augmented information feedback regarding the outcome plays a role in movement control since feedback about the outcome of a movement in terms of the environmental goal (usually termed knowledge of results, KR) is widely recognized as critical to learning (Adams, 1971; Bilodeau, 1966; Schmidt, 1988a). Through this work, we produced evidence that seemed to reveal fundamental, sequentially organized, *generalized motor programs* or units of movement behavior. The notion that such a sequential unit-structure might exist in the kind of skilled actions described here provides new insight into how these underlying structures of the movement are controlled.

We have several goals for this chapter. First, an introduction to and a brief review of supporting evidence for motor programs and generalized motor programs is provided. Next, we describe how alterations in movement control in relatively "complex" tasks occur as a function of practice and feedback. Next, we describe analyses that allow a principled, objective description of fundamental units of action in this task. These units are altered markedly across practice— particularly when feedback is provided to the learners—and are important for the understanding of movement learning and control. Finally, a discussion of this line of research in relation to motor control theory is provided, and some implications for simulating motor behavior are suggested.

6.2 *Motor Programs*

Motor program notions have been conceptualized in various ways, but there are a few features that serve to define these ideas reasonably well. First, the results of early (Lashley, 1917) and more recent (Taub and Berman, 1968) deafferentation research have shown that movements are possible without sensory feedback from the responding limb. These findings support the notion that some central representation, not absolutely dependent on response-produced feedback, is responsible for movement control. A second line of evidence suggests that sensory information processing is too slow for effective moment-to-moment control in rapid movements. Systems that use response-produced feedback are very sensitive to feedback delays, and it is unlikely that quick responses can be controlled if they are critically dependent on the information provided by feedback. Considerable evidence shows us that subjects who are suddenly and unexpectedly asked to change a movement in progress (Henry and Harrison, 1961) or to abort it completely (Logan, 1982; Slater-Hammel, 1960) cannot change the movement response before approximately 200 ms has elapsed; presumably, the movement is being controlled by some motor program in the mean time. Another line of evidence comes from an analysis of reaction-time (RT) conducted by Henry and Rogers (1960), where movement RT depended on the "complexity" of the movement. Because RT measurement begins when the stimulus appears and ends when the movement begins, it is difficult to understand how RT, which occurs *before* the movement, could be affected by something that occurred later (move-

ment complexity), unless additional time is necessary to organize the motor system for more "complex" movements.

Perhaps the strongest line of evidence for the existence of motor programs is provided by the findings from research on the control of rapid limb movements (Shapiro and Walter, 1982; Wadman et al., 1979; Young et al., 1988) in which electrical activity from contracting muscles (EMG) is recorded. In the Wadman et al. (1979) experiment, subjects were asked to generate near-maximal elbow/shoulder extension movements to a target. These "normal" movements were characterized by a strong agonist burst, a nearly simultaneous cessation of the agonist and initiation of the antagonist, followed by a second agonist burst as the antagonist burst ended. During the series of these movements, Wadman et al. unexpectedly prevented (blocked) some movements from occurring. These blocked movements had EMG patterns—for both the agonist and antagonist— that were essentially unchanged for the first 120 ms or so of activity. Also, the temporal onset of the antagonist remained essentially unchanged in both blocked and normal movements. We interpret these findings to indicate that some central structure must be responsible for controlling this action since movements based on peripheral feedback would show little or no (or at least disrupted) antagonist activity.

After the Wadman et al. (1979) work, Young et al. (1988) extended the examination of electromyographic (EMG) patterns to movements that were clearly less than maximal speed. In Figure 6.1 are EMG records from Young et al.'s experiment in which the subject made a quick elbow reversal (flexion-extension) action in various movement times. The bold traces for both the biceps and triceps show the patterning of EMGs during the normal execution of this movement and reveals a distinct temporal structure in which the agonist is active for about 150 ms and is coupled with triceps activity that is characterized by two bursts of activity—the onset of the first burst occurs almost simultaneously with the biceps onset, followed by a larger second burst of activity. A feedback-based view of movement control would argue that the observed patterning is deter-mined by sensory information from the responding limb switching the muscles on and off.[1] Another condition was used, similar to the Wadman et al. work, in which the limb was unexpectedly blocked mechanically to prevent movement from occurring. The EMG patterns for the blocked movement (light lines in Figure 6.1) are almost identical to those for the normal movements for the first 100 ms or so, regardless of the imposed movement time, and then are modified (presumably reflexively) during the later segment of the movement. The impor-tant point is that the triceps muscle is switched on at the proper time, even though the feedback from the "responding" limb must have been massively

1. Other models are also possible that use sensory information from the responding musculature as a critical feature. See Feldman (1974, 1986), for one such example, and Schmidt (1986) for a critique of it.

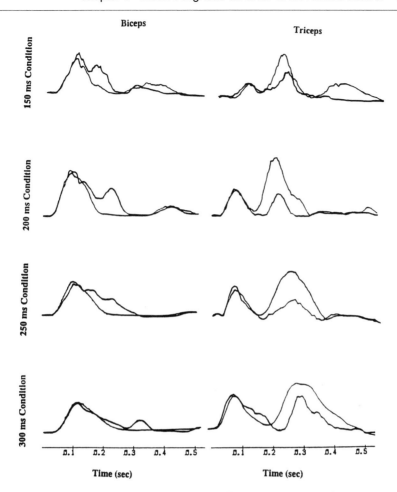

Figure 6.1 Electromyographic recordings from the biceps (left) and triceps for four different movement time conditions (150 ms to 300 ms) as a function of time. The bold traces represent trials from the normal conditions of movement, and the light traces represent trials from conditions where the movement was prevented from occurring.

disrupted. This suggests that the patterning of EMGs was structured before the movement and was carried out in an open-loop process, at least until the reflexive activities could exert an influence.

Original statements of the program view (Lashley, 1917), and even more recent ones (Keele, 1968), have insisted that the movement control be strictly open-loop, with essentially *no* involvement from peripheral feedback. This contention is perhaps too strong, as recent evidence suggests considerable feedback involvement in movement control even for quicker actions. For example, there is

now strong evidence of spindle contributions to the fine details of an ongoing response, and these spindle activities may be responsible for compensations in unexpected loads (Dewhurst, 1967) or the maintenance of important mechanical (springlike) properties of muscles (Crago, Houk, and Hasan, 1976). Recent work by Zelaznik, Hawkins, and Kisselburgh (1983) and Nashner and Berthoz (1978) suggests that vision can also operate far more rapidly than we had earlier believed. In addition, Forssberg, Grillner, and Rossignol (1975) have found that a specific stimulus presented during locomotion (such as a tap on the top of a cat's foot) leads to a completely different response, depending on the phase of the step cycle in which the stimulus is delivered. Analogous findings have been reported in speech motor control by Abbs, Gracco, and Cole (1984) and Kelso et al. (1984). These "reflex reversals" can be interpreted to mean that motor programs, in addition to controlling commands to musculature, are also involved in the "choice" of reflex pathways. In this way, particular subgoals of the an action are carried out faithfully during that phase if the limb is perturbed.

These results do not detract at all from the idea that movements are centrally represented and that feedback can interact with this central structure. Under consistent movement conditions, where peripheral influences are predictable or absent, the central representation could assume the dominant role in movement production. The main idea is that at least quick movements are organized in advance, with some central representation defining the muscular activities that are to occur. Movement is then initiated and carried out, with minimal involvement from response-produced feedback. Current thinking is that some oscillatorlike neural network (motor program or central pattern generator) is activated and that the rhythmic properties of this structure are responsible for the control of movement timing, with this control lasting for one second or longer (Shapiro, 1978).

6.3 *Generalized Motor Programs*

Researchers have properly been concerned that the notion of motor programming seems to require that each movement have a separate program to control it. This has led to logical problems about where so many programs could be stored and how novel movements could be produced (Schmidt, 1975; 1976; 1988a). Various attempts to save the attractive features of movement programs discussed above, while addressing these storage and novelty problems, have resulted in various ways of considering how motor programs could be generalized across a class of movements.

The first suggestion of a generalized motor program came from Armstrong's (1970) experiment in which subjects learned a complex arm movement pattern defined in both space and time. In Figure 6.2, the criterion pattern is shown as the solid line, and a movement that happened to end too early is shown as a dashed line. Armstrong observed that, when the movement was performed too

Figure 6.2 Control stick displacement as a function of elapsed time for movements of different durations. (Redrawn from Armstrong, 1970.)

quickly, the whole movement was speeded up as a unit. Notice that the dashed line leads the solid one by only 90 ms at the first peak, by 230 ms at the trough, and by 620 ms at the third peak. Thus, the entire movement was speeded up more or less proportionally. This suggested that the movement might be represented as an abstract temporal structure that could be produced on any trial by selecting a *rate parameter* to define the particular movement time while maintaining an invariant temporal structure.

Important to this idea was the identification of an invariant feature of the movement, one that remained essentially constant while others (such as overall movement time) changed (Schmidt, 1985a). One such feature is *relative timing*, which describes the overall temporal structure of the action. Invariant relative timing means that the proportion of time devoted to movement segments (for example the time from the first peak until the second) remains constant while the total movement time might change. This invariance seems to be present here, as the value for the solid line (2.94 – 0.75/3.59 = 0.61) and that for the dashed line (2.28 – 0.66/2.90 = 0.56) are approximately the same. Although the invariance is not perfect in this example, it does suggest that some underlying timing structure might be operating.

These and later findings (Shapiro, 1978; Shapiro et al., 1981; Summers, 1977; Terzuolo and Viviani, 1979) show general support for the notion of invariant timing and thereby provide one solution to the storage and novelty problems associated with earlier motor program concepts. Furthermore, they suggest that an abstract motor program structure is one product of motor learning and that each program might have a particular relative timing "signature," allowing us to recognize when one program or another has been produced (Schmidt, 1985b; 1988a).

The research supporting an invariance in relative timing has also revealed other ways that movements can be varied while retaining their original relative-timing structure. One common example is the parameter of movement size, revealed particularly well in handwriting. Consider one's signature, written on a check versus on a blackboard, where there is approximately a tenfold difference in size between them. The two patterns, reduced photographically to the same size, are nearly identical (Merton, 1972), suggesting that the same pattern was produced in both instances but with a variable amplitude parameter. This example is interesting from another perspective when one realizes that the muscles and joints involved in the two actions are different. Check-sized writing involves mainly the fingers with the "heel" of the hand fixed on the writing surface; blackboard writing involves essentially fixing the fingers and moving the elbow and shoulder joints. The similarity between these patterns implies that the movement representation was more abstract than the level of specific muscles and joints. In addition, other parameters, such as direction (Shapiro and Schmidt, 1983), loading (Denier van der Gon and Thuring, 1965; Sherwood, Schmidt, and Walter, 1988), and the slant in writing (Hollerbach, 1981) have been suggested.

In reviewing this research during the past decade, some general conclusions can now be stated. First, there is clear evidence that the patterns of activity in skilled and innate actions "expand" and "contract" with changes in movement time, with the various segments in the action being nearly proportional to movement time. A careful analysis of this problem by Gentner (1987), however, reveals that an exactly *proportional* expansion model is too simple to account for the data. And various nonlinear expansions have been shown in both limb movement studies (Schmidt et al., 1985; Zelaznik, Schmidt, and Gielen, 1986) and in speech motor control (Kelso et al., 1984; Ostry and Cooke, in press). Although these data detract from the idea of a simple, abstract, temporally organized movement program, they do not deny the involvement of *some* abstract structure. In addition, they do not detract substantially from the idea that these abstract structures, however defined, are a major basis for the learning and control of movement.

6.4 *Movement Control in a Coincident Timing Skill*

Recently we have utilized time-series analytical methods to uncover modes of motor control acquired in a coincident timing skill (Young and Schmidt, 1990). In this analysis, two distinct, fundamentally different patterns of action have emerged. One type of movement pattern appeared to be controlled by a single unit motor program, whereas another, more effective movement seemed to be controlled by two sequentially organized units. These findings are described next, as they represent extensions of the motor program concept for relatively complex behaviors.

We had been studying alterations in movement control as a function of practice and information feedback about goal success (knowledge of results,

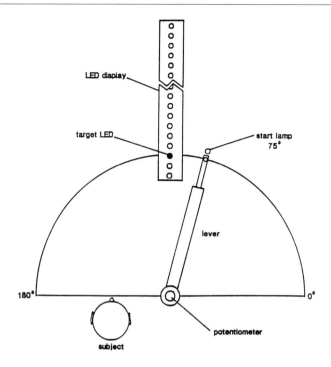

Figure 6.3 A schematic overhead view of the coincident-timing apparatus. The subject begins with the lever at the starting position, backswings (counterclockwise) past the row of LEDs, and then makes a forward swing to "hit" the moving LEDs as they pass the coincidence point.

KR). The study simply contrasted a group of subjects who received KR about the score after each trial with another group of subjects who received no KR information at all (but could use intrinsic feedback mechanisms as a way to obtain information about the outcome). Subjects practiced for 105 trials in an initial acquisition phase and then were tested in 20-trial, no-KR retention tests 10 minutes and 24 hours later.

The task was a coincident-timing skill that is analogous to hitting a moving object (such as a ball) with a hand-held object (such as a bat). The apparatus consisted of a series of sequentially illuminating LEDs and a lightweight aluminum lever and is depicted by the schematic diagram in Figure 6.3. Subjects sat facing the LED display (elevated at a 45° angle from the horizontal plane) and moved a lever with the right forearm. The subject's task was to move the lever in a counterclockwise direction (a backswing action), reverse direction, and then attempt to intercept ("hit") the moving target LED with a follow-through motion in a clockwise direction (a forward-swing movement). In this task, the subject was not highly constrained, as the backswing could begin at any time, the back-

swing distance could be from 90° to 180° at the subject's choice, the forward swing could begin at any time, and the pattern of action in making the forward swing was free to vary.

The subject's goal in this task was to maximize an *outcome* score determined by essentially two interdependent factors, the lever's instantaneous angular velocity, calculated when the lever crossed the target position, and accuracy, the absolute spatial distance (in degrees) the lever was from the target position at the time of target LED illumination (refer to Young, 1988 and Young and Schmidt, 1990, for a more detailed description of the scoring procedure). Generally, the task required the subject to search for an optimum combination of velocity and spatial error that would maximize the task score. Furthermore, the subject was free to choose nearly any pattern of action that he or she desired in order to achieve this goal—making the backswing distance larger or smaller, making the forward swing earlier or later, and so forth.

6.4.1 *Changes in Performance and Movement Control*

The mean performance scores in acquisition indicated that both groups initially performed about equally. But, with practice, the KR group performed more effectively by midway through acquisition and maintained a significant advantage for the remainder of the phase. Not surprisingly, the KR group also performed more effectively, with about 65% higher scores, in both retention tests. In conjunction with the behavioral analysis of these KR effects, an examination of the kinematic patterns produced by subjects in these two groups was completed. Essentially two distinct patterns of actions emerged. These can be seen in Figure 6.4, which contains exemplar position-, velocity-, and acceleration-time traces taken from two representative subjects; the upper lines in the figure were from a subject in the no-KR group, and the lower lines were from a subject in the KR group. A time marker is shown between the two sets of curves.

Whereas there are only minimal differences between the two patterns of position-time lines, notice that these two patterns differ substantially when the velocity time, and particularly the acceleration time, lines are considered. In the velocity time lines, the subject in the no-KR group (top) showed a biphasic velocity pattern, with no apparent break between the positive and negative peaks. The KR subject (lower), however, showed a positive velocity, then a flattening at about 800 ms, followed by the negative line beginning at about 1100 ms. An even more dramatic difference between patterns is evident when the acceleration time line is considered. For the no-KR subject at the top, the acceleration pattern had two phases, positive acceleration in the direction of the backswing followed by a negative acceleration in the direction of the target, again with no apparent break between them. For the KR subject (lower) however, there was a positive acceleration toward the backswing, followed by a small reversal in direction (from about 700 ms through 900 ms), followed by a sharp negative acceleration pattern to move the lever toward the target area. This latter deviation in acceler-

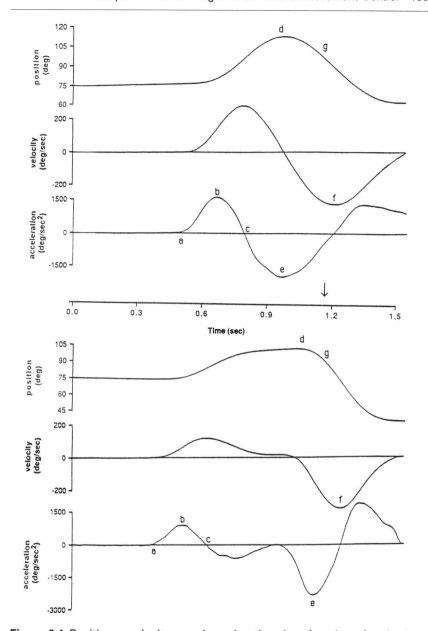

Figure 6.4 Position- , velocity- , and acceleration-time functions for single trials from one subject in the no-KR group (top panel) and another subject in the KR group (lower panel), showing the temporal locations of landmarks a through g (see text for their exact definitions); type I movements (top) are defined as those with biphasic acceleration-time functions, whereas type II movements (lower) have an extra acceleration reversal after point c and before point d. (From Young and Schmidt, 1990; reprinted with permission.)

ation time forms the objective basis for classifying these patterns into two, distinct types. A type I response is characterized by a continuous biphasic pattern, and a type II response pattern demonstrated a reversal in acceleration between the two phases at either end. This classification was easily completed by interactive graphics and unambiguously applied to all trials for all subjects in either group.

In one analysis, we simply counted the number of patterns of each type as they occurred across trials separately for the KR and no-KR subjects. The percentage of type II trials (those with additional acceleration fluctuations as described above) was approximately equal (44%) for both groups at the beginning of acquisition. As practice continued, the percentage of type II trials for the KR subjects increased in acquisition, finally maximizing at about 68% on the delayed retention test. Essentially the opposite pattern was shown for the no-KR subjects, where the percentage of type II trials decreased in acquisition, and they were used minimally (15%) in the delayed retention test. Thus, although the two groups of subjects began the experiment with essentially the same proportion of type II trials, they diverged systematically to the point that the KR subjects were producing type II responses more than four times as often as the no-KR subjects in the final retention test. This and additional analyses made it clear that the presence or absence of KR in acquisition clearly affected the way in which subjects performed this task, with the KR condition producing far more type II responses than the no-KR condition. Furthermore, these were *functional* differences in patterning, in that type II responses tended to be associated with 65% higher scores on the task than type I responses.

6.4.2 *Evidence for Units of Motor Control*

Because the different kinematic patterns might represent separate processes of movement control in these actions, several time-series analyses were completed. We suspected that the type I pattern represented a movement governed by a single program, which was initiated when the backswing began and ran its course essentially unmodified by further sensory information. In addition, type II movements were probably governed by two units—one for the production of the backswing and another for the forward swing—and these two units were "connected" by a period of information processing, during which the movements of the LEDs were sensed and final decisions about when to initiate the forward swing were made. Under this view, the backswing portion of the action was somewhat "irrelevant," serving mainly to position the limb properly for the forward swing and allowing the opportunity for important decisions about when to initiate the forward swing to be made late in the movement sequence. As such, the type I movements are produced by a single motor program, whereas the type II movements are produced by two programs strung together, with a period of visual information processing separating them.

Two kinds of time-series analyses of the kinematic data were completed to provide evidence about these views. Both of these methods, taken from the early work by Weiss (1941), utilize the temporal occurrence of various kinematic landmarks, or distinctive features, of the kinematic lines. Seven unrelated features, as identified in Figure 6.4, were detected in the kinematic records, and the *time* of their occurrence was taken as the data of interest.[2] The temporal occurrences of these various features were used for an analysis of the within-subject correlations among the times for these distinctive features. The second analysis concerns the patterns of within-subject standard deviations (SDs) of the temporal intervals separating these various landmarks. These two styles of analysis, together with their rationale, are discussed in the following sections.

6.4.2.1 *Correlational Analyses.*

Assume that the type II patterns come from movements with two distinct sequential units, and these values are not exactly constant from trial to trial, so there is some nonzero within-subject variance. If so, then from Weiss (1941) it can be argued that the correlations among any two landmarks that were within a given one of these units would be relatively high, whereas the correlations between any two landmarks lying in different units should be relatively low. This is so, in part because these units are supposedly separated by a variable interval of time that could be used for information processing between units. Therefore, the patterns of correlations should reflect the unit structure of the action. More specifically, there should be two separate groups of correlations with relatively uniform, high values associated with landmarks in certain segments of the movement. Furthermore, none of the landmarks in one segment of the record should correlate well with any other landmark in a different segment of the record since the segments are unrelated to each other. With these patterns of correlations, evidence that that movements are controlled by two distinct units is generated. However, if a pattern of uniformly high (or at least moderately high) correlations is found, then this would be evidence that only a single unit was involved.

Using the theory of generalized motor programs (Schmidt, 1985a), a similar set of predicitons can be made about the patterns of correlations. According to this notion, the units are movements controlled by short generalized motor programs that are strung together to form a complete action. Furthermore, each of these motor programs is assumed to have an invariant temporal structure (a constant *relative timing*). So, although the overall (absolute) durations of each subunit will vary from trial to trial, the temporal structure of each unit will remain unaffected. Accordingly, for a given number of trials, the correlations

2. Other dimensions of these features, chiefly representing the ordinate values of the time series shown in Figure 6.4, could have been examined as well, such as the amplitude of peak velocity or the position of the maximum backswing. But the analyses here are restricted to the times these particular events occurred.

between the times of *any* two kinematic landmarks contained in a unit should be nearly 1.0 (attenuated somewhat by errors in measurement and other sources of noise). In addition, for an overall action controlled by two such units separated by a variable interval where no program is running, the temporal location of a feature in one unit will have a correlation of essentially zero with any feature contained in the other unit. However, if there is only one unit governed by a single motor program, then the correlations should be uniformly high across the entire action. And furthermore, if there is no program or central representation for movement, then the correlation should be uniformly low across the action. Thus, by examining the correlational patterns of kinematic data, it is possible to determine if a central pattern of action exists, and to estimate the number of unit structures that control the overall behavior in the coincidence-timing task.

Using seven temporal measures from the movement pattern, the patterns of correlations among them for subjects who showed the strongest tendencies for either type I or type II were examined—five subjects (from the KR group) producing only type II responses in the retention test and five subjects (from the no-KR group) producing only type I responses in the retention test were used. For the type I responses, these values were uniformly around 0.70 but they did decrease very slightly (to around 0.65) as the landmarks became more separated in time from each other; these are shown in the upper portion of Figure 6.5. From the rationale presented above, this suggests a movement governed by a single unit across its total duration period. However, for the type II responses we see a very different pattern (upper right portion of Figure 6.5). Here, the correlations between the time of the first part of the movement (point a) and successively later points were very high (from 0.93 to 0.83) for the landmarks up to point d, but the correlations with point a dropped markedly to about 0.25 for the landmarks located in the last part of the action (points e, f, and g). These results, together with appropriate statistical analysis, showed that the intervals for the subjects generating type I responses produced correlations that were not different from each other. However, for the type II responses, the points a through d were members of a given unit and were not members of the part of the action represented by points e, f, and g. We take this as evidence for at least one programmed unit isolated in the initial part of the action.

Another correlational analysis was performed, but with a different common landmark—the point at which the lever crossed the coincidence point, or point g. Here, the correlations were computed with successively earlier and earlier landmarks, and the results of this analysis are shown in the lower portion of Figure 6.6. For the type I responses shown on the left, again the correlations among the temporal landmarks were uniformly around 0.70 to 0.75, with almost no tendency for changes across landmarks, again suggesting that the entire movement was governed by a single unit for the type I responses. For the type II responses (shown on the right), the correlations between point g and landmarks late in the action (e and f) were around 0.95 or higher, but correlations abruptly dropped to about 0.40 as landmarks in the earlier segment of the movement were paired

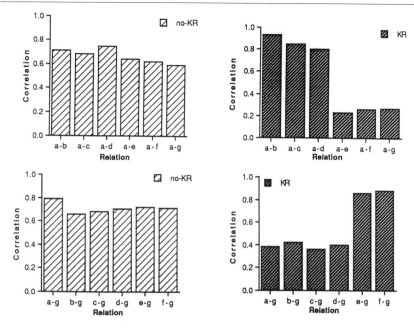

Figure 6.5 In the upper panel, averaged within-subject correlations between the time of the first landmark (a) and the times of the times of the later landmarks (b through g), separately for the type I response (left) and the type II response. In the lower panel, averaged within-subject correlations between the time of the last landmark (point g) and the times of the earlier landmarks (a through f), separately for the type I response (left) and the type II response (right). (From Young and Schmidt, 1990; reprinted with permission.)

with point g. This suggests that another program unit controls the later segment of the movement.

Together, the analyses described in Figure 6.5 suggest that the structure of this action was different for the type I and type II responses. For the type I responses, only one programmed unit could be identified, as there were no obvious changes in the correlations across the landmarks used. For the type II responses, however, there were apparently two programmed units, one made up of parts of the action containing landmarks a through d, and another made up of parts of the action containing landmarks e through g.

6.4.2.2 *Variability Analyses.* Another of Weiss's (1941) methods for understanding the structure of an action was to examine the patterns of variability among the intervals defined by the various landmarks chosen. The idea was that, if two landmarks are contained within a given behavioral unit, then the variability (within subjects, over trials) of the interval of time separating them should be

relatively small, representing the view that such units are rather tightly organized temporally. For two landmarks in different units, the temporal interval separating them should have considerably more variability. This variability between land-marks in different units would be expected to be even higher if the two units are separated by a period were no unit is acting, such as when visual information processing is thought to occur between the two units of muscular activity. This logic leads naturally to an analysis of the SDs of the various intervals among the landmarks that were defined earlier in Figure 6.4, which provides potentially converging evidence about the differential structures of the two kinds of actions discussed here.

In an analysis of the mean within-subject SDs of various intervals, analo-gous to those in the analysis of the correlations, each has a common starting point (point a) but successively later and later endpoints, so that the intervals are a-b, a-c, a-d, ... , a-g. Figure 6.6 (upper portion) provides the landmarks described earlier, again plotted separately for the type I (left) and type II (right) responses. For the type I responses on the left, these SDs increased slightly and gradually as the separation from point a increased, with the SDs ranging from 60 ms for interval a-b to about 80 ms for interval a-g. This would be expected from a single-unit structure, where the cumulative effects of errors in muscular con-traction force and timing (or small errors in measurement) systematically raise the variabilities slightly as longer and longer intervals are measured (Schmidt et al., 1979). The analogous analysis for the type II responses showed relatively small SDs for the intervals a-b and a-c (around 25 to 30 ms), and then an abrupt increase to about 60 ms for the intervals containing later endpoints (a-d through a-g). Statistical analysis indicated significant differences only for the type II responses between the first two intervals and the later ones. This abrupt transi-tion in variability for the type II responses suggests that there was a unit contain-ing points a-c, but expanding the interval slightly to include any of the next later points (point d and beyond) essentially doubled the variability. This interpreta-tion of a unit containing points a-c was consistent with the interpretation of the correlational data discussed above.

In a similar analysis, but this time with the common landmark being point g, the latest landmark, expanding the intervals to include successively earlier initial landmarks, mean SDs (shown in the lower portion of Figure 6.6) revealed a similar set of trends. For the type I responses at the left, there was a pattern of slightly increasing variability as the intervals became longer ranging from about 60 ms to 70 ms. The failure to detect an abrupt shift in variability was again consistent with a single unit of action, but with slightly increased variability as more and more "error" variability is added as the units became longer. In con-trast, the type II responses at the right showed a different pattern, in which intervals near the end of the movement (e-g, f-g) had relatively low variability (around 25 ms), and intervals made up of initial landmarks occurring earlier than point e increased abruptly to about 60 ms. As before, the type II responses had significantly lower variabilities in the last two intervals (e-g, f-g) than the

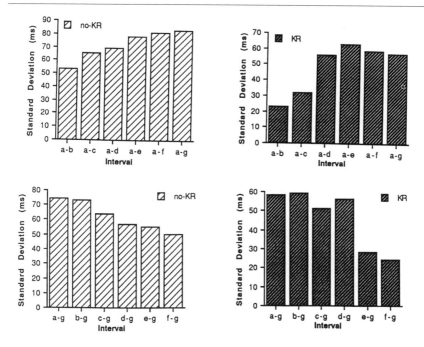

Figure 6.6 In the upper panel, averaged within-subject standard deviations of the durations between landmark a and systematically later landmarks, separately for the type I response (left) and the type II response (right). In the lower panel, averaged within-subject standard deviations of the durations between landmark g and earlier landmarks, separately for the type I response (left) and type II response (right). (From Young and Schmidt, 1990; reprinted with permission.)

remaining ones. However, the variabilities of these intervals were not reliably different for the type I responses. Again, this result is consistent with the notion that there is a unit at the end of the movement (including landmarks e, f, and g). Because expanding the interval to include any earlier landmarks (point d or earlier) more than doubled the variability, the initial part of the final unit occurs approximately at point e.

Taken together, the data from Figure 6.6 provide evidence of a single unit of behavior for the type I responses, as there were no abrupt transitions between the sizes of the SDs as the intervals were expanded to include landmarks distributed across the action. The type II responses showed strong evidence of producing two units of behavior, one located approximately at the beginning of the action (including landmarks a through c), and another located at the end of the action (including landmarks e through g). In this analysis, landmark d seemed to be included in neither unit, as any interval that included landmark d had relatively high variabilities as compared with intervals wholly at the beginning or at the end of the action.

Figure 6.7 Average within-subject relative variabilities (SDs/mean) for intervals defined by successive pairs of adjacent landmarks in the movement, separately for the type I response (left) and the type II response (right). (From Young and Schmidt, 1990; reprinted with permission.)

Relative SDs of Intervals Between Adjacent Landmarks. As an extension of Weiss's (1941) notion for examining the structure of action, the variabilities of each successive interval defined by the sequence of *adjacent* landmarks should reveal the end of one segment and the beginning of another. Progressing through the movement forward in time, we should expect that the variabilities should be relatively low until the last landmark in the first segment is encountered, and then the variabilities for the next interval should be abruptly higher since it contains landmarks in the first *and* second unit. Any large, abrupt increase in the variability should therefore provide evidence about the segment boundaries. With the use of *absolute relative variabilities* (the absolute value of the interval's SD/mean),[3] a final analysis examined the relative variabilities of the adjacent intervals throughout the action in search of the segment boundaries.

The relative variabilities of the adjacent intervals are shown in Figure 6.7, the data from the type I responses on the left and the type II responses on the right. For the type I responses, the relative variabilities increased slightly from about 0.25 to 0.30 as successively later intervals were considered. However, for the type II responses, these relative variabilities increased slightly from 0.12 to 0.18 for the first three adjacent intervals (a-b, b-c, and c-d) but increased sharply to about 0.46 for the d-e interval; this variability was some three to four times as large as those for the previous intervals. The relative variabilities for the intervals following the d-e interval decreased considerably again, to approximately 0.25. Statistical analyses showed that, for the type II responses, the relative variabilities for the d-e interval were larger than all earlier and later intervals, with none of the other intervals being reliably different from each other. For the type I

3. For this analysis, all interval durations must have positive values; that is, variability across trials can sometimes result in a given interval being positive on some trials and negative on others, which could result in artifactually small mean interval durations. The solution used was to evaluate the mean interval duration as the denominator in producing relative variability measures.

responses, the relative variabilities for the various intervals were not reliably different from each other.

Taken together, these findings converge with the earlier analyses to support the hypothesis that the type I responses were controlled as a single motor program (with a positive and negative acceleration-time impulse in its structure), based on the finding of no obviously elevated relative variability for any of the adjacent intervals. In contrast, the type II responses showed a clearly elevated relative variability for the d-e interval, indicating that they segmented the movement into two parts, with the d-e interval containing the boundary between the two programmed units. These adjacent-interval analyses of relative variabilities appear to provide a powerful basis for locating the unit boundaries in such actions.

6.4.3 *Further Evidence for Two Sequentially Programmed Units*

Recently, Lange, Young, and Schmidt (1989) have been concerned with the control of behavior with extended levels of practice. One limitation of the previous experiment is that movement patterns evaluated represented the subjects' initial attempts at solving the task since the practice period consisted of only 100 trials. Accordingly, Lange et al. increased the amount of practice on the coincident-timing task to 1,000 trials with feedback about the outcome over a nine-day period. On day 9, movement patterns for 10 subjects were recorded for analysis

The analyses completed for this experiment were similar to those presented here—analyses for both correlational and interval variability were conducted. A total of 11 temporal landmarks were taken from displacement, velocity, and acceleration records, and these served as the basis data for these analyses. Results from the within-subject correlations indicated two distinct sets of related landmarks. More specifically, the first five temporally occurring landmarks (landmarks 1 through 5) and the last five temporally occurring landmarks (landmarks 6 through 10) were highly intercorrelated, with mean correlations between 0.81 and 0.95. However, correlations between the first and last five landmarks were significantly lower (between 0.36 and 0.42). In addition to these correlations, the analysis of standard deviations for intervals defined by these landmarks revealed similar relationships among the landmarks. Mean within-subject SDs for intervals defined by landmarks 1 through 5 and 6 through 10 were relatively low, ranging from 12.9 to 37.3 ms). In comparison, the SDs for intervals defined by any first and last five landmarks were about twice as high. Together, these two analyses provide further evidence that the behaviors acquired during high levels of practice were similar to the type II responses reported earlier. As we suspected from the first experiment with this task, these actions, which are controlled by two sequentially programmed units separated by a variable time interval, clearly represent an effective pattern of behavior for this coincident-timing skill.

6.5 *Motor Programs as Units of Movement Control*

Our primary focus here has been the detection of units of movement control for different types of behaviors using the motor program as the basic structure representing such units. At a superficial level of analysis (such as position-time records), all subjects appear to make a relatively "continuous," smooth reversal movement. However, when kinematic variables are considered—particularly velocity-time and especially acceleration-time records—it is possible to identify underlying units of action that give insight into the nature of movement control in these activities. With these methods, it has also been possible to document rather marked changes in the organization of these actions with practice.

Early in practice, learners in this task produced a pattern involving a single, biphasic action that consisted of a single movement unit. Later in practice, learners with KR acquired a completely different action to produce the same environmental goal involving a sequence of two distinguishable movement units. We suspect that the two units are separated by a highly variable interval, during which various kinds of information processing occurs, such as the detection and correction of errors produced in the first unit as well as visual information processing related to the time to contact remaining before the pattern of LEDs arrives at the conincidence point. Practice *per se* was not sufficient for this two-unit sequence of action to develop, and this pattern apparently required extrinsic feedback about subjects' success in meeting the environmental goal. These findings are related to the perspectives on movement control and learning issues and are addressed in more detail in the following sections.

6.5.1 *Motor Programs as Units of Action*

In contrast to the several approaches that have attempted to identify the basic units of action (Sternberg et al., 1978; Viviani, 1986), our approach to the unit structure in limb actions was based on several ideas from Weiss (1941), together with the recent thinking about and considerable empirical support for the theory of generalized motor programs (Schmidt, 1985a; 1985b; 1988a). In this view, a unit is considered to be simply a motor program that governs behavior for several hundred milliseconds (Schmidt, 1988a, Chapter 8). These programs should obey the principles of *generalized* motor programs; most importantly, during the time they are operating, they should control actions so that the temporal structure displays essentially invariant relative timing, even though the actual duration of the unit might vary. In addition, we assume that two different generalized motor programs will demonstrate different patterns of relative timing, with each showing its own invariance across changes in overall unit duration.

When applied to the data in the present experiment, the method generates evidence for two different kinds of unit structures, one for the subjects who had received KR during practice (type II patterns) and a second for subjects who had not received KR during practice (type I patterns). More specifically, the type I response pattern seemed to be controlled by one generalized motor program that controlled the entire action from the onset of the movement. In comparison, the type II response, which was clearly more effective for performance (as it was associated with significantly higher scores over the type I responses and emerged with extensive practice), was controlled by two programs. These two independent programs were sequentially organized and separated by a variable information-processing interval.

6.5.2 *Advantages of Movements Controlled by a Two-Unit Structure*

When considering the control of the two-unit response pattern, three advantages appear to suggest why it is associated with effective performance. One major advantage for the two-unit pattern is the fact that the *duration* of the movement governed by the final unit is shorter. It is well known that, for quick actions, the within-subject variability in movement time is nearly proportional to the average movement time; therefore, decreasing the movement duration by shortening the final, programmed segment (here, from about 700 to 200 ms) will have strong effects on temporal variability. Of course, variability in when the lever arrives at the coincidence point is strongly related to variability in spatial position of the lever at the moment the target arrives. Since the latter is a component in the overall score, shorter movement times increase the score by decreasing absolute spatial errors (see Schmidt et al., 1985).

The second advantage for the two-unit structure is that absolute spatial errors are decreased for the two-unit pattern relative to the one-unit pattern because the distance to be moved for the duration of the unit is smaller. Because the first unit controls the limb for the backswing, the final unit must only control the forward swing. In comparison, the one-unit structure must control both the backswing and forward swing. Impulse-variability analyses of this kind of task shows that reducing the movement distance decreases the spatial errors at the endpoint almost proportionally (Sherwood, Schmidt, and Walter, 1988). Therefore, spatial variability at the coincidence point is presumably reduced in the two-unit structure because the distance to be traveled after the final unit is triggered is approximately half that in the one-unit pattern.

A final advantage is that the visual information serving as the "trigger" for the final program occurs closer in time to the coincidence point in the two-unit case than to the one-unit case. Therefore, the estimation of the target arrival time is shorter in the two-unit case, making the perceptual anticipation (Poulton,

1957) more accurate (Schmidt, 1969; 1988a). In addition, the light pattern is spatially closer to the subject when this final response is triggered, probably allowing more stable determinations of the time to trigger the action. These last effects might be relatively small ones, however, based on recent evaluations of coincidence-timing behavior based on optical flow variables, such as time to contact (Lee and Young, 1985). Even so, to the extent that there is some advantage in having the time-to-contact information generated when the moving object is closer to the subject, there might be additional benefits from the two-unit control strategy.

6.5.3 *Support for the Motor Program Perspective*

Over the years, there have been a number of perspectives that have explained complex behaviors. Two contrasting perspectives are the action approach, emerging from ecological psychology, and the motor approach, developing from motor control (see Schmidt, 1988b, for a discussion of these two approaches). Here, we provide evidence that clearly supports the motor control approach and cannot be well explained by the action perspective.

First, the evidence from the "blocked" limb paradigms provides strong support for the motor approach and is not well explained by the ecological approach. Recall that, in these paradigms, rapid movements occur, with a small percentage of these movements being prevented from occurring (by a mechanical block). In a comparative analysis of EMG patterns, the agonist and anatagonist were basically unaffected for the first 120 ms or so when the limb was prevented from moving (Wadman et al., 1979). Moreover, the antagonist activity maintains many of its temporal characteristics (such as temporal onset). Under an action view, the EMG pattern should be emergent from the dynamics of movement since it is not centrally controlled, and blocking the limb unexpectedly should result in a massive disruption in the pattern of EMG activities (Schmidt, 1988b). Clearly, this is not supported here, as EMG patterns were not significantly disrupted until reflexive activities influenced control.

Second, a commonly held generalization about skill acquisition, based on ideas from Bernstein (1967) and others, is that the subject learns to exploit the limb dynamics—the passive, inertial and mechanical properties of the limb to be moved—to simplify and smooth the control, to increase movement velocity, and to decrease energy costs. One important class of muscle dynamics is the so-called "stretch-shorten cycle," in which the performer uses the springlike properties of muscle to increase the accelerations associated with reversing direction, as in the transition from the backswing to the forward swing in the present task. However, in the present task, the successful performers apparently learned a pattern of action that systematically *eliminated* the stretch-shorten cycle. That is, the two-unit pattern involved a prolonged slowing of the lever as the maximum backswing was approached—almost a stop at the maximum backswing position—before the forward swing was initiated (see Figure 6.4). This behavior

appears to reduce the involvement of muscle dynamics and the stretch-shorten cycle rather than increase it, as might be expected.[4] The reasons why these dynamical properties might have been systematically eliminated (if they were) are perhaps related to the heavy penalties imposed on spatial errors here. The use of the stretch-shorten cycle to increase forward-swing velocity probably occurs at considerable cost in terms of spatial errors; forceful muscle contractions are relatively "noisy" processes that result in considerable variability in the resulting trajectory (Schmidt et al., 1979). This noise is acceptable in many tasks in which high velocity is a major goal (as in Schneider et al., in press), but it does not appear to be consistent with the concomitant production of high movement precision as demanded here.

6.5.4 *Implications for Modelling and Animation*

One of main goals of this chapter is to describe the nature of how movements are controlled. In the actions we have considered here, evidence strongly suggests that generalized motor programs are the underlying representations for these bidirectional coincident-timing responses. These movements, which appear to be smooth, continuous behaviors due to the limbs inertial properties, are actually controlled by two sequentially organized sets of programmed units separated by a variable feedback-based interval. Moreover, these programmed units are able to expand or contract in a number of dimensions (time, amplitude) while maintaining specific invariant characteristics (such as relative timing).

Perhaps models of human behavior should be considered in a similar way. For example, human movement simulators may find it beneficial to allow specific programs to generate motion and then utilize feedback-related information to determine effective parameters for a subsequent program. This type of movement control seems particularly useful when responses are heavily constrained to minimize errors. In these situations, the sets of short-duration motor programs enable more accurate control of behavior for longer programs. Furthermore, when the movement becomes more complex, such as the skill discussed here, breaking down the action into components or separate programs that can speed up or slow down in a systematic way may be the most effective solution to the movement problem. This type of movement pattern, which has discrete segments

4. This generalization should be taken cautiously, however. Simply because the *lever* was not moving at the point of maximum backswing position does not necessarily mean that the relevant muscles were not being placed on a stretch; and, there could be other joints "upstream" from the action (for example, the shoulder) that are utilizing the stretch-shorten cycle, and these processes are not seen in our measures of the elbow joint. Analyses with EMG and/or with additional analyses of intersegmental dynamics (Schneider et al., in press) could be used to resolve these issues in future work. However, if the change in motor control seen here does decrease the involvement of the stretch-shorten cycle, it seems to place a limitation on the generalization that practice typically increases the role of passive, dynamical muscle properties.

of control, may represent a class of behaviors seen in numerous natural situations, such as the throwing and striking actions in sport, in dance routines, or in the precise limb movements in music.

References

Abbs, J.H., Gracco, V.L., and Cole, K.J. 1984. Control of multimovement coordination: Sensoriomotor mechanisms in speech and motor programming. *Journal of Motor Behavior* 16:195–231.

Adams, J.A. 1971. A closed-loop theory of motor learning. *Journal of Motor Behavior* 3:111–150.

Armstrong, T.R. 1970. Training for the production of memorized movement patterns. Technical Report No. 26, Human Performance Center, University of Michigan.

Bernstein, N. 1967. *The Co-ordination and Regulation of Movements*. Oxford: Pergamon Press.

Bilodeau, I.M. 1966. Information feedback. In E.A. Bilodeau (Ed.), *Acquisition of Skill*. New York: Academic Press, pp. 255–296.

Crago, P.E., Houk, J.C., and Hasan, Z. 1976. Regulatory actions of the human stretch reflex. *Journal of Neurophysiology* 39:925–935.

Denier van der Gon, J.J. and Thuring, J.P.H. 1965. The guiding of human writing movements. *Kybernetik* 2:145–148.

Dewhurst, D.J. 1967. Neuromuscular control system. *IEEE Transactions on Biomedical Engineering* 14:167–171.

Feldman, A.G. 1974. Change of muscle length due to shift of the equilibrium point of the muscle load system. *Biophysics* 19:544–548.

Feldman, A.G. 1986. Once more on the equilibrium point hypothesis (model) for motor control. *Journal of Motor Behavior* 18:17–54.

Forssberg, H., Grillner, S., and Rossignol, S. 1975. Phase dependent reflex reversal during walking in chronic spinal cats. *Brain Research* 85:103–107.

Gentner, D.R. 1987. Timing of skilled motor performance: Tests of the proportional duration model. *Psychological Review* 94:255–276.

Henry, F.M. and Harrison, J.S. 1961. Refractoriness of a fast movement. *Perceptual and Motor Skills* 13:351–354.

Henry, F.M. and Rogers, D.E. 1960. Increased response latency for complicated movements and a "memory drum" theory of neuromotor reaction. *Research Quarterly* 31:448–458.

Hollerbach, J.M. 1981. An oscillation theory of handwriting. *Biological Cybernetics* 39:139–156.

Keele, S.W. 1968. Movement control in skilled motor performance. *Psychological Bulletin* 70:387–403.

Kelso, J.A.S., Tuller, B., Vatikoitis-Bateson, E., and Fowler, C.A. 1984. Functionally specific articulatory cooperation following jaw perturbations during speech: Evidence for coordinative structures. *Journal of Experimental Psychology: Human Perception and Performance* 10:812–832.

Lacquaniti, F., Terzuolo, C., and Viviani, P. 1983. The law relating kinematic and figural aspects of drawing movements. *Acta Psychologica* 54:115–130.

Lange, C.L., Young, D.E., and Schmidt, R.A. 1989. Extended practice and the identification of units of motor behavior. *North American Society for the Psychology of Sport and Physical Activity Abstracts* 15:39.

Lashley, K.S. 1917. The accuracy of movement in the absence of excitation from the moving organ. *American Journal of Physiology* 43:169–194.

Lee, D.N. and Young, D.S. 1985. Visual timing of interceptive action. In D. Ingle, M. Jeannerod, and D.N. Lee (Eds.), *Brain Mechanisms and Spatial Vision*. Dordrecht: Martinus Nijhoff, pp. 1–30.

Logan, G.D. 1982. On the ability to inhibit complex movements: A stop-signal analysis of typewriting. *Journal of Experimental Psychology: Human Perception and Performance* 8:778–793.

Merton, P.A. 1972. How we control the contraction of our muscles. *Scientific American* 226:30–37.

Nashner, L. and Berthoz, A. 1978. Visual contributions to rapid motor sequences during postual control. *Brain Research* 150:403–407.

Ostry, D.J., and Cooke, J.D. in press. Kinematic patterns in speech and limb movements. In E. Keller and M. Gopnick (Eds.), *Symposium on Motor and Sensory Language Processes*. Hillsdale, NJ: Erlbaum.

Poulton, E.C. 1957. On prediction in skilled movements. *Psychological Bulletin* 54:467–478.

Schmidt, R.A. 1969. Movement time as a determiner of timing accuracy. *Journal of Experimental Psychology* 79:43–47.

Schmidt, R.A. 1975. A schema theory of discrete motor skill learning. *Psychological Review* 82:225–260.

Schmidt, R.A. 1976. Control processes in motor skills. *Exercise and Sport Sciences Reviews* 4:229–261.

Schmidt, R.A. 1985a. Identifying units of motor behavior. *Behavioral and Brain Sciences* 8:163–164.

Schmidt, R.A. 1985b. The search for invariance in skilled movement behavior. *Research Quarterly for Exercise and Sport* 56:188–200.

Schmidt, R.A. 1986. Controlling the temporal structure of limb movements. *The Behavioral and Brain Sciences* 9:623–624.

Schmidt, R.A. 1988a. *Motor Control and Learning: A Behavioral Emphasis* (2nd ed). Champaign, IL: Human Kinetics Publishers.

Schmidt, R.A. 1988b. Motor and action perspectives on motor behaviour. In O.G. Meijer and K. Roth (Eds.), *Complex Movement Behaviour*. North Holland: Elsevier Science Publishers, pp. 3–44.

Schmidt, R.A., Sherwood, D.E., Zelaznik, H.N., and Leikind, B.J. 1985. Speed-accuracy trade-offs in motor behavior: Theories of impulse variability. In H. Heuer, U. Kleinbeck, K.-H. Schmidt (Eds.), *Motor Behavior: Programming, Control, and Acquisition*. Heidelberg: Springer-Verlag.

Schmidt, R.A., Zelaznik, H.N., Hawkins, B., Frank, J.S., and Quinn, J.T. 1979. Motor-output variability: A theory for the accuracy of rapid motor acts. *Psychological Review* 86:415–451.

Schneider, K., Zernicke, R.F., Schmidt, R.A., and Hart, T.J. in press. Learning unrestrained rapid arm movements: Coordination of intersegmental dynamics. *Journal of Biomechanics*.

Shapiro, D.C. 1978. *The Learning of Generalized Motor Programs*. PhD Dissertation, University of Southern California.

Shapiro, D.C. and Schmidt, R.A. 1983. The control of direction in rapid aiming movements. *Society for Neuroscience Abstracts* 9(2), 1031.

Shapiro, D.C. and Walter, C.B. 1982. Control of rapid bimanual aiming movements: The effect of a mechanical block. *Society for Neuroscience Abstracts* 8(2):733.

Shapiro, D.C., Zernicke, R.F., Gregor, R.J., and Diestal, J.D. 1981. Evidence for genralized motor programs using gait-pattern analysis. *Journal of Motor Behavior* 13:33-47.

Sherwood, D.E., Schmidt, R.A., and Walter, C.B. 1988. Rapid movements with reversals in direction: II. Control of movement amplitude and inertial load. *Experimental Brain Research* 86:355–367.

Slater-Hammel, A.T. 1960. Reliability, accuracy, and refractoriness of a transit reaction. *Research Quarterly* 31:217–228.

Sternberg, S., Monsell, S., Knoll, R.L., and Wright, C.E. 1978. The latency and duration of rapid movement sequences: Comparisons of speech and typewriting. In G.E. Stelmach (Ed.) *Information Processing in Motor Control and Learning*. New York: Academic Press, pp. 117–152.

Summers, J.J. 1977. The relationship between the sequencing and timing components of a skill. *Journal of Motor Behavior* 9:49–59.

Taub, E. and Berman, A.J. 1968. Movement and learning in the absence of sensory feedback. In S.J. Freedman (Ed.), *The Neuropsychology of Spatially Oriented Behavior*. Homewood, IL: Dorsey Press.

Terzuolo, C.A. and Viviani, P. 1979. The central representation of learning motor programs. R.E. Talbot and D.R. Humphrey (Eds.), *Posture and Movement*. New York: Raven Press, pp. 113–121.

Terzuolo, C.A. and Viviani, P. 1980. Determinants and characteristics of motor patterns used for typing. *Neuroscience* 5:1085–1103.

Viviani, P. 1986. Do units of motor action really exist? *Experimental Brain Research Series* 15:201–216.

Wadman, W.J., Denier van der Gon, J.J., Geuze, R.H., and Mol, C.R. 1979. Control of fast goal directed arm movements. *Journal of Human Movement Studies* 5:3–17.

Weiss, P. 1941. Self-differentiation of the basic patterns of coordination. *Comparative Psychology Monographs*, 17, Whole No. 4.

Young, D.E. 1988. *Knowledge of Performance and Motor Learning*. Unpublished PhD Dissertion, UCLA.

Young, D.E., Magill, R.A., Schmidt, R.A., and Shapiro, D.C. 1988. Motor programs as control structures for reversal movements: An examination of rapid movements and unexpected perturbations. *North American Society for the Psychology of Sport and Physical Activity Abstracts* 14:25.

Young, D.E. and Schmidt, R.A. 1990. Units of motor behavior: Modifications with practice and feedback. In M. Jeannerod (Ed.) *Attention and Performance XIII*. Hillsdale, NJ: Erlbaum.

Zelaznik, H.N., Hawkins, B., and Kisselburgh, L. 1983. Rapid visual feedback processing in single-aiming movements. *Journal of Motor Behavior* 15:217–236.

Zelaznik, H.N., Schmidt, R.A., and Gielen, C.C.A.M. 1986. Kinematic properties of rapid aimed hand movements. *Journal of Motor Behavior* 18:353–372.

7

Dynamics and Task-specific Coordinations

M. T. Turvey
Center for the Ecological Study of Perception and Action
University of Connecticut, Storrs, Connecticut
Haskins Laboratories, New Haven, Connecticut

Elliot Saltzman
Haskins Laboratories, New Haven, Connecticut
Center for the Ecological Study of Perception and Action
University of Connecticut, Storrs, Connecticut

R. C. Schmidt
Center for the Ecological Study of Perception and Action
University of Connecticut, Storrs, Connecticut
Haskins Laboratories, New Haven, Connecticut

ABSTRACT

A strategy for addressing task-specific movement coordinations is described, motivated by the broad issue of how control is achieved in a system of very many degrees of freedom at multiple scales. The strategy incorporates the sub-disciplines of physical biology and ecological psychology as companion endeavors in an effort to understand coordination in very general terms. Several lines of research pursuing this strategy are described. They demonstrate the reduction of high-dimensional articulatory spaces to low-dimensional task spaces, the mutual influences between these spaces, the variety of means (optic, haptic, mechanical) available for coupling dynamic degrees of freedom and reducing dimensionality, and the rule of intention in harnessing dynamics.

7.1 *Introduction*

The dictionary defines *coordination* as "the bringing of parts into proper relation." Routinely in the course of ordinary everyday activity, an animal coordinates parts of its body with one another and with the objects and events that populate its environment. These coordinations involve bringing into "proper relation" multiple and different component parts (for example, 10^{14} cellular units in 10^3 varieties), at various scales of space and time. Consider the coarse scale of the skeletal system. About 792 muscles in the human body combine to bring about energetic changes at the skeletal joints. If the human body was only an aggregate of hinge joints (which it is not), then it would comprise nearly 100 mechanical degrees of freedom. Starting about 15 to 20 years ago a number of people—most notably, Gelfand, Tsetlin, Gurfinkel, Fomin, Shik, Orlovskii, and Feldman (see Gelfand et al., 1971) in the Soviet Union and Greene, Easton, Boylls, and Arbib (see Greene, 1972) in the United States—attempted to identify the special problems facing coordination in systems of such complexity, and the means of their resolution.

The ideas of Nikolai Bernstein (1967), a Soviet physiologist, played a significant role in instigating and shaping this endeavor. Bernstein argued that the kinematic and dynamic aspects of movements had been undervalued in popular accounts of coordination. He saw the basic problem of coordination as that of mastering the very many degrees of freedom involved in a particular movement—of reducing the number of independent variables to be controlled. Specifically, coordination entailed the control of a complex biomechanical system in which inertia, reactive forces, and postural conditions combined with active muscle forces in producing movements. Such complexity meant that there could be no straightforward relation between outflow or efferentation (e.g., motoneuronal activity) and the resultant movement patterns. Given efferentation's equivocality, essential formative and steering roles must be played by inflow or afferentation (e.g., haptic, optical information).

A modern paraphrase of Bernstein's statement of the problem of coordination reads: The multiple neural, muscular, and skeletal components of movements define a state space of many dimensions. Understanding coordination, therefore, is understanding how such high-dimensional state spaces condense into task-specific state spaces of very few dimensions. However, it would not suffice to focus our attention strictly on the outflow of the movement system in attempting to discover the principles behind coordination. The crucial roles of afferentation, noted above, require that inflow be organized in a way that is suited to the outflow. Thus, attention should be focused equally on the contributions of afferentation to task-specific processes of condensing degrees of freedom. In other words, the problem of coordination holds equally for afference as well as efference or, in more general terms, for perceiving as well as acting. Its resolution must be sought in the examination of perceiving-acting cycles.

7.2 *Physical Biology and Ecological Psychology*

We approach Bernstein's problem, as do a number of our contemporaries (Beek, 1989; Kay, 1989; Kelso, Delcolle, and Schöner, in press; Kugler, Kelso, and Turvey, 1980; 1982), through the subdisciplines of physical biology and ecological psychology. These are companion endeavors in our attempts to understand perceiving-acting cycles in ordinary and extraordinary skilled activities. Both endeavors are directed at understanding coordination in terms of very general principles. Physical biology focuses on general principles having to do with transformations of energy and the time evolution of observable quantities; ecological psychology focuses on general principles having to do with the generating and pick up of information.

7.2.1 *Physical Biology*

A physical approach to biology—as expressed by homeokinetics (Iberall and Soodak, 1987) and synergetics (Haken, 1983), for example—regards living systems as ordinary physical systems that happen to be very complex and are extraordinary in their means of using the principles and laws of physics (Yates, 1982; 1987). Identifying this use is a major challenge. Physical laws and principles are few in number. In contrast, patterns of coordination exhibit great diversity. New methods of observation and measurement, coupled with novel applications of traditional experimental strategies, are needed to disclose the lawful underpinnings of such patterns (Beek, 1989; Kugler and Turvey, 1987; Schöner and Kelso, 1988a). Exacerbating the challenge of identifying what laws are involved and how they are used is the fact that intentions (goals, plans) function as exceptional boundary conditions, either constant or varying in time, that harness physical laws and principles (Kugler and Turvey, 1987). Understanding how intentions play this role is an important challenge in its own right, but it is not outside the purview of experimental investigation (Schöner and Kelso, 1988b). In the most general of terms, understanding this role amounts to understanding the relation between the discrete mode and the continuous mode of functioning characteristic of biological systems—that is, the relation of symbols to dynamics (Kugler and Turvey, 1987; Pattee, 1972).

In our view, three essential and related properties of the symbols constraining movement dynamics are that (1) the relation between these symbols and their referents cannot be merely definitional or associative; (2) what these symbols stand for cannot be other symbols; and (3) how they exert their control cannot be by instructing explicitly all the details of a coordinated movement (in other words, the detail of an intention can only be a small fraction of the detail that would be necessary for a completely formal and explicit specification of a coordinated movement pattern, and yet it must suffice to produce the pattern in full). The implications of these properties considered jointly can be stated as follows. First, the relation between such symbols and their referents must be established

on natural grounds, that is, through natural laws and the local constraints of physical (including neural) structures. Second, this relation must have an explicit embodiment in the form of constraints that cannot be an inherent property of either the symbol vehicle or its referent (Pattee, 1980). And third, the control must be exercised through an implicit harnessing of natural laws and structures that themselves need no instructions (Kugler et al., 1980; Kugler and Turvey, 1987; Pattee, 1980; Turvey and Kugler, 1984).

The conceptual tools and experimental methods of nonlinear (dissipative) dynamics seem especially relevant to addressing coordination in general terms. In particular, one promising way of addressing the role of symbols in a dynamic account of skilled activties is through the concept of *attractor*. An attractor is a set of points S such that, for almost any point in the neighborhood of S, the dynamics approaches S as time approaches infinity. For example, the attractor may be a point, or a closed curve (a limit cycle), or a torus (the surface of a doughnut). In contrast with the preceding attractors that have simple geometries with integral dimensions, another class of attractors exist that have peculiar geometries and may have nonintegral dimensions. These attractors are called "strange."

An attractor can function as a controlling symbol. This concept is appealing since the relation between an attractor as a controlling symbol and the dynamics to which it refers is lawful rather than merely definitional or associative. As noted, an attractor defines a system's asymptotic behavior, and the low dimensional set of equations of motion that describes motion along this attractor can be derived from the higher dimensional equation set describing the original system (Haken, 1983; Thompson and Stewart, 1986). Relatedly, an attractor as a controlling symbol is, by definition, far less detailed than the output to which it refers.

7.2.2 An Ecological Approach to Perception

The essentials of the ecological approach to perception as developed by James J. Gibson (1959; 1966; 1979; Reed and Jones, 1982), can be expressed succinctly: Perception is specific to information, and information is specific to the environment and to one's movements; hence perception is specific to the environment and to one's movements. In more expanded terms, the ecological approach advanced by Gibson comprises a program of research and theory having three parts relating, in turn, to the nature of information, the basis of perception, and the development of perception.

With respect to the first part, it attempts to identify the specificity between the structured energy distributions available to a perceptual system and the environmental and movement properties causally responsible for that structure. This latter specificity is what is meant by "information" in the ecological approach. The specificity is sought at a macroscopic level of description and is expected to be revealed in terms of observables that, in general, will not have been identified in physical theory. One characteristic of these macroscopic observables is their

low dimensionality (meaning, roughly, that very few quantities are needed to describe them). In state spaces of minimal dimensions, these observables wrap up or condense the order present in surrounding energy distributions that are described molecularly in state spaces of very many dimensions.

With respect to the second part, the ecological approach asserts the directness of perception, in the sense that the specificity of perception to information dispenses with any intervening special process, like inference. Integral to this second part is the hypothesis that, for every property perceived, there is a corresponding macroscopic property of the structured energy distribution. This generalized hypothesis of information-perception specificity directs investigation to the uncovering of one-to-one mappings between information and perception. A particular perception results if and only if a particular informative structure is detected. In reference to perception-action cycles, this second part aims at understanding how specificity is preserved over the components of an animal-environment system.

With respect to the third part of the program, it suggests that improvement in perceiving in any given situation follows from the discovery of, and attunement to, information. In any given situation, the lawful regularities between aspects of surface layout and macroscopic properties of structured energy distributions specify a wide range of environmental properties, including the property of interest. In learning to perceive, the perceiver progresses from under- or overdifferentiating the ambient energy distribution to differentiating it precisely (Epstein et al., 1989; Gibson and Gibson, 1955; 1972).

7.3 *Task-specific Coordinations*

One preliminary way to think about a task-specific coordination is in terms of an attractor layout—attractors and their surrounding basins of attraction (Saltzman, 1986; Saltzman and Kelso, 1987; Saltzman and Munhall, 1989). Task-specific coordinations can follow from the simple control of initial conditions that put the system into the basin of a given attractor. The act will then (self) organize by converging onto the attractor. Consider reaching for an object on a table. Very many reaching movements, starting at very many different places within the vicinity of the object, can converge on the object. In dynamic terms, one would say that reaching, regardless of when, where, and with which parts of the body it is conducted, has the features of a system governed by a spatially defined point attractor. If reaching is a task whose dynamics are those of such a point attractor, then the challenge is to understand the embodiment of this invariant task dynamic in variable movement patterns. Our strategy has been to conceptualize the point attractor dynamics as a description of the task in a small number of functionally defined coordinates (defining a so-called *task space*) and then to pursue an understanding of the transformation of coordinates that maps these *intended*, low dimensional task dynamics into the higher dimensional articula-

tory (skeletal, muscular, neural) subspace. Effectively, this mapping defines a task-specific pattern of coupling or coordination among the articulators that acts to convert the articulator subset into a special-purpose device tailored to the intended task.

Planar reaching movements have been shown experimentally to display quasi-straight line path shapes en route to the target object (Flash, 1987; Morasso, 1981). It has been demonstrated (Saltzman and Kelso, 1987) that such reachable objects can be simulated as points in task space that are capable of attracting a multiplicity of different limb trajectories displaying straight-line hand paths. However, quasi-straight lines are not straight lines, and it is important for a dynamic account of reaching to address this discrepancy. In a recent paper, Flash (1987) has suggested on empirical and theoretical grounds that deviations from straight-line hand paths are systematic and may be interpreted as the results of a "competition" between the controlling influences of a straight-line *reference trajectory* in the task space and the inherent biomechanics of the musculo-skeletal apparatus (for example, the posture-dependent stiffness field due to the elastic properties of muscles and tendons, and reactive torques due to inertial, coriolis, and centripetal coupling among joints). In the following sections, we explore more closely the relations between task space and articulatory dynamics in the context of rhythmic biological movements.

7.3.1 *Coordinative Structures as Cooperative States*

Many years ago, the German behavioral physiologist von Holst noted that coordinated rhythmic states entail cooperation among units that, roughly speaking, prefer to be doing something else. Investigating the rhythmic fin movements of Labrus, a fish that swims with its longitudinal axis immobile, von Holst (1938; 1973) observed that each rhythmic unit had a preferred tempo—exhibited when the unit oscillated freely and in isolation from other fin rhythmic units—that had to be compromised when its behavior was coordinated with that of one or more other fin rhythmic units. Von Holst referred to the tendency of a unit to revert, when released from the demands of coordination, to its preferred or inherent dynamics as the "maintenance tendency." The cooperative process that bound together units with different intrinsic dynamics was termed the "magnet effect." He underscored that, even when fins were perfectly synchronized—that is, all oscillating at the same frequency in what he called absolute coordination—the maintenance tendency remained latent. For von Holst, the gathering of components into a single functional organization, a coordinative structure, involved cooperation and competition.

A cooperative state in physical systems can be regarded as three tiered. For example, the vortex arising in a fluid flowing through a pipe may be regarded as an in-between level of organization that is supported by the interplay between the dynamics of the molecular processes "below" and the boundary conditions of the walls of the conduit "above" (Iberall and Soodak, 1987). By analogy, a

coordination may be regarded as three tiered: The lower level comprises the autonomous units with their inherent dynamic preferences; the upper level comprises the intention (goal, plan, schema); and the middle level is the coordination (Kugler and Turvey, 1987; Turvey et al., 1986). A simple coordination of rhythmic movements can be used to express this analogy and its usefulness.

7.3.2 *Absolute Coordination of Pendulumlike Rhythmic Movements*

Imagine a person seated, holding a pendulum in each hand. The pendulums can vary physically in shaft length and/or the mass of the attached bob. Because of these physical magnitudes, a person's comfortable swinging of a hand-held pendulum about an axis in the wrist (with other joints essentially immobile) will exhibit a preferred dynamic. That is, the pendular motions will tend to a particular frequency and a particular amplitude (Kugler and Turvey, 1987). The exhibited intrinsic dynamic is not strictly that that of a gravitational pendulum, however. In particular, the person must use chemical energy in the muscles to sustain the rhythmic movement and must establish a pattern of muscular co-contractions to maintain fairly even periods and amplitudes from cycle to cycle. For bimanual tasks, if the pendulums held in each hand differ in physical dimensions (length, mass), then their intrinsic dynamics—their maintenance tendencies—will not correspond. Consider bringing to bear the following task demands on these rhythmic units: That they oscillate together comfortably at the same frequency in phase (with a 0° phase difference); that they oscillate together comfortably at the same frequency out of phase (with a 180° phase difference); that they oscillate at the most comfortable phase relation, whatever it may be; that they oscillate with the same amplitude, and so on. Each of these task demands, by analogy with ordinary physical cooperativities, results in a different boundary condition or constraint on the same inherent dynamics. Each task demand can be satisfied only by the component rhythmic units departing from their preferred states in particular ways; and each coordination, resulting from the interplay of the task demand and the intrinsic dynamics of the component units, ought to exhibit dynamic idiosyncracies of its own.

Let us focus first on the fate of the component units. Experiments have shown that when a hand-held pendulum is made to depart from its preferred state by the demands of coordination, fluctuations in the period and amplitude of the rhythmic movement increase (Rosenblum and Turvey, 1988). Or, conversely, when a hand-held pendulum oscillates in coordination with another hand-held pendulum at a tempo close to its preferred tempo, then its fluctuations are least. This outcome is consistent with von Holst's maintenance tendency. Another outcome is also consistent. In the experiments just referred to, a person was asked on each trial to swing two pendulums comfortably at the same frequency out of phase.

Across trials the physical dimensions of the pendulums varied, as did the differences between members of a bimanual pair. It turned out that although the person's intent was to have one pendulum swinging forward exactly as the other was swinging backward—that is, a 180° phase difference—the actual phase difference depended systematically on the size of the difference between the dimensions of the two hand-held pendulums and, thereby, the size of the difference between their characteristic frequencies (Rosenblum and Turvey, 1988). Two conclusions follow from this result. One is that the intrinsic dynamics of the component units penetrates the modal coordination state. The phase difference reflects the fact that the intrinsically faster unit leads the intrinsically slower unit (a fact that had been observed by von Holst (1937; 1973), with fish fins, and by Stein, 1977, in the crayfish swimmeret system). The other conclusion is that the intentions to achieve comfortable absolute coordination and a 180° phase relation cannot both be satisfied simultaneously. This latter conclusion nicely underscores how it is that achieving a task-specific coordination (the state "in between") depends on the compatibility of one's goals (the constraints "above") and the characteristic preferences of the component units (the intrinsic dynamics "below").

It has been hypothesized (Wing, 1980; Wing and Kristofferson, 1973) that the temporal variance in a rhythmic movement is decomposable into two independent variances—the variance in a dynamic organization that functions as a timekeeper and the variance in the activation of the muscular components that implement the rhythmic movement. In particular, it was predicted that the correlation between adjacent cycles should be negative (between 0 and −0.5 on the average), and the correlations between nonadjacent cycles should be nonsignificant. The closer the lag 1 autocorrelation approximates −0.5, the larger is the relative contribution of motor variance and the smaller the relative contribution of clock variance to the overall fluctuations in periodicity. Empirically, when people swing two hand-held pendulums in absolute coordination, the lag 1 autocorrelations are significant and in the 0 to −0.5 range, whereas the autocorrelations at higher lags are insignificant—the pattern of results that is required by the assumption of independent "clock" and "motor" processes (Turvey, Schmidt, and Rosenblum, 1989).

This analysis of "clock" and "motor" variance permits further understandings about the relation between the coordinated state and the component units from which it is composed. First, motor variance but not clock variance is found to increase when a rhythmic unit is forced to depart from its preferred tempo by the task demands of absolute coordination (Turvey et al., 1989). These demands serve to increase the proportion of active muscular forces relative to the contributions of the mechanical forces associated with the hand-held pendulum. Second, whereas clock variances are highly correlated across the two (left and right) units in absolute coordination, motor variances are not (Turvey et al., 1989). Third, clock variances of both units are larger when absolute coordination approximates a 180° phase relation than when absolute coordination approxi-

mates a 0° phase relation; the motor variances, in contrast, are unaffected by the mode of coordination (Turvey et al., 1986). These results suggest that, in satisfying the task demands of absolute coordination, the component units (1) are organized according to a modal task space attractor that acts implicitly as a timekeeping function and is more stable when the coordination mode is in phase than when it is out of phase, and (2) the component units become increasingly irregular in the patterning of muscular activity with increasing displacements from their preferred tempos. More generally, we see that it is possible to identify the dynamic properties of the lower level (the component units) and the middle level (the cooperative state) of a coordinative structure and to hypothesize that the notion of preferential or intrinsic dynamics can be extended to the middle level. Thus, two or more rhythmic units may couple better in some ways than in others, and the maintenance tendency may apply, therefore, to combinations of units as well as to isolated units. Before pursuing this idea, let us take a look at the same kind of coordinative structures just examined, but now with the rhythmic units belonging to different people and linked visually.

7.3.3 *Optically Based Coordinations*

Imagine two people sitting side by side, each holding a pendulum. One person holds a pendulum in the right hand and one person holds a pendulum in the left hand. The pendulums, as before, are swung about an axis in the wrist. The free hand and arm, which is the arm closest to the other person, rests on the thigh. The task of the two people is to watch each other closely and coordinate the swinging of the two pendulums such that they oscillate at the same frequency and out of phase. Paralleling the experiments described above, the physical dimensions of the pendulums can be the same or different, and the pairings of pendulum dimensions change from trial to trial. Results from an experiment conducted in the preceding fashion (Schmidt, 1988) reveal the same pattern in two-person, visually based coordination as is found in the more familiar one-person, haptically based coordination (where *haptic* refers to the perceptual system by which one knows about relations among body segments and properties of adjacent surfaces by means of the body). First, the two oscillating units can achieve and maintain absolute coordination (1:1 frequency locking). Second, the maintenance tendency is in evidence, in that fluctuations in frequency and amplitude tend to increase as a unit is forced to oscillate, by the demands of absolute coordination, at a nonpreferred frequency. Third, the phase relation between the two units is exactly 180° out of phase only when the inherent frequencies of the two units are identical. Otherwise the phase relation increases systematically with the difference between the characteristic frequencies of the two units.

The latter result is especially important. As far as we can tell, each of the following conditions exhibit phase relations in absolute coordination with one and the same dependency on the intrinsic frequencies of the component rhythmic units: spontaneous rhythmic fin movements of decapitated fish; oscillations of

crayfish swimmerets induced by stimulating "command neurons"; voluntary rhythmic movements of pendulums held in a person's left and right hands; and voluntary rhythmic movements of a pendulum held in the right hand of one person and a pendulum held in the left hand of another person. One reading of this convergence is that common dynamic principles are at work. If that is a correct reading, then recognition must be given to the possibility that these principles apply when the coupling is informational (Kugler and Turvey, 1987; Schmidt, 1988). Presumably, between-person visual coordination is based on optical information specific to the dynamics of the component rhythmic units. The observed convergence of phase-locking phenomena might then suggest that coordination instanced in other ways is similarly based on information specific to dynamics.

7.3.4 *Sudden Jumps in Haptically Based and Optically Based Coordinations*

Let us now turn, as promised, to the inherent dynamics of the cooperative, modal level of organization sustained by the interplay of the intentional constraints "above" and the dynamics of the rhythmic units "below." We shall consider these cooperative or modal dynamics in the context of an analogy with the simplest type of self-organization in physics, the phase transition. Under certain conditions, one type of interlimb coordination gives way suddenly and spontaneously to another. The phenomenon in question can be observed in a paradigm in which a person is required to oscillate the two index fingers (or two hands) at the same frequency (Kelso, Scholz, and Schöner, 1986; Scholz, 1986). Frequency is varied by a metronome that the person tracks; it acts as a control parameter. The phase relation between the body segments is interpreted as an order parameter. A parameter of the latter kind does very much what its name suggests—it quantifies the order present in a collection of things. Such parameters are essential in cases where there is a lot of detail and one needs a simple measure to keep track of all this detail, especially if it is undergoing a fairly abrupt change. Results show that the order parameter for interlimb coordination is more stable at some values than others. With increasing frequency, an out-of-phase interlimb coordination switches abruptly to an in-phase coordination. In phase, however, does not switch to out of phase, and the out-of-phase to in-phase transition is not reversed by a reduction in frequency. The in-between level of organization has an inherent dynamics marked by a preference for limbs moving together in the same direction.

Of particular importance with respect to the drawing of parallels with physical phase transitions is the fact that the order parameter exhibits critical slowing down (if perturbed, it takes longer to recover closer to the transition point) and, under certain conditions, the order parameter exhibits critical fluctuations (the standard deviation grows significantly as the transition point gets closer). These conditions are that the fast time scale associated with the relaxation back to out of phase is notably less than the time scale of change in the control parameter,

which is notably less, in turn, than the slow time scale associated with the passage from out of phase to in phase. Order parameter fluctuations do not increase prior to the sudden behavioral change when the slow time scale is less than the time scale of the control parameter.

The same phenomenon of a sudden transition in coordination, exhibiting many of the same criterial properties, has been observed when two limbs are connected optically between two people (Schmidt, 1988; Schmidt, Carello, and Turvey, 1990). In the experiments in question, two seated people each oscillated a leg with the goal of coordinating the two legs out of phase (180°) or in phase (0°) as the frequency of the movement was increased. To satisfy the goal, the two people watched each other's lower leg. The between-person visual coordination case matches the within-person haptic coordination case: A transition occurs, it occurs in only one direction (180° to 0°), and it is accompanied, under certain conditions, by critical fluctuations. The between- and within-person cases involve the same relations among the same observable quantities despite the obvious differences between the two cases (e.g., the nervous systems of two people vs. the nervous system of one person; using the visual perceptual system in between-person coordination vs. using the haptic perceptual system in within-person coordination).

The sudden changes in haptic and visual instances of interlimb coordination may be taken as examples of a process in which the attractor layout in task space evolves during the execution of the activity. The implication is that very general dynamic and informational principles are at work and that a comparison of behavioral discontinuities in movement systems with phase transitions in physical systems may prove to be be more than mere analogy. In both of the above cases, the differential stability of the two phase relations and the transition between them can be accommodated under the assumption that the system of coordinated limbs is governed by a smooth potential function whose shape depends on both phase (order parameter) and frequency (control parameter). The function can be so defined that the minima of the potential (attractors) are located at 180° and 0°, the function's global minimum is at 0° and the 180° local minimum is annihilated at some critical control parameter value (Haken, Kelso, and Bunz, 1985).

7.4 *Concluding Remarks*

We have sketched an orientation to coordination that emphasizes (1) the formation of low-dimensional, task-space dynamical systems through the appropriate fashioning of coupling functions among the degrees of freedom of higher-dimensional articulatory spaces; (2) the mutual influences of these two dynamic levels on each level's behavior; (3) the wide range of sources of coupling influences (haptic, optic, mechanical) between dynamic degrees of freedom; and (4) the role of intention in constraining and harnessing the dynamics of the perception-action cycle.

Acknowledgments

Preparation of this manuscript has been supported by the following NIH grant NS-13617, NSF grant BNS-8520709, and NIH grant RR-05596, awarded to Haskins Laboratories, and NSF grant BNS-8811510 awarded to the first author.

References

Beek, P.J. 1989. Timing and phase-locking in cascade juggling. *Ecological Psychology* 1:55–96.

Bernstein, N.A. 1967. *The Coordination and Regulation of Movements.* London: Pergamon Press.

Epstein, W., Hughes, B., Schneider, S.L., Bach-Y-Rita, P. 1989. Perceptual learning of spatial-temporal events: Evidence from an unfamiliar modality. *Journal of Experimental Psychology: Human Perception and Performance* 15:28–44.

Flash, T. 1987. The control of hand equilibrium trajectories in multi-joint arm movements. *Biological Cybernetics* 57:257–274.

Gelfand, I.M., Gurfinkel, V.S., Tsetlin, M.L., and Shik, M.L. 1971. Some problems in the analysis of movements. In I.M. Gurfinkel et al. (eds.), *Models of the Structural-Functional Organization of Certain Biological Systems.* Cambridge: MIT Press.

Gibson, J.J. 1959. Perception as a function of stimulation. In S. Koch (Ed.), *Psychology: A Study of a Science* (Vol. 1). New York: McGraw-Hill.

Gibson, J.J. 1966. *The Senses Considered as Perceptual Systems.* Boston: Houghton Mifflin.

Gibson, J.J. 1979. *The Ecological Approach to Visual Perception.* Boston: Houghton Mifflin.

Gibson, J.J. and Gibson, E.J. 1955. Perceptual learning: Differentiation or enrichment? *Psychological Review* 62:32–41.

Gibson, E.J. and Gibson, J.J. 1972. The senses as information-seeking. *The London Times Literary Supplement,* June 23, pp. 711–712.

Greene, P.H. 1972. Problems of organization of motor systems. In R. Rosen and F.M. Snell (eds.), *Progress in Theoretical Biology* (Vol. 2). New York: Academic Press.

Haken, H. 1983. *Advanced Synergetics.* Heidelberg: Springer-Verlag.

Haken, H., Kelso, J.A.S., and Bunz, H. 1985. A theoretical model of phase transitions in human hand movements. *Biological Cybernetics* 51:347–356.

Iberall, A., and Soodak, H. 1987. A physics for complex systems. In F.E. Yates (ed.). *Self Organizing Systems: The Emergence of Order.* New York: Plenum.

Kay, B.A. 1989. The dimensionality of movement trajectories and the degrees of freedom problem: A tutorial. *Human Movement Science* 7:343–364.

Kelso, J.A.S., Delcolle, J.D., and Schöner, G. 1990. Action-perception as a pattern formation process. In M. Jeannerod (ed.), *Attention and Performance XIII*. Hillsdale, NJ: Erlbaum.

Kelso, J.A.S., Scholz, J.P., and Schöner, G. 1986. Nonequilibrium phase transitions in coordinated biological motion: Critical fluctuations. *Physics Letters A* 118:279–284.

Kugler, P.N., Kelso, J.A.S., and Turvey, M.T. 1980. On the concept of coordinative structures as dissipative structures: I. Theoretical lines of convergence. In G.E. Stelmach and J. Requin (eds.), *Tutorials in Motor Behavior*, Amsterdam: North-Holland, pp. 3–47.

Kugler, P.N., Kelso, J.A.S., and Turvey, M.T. 1982. On the control and coordination of naturally developing systems. In J.A.S. Kelso and J.E. Clark (eds.), *The Development of Movement Control and Coordination*. New York: Wiley, pp. 5–78.

Kugler, P.N., and Turvey, M.T. 1987. *Information, Natural Law and the Self-Assembly of Rhythmic Movement*. Hillsdale, NJ: Erlbaum.

Morasso, P. 1981. Spatial control of arm movements. *Experimental Brain Research* 42:223–227.

Pattee, H.H. 1972. The nature of hierarchical controls in living matter. In R. Rosen (Ed.), *Foundations of Mathematical Biology*. New York: Academic Press.

Pattee, H.H. 1980. Clues from molecular symbol systems. In U. Bellugi and M. Studdert-Kennedy (eds.), *Signed and Spoken Language: Biological Constraints on Linguistic Form*. Weinheim: Verlag-Chemie.

Reed, E.S. and Jones, R. 1982. *Reasons for Realism: Selected Essays of James J. Gibson*. Hillsdale, NJ: Erlbaum.

Rosenblum, L.D., and Turvey, M.T. 1988. Maintenance tendency in coordinated rhythmic movements: Relative fluctuation and phase. *Neuroscience,* 27:289–300.

Saltzman, E. 1986. Task dynamic coordination of the speech articulators: A preliminary model. *Experimental Brain Research* Ser. 15:129–144.

Saltzman, E. and Kelso, J.A.S. 1987. Skilled actions: A task dynamic approach. *Psychological Review* 94:84–106.

Saltzman, E.L. and Munhall, K.G. 1989. A dynamical approach to gestural patterning in speech production. *Ecological Psychology* 1:333–382.

Schmidt , R.C. 1988. *Dynamical Constraints on the Coordination of Rhythmic Limb Movements Between Two People*. Doctoral dissertation, University of Connecticut, Storrs.

Schmidt, R.C., Carello, C. and Turvey, M.T. 1990. Phase transitions and critical fluctuations in the visual coordination of rhythmic movements between people. *Journal of Experimental Psychology: Human Perception and Performance* 16:227–247.

Scholz, J.P. 1986. *A Nonequilibrium Phase Transition in Human Bimanual Movement: Test of a Dynamical Model.* Doctoral dissertation, University of Connecticut, Storrs.

Schöner, G., and Kelso, J.A.S. 1988a. Dynamic pattern generation in behavioral and neural systems. *Science* 239: 1513–1520.

Schöner, G., and Kelso, J.A.S. 1988b. Dynamic patterns in biological coordination: Theoretical strategy and new results. In J.A.S. Kelso, A.J. Mandell, and M.F. Schlesinger (eds.), *Dynamic Patterns in Complex Systems*, Singapore: World Scientific, pp. 77–102.

Stein, P.S.G. 1977. A comparative approach to the neural control of locomotion. In G. Hoyle (Ed.), *Identified Neurons and Behavior of Arthropods*, New York: Plenum Press, pp. 227–239.

Thompson, J.M.T., and Stewart, H.B. 1986. *Nonlinear Dynamics and Chaos.* New York: Wiley.

Turvey, M.T., and Kugler, P.N. 1984. An ecological approach to perception and action. In H.T.A. Whiting (ed.), *Human Motor Actions: Bernstein Reassessed*, Amsterdam: North-Holland, pp. 373–410.

Turvey, M.T., Rosenblum, L.D., Schmidt, R.C., and Kugler, P.N. 1986. Fluctuations and phase symmetry in coordinated rhythmic movements. *Journal of Experimental Psychology: Human Perception and Performance* 12:564–583.

Turvey, M.T., Schmidt, R.C., and Rosenblum, L.D. 1989. "Clock" and "motor" components in the absolute coordination of rhythmic movements. *Neuroscience* 33:1–10.

von Holst, E. 1937/1938; 1973. *The Behavioral Physiology of Animal and Man: The Collected Papers of Erich Von Holst.* Coral Gables, FL: University of Miami Press.

Wing, A.M. 1980. The long and short of timing in response sequences. In G.E. Stelmach and J. Requin (Eds.), *Tutorials in Motor Behavior*, Amsterdam: North-Holland, pp. 469–485.

Wing, A.M. and Kristofferson, A.B. 1973. Response delays and the timing of discrete motor responses. *Perception and Psychophysics* 14:5–12.

Yates, F.E. 1982. Outline of a physical theory of physiological systems. *Canadian Journal of Physiology and Pharmacology* 3: 217–248.

Yates, F.E. (ed.) 1987. *Self Organizing Systems: The Emergence of Order.* New York: Plenum Press, 1987.

8

Dynamic Pattern Generation and Recognition

J. A. S. Kelso
A. S. Pandya
Program in Complex Systems and Brain Science
Center for Complex Systems
Florida Atlantic University
Boca Raton, Florida

ABSTRACT

We use the language of nonlinear dynamical systems in an operational approach to understanding the temporally coordinated behavioral patterns produced by biological systems. Key concepts are the characterization of behavioral patterns by collective variables, or *order parameters*, in the sense of Haken's (1983) synergetics, the determination of the dynamics of these patterns, and the study of their stability. Observed patterns produced by the cooperation among multiple moving components (such as the phase relations among the four legs of a quadruped) can be mapped as stable stationary states onto attractors of the order parameter dynamics. Pattern change is demonstrated to occur in theory and experiment through loss of stability of the order parameter (a nonequilibrium phase transition). Such transitions are associated with hysteresis, fluctuation enhancement, and slowing down of the order parameter. Identifying the nonlinear dynamics of pattern formation enables us to synthesize the patterns and create computer displays for perceivers to identify. Preliminary perception experiments suggest that the relevant information for categorizing different dynamic patterns is carried in the low-dimensional order parameter dynamics that lawfully characterize the pattern's formation.

8.1 *Introduction*

Coordinated movement is a wonderful example of the dynamic patterns found in nature, made all the more apparent by advances in motion analysis technology (see Figure 8.1). Patterned behavior may be observed at many scales of observation and in many different systems, ranging from the undulatory motions of worms to the production of human language. We immediately recognize the gait of a horse, for example, and are quick to note when it breaks from a trot into a gallop. Similarly, linguists can classify the sounds of all known languages into a small, so-called universal, set of phonemes. The dynamic visual patterns of the horse and the acoustic patterns created in human speech may seem unrelated, but each pattern is generated in nature and admits to categorization. What information serves as the basis for such classification? Here we explore the idea that the ordered information that characterizes the *generation* of dynamic behavioral patterns is the same that perceivers use to identify, discriminate among, and classify such patterns.

This observation is not the motor theory of speech perception in another guise (Liberman and Mattingly, 1985). Rather, our aim is to demonstrate explicity that the abstract dynamics of pattern *formation* and pattern *recognition* are one and the same (see also Haken and Fuchs, 1988, for a related but different approach). That is, the relevant (i.e., meaningful) information for perceiving and recognizing certain dynamic visual patterns may be carried in the low-dimensional dynamical laws that characterize the pattern's generation. This conjecture would not have been possible without the detailed study of coordinated behavioral patterns and their (nonlinear) dynamics. Let us backtrack a bit in order to see why this is so.

Figure 8.1(a) Biomechanical displays consisting of rigid, connected segments corresponding to limbs. (a) A golf player is shown taking a swing.

(b)

(c)

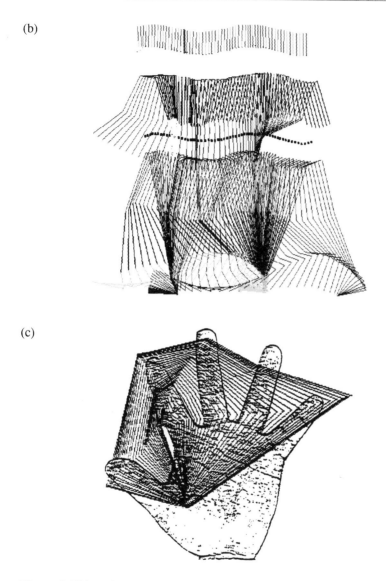

Figure 8.1(b) and (c) Biomechanical displays consisting of rigid, connected segments corresponding to limbs. (b) walking person; (c) Grasping motion using the WATSMART System (Northern Digital, Inc.). IREDS were placed on tips of all digits and each finger IRED was attached to the palm IRED. Each fingertip IRED was also connected to each other. The polygon form is created by stick figures. (a) and (b) were obtained using the motion analysis system of Peak Performance Technologies, which digitizes the motion on a computer screen. (Reprinted with permission from Peak Performance Technologies, Inc., Englewood, Colorado.)

8.2 The Language of Synergetics (Nonlinear Dynamics)

Kugler, Kelso and Turvey (1980) drew an analogy between the order and regularity exhibited in human and animal motion and structure formation in open, nonequilibrium physical and chemical systems, especially in the theory of dissipative structures (Prigogine, 1980) and Haken's synergetics program (Haken, 1983). In fact, in the first edition of *Synergetics*, Haken (1983, p. 4) already intuited that locomotion could be viewed as a macroscopic spatiotemporal pattern emerging from the dynamics of very many microscopic processing steps. In synergetics (Haken, 1983):

1. Spatial and temporal patterns arise spontaneously in a so-called self-organized fashion when "control parameters" are changed. These control parameters are unspecific to the resultant patterns; they "control" only in the sense of leading the system through instabilities. Pattern formation thus corresponds to a nonequilibrium phase transition.

2. Close to critical values of the control parameter(s), very high dimensional systems (~10^{12} atoms in a laser, 10^{11} molecules in a fluid, and so forth) may be completely described by the low-dimensional dynamics of a collective variable (or order parameter) that characterizes the emerging patterns.

3. The order parameter dynamics, though low dimensional, are nonlinear and hence are capable of exhibiting *behavioral complexity* (such as multiple patterns, change of pattern, even deterministic chaos).

Of course, when we come to questions of how the nervous system generates patterns of behavior, the path from the "microworld" of 10^{14} neurons and neuronal connections, 10^3 different cell types, and hundreds of active chemicals to the "macroworld" of behavior patterns is not so transparent. The goal of understanding how the brain *orchestrates* its complex systems of neurons and molecular machinery in the production of behavior (Koslow, 1984) seems a remote one.

The present approach (see also Kelso and Schöner, 1987; 1988; Schöner and Kelso, 1988a) is to use synergetics as a *language* for understanding such complexity, a language through which the principles of orchestration in complex systems may be expressed. This language emphasizes dynamical processes at several scales of observation and in different systems; it is level-independent in this sense. There is, therefore, no real tension among molecular, microscopic, and macroscopic behavioral approaches. The *reduction* is to find the laws at one level and derive them from another. Our basic assumption is that the laws of low-dimensional, nonlinear dynamical systems govern behavioral patterns at several levels of description and in different experimental systems. In fact, evi-

dence is accumulating at a rapid rate in support of this view. We want to emphasize that the extent to which the universal language of dynamical systems (Glazier and Libchaber, 1988) has indeed emerged, it has done so around *specific effects observed in specific experimental model systems.* In our opinion, this language has been formed or even *forced* by these effects. We speak of the crucial importance of identifying phase transitions or bifurcations in experimental model systems: phase transitions refer to those critical points around which the system's behavior changes qualitatively. Only at these special entry points is it possible to identify collective variables or order parameters for patterns and their nonlinear dynamics (stability, loss of stability). In fact, it was the discovery of abrupt, qualitative changes in coordinated movement behavior that formed the cornerstone of the present approach, moving us from metaphor to physical reality (Kelso and Schöner, 1988). Signature features of nonequilibrium phase transitions were observed and the underlying mechanisms identified (e.g., loss of stability as seen in fluctuation enhancement and critical slowing down of the order parameter). A number of generalizations have followed since the original finding, some of which we mention below.

8.3 *Dynamic Pattern Theory: A Brief Summary*

Building on synergetics, the main idea is to view patterns of coordination or, more generally, behavior patterns, in terms of their dynamics. We can express the theory in terms of a number of strategic steps, elsewhere stated as a set of theoretical propositions (Kelso and Schöner, 1987; 1988; Schöner and Kelso, 1988a):

1. Find the order parameters (collective variables) that characterize function-specific behavioral patterns empirically at one's chosen level of observation (kinematic, electro-myographic (EMG), neuronal).

2. Map the collective variables defining patterns onto attractors, and determine the dynamics of these collective variables. That is, near transitions, study stability and loss of stability. Under certain time-scale relations (see Kelso et al., 1987), the theory predicts and provides theoretically founded measures for observing stability and its loss (Schöner, Haken, and Kelso, 1986).

3. Identify control parameters whose role is not to prescribe behavior but to lead the system through available collective states.

4. Do steps 1–3 for lower levels of description, that is, identify the components and their dynamics.

5. Establish the relation between different levels of description (the patterns and the components) by deriving the pattern dynamics from cooperative

coupling among the components. This macro-micro reduction can be continued, both in principle and in practice, across several scales of observation.

The theory originated from studies of human movement coordination in rhythmic bimanual tasks, in which spontaneous switches of coordination were observed as a parameter (movement frequency) was changed (Kelso, 1981; 1984). If the two hands were "prepared" in an anti-phase coordinative pattern, a spontaneous shift to an in-phase pattern occurred at a certain critical frequency. No such switching occurred if the sytem was prepared in the in-phase pattern. In detailed experimental (Kay et al., 1987; Kelso, 1984; Kelso and Scholz, 1985; Kelso, Scholz, and Schöner, 1986; 1988; Scholz and Kelso, 1989; Scholz, Kelso and Schöner, 1987) and theoretical work (Bunz and Haken, 1987; Haken, Kelso, and Bunz, 1985; Schöner, Haken and Kelso 1986; Schöner and Kelso, 1988c; 1988d; 1988e) it was shown that:

1. the movement patterns could be characterized by a collective variable, relative phase, φ, which thus served as an order parameter in the sense of synergetics;

2. the two stable patterns could be modeled as point attractors, bistable in one parameter régime and monostable in another;

3. switching of patterns was due to loss of stability of the attractor for antiphase motion (a nonequilibrium phase transition);

4. the dynamics of the switching process were well-characterized by the stochastic dynamics of relative phase; and

5. the collective variable dynamics could be derived from a nonlinear coupling between the hands modeled as nonlinear, limit cycle oscillators.

Such cooperative coupling affords a rigorous definition of the relation between different levels of description and illustrates how the compression of degrees of freedom is possible (from the four-dimensional positions and velocities of left and right hands to the point attractor dynamics of relative phase). In short, both stability and change of observed temporal patterns emerge from a simple (though stochastic and nonlinear) dynamic law that can be derived or synthesized from a more microscopic description (see Section 8.4).

The theory-experiment relation has been extended to a number of other examples of pattern formation, including the coordination among multiple limbs, action-perception patterns, intended behavioral patterns, and environmentally required behaviors. (For most recent reviews, see Jeka and Kelso, 1989; Schöner and Kelso, 1988b.) We mention two such extensions because they are central to establishing the link between the dynamics of behavioral patterns and the perception of these dynamic patterns. But first we present a brief discussion of the basic theoretical model that has served as a foundation for further efforts.

8.4 Dynamic Modeling

8.4.1 Two Oscillatory Components

A concrete mathematical model of the phase transition in bimanual coordination was first determined by Haken, Kelso, and Bunz (1985) and elaborated to fully incorporate stochastic aspects by Schöner, Haken, and Kelso (1986). The model:

$$\dot{\varphi} = -\frac{dV}{d\varphi} + \sqrt{Q}\,\xi_t \tag{1}$$

with $V(\varphi) = -a\cos(\varphi) - b\cos(2\varphi)$ and ξ_t is Gaussian white noise of zero mean, unit variance, and strength Q, captures the phase transition in bimanual coordination. For $a/4b < 1$, the model possesses two attractors at relative phase equal to 0 and π, whereas for $a/4b > 1$ only the $\varphi = 0$ phase relation remains stable (see Figure 8.2). Equation (1) has been shown to describe in detail the dynamics of the transition between these régimes, including the presence of enhanced fluctuations, critical slowing down as the system loses stability, and the distribution of switching times from one coordinative state to the other. The model is minimal, in that it does not allow for any other than the observed attractor types (fixed point attractors) or attractors (in-phase and anti-phase patterns). Its func-

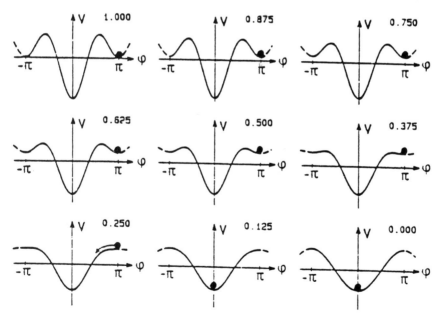

Figure 8.2 The potential V/a for the varying values of b/a. The numbers refer to the ratio b/a. (From Haken, Kelso, and Bunz (1985), reprinted with permission.)

tional form results if the 2π periodicity of the angular variable, relative phase, is used in a Fourier expansion in which (due to the minimality requirement) only the two lowest terms are kept. Note the symmetry under $\varphi \rightarrow -\varphi$, which corresponds to a symmetry between the left and right hands. Such an assumption is realistic in light of experimental results in which no systematic left-right asymmetries were found.

8.4.2 Multiple Oscillatory Components

The theory has recently been generalized to systems with multiple (= four) oscillatory components by Schöner, Jiang, and Kelso (1990). The experimental model system is the interlimb coordination patterns of quadruped gaits. Theoretically, a *set* of relative phases is introduced as the collective variable characterizing various coordination patterns. Gaits are classified by their symmetry properties, where symmetry is defined as invariance of a phase vector under certain operations. For instance, the idealized patterns of jump, gallop, trot, and pace emerge as the only patterns that are left invariant by front-hind, left-right, and time inversion operations (see Figure 8.3). Subgroups that remove front-hind symmetry lead to other patterns, such as the walk.

We can readily extend Equation (1) to the case of multiple dynamic patterns, for example, the many gaits adopted by quadrupeds (Schöner, Jiang, and Kelso, 1990). Coordination patterns (e.g., walk, trot, pace, gallop) again correspond to stable solutions of the gait dynamics under certain symmetry arguments. The four basic patterns of symmetry—trot, pace, gallop, and jump—are all stationary solutions of the following equation:

$$
\begin{aligned}
\dot{\varphi}_{rh} &= A_1 \left[\sin(\varphi_{rh} - \varphi_{lh}) + \sin(\varphi_{lf}) \right] + A_2 \left[\sin(2(\varphi_{rh} - \varphi_{lh})) + \sin(2\varphi_{lf}) \right] \\
&\quad + 2C_1 \sin(\varphi_{rh}) + 2C_2 \sin(2\varphi_{rh}) \\
\dot{\varphi}_{lh} &= A_1 \left[\sin(\varphi_{lh} - \varphi_{rh}) + \sin(\varphi_{lf}) \right] + A_2 \left[\sin(2(\varphi_{lh} - \varphi_{rh})) + \sin(2\varphi_{lf}) \right] \\
&\quad + C_1 \left[\sin(\varphi_{lh} - \varphi_{lf}) + \sin(\varphi_{rh}) \right] + C_2 \left[\sin(2(\varphi_{lh} - \varphi_{lf})) + \sin(2\varphi_{rh}) \right] \\
\dot{\varphi}_{lf} &= 2A_1 \sin(\varphi_{lf}) + 2A_2 \sin(2\varphi_{lf}) \\
&\quad + C_1 \left[\sin(\varphi_{lf} - \varphi_{lh}) + \sin(\varphi_{rh}) \right] + C_2 \left[\sin(2(\varphi_{lf} - \varphi_{lh})) + \sin(2\varphi_{rh}) \right]
\end{aligned} \tag{2}
$$

Analytical and numerical methods are used to derive the phase diagrams shown in Figure 8.3. In Figure 8.3(a), only the four basic patterns exist, and at each parameter point only one of these is stable. When both A_2 and C_2 are negative, the stability régimes overlap (Figure 8.3(b)). In two linear stripes of width, $4|C_2|$ and $4|A_2|$ along the A_1 and C_1 axes, the system is bistable. Here, then, is another example of multistability due to the nonlinear nature of the dynamics of Equation 2. Patterns of lower symmetry first appear when $A_2 < 0$ and $C_2 > 0$ (Figure 8.3(c)). One can easily see from these examples that the dynamics allow multiple stable patterns and transitions (both abrupt and continuous) among these patterns. As before, experimental measures of loss of stability are available to test the phase transition account of gait changes.

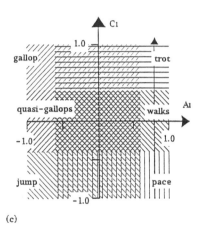

Figure 8.3 Phase diagrams for locomotion of a quadruped. Sections of the phase diagram of Equation (2) in the (A_1, C_1) parameter plane show régimes where the different solutions are stable for various values of A_2 and C_2: $A_1 = C_2 = 0$(b) $A_2 = -0.3$Hz, $C_2 = -0.2$Hz;(c) $A_2 = -0.3$Hz, $C_2 = 0.2$Hz. (From Schöner, Jiang, and Kelso (1990), reprinted with permission.)

8.5 *Phase Transitions in Single, Multijoint Limb Patterns: A Gateway to Dynamic Pattern Recognition*

Relative phase is a remarkable constraint on the temporal organization of behavior patterns at several levels of description. (Kelso, Schöner, Scholz, and Haken, 1987; Schöner and Kelso, 1988a). It turns out, however, also to play a major role in characterizing the dynamics of *single, multijoint limb behavior*. This point is of considerable interest to robotics, which is concerned, for example, with the

question of how the trajectory of an end-effector (say, the hand) relates to the angular coordinates of the joints (say, the elbow and wrist), the so-called inverse kinematics problem (see, e.g., Saltzman and Kelso, 1987). The recent discovery of phase transitions in single multijoint limb patterns (Kelso, Wallace, and Buchanan, in press) via exactly the strategy spelled out in Section 8.3 also opens up the way to pattern synthesis, which is crucial for testing our ideas about dynamic pattern recognition. Briefly, we studied four different initial conditions: flex (extend) the elbow and flex (extend) the wrist together in a cyclical fashion, flex the elbow while extending the wrist, and vice versa (see also Kots and Syrovegin, 1966). These two tasks were performed with the forearm *pronated* or *supinated*. A graphic depiction of the two basic patterns is shown in Figure 8.4. The multiple vectors created between infrared light emitting diodes (IRED)

(a)

(b)

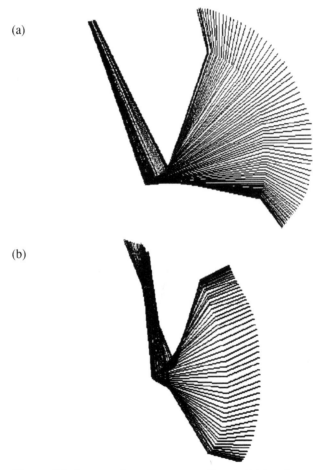

Figure 8.4 Arm motions corresponding to (a) in-phase movement and (b) antiphase movement produced by subjects in Kelso, Wallace, and Buchanan's experiment

placed on the joints nicely illustrate the patterns observed. Subjects were instructed to synchronize peak elbow flexion to an auditory metronome whose frequency increased from 1.0 Hz to 2.25 Hz in steps of 0.25 Hz with 10 cycles of motion per frequency plateau. They were told that should they feel the pattern begin to change not to resist the change in pattern (similar to the "do not intervene" instructions used by Asatryan and Feldman, 1965, in their single-limb perturbation studies). The subject's task was always to maintain a one-to-one frequency relationship with the metronome. As in earlier work on phase transitions *between* the hands, when the forearm was in the supine posture, condition 2 (the anti-phase mode of coordination) switched to the in-phase pattern at a certain critical frequency, but not vice versa. Enhancement of fluctuations in the relative phase between elbow and wrist was observed, indicating loss of pattern stability.

This new transition has nothing to do with a *muscle-specific* organization between homologous muscle groups, such as the elbow and wrist flexors, working together. When the forearm is *pronated*, the most stable pattern is between flexion (extension) of the elbow and extension (flexion) of the wrist! In short, the coordinative constraints are spatially dependent. Experiments that independently vary spatial orientation and movement frequency are under way. For example, if forearm orientation angle is varied continuously, a homologous muscle organization should switch to a *spatially* dependent organization at a critical orientation angle. In the language of nonlinear dynamics, there are two control parameters that move the system through different patterns, frequency and spatial orientation.

For the simple case, however, the relative phase dynamics (Equation (1)) identified earlier by Haken, Kelso, and Bunz (1985) for the switching dynamics between the hands works beautifully for the single, multicomponent limb allowing for the differential characterization of the patterns and their dynamics. Specifically:

1. Two stable patterns, corresponding to attractors of the relative phase dynamics, exist in rhythmic multijoint limb behaviors; which one is observed depends on the initial preparation of the system.

2. A transition from one attractor to the other occurs at a critical control parameter value.

3. Beyond the transition, only one pattern is observed; the system shifts from a bistable to monostable régime.

4. When the control parameter, frequency, is decreased, the system remains in the same basin of attraction, that is, it exhibits hysteresis.

5. Predicted features of nonequilibrium phase transitions, such as critical fluctuations in the order parameter relative phase, are observed in experiment (Kelso, Wallace, and Buchanan, in press).

8.6 *From Dynamic Pattern Generation to Dynamic Pattern Recognition: A Research Program*

Knowing the nonlinear dynamics of the collective variables (or order parameters) for these behavior patterns, we can now ask the question raised at the beginning: Does the information that allows us to distinguish one pattern from the other lie in the very order parameter dynamics that govern the patterns' formation? The fact that a given behavior pattern is stable over a range of parameter values and then loses stability at a critical point hints strongly at a basis for perceptual invariance *and* categorization of these dynamic patterns (see also Tuller and Kelso, 1990). If the theoretical underpinnings of von Holst's (1973) *temporal gestalts* (a restricted set of stable temporal forms) indeed lie in the order parameter dynamics, then at least three further lines of research open up. First, it should be possible to manipulate the order parameter synthetically, thereby creating a physical continuum of values from which one can test for categorical effects. Moreover, putative dynamic aspects of such categorization abilities are now open to study, such as hysteresis and loss of stability. Second, and conversely, it should be possible to manipulate metrical features other than the order parameter, relative phase, such as amplitudes of motion, differential lengths of contributing components, frequency of motion, orientation of displays, and so on, *ad infinitum*. Only transformations that disrupt the relative phasing should destroy the perceived ordering of the dynamic pattern. For instance, gait identification and classification should be based entirely on the relative phasing among the rhythmically moving components (the identified order parameter) and not on any other surface features (whether it is a cat, a horse, or a walking machine). Third, if the meaningful information for recognizing dynamic visual patterns lies only in attractors of the phase dynamics, then it should be possible to implement fast and efficient pattern-recognition algorithms in neural networks for these kinds of dynamic patterns. All present pattern recognition and associative learning schemes code the initial input arbitrarily—for example, as pixels. Order parameters for pattern recognition are either ignored or guessed at. In the present approach, the coding is not arbitrary; rather, the coding is specific to identified order parameters for the patterns and their dynamics, the search for which constitutes a lengthy and continuing research effort.

8.7 *Simulation and Experimentation*

Although all three of the above research directions are currently being pursued, here we address only the issue of the informational basis for categorization of dynamic movement patterns. Our results are from preliminary experiments on ten human observers. We take the lead from the research program pioneered by Gibson (1979) and Johansson (see Johansson, 1985, for a recent review). Each is concerned with the informational basis for visual events (see Mace, 1985, for

comparisons and contrasts). There is plenty of evidence that the human visual system can extract information from optics. Johansson (1973), using only lights mounted on the joints of a person, demonstrated that perceivers could easily determine whether the (otherwise invisible) actor was walking, climbing, doing push-ups, and so forth. Cutting and others, in an extensive set of studies, have shown that even the gender of a walker can be accurately perceived from the relational structure among the lights alone, with all other cues removed. The "deep structure" underlying gender identity appears to lie in the center of movement defined by the relative motion of hips and shoulders (see Cutting and Proffitt, 1981, for a review). Runeson and Frykholm (1981, 1983) have demonstrated the astonishing ability of perceivers to judge the amount of weight lifted by an actor through information about dot patterns alone. They argue that unique patterns of dot motion result from mechanical constraints on the lifter's motion. Runeson and Frykholm (1983) even formulated a principle called kinematic specification of dynamics (KSD), which proposes that kinematic information for biological motion specifies and is specified by physical and energetic aspects of motor control. Bingham (1987) has further attempted to relate the many physiological and anatomical properties of muscles and joints to the informative value of different forms of motion. In all these cases, the visual perception of mechanical events (such as force or mass) is specified through only kinematic features (such as velocity or acceleration). (See Johansson, 1985, for a review.) The question arising from these various studies is not whether the visual system can extract "higher order" information from kinematic displays. Clearly these and other demonstrations attest to that ability (Berthenthal, Proffitt, and Kramer, 1987; Todd, 1983). Rather, the issue concerns the *informational basis* underlying the perception of these events. Our identification of order parameters for certain kinds of dynamic patterns suggests that the information lies in the *phase relation* among kinematic events, not in the kinematic features themselves.

For our present purposes, we captured forms of motion by modelling articulated limbs as a collection of rigid, connected segments, (see Figures 8.1 and 8.5), although point light displays may also be easily created. We used computer simulations to generate and display these dynamic stick patterns in order to mimic the movements of multiple limbs of animals and humans. All development of production animation was carried out using a VAXstation 3200, but we expect to make future developments using high-end graphics.

Synthesis allowed us to generate stimuli that differed only in the phase relationship among different moving components. Stimuli consisted of three connected line segments, whose orientations and relative positions were varied in a cyclical fashion as a function of time. The line segments represent a human arm that performs a motion, with different phase relationships between the upper arm, forearm, and hand (see Section 8.5). There were five degrees of freedom (Figure 8.6) whose values at any given moment determined a particular configuration of limb segments in the visual display. The position of the shoulder (X,Y) may move up, down, forward, and backward. The angle of the upper arm, α, can

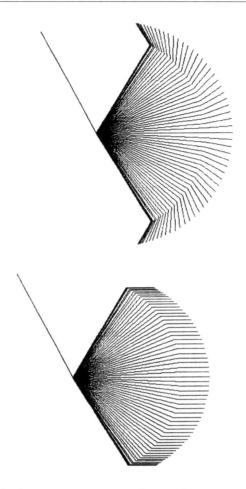

Figure 8.5 Synthetic patterns corresponding to the arm motion shown in Figure 8.4

be rotated about the shoulder; the angle of the forearm, β, can be rotated about the elbow; and the angle of the hand, γ, can be rotated about the wrist. When presented on the display screen, the upper arm was 6.5 cm long, the forearm was 6.0 cm long, and the hand was 1.5 cm long.

Each arm movement cycle was divided into 360 time periods, and any given relationship between different limb segments remained the same during a single cycle. The motion of the forearm was generated by varying the horizontal and vertical positions of the wrist sinusoidally. The horizontal wrist position was always 90 degrees out of phase with the vertical wrist position. The horizontal and vertical positions of the finger tip relative to the elbow were also varied

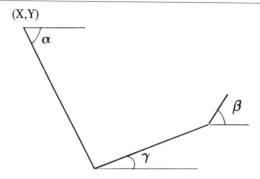

Figure 8.6 Human arm represented by line segments corresponding to the upper arm, forearm and hand. (X,Y) indicates the shoulder position. α, β, γ are the degrees of freedom corresponding to rotation of segments.

sinusoidally, and the relative phase between the angle at elbow and the angle at the wrist was kept constant. For the set of experiments presented here, the position of the shoulder and the elbow remained fixed during the arm motion. Representative limb configurations corresponding to different categories are shown in Figures 8.5a and 8.5b.

Thirteen displays were constructed with the relative phase angle changing at 30-degree intervals from 0 to 360. A sequence of 130 displays was created using each of the 13 displays 10 times and then randomizing them. The observers were seated in front of the video monitor and were presented with the two basic patterns, called A (Figure 8.5a) and B (Figure 8.5b). The actual arm motions corresponding to these two dynamic patterns were also demonstrated to the subjects (see Figure 8.4). Observers were given an opportunity to view the computer simulations until they felt clear about the two basic patterns. Then they were given an answer sheet and told that 130 patterns belonging to either class A or class B would be presented to them on the monitor. They were instructed to carefully examine each display and indicate on the answer sheet whether the pattern belonged to class A or class B. Following these instructions, the observer was presented with a random sequence of the 130 displays. Each display consisted of two complete cycles of arm motion with a fixed relative phase. There was a five-second interval between the displays for the observer to respond. Figure 8.7 shows the results of the identification (labeling) test, in which the percentage of in-phase (A) responses is plotted as a function of stimulus location on a relative phase continuum spanning the two categories. Clearly, the labeling probabilities change abruptly along the continuum for all ten subjects tested (Figures 8.7(a) and 8.7(b)). Around a phase difference of 90 degrees, the identification function has a rather steep slope, indicating that this point corresponds to a category boundary. Mean variability, as represented by the error bars, is negligible within each category but is quite large at the boundary, defining the points

Figure 8.7 Results of identification test, where percentage of in-phase responses are plotted as a function of phase relation. (a) First set of 5 subjects; (b) Second set of five subjects; (c) Result of averaging over all 10 subjects.

at which responses in both categories are equiprobable (see Figure 8.7(c)). Again around 270 degrees, large variability accompanied by a steep slope indicates a second boundary between the two categories. Note that, due to the 2π periodicity of relative phase, the phase angles of 0 degrees and 360 degrees correspond to the same anchor points, whereas 180 degrees corresponds to the second anchor.

As Todd (1983) notes, not much is known about the precise nature of perceptual information provided in biomechanical motion displays. Yet identification of complex patterns of movement as a fundamental aspect of perception is evident as early as age three months (Berthenthal et al., 1987). The preliminary evidence presented here indicates that human observers can readily categorize dynamic visual patterns into one "gait" or another.[1] But clearly many questions and empirical issues remain to be resolved (see Section 8.6). It will be intriguing, nevertheless, to explore the full implications of the present operational approach, namely, that certain *perceptual constraints* (Marr, 1982) correspond to the very abstract (but measurable) dynamics identified experimentally as *production constraints* for coordinated behavior patterns. Methodologically, phase transitions hold the key to uncovering the fundamentally abstract nature of these dynamics that govern spatiotemporal ordering in real physical structures..

Acknowledgments

The research reported here is supported by NIMH (Neurosciences Research Branch) Grant MH 42900–01, the U.S. Office of Naval Research (Perception Sciences) Contract No. N00014–88-J-1191, and a grant from the Florida High Technology and Industry Council. We would like to thank H. Haken for helpful discussions and encouragement.

References

Asatryan, D.G. and Feldman, A.G. 1965. Functional tuning of the nervous system with control of movement or maintenance of a steady posture. *Biophysics* 10:925–935.

Bertenthal, B.I., Proffitt, D.R., and Kramer, S.J. 1987. Perception of biomechanical motions by infants: Implementation of visual processing constraints. *Jour-*

1. Using relative phase as the identified order parameter, Haken, Kelso, Fuchs, and Pandya (in press) have recently introduced a neural network algorithm that encodes and classifies by computer the multijoint limb trajectory patterns produced and perceived here by people. The entire approach, in which order parameters represent different macroscopic states of the neural network, can be appreciably generalized to more complicated patterns of biological motion such as Johansson's point light displays.

nal of Experimental Psychology: Human Perception and Performance 13: 577–585.

Bingham, G. 1987. Kinematic form and scaling: Further investigations on the visual perception of lifted weight. *Journal of Experimental Psychology: Human Perception and Performance* 13:153–177.

Bunz, H. and Haken, H. 1987. Quantitative theory of changes in oscillatory hand movements—applications of synergetics. In L. Rensing, U. an der Heiden and M.C. Mackey (Eds.), *Temporal Disorder in Human Oscillatory Systems*. Heidelberg, Berlin: Springer Verlag.

Cutting, J.E. and Proffitt, D.R. 1981. Gait perception as an example of how we may perceive events. In R.D. Walk and H.L. Pick (Eds.) *Intersensory Perception and Sensory Integration*. New York: Plenum.

Gibson, J.J 1979. *The Ecological Approach to Visual Perception*. Boston: Houghton Mifflin.

Glazier, J.A. and Libchaber, A. 1988. Quasiperiodicity and dynamical systems: An experimentalist's view. *IEEE Transactions on Circuits and Systems* 35:790–809.

Haken, H. 1983. *Synergetics: An Introduction*. (3rd Ed.). Heidelberg: Springer-Verlag.

Haken, H. and Fuchs, A. 1988. Pattern formation and pattern recognition as dual processes. In J.A.S. Kelso, A.J. Mandell, and M.F. Shlesinger (Eds.), *Dynamic Patterns in Complex Systems*. Singapore: World Scientific.

Haken, H., Kelso, J.A.S., and Bunz, H. 1985. A theoretical model of phase transitions in human hand movements. *Biological Cybernetics* 51:347–356.

Haken, H., Kelso, J.A.S., Fuchs, A. and Pandya, A.S. in press. Dynamic pattern recognition of coordinated biological motion. *Neural Networks*.

Jeka, J.J. and Kelso, J.A.S. 1989. The dynamic pattern approach to coordinated behavior: A tutorial review. In S.A. Wallace (Ed.), *Perspectives on the Coordination of Movement*, pp. 3–45.

Johansson, G. 1973. Visual perception of biological motion and a model for its analysis. *Perception and Psychophysics* 14: 201–211.

Johansson, G. 1985. About visual event perception. In W.H. Warren and R.E. Shaw (Eds.), *Persistence and Change: Proc. of the First Int. Conf. on Event Perception*. Hillsdale, NJ: Erlbaum.

Kay, B.A., Kelso, J.A.S., Saltzman, E.L., and Schöner, G. 1987. Space-time behavior of single and bimanual rhythmical movements: Data and limit cycle model. *Journal of Experimental Psychology: Human Perception and Performance* 13:178–192.

Kelso, J.A.S. 1981. On the oscillatory basis of movement. *Bull. Psycho. Soc.* 18:63.

Kelso, J.A.S. 1984. Phase transitions and critical behavior in human bimanual coordination. *American Journal of Physiology,* 246: R1000-R1004.

Kelso, J.A.S., Scholz, J.P. 1985. Cooperative phenomena in biological motion. In H. Haken (Ed.), *Complex Systems: Operational Approaches in Neurobiology, Physics and Computers.* Berlin: Springer-Verlag, pp. 124–149.

Kelso, J.A.S., Scholz, J.P., and Schöner, G. 1986. Nonequilibrium phase transitions in coordinated biological motion: Critical fluctuations. *Physics Letters A* 118:279–284.

Kelso, J.A.S., Scholz, J.P., and Schöner, G. 1988. Dynamics governs switching among patterns of coordination in biological movement. *Physics Letters A* 134(1):8–12.

Kelso, J.A.S. and Schöner, G.S. 1987. Toward a physical (synergetic) theory of biological coordination. *Springer Proceedings in Physics* 19:224–237.

Kelso, J.A.S. and Schöner, G.S. 1988. Self-organization of coordinative movement patterns. *Human Movement Science* 7:27–46.

Kelso, J.A.S., Schöner, G., Scholz, J.P., and Haken, H. 1987. Phase-locked modes, phase transitions and component oscillators in biological motion. *Physica Scripta* 35:79–87.

Kelso, J.A.S., Wallace, S. and Buchanan, J. in press. Order parameters for the neural organization of single multijoint movement patterns.

Koslow, S.H. 1984. Preface, in *The Neuroscience of Mental Health.* DHHS Pub. No. (ADM) 85–1363.

Kots, Y.A. and Syrovegin, A.V. 1966. Fixed set of variants of interaction of the muscles of two joints used in the execution of simple voluntary movements. *Biophysics* 11:1212–1219.

Kugler, P.N., Kelso, J.A.S. and Turvey, M.T. 1980. On the concept of coordinative structures as dissipative structures: Theoretical lines of convergence. In Stelmach, G.E. and Requin, J. (Eds.), *Tutorials in Motor Behavior.* Amsterdam: North-Holland, pp. 3–45.

Liberman, A.M. and Mattingly, I.G. 1985. The motor theory of speech perception revised. *Cognition* 21:1–36.

Mace, W.M. Johanson's approach to visual event perception—Gibson's perspective. In W.H. Warren and R.E. Shaw (Eds.), *Persistence and Change: Proc. of the First Int. Conf. on Event Perception.* Hillsdale, NJ: Erlbaum.

Marr, D. 1982. *Vision.* San Francisco: W.H. Freeman.

Prigogine, I. 1980. *From Being to Becoming.* San Francisco: W.H. Freeman.

Runeson, S. and Frykholm, G. 1981. Visual perception of lifted weight. *Journal of Experimental Psychology: Human Perception and Performance* 7:733–740.

Runeson, S. and Frykholm, G. 1983. Kinematic specification of dynamics as an informational basis for person and action perception. *Journal of Experimental Psychology: General* 9(4), 580–610.

Saltzman, E.L. and Kelso, J.A.S. 1987. Skilled actions: A task dynamic approach. *Psychological Review,* 94:84–106.

Scholz, J.P., and Kelso, J.A.S. 1989. A quantitative approach to understanding the formation and change of coordinated movement patterns. *J. Motor Behavior* 21:122–144.

Scholz, J.P., Kelso, J.A.S., and Schöner, G. 1987. Nonequilibrium phase transitions in coordinated biological motion: Critical slowing down and switching time. *Physics Letters A* 8:390–394.

Schöner, G., Jiang, W. and Kelso, J.A.S. 1990. A synergetic theory of quadrupedal gaits and gait transitions. *Journal of Theoretical Biology* 142:359–391.

Schöner, G., Haken, H., and Kelso, J.A.S. 1986. A stochastic theory of phase transitions in human hand movements. *Biological Cybernetics* 53:247–257.

Schöner, G., and Kelso, J.A.S. 1988a. A synergetic theory of environmentally specified and learned patterns of movement coordination. I. Relative phase dynamics. *Biological Cybernetics* 58:71–80.

Schöner, G., and Kelso, J.A.S. 1988b. A synergetic theory of environmentally specified and learned patterns of movement coordination. II. Component oscillator dynamics. *Biological Cybernetics* 58:81–89.

Schöner, G., and Kelso, J.A.S. 1988c. Dynamic patterns of biological coordination: Theoretical strategy and new results. In J.A.S. Kelso, A.J. Mandell, and M.F. Shlesinger (Eds.), *Dynamic Patterns in Complex Systems*. Singapore: World Scientific.

Schöner, G., and Kelso, J.A.S. 1988d. Dynamic pattern generation in behavioral and neural systems. *Science* 239: 1513–1520.

Schöner, G., and Kelso, J.A.S. 1988e. A dynamic pattern theory of behavioral change. *Journal of Theoretical Biology* 135:501–524.

Todd, J.T. 1983. Perception of gait. *Journal of Experimental Psychology: Human Perception and Performance* 9(1):31–42.

Tuller, B. and Kelso, J.A.S. 1990. Phase transitions in speech production and their perceptual consequences. In M. Jeannerod (Ed.), *Attention and Performance XIII*. Hillsdale, NJ: Erlbaum.

von Holst, E. 1973. On the nature of order in the central nervous system. In R. Martin (Trans.), *The Collected Papers of Erich von Holst*. Coral Gables, Florida: University of Miami press. (Original work published 1939.)

Learning Motor Programs

9

A Computer System for Movement Schemas

Peter H. Greene
Dan Solomon

Computer Science Department
Illinois Institute of Technology
Chicago, Illinois

ABSTRACT

We are developing a computer system, using a Xerox LISP machine linked to an Encore computer, for representing our idea of a movement schema. We recount the motivation for this work, describe work in progress to develop this computer system, and sketch a broader context toward which we shall direct this research.

9.1 *Motivation*

Our current approach to simulating actions springs from a desire (Greene, 1959) to study the structure of perception, motor skills, and thinking in persons and future computers. We have tried to model on a digital computer some features of a baby's sensorimotor development. The baby becomes able to recognize and manipulate objects, taking into account their movements and other spatial relationships, and performs purposeful actions. These actions are more naturally described in terms of their effects on the world than in terms of muscle movements because totally different combinations of muscle contractions might produce the same desired effect. By working between the physiological level (which is not cognizant of task-level considerations) and the usual symbolic programming level (which often manipulates structures that have already been formed elsewhere), we hoped to learn how the sensorimotor structures themselves come into existence.

With this motivation, Greene and Ruggles (1963) wrote a computer model of the interaction of head and hand movements and sucking reflexes, with the aim of modeling aspects of Piaget's (1952, 1954) stage I and stage II of sensori-motor development. In stage I, the infant uses reflexes, mainly involving movements that put things into the mouth; stage II, the infant keeps repeating these procedures, adapting them to the environment and generalizing their applicability to new situations. For instance, empty grasping movements unrelated to the presence of objects evolve to become purposeful movements to grasp objects and bring them to the mouth. Stage III prolongs good experiences by repeating desirable procedures that have been discovered by chance. Stage IV applies them to new situations. Stage V adds experimentation to learn about, rather than to preserve, an element of experience, and stage VI can make predictions and discover new means of actions by manipulating internal representations of the world.

We summarize our previous discussion of this computer model, which we hoped would give us enough insight into stages I and II for us to imagine how they could evolve into the later stages.

We modeled Piaget's infant to include a half dozen devices that corresponded to basic activities, such as moving the head, sucking, moving the arms, or grasping. When a device was active, it manifested some or all of a set of possible patterns of behavior. A device might turn on spontaneously because of an external stimulus or because of an influence from another active device.

Interpreting Piaget in terms of these devices, if you touch the hand of a stage I infant with a rattle, the "grasping device" will be activated and perform grasping movements. If you take the rattle away before it has been actually grasped, the "grasping device" will turn off, and the infant will act as though the rattle has ceased to exist. Piaget thought that objects as such had no meaning at this stage so that grasping was merely a succession of unrelated activities of excitable mechanisms. During stage II, the infant makes simple adjustments of these mechanisms to adapt them to the environment.

The acquisition of means to prolong these interactions with the environment, together with certain mechanisms of incipient appreciation of objects, not known to Piaget, gradually leads to the concept of permanence of objects. For instance, in stage II, the movement patterns of the grasping device come to persist for a while after stimulation has been removed. Now, if you withdraw the rattle after the grasping movements have started, the infant may still be able to recover it, but only if it happens to be located in the trajectory of the grasping movements, which are only repetitions of the previous movements. Although it may appear that the infant is searching for the object, it is actually only that the activity has been repeated—as yet, there is no concept of objects.

We continue our simplified paraphrase of Piaget. As stage II progresses, the "eye device" develops stronger connections to the "hand device." Now, the hand patterns may be activated in the absence of direct stimulation to the hand, and a certain degree of object permanence is achieved. Once the object is in some

sense the intersection of a number of organized activities of different mechanisms, it cannot vanish so easily. But if you hide the rattle, that is, remove it from all action patterns, the baby will act as if it no longer exists.

In stages III and IV, the "devices" remain on even longer, and the baby will retrieve a rattle that has been placed under a pillow. As additional concepts of the environment are formed, the child becomes increasingly able to look for hidden objects.

Piaget noted that, if you open and close your eyes, the young baby may "imitate" you by opening and closing his mouth. Many different patterns belong to or excite the same "device," and later, diverse, highly differentiated movements may derive from precursors that are so related. For a "device" to contain representations of what other "devices" will do would aid in adapting the working of all the devices to the same purpose. Some of these representations might arise because of similarities in the patterns initially produced by the various devices. Similar patterns are grouped together on the basis of their effects on the environment rather than on their physiological similarity. For instance, the mouth turns toward the nipple, takes it in, and sucks; the eyes turn toward an object and look at it; the hand moves toward an object, grasps, and holds it. How is recognition of these similarities used in cognition?

In our model, each head movement pattern consists of two parts: the movement itself and the conditions for activating it. Each movement pattern is triggered when an associated numerical variable exceeds a threshold. These variables could receive an increment from stimuli and might increase gradually in the absence of stimuli, so that a pattern would sometimes occur spontaneously. An increment produced by a stimulus dissipates with time but might rise to the threshold by accumulating increments from repeated stimuli. We modeled these variables by nonoscillatory second-order equations (which could represent the difference between first-order excitatory and inhibitory variables, in a way that had been studied by Rashevsky, 1960, and his followers to model excitation of neural pathways, although that interpretation is not required). Upon onset of a stimulus of constant intensity, such a variable could increase to an asymptotic value, perhaps with an initial overshoot, or could decrease to an asymptotic value, perhaps with an initial undershoot. We could model persistence of hand movements after the grasped object is withdrawn simply by increasing the two time constants of the excitation variable for the grasp pattern, so that it decays more slowly when the stimulus ends.

We programmed such head patterns as head-drifting-at-random, head-rapidly-back-and-forth, head-turning-in-one direction, and sucking-when-head-is-touched-and-sometimes-otherwise. The way that the mouth sometimes found the nipple illustrates how these patterns might be combined to give an impression of a purposeful act, searching. If the head was touched by the nipple near the mouth, back-and-forth was triggered. Each time the mouth brushed past the nipple, a sucking intensity variable received an increment. We introduced an interaction between patterns such that, as sucking intensity increased, the ampli-

tude of the back-and-forth movement decreased. If the central point of this movement was near the nipple, then the mouth touched the nipple on each excursion, so that the sucking intensity received an increment before the previous increment had completely decayed. Thus, the sucking intensity kept rising, which made the head excursions still shorter and made the sucking intensity rise, ultimately reaching the activation threshold for sucking as the mouth converged toward the nipple. We did not simulate the muscle movements of sucking, which was for us just a numerical intensity together with a set of relations with other activities. For instance, sucking was correlated not only with reduced mobility of the head (suppressing the random movements and the back-and-forth component so useful for searching) but also with reduced mobility of the arms and increased fixation of the eyes. At the same time, sucking had the rewarding effect that one may suppose to strengthen concurrently active patterns and to reinforce connections between such patterns. We commented that these relations made sucking well suited to serve as a prototype for acts of attention, for behavior treating objects as having permanent identity, and for sensorimotor behavior involving spatial relations.

In regard to attention, sucking is the first and simplest of acts that prolong rewarding experiences and suppress disturbing influences. In regard to the integrity and permanence of objects, the simultaneous stabilizing effects on many centers of activity ensure that the object cannot vanish because it is being tracked simultaneously by all these centers. Reinforcement of connections between activities, such as moving the eyes and moving the hands, which tend to occur together in many rewarding situations, provides the possibility of coordinating these activities in such a way that the object is recognized as unchanged as it passes from the domain of one activity to that of another.

One can imagine much more efficient ways of finding the nipple; the operations we described were meaningful only in their possibility of growth into later forms of organization. We felt that essential problems of this growth concerned piecing together of partial acts, effective in limited domains, into actions performed by whichever groups of effectors may be best suited to conditions varying over a large range. We needed a way to describe how details of highly differentiated organizations (such as muscle coordinations in moving the hand toward an object to grasp it) may be related to their common less-differentiated precursors (such as sucking, which merely switches on when the head makes a crude movement toward an impinging object). This is all the more necessary because often details may need to be coordinated, not on the basis of external similarity but because they both serve the same purposeful act and thereby take their places in a common hierarchy of structures.

Given our lack of understanding of these issues, we felt that we could not possibly understand how the infant learned all these things, because we did not even know the data structures that could hold them if they had already been learned; this discouraging conviction led to suspension of work on the computer model, whose most definite success was its acronym.

Our present return to this problem stems from sporadic insights over a discouragingly long period. Greene (1971; 1972; 1982; 1984) pointed out the centrality of the work of a Soviet school of neurophysiology, which showed how the brain's task of controlling the large number of degrees of freedom of the neuromuscular system is made possible by the formation of muscle synergies, and these publications helped popularize this work in the West. Greene (1977) discussed, in general terms, a style of exploiting simplifications that occur in special situations that underlies the ability of our motor systems to work so well, and it presented a very tentative formalism for considering how partial acts are pieced together. One of our aims is to model motor organization that is complex enough for its study to require this formalism.

Simple observations of arm movements showed that the intention to perform a meaningful action can organize muscles into a synergy. For example, an attempt to write upside down and backwards with the nonpreferred hand is hesitant and confused, whereas one can write fluently by holding the pen in the preferred hand and moving the paper rather than the pen—although the movements of the nonpreferred hand are the same in each task. Particular patterns of wrist and elbow movement are difficult and slow, whereas performing familiar actions requiring hand movements is easy and quick, even if the action entails the very same wrist and elbow movements as the first task.

Extending the idea that actions can organize synergies, Greene (1988) conceived movements to be composed of prototypical deviations from prototypical movement plans, from which needed adjustments and coordinations are projected into them, as efficiently as a metaphor transfers information from a known domain into the new thing you are describing. Greene (1988) sketched a conceivable organization of prototypical schemas.

The organization was based on the idea of inheritance (as in frames and object-oriented programming) as an important way of organizing local actions and of understanding how actions are related to their less differentiated precursors. Classes of actions are regarded as objects, with a very general DO-SOMETHING at the top. DO-SOMETHING has only the methods "start" and "stop"—any more specialized action can start and stop, although it will supplement or replace the inherited generic method with a its own more customized version. Below this DO-SOMETHING-QUANTITATIVE, which knows how to do things "more" or "less." A specialization, of paramount importance to beings with limited resources, is DO-SOMETHING-WITH-EFFORT, which can do things "harder," and should somehow be able to understand "trying" and "overcoming." Much more specialized motor actions that DO-SOMETHING-WITH-EFFORT include PUSH and LAUNCH. These are grounded in physical feelings common to all of us and serve as prototypes for analogy with any form of effort (say, mental effort) as well as prototypes for social actions such as LAUNCHing a campaign, which gains or loses momentum. By means of such considerations, and by constructing Schankian scripts for motor actions, we hoped to link move-

ment theory with current linguistic thought (Lakoff and Johnson, 1980) about representation of meaning and the central role of metaphor in language.

According to this view, movements are composed through inheritance from, and specialization of, prototypical movements. The efficacy of well-chosen metaphorical words, in comparison with specifying space-time coordinates, in coaching athletes and dancers results from the fact that analogies and metaphors would project information into an object-oriented motor system as efficiently as they project information of a more cognitive nature (just consider the efficiency of "We can play hardball too...just let them try to call foul!" as compared to its explication) (Lakoff and Johnson, 1980). Whereas traditional robotics uses artificial intelligence methods to decide what the robot should do, and switches to differential equations to do it, "natural robotics" retains the former down to the lowest levels of the motor system.

Our work in progress, explained in Sections 9.2, 9.3, and 9.4, is our attempt to begin such a program of research.

9.2 *Descriptions of Some Schemas*

Our view of a motor schema (Greene, 1988) is a quite general one; a schema is any typical pattern of movement, coordination, or control that might be combined with other such patterns in carrying out a motor task. Schemas are arranged in a hierarchy, in which lower level ones inherit characteristics from higher level ones. This makes it easy to represent new movement patterns as specializations or generalizations of existing ones. Schemas may call upon other schemas, called components, to perform parts of their assigned tasks. The dynamically created component hierarchy thus formed must be distinguished from the static inheritance hierarchy described above.

One very basic kind of schema is a "mode," a pattern of arm movement in which only one degree of freedom occurs, either by keeping all but one joint rigid or by coupling the motions of two or more joints. We rather arbitrarily define five "modes" of movement of a three-link arm:

1. Sh Shoulder moves while other joints are rigid

2. El Elbow moves while other joints are rigid

3. Wr Wrist moves while other joints are rigid

4. Ex Extension, with joints moving proportionally

5. Par Lower arm stays parallel to its previous position

These are chosen so that the directions of initial movement of the hand are widely enough spaced to have one of them close to any desired direction of movement. Movements in intermediate directions may be effected by combining two of the modes. Combining two of the modes may also be used to straighten the curved trajectories resulting from such "joint-interpolated" movements

(Hollerbach and Atkeson, 1985) or to correct other deviations from desired trajectories.

Another kind of basic schema involves effort. Following Atkeson and Hollerbach's idea of performing speed and load scaling by separating torques into various components needed to drive the arm, counteract gravity, drive a load, and so forth, we can define schemas corresponding to different components of the torques. By describing effortful movements in terms of schemas, rather than just by writing down the appropriate equations, we can associate extra information with each kind of effort, which allows greater flexibility in combining them. By describing relationships between different movement and effort patterns in an object-oriented hierarchy, we can show how one pattern may be derived from another or from a combination of several others.

Schemas with a multiphase pattern, including a noneffortful and an effortful component, make up another important family. An example of these is a LAUNCH, in which an object is moved, then released. Common features of related actions, such as pushing an object across a table and throwing a ball, may be conveniently represented by a general schema like LAUNCH. At the next, more general level, common features of types of actions like LAUNCHES, CATCHES, and HITS might be represented in a "two-phase" schema.

Higher level control processes may also be described in terms of schemas, and the schema hierarchy provides a convenient way to represent hypotheses about the development of increasingly refined methods of control. For example, we suggest that, in repeated nipple-searching actions, an infant might first learn a "binary-control" schema, in which the controlled variable ("to move or not to move") and the observed variable ("have nipple or don't have nipple" or, at first, more precisely, "GOOD-FLASH or blank") are either on or off, and control is correspondingly simple. More sophisticated treatment of the nipple-search task, or other tasks, would lead to the development of progressively more effective schemas, such as "quantitative-control," where the variables have three values (bigger, same, smaller), and "quantitative control" (conventional "proportional control"), where the variables are continuous and are related accordingly. Use of the schema idea, rather than simple black-box programs for control, more readily suggests how this development might take place. Continuing along these lines, by applying the same principles already learned in quantitative control to derivatives and integrals and combining the results, a high-level "PID" schema might evolve, applicable to a variety of tasks.

Of course, basic schemas like modes, efforts, and control algorithms cannot develop independently of each other; most actions involve all three types and more. An example of how modes and control schemas might have been combined in the development of reaching movements demonstrates a bit more about the organization of schemas. A one-dimensional nipple search is treated here as prototypical (though this task is really two-dimensional) for simplicity. Through a generalization process, ONE-DIMENSIONAL-GROPE becomes the most general schema of a family of gropes, of which the original prototype, NIPPLE-

SEARCH, is now just one member. By replacing some components of the schema that were originally specific to the NIPPLE-SEARCH action, most importantly the "mode," with ones specific to reaching, the ONE-DIMEN-SIONAL-GROPE-WITH-HAND is developed. By augmenting the sensory component of touch with that of vision and modifying the control component, a one-dimensional REACH is produced, which may be further specialized to effect TWO-DIMENSIONAL-REACHing, and so on.

An important feature of this example, which is a key to the schema idea, is that new schemas may be created by modifying slots of existing ones while maintaining the basic structure, rather than starting from scratch. This important feature of learning is also a key feature of the "object-oriented" style of programming, so that object-oriented programming has been the natural means of implementation of these ideas. An important difference between our application of object-oriented programming and its usual use (though not in some artificial intelligence applications) is that the model of learning hinted at in the above examples requires that the schema hierarchy not maintain strict "parent-child" relationships. For example, mathematically, pushing a frictionless mass is a special case of pushing a mass acted upon by friction and a spring, in which the coefficient of friction and the spring constant happen to be zero. However, psychologically, and pedagogically (in sensorimotor learning, as well as in school), the frictionless mass is a simpler prototype, and the mass with friction and spring are learned later as a more complicated system, represented in terms of its deviations from the "ideal" frictionless, springless case. Thus, a more general schema may originally be represented in the hierarchy as a "child" of a specific prototype, though processes of consolidation of learning may reverse this order into the more conventional object-oriented arrangement, with the more specific one as a "child" of the more general.

9.3 *Computer Implementation*

We have implemented a system (called MOOSE, for Movement by Object-Oriented Schema Execution) for testing this schema model of motor coordination, using LOOPS (LISP Object-Oriented Programming System) on a Xerox 1108 LISP machine. Schemas are represented as LOOPS objects, which are activated by sending messages (calls to methods of the schemas). Each schema contains variables describing its parameters and its components, which are other schemas or, at the lowest level, basic processes like oscillators, function generators, and sensory functions. Schemas also have methods by which they may be sent messages to do general things like "speed up," "do it harder," and so on. Both variables and methods are inherited from a schema's parent in the inheritance hierarchy, its "superclass."

As an example, here is a description, greatly simplified for clarity, of the family of gropes and reaches as implemented in MOOSE:

```
1-D Grope:
     Superclass: Schema
     Components: (mode control contact)
     control: Binary-Control
               Observed-var: contact:out
               Controlled-var: mode:stopcondition

Nipple-search:
     Superclass: 1-D grope
     mode: Head-oscillation
     contact: Mouth-contact

1-D Hand-Grope:
     Superclass: 1-D grope
     mode: Extend
          speed: slow
     contact: Hand-Contact

1-D Reach:
     Superclass: 1-D HandGrope
     components: mode control contact distance control2
     distance: Distance-to-contact
     control2: P-control (* proportional control *)
               observed: distance:out
               controlled: mode:speed

2-D Reach:
     Superclass: 1-D Reach
     components: mode control contact distance control2
               mode2 control3 added lateral-distance
     mode2: Elbow
     control3: P-control
               observed: lateral-distance:out
               controlled: mode:speed
     added: addition (* process to combine two modes *)
     lateral-distance: Lateral-distance
```

Note that the components variable lists all the needed components for each schema and that the individual components, with their properties, are separate variables that may be present in the schema itself or be inherited from above. When a schema is activated, it activates its components, using the parameters for them that are stored in its own description or the inherited one.

9.4 *A Broader Context for the Future*

As we take stock of experiments in progress using this system, we increasingly suspect that, for certain subtasks, neural net implementations can be more appropriate than the traditional programming mechanisms of our system, and should replace some of them, provided we do not throw out the symbolic structure that attracted us to these programming mechanisms. Thus better equipped, we return closer to the original motivations of our work.

We have been invited to sketch the broader context of the work reported above; this is still too speculative for us to wish to write more than our general motivation.

Basing our ideas on unexpected similarities between our formulation of movement and specific recent work in linguistics and cognition, we see a way to attempt to unite movement, sensation, and affect into a sensorimotor underpinning for language, thought, and the emergence of a unified self. There are now enough new pieces of the puzzle for us to believe the time might be ripe to do this.

Our formulation of movement was developed independently of, yet strikingly resembles, recent theories of thinking and language that emphasize prototypes, metaphor as basic to meaning, and cognitive grammar. The similarities suggest how to extend the ideas to provide a sensorimotor underpinning for aspects of the development of language, in a way that unites movement, feelings, and linguistic structure, and seems to lead to the emergence of a unified self. In our theory, sensation and affect play a central role in relating schemas of physical movement and force to psychological and linguistic phenomena. The sensorimotor organization would appear to underlie an emerging conception among psycholinguists of meaning and language (and their effects on feelings and actions) as primarily based on metaphor.

We have speculated that the schemas might allow some kind of preverbal understanding of important concepts—for example, the DO-SOMETHING-WITH-EFFORT schema could, by comparing forces, understand *try, try harder, overcome, prevent, despite, refrain from*. This schema may *give up* when the effort is too great. It may react to psychological efforts through evoked feelings of analogous physical schemas, such as LAUNCH-A-PHYSICAL-MASS.

Simple observations of arm movements show that the difficulty of a movement depends not only on the movement itself but primarily on the meaningful action for which it is intended. Perhaps the only movements that work fluently and adaptively are those linked to schemas in the system described above. The people who can talk to muscles best—athletic and dance coaches—do so in terms of metaphorical speech about meaningful actions, not about muscle movements.

These ideas about movement grew independently of studies of language that show how much of meaning and language structure is conveyed through metaphors based on schemas for those things we all have in common, such as force,

movement, balance, and directions in space (Lakoff and Johnson, 1980; Lakoff, 1987). One might suppose that metaphorical language, parables, and myths are engineered to directly excite these schemas in order to explain why they are more immediately compelling than intellectualized explanations, which must be first mapped into schemas before they can affect one's behavior. The fact that our research, starting from the motor end ignorance of the linguistic end, came to the same sort of structure as that adduced by the linguists, gives us hope for uncovering mechanisms to link the two.

In addition, these and other linguistic studies (Langacher, 1987; Pinker, 1989) show that many features of syntax depend on ideas of space, force, balance, causality, and other abstract concepts. If so, our nervous system must be sensitive to these things, which are just the things that would underlie Piagetian type sensorimotor development and that we imagine to take part in the schemas mentioned above. If sensorimotor behavior and linguistic meaning are based on the same kinds of structure, one would expect evolution to have built the latter upon the preexisting former.

As just enough of an example to give the flavor, we consider an important specialization of the DO-SOMETHING-WITH-EFFORT, the prototypical schema of pushing a mass so as to accelerate it, perhaps so it keeps going for a while. We do this to external objects and to our body and limbs. Bodily feelings are associated with these efforts. The more mass, or the farther or faster it must go, or the more resistance it must overcome, the more the effort. A task that requires mental effort can be matched to this schema of physical effort—the more questions we must study for the exam, or the harder the questions, the more mental effort. We will investigate how mappings between such analogous schemas could transfer information from one to the other.

Our view suggests that, in general, our motor schemas could include concrete motor-affective prototypical instances of verbs such as *try* and *prevent*, to which more abstract instances could be linked. These concrete instances can be small quantitative or qualitative simulations of dynamical systems (for example, competing forces pushing a mass, linked to "feelings" of the forces). We can start attempting to represent verbs in terms of these concrete simulations. In modeling these on a computer, we may make use of the organizer and scheduler of processes programmed by Dan Solomon (1989) for his doctoral dissertation.

Returning to the model of Piaget's stage I of sensorimotor development, random movement of the infant's head leads to contact of the nipple with the mouth, and thence to immobilization of the head and to sucking, which is a prototypical precursor of both *success* and *attention*. Movements of the hand result in contact with an object, immobilization, and grasping. Movements of the eyes lead to fixation on an object. All these actions have similar structure and result in similar successes. The random movement is replaced by a back and forth search, which later becomes part of *trying*. We shall attempt to make computer models of such schemas, to guide us in thinking about just how *links from one to another* can allow a person to make use of the abstract structure

common to all, and how links from more abstract concepts or actions to the feelings associated with these primordial schemas can help a person place individual actions within a context of related actions. We would have to treat these feelings not in their subjective aspect but as signals that turn on various other feelings, mechanisms, and dispositions to act.

This theory, if successful, would provide a unified conception of the self, derived from the fact that all actions are linked through the same set of motor-affective prototypes and feelings, and would account in a specific way for the fact that most of our knowledge about words is actually nonverbal. For example, we usually know which of two approximately synonymous words is more appropriate to a given context, without being able to define either. This could be because they are linked to slightly different constellations of prototypes and feelings, which, in turn, are linked to slightly different mechanisms and dispositions to act. All this knowledge is nonverbal.

In seeking connectionist models for higher motor and mental functions, we would attempt first to develop our ideas of their sensorimotor underpinnings sketched here and model the latter with neural nets rather than seeking to model the higher functions directly in terms of neural nets. (A visiting Martian who encountered a television set and wanted to build one out of resistors, capacitors, and transistors would do well first to understand how to build a TV from tuners and amplifiers, next, study how to build those from more elementary circuits, and finally, study how to build the elementary circuits from resistors, capacitors, and transistors.) Psycholinguistics, psychology, and study of neural nets have provided enough new pieces of the puzzle for us all to put them together and see the picture.

References

Atkeson, C.G. and Hollerbach, J.M. 1985. Kinematic features of unrestrained arm movements. *J. Neuroscience* 5:2318–2330.

Greene, P.H. 1959. An approach to computers that perceive, learn, and reason. *Proc. 1959 Western Joint Computer Conference*, pp. 181–186.

Greene, P.H. 1971. Introduction to I. M. Gelfand (Ed.-in-chief), with V.S. Gurfinkel, S.V. Fomin, and M.I. Tsetlin (Assoc. Eds.), *Models of the Structural-Functional Organization of Certain Biological Systems* (transl. by C.R. Beard). Cambridge, MA.: MIT Press.

Greene, P.H. 1972. Problems of organization of motor systems. In R. Rosen and F.M. Snell (Eds.), *Progress in Theoretical Biology*, Vol. 2. New York: Academic Press, pp. 303–338.

Greene, P.H. 1977. Strategies for heterarchical control—An essay. I. A style for controlling complex systems. II. Theoretical exploration of a style of control. Tech. Rep. 77–8, 77–9, Computer Science Dept., Ill. Inst. Technology.

Greene, P.H. 1982. Why is it easy to move your arms? *Journal of Motor Behavior* 14:260–286.

Greene, P.H. 1988. The organization of natural movement. *J. Motor Behavior* 20:180–185.

Greene, P.H. and C.C. Boylls, Jr. 1984. Bernstein's significance today. In J.H.Y. Whiting (Ed.), *Bernstein Reassessed*. Amsterdam: North Holland-Elsevier.

Greene, P.H. and Ruggles, T.L. 1963. CHILD and SPOCK—Computer having intelligent learning and development; simulated procedure for obtaining common knowledge. *IEEE Trans. on Military Electronics* MIL-7(2,3):156–159.

Hollerbach, J.M. and Atkeson, C.G. 1985. *Deducing Planning Variables from Experimental Arm Trajectories*. Cambridge, MA.: MIT Center for Biological Information Processing, Artificial Intelligence Laboratory.

Lakoff, G. 1987. *Women, Fire, and Dangerous Things: What Categories Reveal about the Mind*. Chicago: University of Chicago Press.

Lakoff, G. and M. Johnson. 1980. *Metaphors We Live By*. Chicago: University of Chicago Press.

Langacher, R.W. 1987. *Foundations of Cognitive Grammar*, Vol. 2. Stanford, CA.: Stanford University Press.

Piaget, J. 1952. *The Origins of Intelligence in Children*. Trans. by M. Cook. New York: International Universities Press, Inc.

Piaget, J. 1954. *The Construction of Reality in the Child*. Trans. by M. Cook. New York: Basic Books Publishing Co.

Pinker, S. 1989. *Learnability and Cognition*. Cambridge, MA.: MIT Press.

Rashevsky, N. 1960. *Mathematical Biophysics*, 3rd and revised edition. New York: Dover Publications, Inc.

Solomon, D. 1989. *An Object-Oriented Representation for Motor Schemas*. Doctoral Dissertation. Chicago: Illinois Institute of Technology.

III

MOTION CONTROL ALGORITHMS

10

Constrained Optimization of Articulated Animal Movement in Computer Animation

Michael Girard

Stichting Computeranimatie
Groningen Polytechnic
Groningen, The Netherlands

ABSTRACT

The computer animation of animal motion requires the use of constrained optimization techniques to produce natural expressive motion. A new algorithm is given for optimizing limb movement in terms of both kinematics and dynamics-based variables and constraints. The algorithm uses dynamic programming to solve for a minimum-cost speed distribution along a parametric splined path. The difficulty in extending constrained optimization techniques to the simulation of coordinated body motion is discussed.

10.1 *Introduction*

Until recent years, the computer animation of articulated figures, such as legged animals and human forms, was carried out using general purpose key-frame computer animation systems. These systems could be used to animate articulated limbs by interpolating joint angles. Computing the limb's cartesian-space position from its joint angles is called *forward kinematics*.

However, a major shortcoming of these systems is that joint interpolation may not be used to move the end of the limb along a specific path. Goal-directed movements, such as moving the hand to open a door or planting a foot at a specific place on the ground, require the computation of *inverse kinematics*: solving for the set of joint angles that places the end of the limb at a desired location and orientation. Research in the robotics community on inverse kinematic control has been successfully applied to computer animation (Girard, 1987; Korein and Badler, 1982).

A current trend in animation research has been directed toward incorporating the simulation of *dynamics*. Here we are interested in computing the relation between joint forces and joint accelerations. As with kinematic problems, robotics research on the dynamics of articulated limbs has led to efficient general purpose algorithms (Featherstone, 1988), some of which which have been employed in computer animation systems (Armstrong et al., 1986; Wilhelms, 1985).

However, the mechanics of movement may not be derived solely from dynamic simulation unless the articulated animal is a passive string of linked bodies, such as a marionette. The forces necessary for coordinated animal movements, such as reaching and walking, must somehow be determined. Due to the nonlinear relationship between joint forces and limb movement and the need to satisfy constraints on a movement's path, speed, and energy expenditure, modeling coordinated motion is fundamentally a problem of *control*. Furthermore, empirical studies of coordinated animal motion suggest that limb trajectories and body movement seem to be formulated in terms of *optimization* of performance, such as minimization of jerk about the end of the limb.

This chapter presents a new algorithm that employs dynamic programming to optimize limb trajectories formed by splined free-form paths. The approach is especially robust, in that the optimization performance criteria may be based on both kinematic and dynamics-based quantities. Furthermore, constraints on movement (such as maximum achievable joint torques or joint velocity bounds) may be easily incorporated.

For the purposes of completeness, the kinematics and dynamics of limbs will be briefly reviewed in the second and third sections. The author's constrained optimization algorithm for articulated limb movement will be discussed in the fourth section. The fifth section extends the issue of modeling the dynamics and control of limbed motion to consider the coordination of an animal's entire body and examine the application and shortcomings of constrained optimization techniques in the context of body motion.

10.2 *Forward and Inverse Kinematics*

An arbitrary limb may be specified using the kinematic notation presented by Denavit and Hartenberg (1955). In their notation, a coordinate system for every

Figure 10.1 Link Parameters Associated with Link i

individual degree of freedom present in the limb is parametrically specified. Four parameters are used to define a linear transformation matrix between adjacent coordinate systems: the length of the link a, the twist of the link α, the distance between links d, and the angle between links θ (see Figure 10.1).

By applying successive matrix multiplications between adjacent links, starting at the base of the limb, each link may be transformed from its own coordinates to to the world coordinate space. Using the Denavit and Hartenberg scheme, solving for the world-space coordinates of the end of the limb, given the joint angles θ (the forward kinematics problem), is therefore easily computed.

Solving the inverse kinematic problem is difficult, due to its nonlinearity and the fact that the animal limbs we wish to model typically have limb geometries with more than six degrees of freedom. Therefore, we must adopt inverse-kinematic techniques suitable for the class of redundant limbs. Resolved motion rate control has been devised for this purpose. This technique linearizes the kinematic equations of motion about a point and solves for the position of the end-effector in terms of its velocity or "rate" (Whitney, 1969; Klein and Huang, 1983; Liegeois, 1977; Maciejewski and Klein, 1985).

The jacobian maps linear incremental changes in the limb's joints into incremental changes in the end-effector's position. The inverse mapping of the jacobian, therefore, solves for the required $\Delta\theta$ in joint-space to achieve a desired $\Delta\rho$ of the end-effector in cartesian space.

For redundant limbs, the joint-space is of higher dimension than the six-dimensional cartesian space of the end-effector. Therefore, in the redundant case, the jacobian transformation has a null space containing an infinite number of joint-space rates that will produce no end-effector motion (see Figure 10.2).

This, of course, implies that there will also be an infinite number of solutions for nonzero end-effector movements since null-space joint rates may be added to any limb movement without influencing the end-effector.

Klein and Huang (1983), in their review of resolved motion rate control, note that mapping the pseudoinverse of the jacobian, J^+, produces the minimum

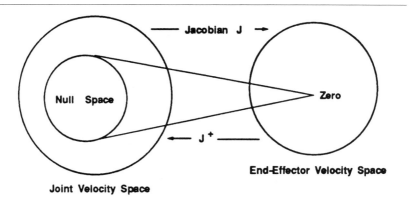

Figure 10.2 Forward and Inverse Kinematics

norm solution by moving the joints as little as possible to achieve some new desired end-effector position. However, they also observed that, for the least squares minimum norm solution, periodic end-effector trajectories will not produce periodic joint-space solutions. This has the problem that, in the context of animation, links will appear to be loosely connected objects that drift as if they are being pulled by the end of the limb. A more general solution that prevents joint-space drifting is given by (Whitney, 1969; Liegeois, 1977; Klein, 1983; Maciejewski, 1985):

$$\Delta \vec{\theta} = J^+ \Delta \vec{x} + (I - J^+ J)\vec{z}$$

where I is an $n \times n$ identity matrix and z is an arbitrary vector in $\Delta \theta$-space.

The matrix operator $(I - J^+ J)$ projects any desired joint-space rate vector z into the null space of the jacobian, thereby ensuring that the desired end-effector motion is not altered.

The most natural way of specifying a desired joint-space position is to move toward a rate z that minimizes the limb's deviation from some desired joint-space position Λ. That is, we compute z in the above equation as:

$$z = \nabla H \text{ with } H = \sum_{i=1}^{n} \alpha_i (\theta_i - \Lambda_i)^2$$

where θ_i is the ith joint angle, Λ_i is the center angle of the ith joint angle, and α_i is a center angle gain value between zero and one.

The center angles define the desired joint angle positions and their associated gains define their relative importance of satisfaction. From the animator's point of view, the gains may be thought of as "springs" that define the stiffness of the joint about some desired center position (Ribble, 1982).

10.3 *The Dynamics of Limbs*

The kinematics of a limb's structure define its geometric and topological characteristics. By contrast, the dynamics of movement is concerned with its Newtonian mechanical properties. That is, given the mass and moment of inertia of each link in the limb and the presence of external forces, dynamics defines the relationship between the forces applied at the joints and the acceleration, velocity, and position of the limb.

The computation of accelerations, given current position and velocity from joint torques, is called the *forward dynamics problem.* Solving this problem allows us to simulate the dynamics of the linked system from given input torques.

The use of forward dynamics must be coupled with control strategies if coordinated goal-directed movement (or animation) is desired. The control of real robot manipulators is typically carried out by planning an ideal reference trajectory and then calculating the torques required to keep the manipulator on the prespecified path. Computing torques to achieve desired motion is the inverse dynamics problem (see Figure 10.3).

Solutions to the forward and inverse dynamics problem for linked systems have been well understood in the robotics field for many years. A comprehensive treatment of robot dynamics may be found in Featherstone, 1988 and Hollerbach, 1982. The primary contribution of research in articulated dynamics has been to develop recursive solutions (Luh et al., 1980; Walker and Orin, 1982; Armstrong and Green, 1985) that are dramatically faster than the earlier non-recursive methods.

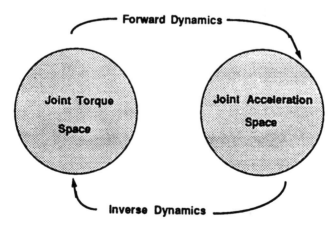

Figure 10.3 Forward and Inverse Dynamics

10.3.1 *Recursive Newton-Euler Inverse Dynamics*

The nonrecursive general equation for the inverse dynamics of limbs takes the form (Featherstone, 1988):

$$Q_i = \sum_{j=1}^{n} H_{ij}\, \ddot{q}_j + \sum_{j=1}^{n} \sum_{k=1}^{n} C_{ijk}\, \dot{q}_j\, \dot{q}_k + g_i$$

where Q_i, \ddot{q}_i, \dot{q}_i are the joint forces, accelerations, and velocities, and H_{ij}, C_{ijk}, g_i are the inertial, Coriolis, and gravitational coefficients.

The Newton-Euler method calculates joint torques, Q, given joint accelerations, d^2q/dt^2, by using recursion to eliminate the execution of repeated calculations. The recursion proceeds in two directions. The forward execution starts from the base of the limb and advances toward its end, recursively accumulating values for the net velocities, accelerations, and forces acting on each link. Once these net values are known, a backward procedure, beginning at the end of the limb and proceeding toward its base, computes the recursive relations of the forces transmitted between connecting links and the torques that must be applied at the joints to realize these forces.

10.3.2 *Simulation of Forward Dynamics*

In the real world, limbs move when forces are applied. The computation of forward dynamics is required for simulating the actual behavior of real mechanical systems and robot manipulators. Forward dynamics computations fall into two categories. The first calculates recursion coefficients and propagates motion and force constraints in the spirit of the recursive inverse dynamics calculations. Armstrong and Green (1985) and Featherstone (1988) have devised algorithms that belong to this class.

The second approach is to solve the set of simultaneous equations for the unknown accelerations d^2q/dt^2 in:

$$Q = H(q)\, d^2q/dt^2 + C(q,dq/dt)$$

This is the most widely used method, due to its speed for limbs having less than nine degrees of freedom.

Walker and Orin (1982) have devised and analyzed several methods that solve these simultaneous equations efficiently by utilizing recursive techniques. In the computer graphics literature, Isaacs and Cohen (1987) also use the simultaneous equation solution method, but their approach is nonrecursive and therefore is much more inefficient.

10.3.3 *Time Complexity of Dynamics Algorithms*

Walker's (1982) inverse dynamic formulation was refined by Luh, Walker, and Paul in 1980. Due to their recursive formulation, they achieve $O(n)$ time complexity (Featherstone, 1988). Nonrecursive methods are much slower, due to

their explicit calculations of the $O(n^2)$ quantities in H_{ij} and the $O(n^3)$ quantities in C_{ijk} (Featherstone, 1988). In practice, the difference between the two is dramatic. For example, for a six degree-of-freedom limb, the recursive Newton-Euler method may be 100 times faster than the nonrecursive approaches (Featherstone, 1988; Hollerbach, 1982).

Armstrong and Featherstone have proposed $O(n)$ forward dynamics algorithms that propagate values recursively, in the spirit of the inverse dynamics calculations. However, Featherstone points out that for $n < 9$, the $O(n^3)$ linear equation solvers that use inverse dynamics to calculate H and C are more efficient, due to the small coefficients associated with their n^3 terms (Featherstone, 1988).

10.4 *Modeling Natural Limb Motion*

Modeling the kinematics and dynamics of limbs is a necessary but not sufficient step toward simulating coordinated limb motion. Understanding the dynamics and kinematics of limb motion gives us nothing more than a translation between representational spaces—joint space, cartesian space,, and torque space. The question of how to control movement to achieve coordinated goals or to form expressive qualities of movement remains unresolved. Where does the locus of control reside, in joint space, cartesian space, or torque space?

10.4.1 *Coordinated Movement and Weighted Performance Optimization*

Empirical studies have been conducted to determine how humans and other animals execute coordinated goal-directed motions. Especially noteworthy are the analyses of unrestrained arm movements in humans. It was discovered that the normalized speed(time) graph of the hand's motion between two stationary points in space was invariant with respect to the points chosen, the load carried, the speed of motion, and the distance traveled. Furthermore, the shape of this graph matched that predicted by an optimization for minimum-jerk about the hand (Atkeson, 1984; 1985; Flash, Tamar, and Hollerbach, 1984; Hogan, 1986) (see Figure 10.4).

Stated mathematically, minimization of jerk over a path $\zeta(t)$ is formed in terms of the mean squared magnitude of the cartesian jerk (the third derivative, the hand's rate of change of acceleration). That is, we wish to minimize:

$$J = \int_{t_0}^{t_1} | d^3 \zeta(t) / dt^3 |^2 \, dt$$

The notion that limb trajectory formation is formulated in terms of the hand's coordinate system is also supported by Morasso's study (1983) of free-form arm movements. He found that the tangential speed of the hand was inversely proportional to the curvature of its path (see Figure 10.5).

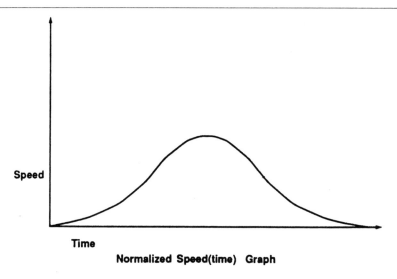

Figure 10.4 Shape of Graph for Linear Movements

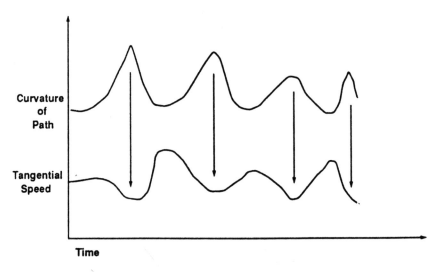

Figure 10.5 Minima in Hand Speed Occur at Maxima in Path Curvature

In other words, much like a race car, the hand tends to speed up on the straightaways and slow down on the curves. A minimization of jerk found in the point-to-point movements would also produce the maximally smooth relationship for curved movements (Hogan, 1986; Atkeson and Hollerbach, 1985; Flash, Tamar, and Hollerbach, 1984).

It is clear, however, that not all limb movement may be characterized by control strategies that optimize end-effector trajectories. In contrast to coordinated arm movements, swinging motion, such as is found in legs during walking, is best understood as a minimization of expended energy or work rather than as jerk about the foot (Nagurka, 1971; Ghosh, 1976; Nelson, 1983). It seems likely that in natural trajectory formation, several performance indices are simultaneously operative (Nelson, 1983). The precise weights corresponding to each index depend on the limb's function and task.

The computer animator is interested in designing trajectories that are natural and expressive. The question then arises, how do we formalize expressive qualities in limb movement?

Aside from the functional behavior, such as reaching or throwing a ball, it seems clear that the actual path taken during an expressive limb motion, due to its foundation in culture, behavior, and language, may not be quantitatively determined. However, the distribution of speed along that path could be optimized, subject to the constraints on the initial and final states of the movement, $\zeta(t_0)$ and $\zeta(t_n)$, and a free-form path designed by the animator.

What optimization criteria should be applied in the determination of an expressive velocity distribution? Do expressive qualities of movement correspond to specific optimal performance indices? This mapping remains a topic for investigation, but it seems likely, based on studies of natural movement cited above, that the following correspondences will hold:

coordinated goal–directed motion = minimum jerk about hand
relaxed swinging motion = minimum energy expenditure

The establishment of additional correspondences remains a promising domain for future research.

10.4.2 *The Optimal Velocity Distribution Problem*

In the context of computer animation, the limb trajectory generation problem becomes a matter of finding the optimal velocity distribution along the path in which the end-condition timing and placement are determined by the animator. Formally, it may may be stated as follows: Given the specification of a parameterized joint-space limb path $\zeta(t)$, find the distribution of n positions along that path: $\zeta(u_1)$, $\zeta(u_2)$, $\zeta(u_3)$,..., $\zeta(u_n)$ where $\zeta(u_1)$ is the initial position at time t_1, $\zeta(u_n)$ is the final position at time t_n, and

$$J(u) = \int_{u_0}^{u_n} \mathcal{F}(\tau(u), \zeta(u), p(u))\, du$$

where $\tau(u)$ is the torque function of the limb, $\zeta(u)$ is the joint-space position of the limb, $p(u)$ is the cartesian-space position of the limb, such that d constraint functions $C_i(\tau(u), \zeta(u), p(u))$, $i = 1...d$ are satisfied.

The solution of the limb trajectory formation problem is nontrivial. Analytical optimal control techniques have been formulated for simple straight-line trajectories (Sahar and Hollerbach, 1985; Flash, Tamar, and Hollerbach 1984; Nelson, 1983) but fail to work on curved paths. For example, Kyriakopoulos and Saradis attempted to apply optimal control methods (using the calculus of variations) to the minimization of jerk along a prespecified path. Unfortunately, even in the absence of constraints and dynamics, the method yielded a nonlinear two-point boundary problem with no closed-form solution (Kyriakopoulos and Saradis, 1988).

Further complications arise because the constraints on robot manipulator movement (as well as natural limb motion) are complex combinations of geometrical, kinematical, and dynamical functions, such as the maximum achievable torques of the robot arm, constraints on jerk and joint velocities, and limits on noncolliding joint positions (Lin, Chang, and Luh, 1983).

Thus, the problem falls into the field of nonlinear constrained optimization (Kirk, 1970; Bryson and Ho, 1975). Dynamic programming has been advocated by many robotics researchers (Sahar and Hollerbach, 1985; Pfeiffer and Johanni, 1987; Shin and McKay, 1986; Kircanski and Vukobratovic, 1982; Singh and Leu, 1987), due to its generality and well known capability for solving non-linearly constrained systems. The strategy taken by dynamic programming is to discretize the state space of the limb's movement and then find the minimum cost path from the start state to the final state. As the sampling resolution of the discretization increases, the path computed by dynamic programming will converge to the continuous-time solution (Kirk, 1970).

Of course, if the dimension of the state space is large (more than three variables), the memory required will also become prohibitive. Therefore, the technique is only feasible for path synthesis if the number of joints is small. Sahar and Hollerbach found the minimum-time paths for a two-degree-of-freedom manipulator by dynamic programming over a tessellation of the limb's two-dimensional joint-space (Sahar, 1985). However, if the limb's movement is constrained to a path $\zeta(u)$, as is the case in our optimal velocity distribution problem, an otherwise n degree of freedom system is reduced to one dimension in u, thereby alleviating dynamic programming's "curse of dimensionality."

The problem of synthesizing constrained optimal velocity distributions for robotic manipulators has been addressed by Kircanski and Vukobratovic (Kircanski, 1982). The approach I advance is similar to their technique but more robust and suited to the requirements of computer animation. In light of this similarity, I present a description of their approach first.

10.4.3 *Solving for Optimal Trajectories with Dynamic Programming*

The optimal velocity distribution algorithm developed by Kircanski and Vukobratovic begins with an initial distribution $\zeta(u_i)$, with one position for each time (or frame) $i = 1 \ldots n$. A reasonable first guess would be to distribute the

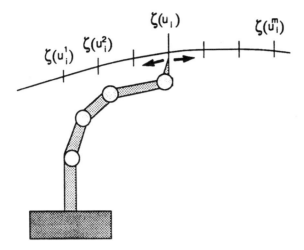

Figure 10.6 m Variations About a Position at Time i

positions at equal intervals (or constant speed). Since the path we are interested in optimizing is a free-form spline, the methods I described on arclength reparametrization may be used for this purpose.

The next step is to form m different variations about the initial limb position $\zeta(u_i)$ for each time i: $\zeta(u_i^1)$, $\zeta(u_i^2)$... $\zeta(u_i^m)$. These variations form a set of m positions, out of which one will be chosen for inclusion in the final optimal distribution (see Figure 10.6)

Depending on the performance index to be optimized, the state of the limb must include not only the position but higher order time derivatives as well. By computing finite differences between all possible successive positions, we may approximate the velocity at a given time, thereby forming the state s_i^j at $t_i = (p_i, v_i)^j$ where $v_i = p_{i+1} - p_i$ and $j = m^2$. This process of accumulating higher order terms in the state may be recursively invoked, resulting in m^{c+1} possible states at each time step, where c is the order of the derivative, with m^c transitions possible between a states s_i and s_{i+1} (see Figure 10.7).

The set of all possible distributions formable by the product-space of each of the variations is exponentially large, consisting of m^{cn} possible trajectories. By using dynamic programming, however, the optimum distribution of this exponential space can be computed in linear time.

Working backward from the final state to the initial state, the dynamic programming solution recursively computes the cumulative cost from state $s_{(i-1)}^j$ to s_i^k:

$$COST\ (s_{i-1}^j) = \overset{MIN}{k\ J(s_{i-1}^j) + COST(s_i^k)}$$

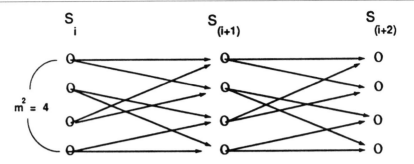

Figure 10.7 Part of the Dynamic Programming Graph, with $m = 2$ and $c = 1$

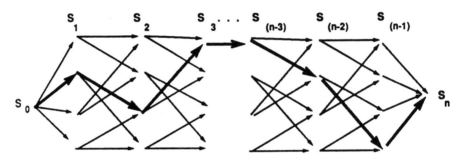

Figure 10.8 Optimal Minimum Cost Path, with $m = 2$ and $c = 1$

where $k = 1 \dots m^c$. When the algorithm reaches the start node, the minimum cost path in the graph will be found. This path corresponds to the optimal velocity distribution (see Figure 10.8).

At each cost evaluation, each of the constraint functions $C_i(\tau(u),\ \zeta(u),\ p(u))$, $i = 1 \dots d$ may be easily incorporated into the dynamic programming optimization by excluding choices which are in violation. Thus, the presence of constraints that reduce the search space may actually improve the efficiency of the program (search-space reductions must be traded off against the time required to evaluate these constraint functions).

In spite of the generality of the Kircanski/Vukobratovic algorithm, it becomes impractical for cases in which the speed of the limb changes dramatically. If we assume that our initial distribution is at constant speed, and that the variations are placed at equal distances on the path $\Delta|\zeta(u)|$, then the smallest acceleration possible will be $\Delta|\zeta(u)|$. Furthermore, the upper bound for the sum of accelerations (in one direction) taken over the path will be $m(\Delta|\zeta(u)|)$ (see Figure 10.9).

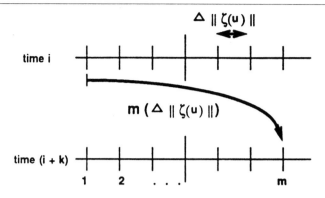

Figure 10.9 Resolution and Range of Acceleration Assuming Initial Constant Speed Distribution

10.4.4 *Optimizing Splined Trajectories with Dynamic Programming*

The basis for the author's optimization algorithm is the use of spline interpolation in the formation of the velocity distribution. Let $S(u)$ be a spline interpolated trajectory in a limb's joint-space, with $S(i) = V_i$. Rather than constructing variations in placement at every time sample, variations are formed in the placement of the spline's control points, v_i at equal time intervals, t_i, $i = 1 \ldots n_s$. Then the trajectory is formed by spline interpolation of optimal control point distribution. The principal advantage here is that both small increments in speed (resolution) and large magnitudes in acceleration (range) may be realized by interpolation of the relatively small number of discretized control point variations.

The algorithm begins with an initial control point distribution $V_1, V_2, \ldots V_{ns}$. For each V_i, m variations $V_i^1, V_i^2, \ldots V_i^m$ are formed such that:

$$V_i^j = S(u_i + (j - m/2)(\Delta u))$$

where Δu = the parametric range in variation (see Figure 10.10).

Although the variations are taken from the initial path, changing the location of a control point may slightly alter this path. However, in cases where path preservation is critical, the insertion of new control points without altering the path (Mortenson, 1985) may be used to reduce the path deviation caused by the variation.

Given that the local support for the spline blending functions is over four control points, path segment PS_i between V_i and V_{i+1} will be influenced by variations in V_{i-1}, V_i, V_{i+1} and V_{i+2}. Therefore, for each path segment having m variations in control point placement, there are m^4 path segment variations.

Now, the optimal distribution of control points may be found by minimizing the cost evaluated over the sequence of path segments formed by the distribution. In this context, a node in the dynamic programming graph becomes the ith

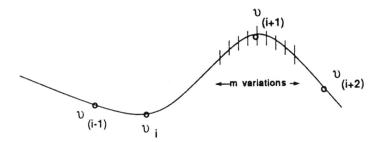

Figure 10.10 Splined Path Segment Variations

path segment associated with one of the m^4 variations of control points V_{i-1}, V_i, V_{i+1}, and V_{i+2}. Since the first three control points of the $(i + 1)^{th}$ path segment are the same as the last three control points of the ith path segment, there are only m possible transitions that must be considered at each path segment node.

The algorithm for finding the optimal control point distribution may be computed with the dynamic programming step defined as:

$$COST (PS_i^j) = J(PS_i^j) + k \overset{MIN}{COST}(PS_{i+1}^k)$$

where $i = 1$ to number of path segments, $k = 1$ to m, and $j = 1$ to m^4, m = number of variations.

As with the Kircanski/Vukobratovic approach, constraint equations, C_i, are evaluated at each node PS_i^j. If a constraint is violated for a particular path option, that branch is simply culled from consideration as the minimum cost path. In this fashion, only the feasible solution regions of the graph are searched for an optimal path.

Note that the weighted performance index J is computed over a spline-interpolated path segment. Therefore, higher order path derivatives, such as joint speed and acceleration, may be derived analytically without the costly growth in states associated with forward difference approximations used in the Kircanksi/Vukobratovic algorithm.

For cases in which the smoothness of the hand or foot is desired (minimization of jerk), the velocity distribution is formed in terms of the cartesian-space path swept out by the end of the limb. However, since joint-space functions and constraints must also be considered, inverse kinematics are employed in the optimization process. Aside from kinematic constraints on joint ranges and speeds, optimizations that involve dynamics, such as the minimization of energy expenditure, are computed in joint-space. The recursive Newton-Euler inverse dynamics procedure receives the joint-space position, velocity, and acceleration from the inverse kinematics computation at every frame during the evaluation of $J(PS_i^j)$. The flow of control between the various computational modules in the calculation of $J(PS_i^j)$ is shown in Figure 10.11.

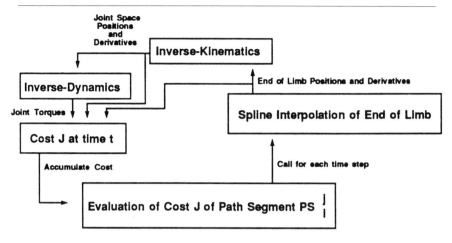

Figure 10.11 Flow Chart of Path Segment Performance Computation

The space/time complexity of the dynamic programming approach outlined aboved is $O(m^5 nkd)$, where m is the number of variations, k is the number of joints, n is the number of frames, and d is the number of constraints. Although the exponent on the variational term m is quite high—with m^4 path segments having m possible transitions—the solution is linear in the number of frames, number of variables and the number of constraints. Due to the range and resolution achieved by interpolating increments in velocity, $m = 5$ is typically sufficient.

A means of increasing the efficiency and the precision of the algorithm is to apply what I shall call *gradual refinement*. This procedure iterates the dynamic programming over increasingly smaller ranges in variation Δu, each time starting with an initial distribution equal to the optimal distribution of the previous iteration. With gradual refinement, we may use small values for m and still achieve a fine resolution.

Even without the use of gradual refinement, the computational complexity of dynamic programming in velocity distribution problems compares very favorably with other nonlinear numerical optimization techniques, such as gradient-based mathematical programming strategies (Gill, Murray and Wright, 1981) called "spacetime constraints" by Witkin and Kass (1987) in the animation literature. These methods, which attempt to descend the slope of a single multivariant function of J in order to find local minima, must compute and solve equations involving jacobian matrices with knd elements and Hessian matrices with $(kn)^2$ elements, resulting in a computational complexity of $O((kn)^2 + knd)$ at every iteration. Furthermore, gradient-based techniques may become hopelessly bogged down or permanently trapped in local minima (Ghosh, 1976; Bryson, 1975; Kirk, 1970).

10.5 *Modeling Coordinated Body Motion*

As we move from the problems of modeling and designing movement of limbs toward the broader issue of animating the entire body of an articulated animal, the complexity of the task is increased by several orders of magnitude. There are several reasons why this is so. The first, and perhaps most obvious, source of complexity is that the whole of body motion is much more than the sum of the parts. The limbs, hands, feet, head, and spine of an articulated animal all work in concert to achieve a dynamically balanced coordinated motion in the presence of gravity and external reaction forces acting on the feet. In reality, the animal is solving the mechanics of an extremely large-scale nonlinear system.

10.5.1 *Newtonian Mechanics and Sensory-Motor Coordination*

In the past decade, significant research in robotics has been directed toward studying and building multilegged walking and running machines. Due to the difficulty of maintaining balance on two legs, most research has concentrated on the problems of walking with four or six legs. (Mcghee and Iswandhi, 1979; Orin, 1982; Waldron, 1981; Pearson and Franklin, 1984; Lee, 1984). To date, walking machines with two legs must move haltingly slow in order avoid falling over (Muira and Shimoyama, 1984). Raibert's running machines, although much simpler in form than any real animal, cannot easily turn corners or change gaits (Raibert, Brown, and Chepponis, 1984; Murphy and Raibert, 1984). It is safe to say that the control problems associated with tasks as seemingly elementary as locomotion are not well understood.

The problem of animating articulated animals is further complicated by the fact that we are interested in simulating the movement of real animals, not just articulated systems of our own design. Aside from the substantial increase in complexity found in real biological systems, the problem is shifted from the already difficult task of understanding the mechanics of movement to the more empirical question of understanding how a particular animal solves the mechanics of movement. Hence, the simulation of articulated animal motion must encompass both Newtonian mechanical laws and the articulated animal's sensory-motor coordination that operates within these laws.

10.5.2 *Limb and Body Trajectories*

In order to define free-form body movement, the author's animation system, PODA, supports the composition of *body trajectories*. A body trajectory, in effect, is nothing more than a sequence of body postures—it is the union of the spine, head, and various limb trajectories. The pelvis is also given a trajectory. When the feet are planted on the ground, the pelvis may be envisioned as an end-effector moving from its legs. Expressive movement may frequently involve both pelvic translations and rotations. The specification of movement by a

sequence of body postures provides the animator with an intuitive, visually oriented method for designing body movement.

From the animator's standpoint, body trajectories are composed, remembered, and recalled in the same fashion as limb trajectories. Menu-driven interaction is provided for inserting, replacing, deleting, storing, and retrieving postures and posture sequences.

10.5.3 *Translational Dynamics of Body Movement*

In the PODA animation system, each posture includes a specification of which legs are supporting the animal from the ground. As the animator "flips through" each posture in a sequence, the number of the posture and the support/nonsupport state of each leg are displayed in the viewing window. Unsupported postures (those having no supporting legs) are performed as if the animal is in the air.

In most movements, for example, the height and overall form of the body at the instant of becoming airborne and at the instant of becoming earthbound are not fixed; e.g., one might hop from a crouched position with the knees bent or hop with the legs nearly fully extended. Therefore, the vertical heights of the supporting postures that immediately precede and follow the unsupported postures are used by PODA as a guide for simulating the vertical motion of the pelvis. A *support profile* is constructed by recording the nonsupport durations that occur between these transition body postures.

The height of the body at liftoff and touchdown must match the heights at the transition postures that have been specified by the animator. The calculation of the upward velocity at liftoff (and subsequent downward velocity as the body lands) may be easily calculated in terms of the animator's choice of gravitational acceleration and the differences in body height.

As in the treatment of vertical dynamics, the horizontal motion of the body must take into account whether the animal is in the air or on the ground. Accordingly, the support profile becomes an input parameter to the horizontal dynamics model.

While the articulated animal is on the ground, PODA computes the animal's center of mass and measures its velocity as the backward difference between positions at successive frames: $Vcom_t = Pcom_t - Pcom_{t-1}$. Newton's laws of motion tell us that, when the animal is in the air, because there can be no horizontal forces brought to bear on the body (assuming the absence of wind resistance), the center of mass of the animal should move at a constant velocity, $Vcom$ projected on the horizontal ground plane. The magnitude and direction of $Vcom$ will therefore be determined at the initial point of liftoff as the articulated animal makes a transition from being on the ground toward being in the air. At each frame t in the air, the animal is translated so that:

$$Pcom_t = Pcom_{liftoff} + (t - liftoff)\, Vcom_{liftoff}$$

The laws that govern an animal's translational motion when its feet are on the ground may not be so easily characterized. For example, given that the projection of an animal's center of mass remains within the region bounded by its points of contact with the ground, the animal's center of mass may move in practically arbitrary free-form patterns, restricted only by its muscular capabilities.

The physical feasibility of movements when the projection of the center of mass moves outside the support region is also hard to ascertain, especially if we allow for frictionally induced foot forces that may pull or push the animal in any direction. If we assume that pulling forces are negligible, then leg forces may only accelerate the body's center of mass along a vector directed from the point of support to the center of mass: $Acom = Pcom - Psupport$. In cases where the center of mass is outside the support region, the animal should be really be falling in directions in which the velocity has no components directed in opposition to $Acom$. Future research needs to be directed toward developing models for coordinated falling motion that may occur when weight is shifted from one foot to another.

10.5.4 *Angular Dynamics: Movement Design and Dynamic Stability Constraints*

Ideally, computer animation systems should help us to easily design ballistic motions, wherein the articulated animal performs a set of specified movements in the air and then lands in a dynamically stable posture that anticipates the next movement. During the flight phase, the movement of limbs may induce angular accelerations about all three axes (Kane and Smith, 1968; Ghosh 1976). Simulating the angular dynamics from a given set of limb motions is easily computed: The angular motion of a limbed body follows from the application of the conservation of angular momentum about the principal axes of rotation (Kane, 1970; Wilhelms, 1985; Armstrong and Green, 1985; Raibert, forthcoming). However, in the interest of insuring dynamically stable landing positions, we must solve the inverse problem—what body motions will produce some desired body orientations?

For example, consider the problem of finding the limb movements a diver performs in order to achieve some desired posture and orientation at the time of contact with the water. The problem is that the dynamics of body movement in free fall is a direct consequence of the precise *kinematic* actions of the body's limbs, head, and torso.

Formally, the problem could be stated as follows: Given some initial body angular liftoff position and velocity, S_0 at time t_0, solve for the set $M(S_0, S_n, T)$ of feasible body movements during time T so that the body is in state S_n at touchdown time $t_n = t_0 + T$.

If we restrict ourselves to an analysis of specialized movements that are symmetric about all but a single rotation axis, such as Kane's analysis of scissor

leg movements to achieve rotations in zero-gravity (Kane, 1970), Spaepen's study of a backward flip (Spaepen and Stijnen, 1984), or Ghosh's investigation of a kip-up maneuver on the horizontal bar (Ghosh, 1976), it is often possible to solve for how specialized movements should be varied in order to achieve desired postural goals.

Hodgkins and Raibert, in their paper on biped gymnastics (Raibert, 1988), cite Richard Fosbury's introduction of a previously unknown method for executing a high jump (with one's back facing down) as an illustration of the difficulty in modeling complex dynamic skills. The motion problem of finding strategies to maximize a human's jumping height is an isolated case of a more generally constrained optimization problem. Given a limbed robot's initial position A and goal position B, solve for the set of movements that optimize function D under constraints C. Here A is the liftoff position, B is a landing position, C is the maximum achievable forces generatable by a human's musculature, and D is the jumping height.

One may easily imagine other dynamic coordination problems of this type (aside from the obvious gymnastic and athletic ones). For example, consider an astronaut moving in a zero-gravity environment. In this case, we might wish to solve for the limb movements that turn the body, in minimum time, between two orientations (Kane and Smith, 1968). Dancers provide another example of intelligent motion as they are able to satisfy the formation of several postures in the air within the constraints of the timing and required angular body dynamics dictated by the choreography.

Very little work has been done to address motion tasks with this degree of dynamic complexity. Marc Raibert and his coworkers at MIT's AI lab recently programmed a running biped robot to execute a forward flip. The strategy employed was to maximize flight duration and adjust the pitch rate by inducing a high angular velocity at liftoff. The flip was achieved by applying a sequence of known movements and adjusting their parameters until success ensued.

Hodgkins and Raibert point out that the sequence, or task-level strategy for performing the flip, was formulated by the human researchers rather than being derived computationally. Understanding the reasoning process that guided the human decisions, based on their knowledge of the mechanics of the problem, is an area that needs more attention.

In any case, it seems likely that specialized parametric movements performed by the dancer, diver, high jumper, and gymnast may not be derived by constrained optimization algorithms because the dimension of the problem space is both astronomically large and highly nonlinear.

10.6 *Conclusion*

It should be clear to the reader that the simulation and control of natural articulated animal motion is difficult. Constrained optimization algorithms, such as the

one introduced in this chapter, should help animators achieve expressive and natural limb motion. However, control schemes that allow animators to design body movements that are dynamically simulated are yet to be worked out.

To this end, specialized models in the spirit of Kane's scissor kicking in zero-gravity (Kane, 1970) or Raibert's forward flip (Raibert, forthcoming) need to be researched and incorporated into a repertoire of skilled behaviors that may be invoked and controlled by the animator. The question of whether specialized behaviors could be logically inferred or derived from a general purpose knowledge-base or mechanical reasoning system needs to be addressed.

Another broad research domain, not even touched on in this chapter, is to incorporate motion planning skills into articulated animals, so that they may carry out tasks that involve nontrivial geometric relationships with their environment. To do this, the strategies animals use to grasp objects and avoid undesirable collisions with obstacles must be well understood.

References

Alexander, R. 1984. The gaits of bipedal and quadrupedal animals, *The International Journal of Robotics Research* 3(2).

Armstrong, W. and Green, M.W. 1985. The dynamics of articulated rigid bodies for purposes of animation, *The Visual Computer* 1(4).

Armstrong, W.W., Green, M., and Lake, R. 1986. Near-real-time control of human figure models, *Proceedings of Graphics Interface '86*.

Atkeson, C.G. and Hollerbach, J.M. 1984. Kinematic features of unrestrained arm movements, AI Memo 790.

Atkeson, C.G. and Hollerbach, J.M. 1985. Characterization of joint-interpolated arm movements, AI Memo 849.

Bryson, A. and Ho, Y. 1975. *Applied Optimal Control*, John Wiley, New York.

Chang, Pyung H. 1986. A closed form solution for inverse kinematics of robot manipulator with redundancy, AI Memo 854.

Denavit, J. and Hartenberg, R. 1955. A kinematic notation for lower-pair mechanisms based on matrices, *J. App. Mech.* 77:215–221.

Featherstone, R. 1988. *Robot Dynamics Algorithms*, Kluwer Academic Publishers, Norwell, MA.

Flash, T. and Hollerbach, J.M. 1984. The coordination of arm movements: An experimentally confirmed mathematical model, MIT AI Memo 786, MIT Artificial Intelligence Laboratory.

Ghosh, T. 1976. Analytic determination of an optimal human motion, *Journal of Optimization Theory and Application* 19(2).

Gill, P., Murray, W., and Wright, M. 1981. *Practical Optimization*, Academic Press, San Francisco, CA.

Girard, M. and Maciejewski, A. 1985. Computational modeling for the computer animation of legged figures, *Computer Graphics, ACM SIGGRAPH Proceedings.*

Girard, M. 1987. Interactive design of 3D computer-animated legged animal motion, *IEEE Computer Graphics and Applications*J.

Hogan N. 1986. Coordinating multijoint motor behavior, *Journal of Neuroscience* 4(11).

Hollerbach, J.M. 1982. Dynamics, in: Brady, J.M., Johnson, T.L., Lozano-Perez, T., Hollerbach J., and Mason, M.T. (eds), *Robot Motion: Planning and Control*, MIT Press, Cambridge, MA.

Isaacs, P. and Cohen, R. 1987. Controlling dynamic simulation with kinematic constraints, behavior functions and inverse dynamics, *Computer Graphics, ACM SIGGRAPH Proceedings.*

Ivaldi, F., Morasso, P., and Mussa, A. 1982. Trajectory formation and handwriting: A computational model, *Biological Cybernetics* 45(2).

Kane, T. and Smith, P. 1970. Human self-rotation by means of limb movements in zero gravity, *J. Biomechanics* 3:167.

Kircanski, M. and Vukobratovic, M. 1982. A method for optimal synthesis of manipulation robot trajectories, *Trans. ASME, J. Dynamic Systems, Measurements and Control* 104.

Kirk, D. 1970. *Optimal Control Theory, An Introduction*, Prentice Hall, Englewood Cliffs, NJ.

Klein, C.A. and Huang, C.H. 1983. Review of pseudoinverse control for use with kinematically redundant manipulators, *IEEE Transactions on Systems, Man, and Cybernetics* SMC-13(2):245–250.

Kochanek D. and Bartels, R. 1984. Interpolating splines with local tension, continuity, and bias control, *Computer Graphics, ACM SIGGRAPH Proceedings.*

Korein, J.U. and Badler, N.I. 1982. Techniques for generating the goal-directed motion of articulated structures, *IEEE Computer Graphics and Applications*, pp. 71–81.

Kyriakopoulos, K. and Saradis, G. 1988. Minimum jerk path generation, *IEEE Conf. on Robotics and Automation.*

Lee, Wha-Joon. 1984. *A Computer Simulation Study of Omnidirectional Supervisory Control for Rough-terrain Locomotion by a Multilegged Robot Vehicle*, PhD Dissertation, Ohio State University, Columbus, OH.

Liegeois, A. 1977. Automatic supervisory control of the configuration and behavior of multibody mechanisms, *IEEE Transactions on Systems, Man and Cybernetics* SMC-7(12).

Lin, C., Chang, P., and Luh, J. 1983. Formulation and optimization cubic polynomial joint trajectories for industrial robots, *IEEE Trans. Automatic Control* AC-28(12).

Luh, J., Walker, M., and Paul, R. 1980. On-line computational scheme for mechanical manipulators, *Trans. ASME, J. Dynamic Systems, Measurements and Control* 120.

Lundin, R.V. 1984. Motion simulation, *Nicograph Proceedings*, pp. 2–10.

Maciejewski, A.A. and Klein, C.A. 1985. Obstacle avoidance for kinematically redundant manipulators in dynamically-varying environments, *The International Journal of Robotics Research* 4(3).

McGhee, R.B. and Iswandhi, G.I. 1979. Adaptive locomotion of a multilegged robot over rough terrain, *IEEE Transactions on Systems, Man, and Cybernetics* SMC-9(4):176–182.

Millman R. and Parker G. 1977. *Elements of Differential Geometry*, Prentice Hall, Englewood Cliffs, NJ.

Morasso, P. 1983. Three dimensional arm trajectories, *Biological Cybernetics* 48(3).

Mortenson, M.E. 1985. *Geometric Modeling*, John Wiley & Sons, New York.

Miura, H. and Shimoyama, I. 1984. Dynamic walk of a biped, *The International Journal of Robotics Research* 3(2):60–74.

Murphy, K.N. and Raibert, M.H. 1984. Trotting and bounding in a planar two-legged model, *Fifth CISM-IFTOMM Symposium on Theory and Practice of Robots and Manipulators*, Udine, Italy.

Nagurka, M. 1971. Predicting segment trajectories of a locomotion model by a suboptimal control algorithm *Mathematical Biosciences*, 10.

Nelson, W.L. 1983. Physical principles for economies of skilled movements, *Biological Cybernetics* 46(2).

Noble, B. 1975. Methods for computing the Moore-Penrose generalized inverses, and related matters, in *Generalized Inverses and Applications*, ed. by M.A. Nashed, Academic Press, New York, pp. 245–301.

Orin, D.E. 1982. Supervisory control of a multilegged robot, *International Journal of Robotics Research* 1(1):79–91.

Orin, D.E. and Schrader, W.W. 1983. Efficient jacobian determination for robot manipulators, *Sixth IFToMM Congress*, New Dehli, India, December 15–20.

Paul, R. 1981. *Robot Manipulators*, MIT Press, Cambridge, MA.

Pearson, K.G. and Franklin, R. 1984. Characteristics of leg movements and patterns of coordination in locusts walking on rough terrain, *The International Journal of Robotics Research* 3(2):101–107.

Pfeiffer, F. and Johanni, R. 1987. A concept for manipulator planning, *IEEE Journal of Robotics and Automation* RA-3 2.

Raibert, M.H., Brown, H.B., Jr., and Chepponis, M. 1984. Experiments in balance with a 3D one-legged hopping machine, *The International Journal of Robotics Research* 3(2):75–82.

Raibert, M.H. Biped gymnastics, submitted for publication.

Ribble, E.A. 1982. *Synthesis of Human Skeletal Motion and the Design of a Special-Purpose Processor for Real-Time Animation of Human and Animal Figure Motion*, Master's Thesis, The Ohio State University.

Sahar, G. and Hollerbach, J. 1985. Planning of minimum time trajectories for robot arms, *IEEE Intern. Conf. on Robotics and Automation*.

Shin, K. and Mckay, N. 1986. A dynamic programming approach to trajectory planning of robotic manipulators, *IEEE Trans. Automat. Control* ACV-31(6).

Singh, S. and Leu, M. 1987. Optimal trajectory generation for robot manipulators using dynamic programming, *Trans. ASME, J. Dynamic Systems, Measurements and Control* 109.

Smith, P. and Kane, T. 1968. On the dynamics of the human body in a free fall, *Journal of Applied Mechanics*, p. 167.

Spaepen, A. and Stijnen, V. 1984. Two-dimensional simulation of human movements during take-off and flight phases, *Biomechanics VII*, University Park Press, Baltimore, MD.

Steketee, S. and Badler, N. 1985. Parametric keyframe interpolation incorporating kinetic adjustment and phrasing control, *Computer Graphics, ACM SIGGRAPH Proceedings*.

Tan, H. and Potts, R. 1988. Minimum time trajectory planner for discrete dynamic robot model with dynamic constraints, *IEEE J. of Robotics and Automation* 4(2).

Vukobratovic, M. and Stokie, D. 1983. Is dynamic control needed in robotic systems, and, if so, to what extent? *The International Journal of Robotics Research* 2.

Waldron, K.J. 1973. The use of motors in spatial kinematics, *Proceeding of the IFToMM Conference on Linkages and Computer Design Methods*, Bucharest, June, Vol. B., pp. 535–545.

Waldron, K.J. 1981. Geometrically based manipulator rate control algorithms, *Seventh Applied Mechanics Conference*, Kansas City.

Walker, M. and Orin, D. 1982. Efficient dynamic simulation of robot mechanisms, *Trans. ASME, J. Dynamic Systems, Measurements and Control* 104.

Whitney, D.E. 1969. Resolved motion rate control of manipulators and human prostheses, *IEEE Transactions on Man-Machine Systems* MMS-10(2):47–53.

Wilhelms, J. 1985. *Graphical Simulation of the Motion of Articulated Bodies Such as Humans and Robots, with Particular Emphasis on the Use of Dynamic Analysis*, PhD Dissertation, University of California, Berkeley, CA.

Witkin, A. and Kass, M. 1987. Spacetime constraints, *Computer Graphics, ACM Computer Graphics, SIGGRAPH Proceedings*.

Yeh, S. 1984. *Locomotion of a Three-Legged Robot Over Structural Beams,* Masters Thesis, Ohio State University, Columbus, OH.

Zeltzer, D.L. 1984. *Representation and Control of Three Dimensional Computer Animated Figures,* PhD Dissertation, Ohio State University, Columbus, OH.

11

Goal-directed Animation of Tubular Articulated Figures or How Snakes Play Golf

Gavin Miller

Media Technologies Group
Apple Computer, Inc.
Cupertino, California

ABSTRACT

This chapter describes the simulation of snake locomotion using a mass-spring system. The locomotion is controlled by a behavior function which allows the snake to be steered toward a target.

11.1 *Introduction*

The animation of articulated figures may be thought of as applying to two different types of structures. The first type are those animals and mechanisms that have rigid skeletons connected together with joints. The skeletons may have complex topologies, such as arms and legs, and require consideration of the dynamics of hierarchical rigid structures (Isaacs and Cohen, 1987). The second type of structure is topologically simple, consisting of a tube that can bend and stretch and may be modeled using simple formulations of elastically deformable materials. Worms have no skeleton and so naturally lend themselves to this description. Snakes do have skeletons, with many links, but may be approximated using a continuum model.

This chapter concentrates on snakes and worms and describes mechanisms of locomotion for such creatures. Special emphasis is given to steering and

control for snake locomotion. In particular, the problem of bringing a snake head within close proximity to a target is addressed. This activity is important in hunting and such whimsical activities as playing golf.

11.2 *Mass-Spring Systems*

A straightforward model of elastic materials is to consider a number of mass points connected with springs. The simplest extended structure consists of a linear array of point masses with springs between the nearest neighbors. This will define a chain without any restriction on bending at each mass point. If restoring torques are included at each mass point, the system will more closely resemble the properties of rope. Unfortunately, such a simple formulation is inadequate to describe snakes and worms. The linear elements may be twisted without putting up any resistance. For a straight line element, this does not matter, but, if the torques had a constant offset value to make a circular arc, the masses could be deformed into a helix without changing the energy of the system. Also, the mass points eventually have to be clothed in a surface, which requires an unambiguous coordinate frame at every mass point.

If motion is restricted to lie in a plane, these objections no longer apply. This may be very useful for making real-time implementations of snakes and worms on low-end graphics workstations However, since real three-dimensional tubes both deform and twist, a more general solid representation is needed. A simple tubular structure without these problems may be implemented using a triangular cross-section mesh. This is more efficient than the square cross-section system described in Miller (1988).

Figure 11.1 shows such a tubular structure. The variable i is the index around the circumference of the tube, and the variable j is the index along the length of the tube.

The tubular structure may be animated as follows.

1. The forces on the mass points are computed using the tension equation for the springs and the effects of external objects, wind, and gravity.

2. The forces are converted to accelerations by dividing by the mass of each particle, and then the accelerations are integrated twice to find the new positions.

These two steps are repeated once every time step, which may be less than a frame time.

Such a system will behave as an elastic bar flexing and twisting passively in response to external stimulus. Active, animate creatures, however, create motion by muscle contractions. This may be simulated by changing the spring rest lengths as a function of time.

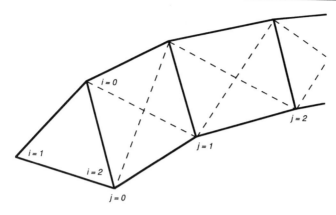

Figure 11.1 Triangular Cross-Section Tube

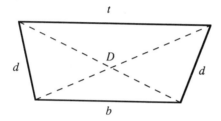

Figure 11.2 Diagonal of a Quadrilateral

For instance, to make the tube flex horizontally to the left, axial springs for which $i = 1$ would be expanded, and those for which $i = 2$ would be contracted. If the diagonal spring rest lengths were left unchanged, the tube would buckle out of the horizontal plane, which is undesirable.

Given that the side springs of a quadrilateral are the lengths shown in Figure 11.2,

$$D = \sqrt{d^2 + tb}$$

where D is the length of the diagonals of the quadrilateral, d is the length of the two equal sides, t is the length of the top edge, and b is the length of the bottom edge.

If these consistent spring lengths are applied to the tubular model, the tube will deform horizontally. Vertical deformations may be achieved by expanding or contracting axial springs for which $i = 1$ and $i = 2$ in phase with each other and out of phase with those for which $i = 0$. Axial compression or expansion of the segment may be achieved by varying all three axial spring lengths in phase with each other.

11.3 *Friction and Locomotion*

Being able to bend a tubular structure may not be sufficient to achieve locomotion. Any forces generated between internal elements of the structure will leave the center of mass unchanged. To achieve locomotion it is necessary for the system to exert forces on its environment opposite to the direction of motion. Any system on a perfectly smooth horizontal plane will be unable to propel itself horizontally by exerting a force on the surface. However, with the introduction of friction, the situation is changed.

Walking systems make use of isotropic friction to propel themselves forward by changing pressure from one foot to another. The lateral frictional force that may be sustained increases with the normal pressure. Snakes and worms, however, are almost always in contact with the ground and have to use different mechanisms for exerting horizontal forces. The interaction forces split into two categories, macroscopic friction and microscopic friction.

Macroscopic friction occurs when an object, such as a snake, interacts with large-scale objects by pushing against them by reconfiguring its body shape. A number of experiments have been done with snakes traversing smooth horizontal planes sparsely populated with vertical pegs. The snakes rub themselves against the pegs and propel themselves along, forming an s-curve from head to tail. This form of flexing leaves the center of mass of the snake unchanged if the pegs are removed. This form of snake locomotion has received considerable attention in the biological literature and is called *horizontal undulatory progression* (Gans, 1962; 1966; 1970; Gray 1946; Gray and Lissmann, 1949). It seems essential for correct animation of tree-climbing snakes and snakes passing by rocks and boulders. However, the reliance on having suitable leverage points for the snake to achieve forward motion makes it difficult to apply to goal-directed animation.

Microscopic friction occurs where a surface microstructure interacts with the small-scale features of a surface. A good example is the functioning of a wheel, which may be considered to be a tubular structure. The normal force on the surface due to gravity allows a lateral frictional force to be exerted parallel to the surface. If the tubular system were to form itself into a ring, and assuming it could balance itself, the ring would stay still on horizontal terrain or roll down a hill. For the system to propel itself forward, it has to apply a torque to the area of the ring in contact with the surface.

This may be achieved in two ways. One is to have a separate system attached to the "wheel" that moves the center of mass of the total system away from the center of the wheel. Alternatively, the wheel may become oblate (see Figure 11.3). This is achieved by adding a sinusoidal term to the constant flexing required to form a ring. By changing the phase of the sinusoidal term, the oblate ring may propel itself forward. This technique is used in modified form by sidewinder snakes. The snake flexes itself into an oblate helix, which travels from the head to the foot of the snake. It leaves approximately linear diagonal tracks in sand. This form of motion minimizes contact with hot sand and works

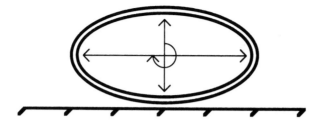

Figure 11.3 Oblate Wheel Locomotion

well on crumbly surfaces, where the whole body weight can be concentrated in a small surface area.

A form of microscopic friction that is directional can by achieved by a creature covered with scales or hairs aligned along the tubular axis. Figure 11. 4 illustrates a two-mass, one spring worm. The scales will interact with the small protuberances on a surface in such a way that they slide one way and grip the other. If the spring L is expanded, scale A will grip and scale B will slide. If the spring is contracted, scale B will grip and scale A will slide. Both processes propel the worm in the same direction.

Snakes have scutes on their undersides that also provide this sort of directional friction on some surfaces. Experiments show that on rough sandpaper, snakes have between three and five times more friction being dragged backward than forward (Gray and Lissmann, 1949). This directional friction allows other methods of locomotion over surfaces that lack macroscopic features to push against. Some snakes are able to slide their scutes forward and backward over their ribs. The snake then moves forward along a smooth path and is able to pass through narrow openings and climb along the boughs of trees. This is called rectilinear progression (Lissmann, 1949).

A second form of locomotion that uses directional friction is concertina progression. The snake forms an s-curve in the middle of the body with the neck and tail being kept straight. Unlike horizontal undulatory progression, the phase of the flexing is fixed. The snake progresses forward by expanding and contracting the amplitude of the coils. As the coil expands, the rear of the snake grips the ground and the head is thrust forward. As the coil contracts, the tail is pulled toward the head.

This pattern of movement may still be used if the snake is in a smooth channel with rough walls. The snake coils up at the front and pushes against the walls to achieved a good grip. The tail is then brought up behind and coiled up, and the head is then pushed forward (Gans, 1966; 1970; Gray, 1946).

Concertina progression has several advantages. The first is the lack of reliance on vertical pegs or obstacles for locomotion. The second is that the snake's head remains fixed relative to the body so that the snake can bring its head in

direction of motion

Figure 11.4 A Two-Mass, One-Spring Worm

close proximity to a prey. For this reason concertina progression is used during hunting by some snakes (Klauber, 1982). If one applies the right friction model, the motion of the snake is fairly predictable.

11.4 *A Steering Mechanism for Concertina Progression*

Given the robust and simple nature of concertina progression, it is a natural candidate for giving a synthetic snake goal-directed behavior. Two important components of this behavior are the ability to steer the snake and the ability to control its speed. These can be controlled by the equations

$$a_t = a((1 - v) - v \cos(\phi(t)))$$
$$b_t = \frac{b(1 + \cos(\varphi(t)))}{2}$$
$$L_{1,j} = 1$$
$$L_{2,j} = 1 + b_t + a_t \sin(\omega_{long} j)$$
$$L_{3,j} = 1 - b_t + a_t \sin(\omega_{long} j)$$

where

 a is the maximum amplitude of the curvature of the coils,
 b is the amount of turning to the left or right for the snake,
 v is the amplitude of the time-dependent flexing of the snake,
 $\phi(t)$ is the phase angle which varies linearly with time,
 ω_{long} the wave number for the coils along the snake, and
 $L_{i,j}$ is a factor applied to the rest length of the axial springs at cross-section j.

It is important to note that b_t is varied in such a way that it is small when the amplitude a is greatest. If the snake tries to turn too sharply when the coils are

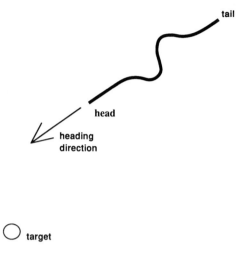

Figure 11.5 Snake with Target Geometry

compressed, it will collide with itself. To avoid this, the snake curves its body only when it is extended. For a 36-segment snake with a $\omega_{long} = 0.62$ and $a = 1.0$, adequate turning performance may be achieved with $b = 0.01$. Any larger bias values lead to the snake tying itself in knots.

11.5 *Homing System for Concertina Progression*

The actual speed of progression of such a snake will be proportional to the value of v and will also be proportional to the rate at which the phase increases with time. For the simulations attempted by the author, only the speed variable v was used for control. Given the ability to control the speed and turning of the snake model, the next stage was to implement a control loop to make it home in on a target. Special consideration has to be given to the limitations of this form of snake locomotion. First, the snake may turn sharply for some fraction of its motion cycle and only weakly during other parts. The precision of steering control also decreases with the speed of the snake. To overcome these problems, it is necessary to make the snake slow down as it approaches its target.

The snake turning rate is controlled by the equation

$$b = k_1 \sin(\theta)$$

where θ is the angle between the heading direction and the direction from the head of the snake to the target. The snake is slowed when it approaches the target by the equation

$$v = v_{far} - (v_{far} - v_{near})e^{-g/k_2}$$

Figure 11.6

where v_{near} is the speed of the snake when it is near to the target, v_{far} is the speed of the snake when it is far away from the target, g is the distance from the head to the target, and k_2 is the exponential decay constant from v_{near} to v_{far}.

The direction of the snake is taken to be the head position minus the tail position. This works well for concertina progression but may be problematic for horizontal undulatory progression The snake homes successfully only if the target is stationary as it gets close to it. Given this limitation, the snake brings its head to within a fine tolerance of the target position. The target can then be grabbed by the snake or pushed away. For the golf animation, the snake sucks the ball into its mouth and then throws it away with an impulse to the ball. As the target leaves the snake, the snake begins to move off toward the ball, catching up with it after the ball has come to rest. In the grabbing animation, the snake grabs the ball and then has a new target behind it off screen. If the target position changes too suddenly, the snake thrashes about wildly and ties itself in knots. To avoid this the new target position was blended with the old target position over a number of frames. Subsequent to the workshop, these techniques were used successfully in the production of an animated film (Miller and Kass, 1989) in which the ball was replaced by a film canister. Figure 11.6 shows the snake biting the target after approaching it using concertina progression.

11.6 Conclusions

The animation of snakes and worms draws on the physics of elastically deformable materials. It also introduces a number of ideas from biology, such as directional friction models for snake skin and the different modes of snake locomo-

tion. For concertina progression, it is possible to make the snake pursue a target successfully. This leads to the possibility of completely automatic animations based on a few simple rules specified by an animator.

Acknowledgments

This work was carried out at Apple Computer, Inc. as part of Media Technologies in the Advanced Technology Group. Michael Kass was very helpful in obtaining information about the locomotion of snakes as well as with the production of Figure 11.6 and the associated animation.

References

Gans, C. 1962. Terrestrial locomotion without limbs, *American Zoologist* 2:167–182.

Gans, C. 1966. Locomotion without limbs, *Natural History* LXXV(2):10–17.

Gans, C. 1970. How snakes move, *Scientific American* 222(6):82–96.

Gray, J. 1946. The mechanism of locomotion of snakes, *Journal of Experimental Biology*, p. 101.

Gray, J. and H.W. Lissmann. 1949–50. The kinetics of locomotion of the grass-snake, *Journal of Experimental Biology* 26:354–367.

Isaacs, P.M. and M.F. Cohen. 1987. Controlling dynamic simulation with kinematic constraints, behavior functions and inverse dynamics, *Computer Graphics* 21(4):215–224.

Kaluber, L.M. 1982. *Rattlesnakes, Their Habits, Life Histories and Influence on Mankind*, Berkeley, CA: University of California Press.

Lissmann, H.W. 1949–50. Rectilinear locomotion in a snake (*boa occidentalis*), *Journal of Experimental Biology* 26:368–379.

Miller, G.S.P. 1988. The motion dynamics of snakes and worms, *Computer Graphics* 22(4):169–178.

Miller, G.S.P. and M.Kass. 1989. *Her Majesty's Secret Serpent*, Apple Computer Inc. Submission to SIGGRAPH 1989 Film and Video Show.

12

Human Body Deformations Using Joint-dependent Local Operators and Finite-Element Theory

Nadia Magnenat-Thalmann
University of Geneva
Geneva, Switzerland

Daniel Thalmann
Swiss Federal Institute of Technology
Lausanne, Switzerland

ABSTRACT

This chapter discusses the problem of improving the realism of motion not from the joint point-of-view as for robots, but in relation to the deformations of human bodies during animation. Two methods for improving these deformations are described. The *joint-dependent local deformation* (JLD) approach is convenient when there is no contact between the human being and the environment. A finite element method is used to model the deformations of human flesh due to flexion of members and/or contact with objects.

12.1 *Introduction*

One of the main challenges for the next few years is the creation and realistic animation of three-dimensional scenes involving human beings conscious of their environment. This problem should be solved using an interdisciplinary

approach and an integration of methods from animation, mechanics, robotics, physiology, psychology, and artificial intelligence. The following objectives should be achieved:

- Automatic production of computer-generated human beings with natural behavior

- Reduction of the complexity of motion description

- Improvement of the complexity and the realism of motion; realism of motion needs to be improved not only from the joint point of view as for robots, but also in relation to the deformations of bodies during animation.

In this chapter, we emphasize the third objective and propose two types of solutions to this problem:

1. *A geometric approach*: The mapping of surfaces using *joint-dependent local deformation* (JLD) operators. This approach is convenient when there is no contact between the human being and the environment.

2. *A physics-based approach* using a finite element method to model the deformations of human flesh due to flexion of members and/or contact with objects.

Modeling for synthetic actors frequently uses skeletons made up of segments linked at joints. This is suitable for parametric key-frame animation, kinematic algorithmic animation, or dynamics-based techniques (Magnenat-Thalmann and Thalmann, 1988). The skeleton is generally surrounded by surfaces or elementary volumes (Badler and Smoliar, 1979; Magnenat-Thalmann and Thalmann, 1990) whose sole purpose is to give a realistic appearance to body. The model developed by Komatsu (1988) uses biquartic Bezier surfaces, and control points are assigned to the links. Catmull (1972) used polygons, and Badler and Morris (1982) used a combination of elementary spheres and B-splines to model the human fingers.

Chadwick et al. (1988; 1989) propose an approach that combines recent research advances in robotics, physically based modeling and geometric modeling. The control points of geometric modeling deformations are constrained by an underlying articulated robotics skeleton. These deformations are tailored by the animator and act as a muscle layer to provide automatic squash and stretch behavior of the surface geometry.

12.2 *Environment-independent Deformations and JLD Operators*

12.2.1 *The Concept of JLD Operator*

For the deformation of the bodies, the mapping of surfaces onto the skeleton may be based on the concept of JLD operators (Magnenat-Thalmann and Thalmann,

Figure 12.1 The Effect of JLD Operators

1987), which are specific local deformation operators depending on the nature of the joints. These JLD operators control the evolution of surfaces and may be considered as operators on these surfaces. Each JLD operator will be applicable to some uniquely defined part of the surface, which may be called the *domain of the operator*. The value of the operator itself will be determined as a function of the angular values of the specific set of joints defining the operator. Figure 12.1 shows deformations using JLD operators.

When the animator specifies the animation sequence, he defines the motion using a skeleton, which is a wire-frame character only composed of articulated line segments. In order to animate full 3-D characters, the animator has also to position a skeleton according to the body of the synthetic actor to be animated. This operation must be very accurate, and it takes time. However, it is a useful process, because animation is completely computed from the skeleton.

When the skeleton has been correctly positioned, the software will transform the character according to the angles required by the animation without any animator intervention.

Unfortunately, the procedure of positioning the skeleton is probably the longest stage apart from digitizing the shapes. This procedure is very important, because all the mapping of the surface shapes are based on the skeleton position relatively to the surface shapes. If a skeleton point is badly positioned, the joint will probably cause abnormal surface deformations in the animation.

For illustrating this procedure, we shall use an actor skeleton of 87 points. Each of these points belonging to the skeleton should be positioned relative to the flesh (considered as the *actor* surface) by the animator. But the problem arises: where to position the points?

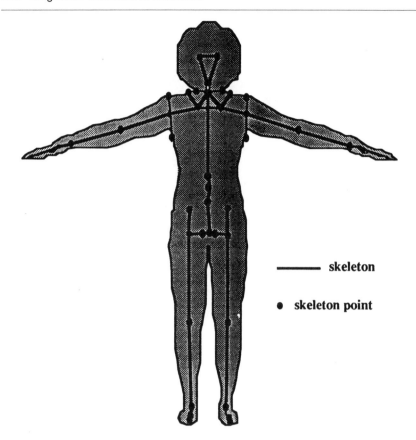

Figure 12.2 Points for Body Positioning

The answer to this question is rather simple for points used as joints: Points should be positioned at the center of the joint. For all points representing the extremity of a limb, points should be at the center of the extremity of the limb. Unfortunately, these two rules are insufficient to position all skeleton points. There are extra rules to follow. Figure 12.2 shows where to position these points.

12.2.2 *JLD Operators for Hand Covering*

The case of the hand is especially complex (Magnenat-Thalmann et al., 1988), as deformations are very important when the fingers are bent, and the shape of the palm is very flexible. Links of fingers are independent, and the JLD operators are calculated using a unique link-dependent reference system. For the palm, JLD operators use reference systems of several links to calculate surface mapping. In order to make the fingers realistic, two effects are simulated: joint roundings and muscle inflation. The hand mapping calculations are based on normals to each

proximal joint. Several parameters are used in these mapping calculations and may be modified by the animator in order to improve the realism of muscles and joints. These parameters include:

- the flexion axis at each joint;

- a parameter to control the inflation amplitude of a joint during the flexion;

- a parameter to define the portion of link to round during a joint flexion;

- a parameter to control the inflation amplitude of muscles inside the hand during a flexion;

- a parameter to define the location of the point where the inflation of the internal muscles is maximum during a flexion.

12.2.2.1 *Mapping Algorithm* The initial and final normals are first determined for both joints of the link. Then, a modified normal is calculated as the average of the initial and final joint normal. This modified normal is then used as *y*-axis of the coordinate basis, and it will allow the simulation of the external rounding of a joint during a flexion. For palm links, normal and modified normal calculations are also required for the neighbor links. Then, a loop is performed on all vertices associated with the link to be covered, and for each vertex, the process is:

> Look for the 3-D coordinates of the vertex in the digitized character.
> Calculate the following information to localize the vertex relative to the link:
>> Determine a projection of the vertex on the link.
>> Calculate the ratio
>>
>> $$R = \frac{\text{distance between the projection and the proximal joint}}{\text{distance between the projection and the distal joint}}$$
>>
>> where the proximal joint is the nearest joint to the wrist and the distal joint is the other joint.
>> Calculate the "vertex thickness," which is the distance between the vertex and its projection on the link.

A projection is also determined on the link in its final position by calculating $R(PF.D - PF.P) + PF.P$ where R is the above ratio, $PF.P$ is the final position of the proximal joint and $PF.D$ the final position of the distal joint. If the link to be covered is a link of the palm, the same projection calculations are performed, but relative to the neighbor link, in order to obtain an initial projection and a final projection on this link. These projections are used to simulate a virtual link between the vertex projection on the link to be covered and the vertex projection on the neighbor link. The projection of the final position is also used as a reference point or position relative to the link, in order to allow the transformation from the initial position to the final position. This virtual link allows the calculation of a scale factor:

$$F = \frac{\text{length of the virtual link at the initial position}}{\text{length of the virtual link at the final position}}$$

If the neighbor link in the final position is farther from the link to be covered than in the initial position, the scale factor F will be greater than 1, otherwise it is in the range [0,1]. In this latter case, the distance between both links has decreased relative to the initial position, and an inflation should be generated.

12.2.2.2 *Case of Fingers* Links of fingers are independent, and the JLD operators are calculated using a unique link-dependent reference system. In the case of external vertices (upper side of the hand), the link is divided into three areas, using the parameters given by the animator. A different coordinate basis is calculated for each area, because the simulation of joint rounding may be very different for each joint, due to the type of flexion. The normals at each joint are used as y-axes of the coordinate bases (the positive direction is towards the upper part of the hand); the middle area is a buffer and uses an interpolated normal between normals of the other areas. In the case of internal vertices (lower side of the hand), the muscle is inflated along the whole link length.

12.2.2.3 *Case of Palm* For the palm, JLD operators use reference systems of several links to calculate surface mapping. In the case of external vertices, three areas are specified (see Figure 12.3). Areas along each of both links (areas 1, 4, 7 and areas 6, 3, 9) are determined as in the case of single links using animator-defined parameters, and they are processed as above. However, these parameters are also used to determine areas between the links, as shown in Figure 12.3 (areas 2, 5, 8). For these inbetween areas, the calculation of the bases is different, because there are no roundings to be calculated. In the case of internal vertices, we have only three areas: one for the link to be covered, one for the neighbor link and one inbetween area. No internal inflation has to be calculated.

Figure 12.4 shows a sequence of hand animation. Coordinates may be then modified in order to simulate muscle inflations and the roundings of joints for improving the realism, as shown in Figure 12.5.

12.3 *Environment-dependent Deformations and Finite-Element Theory*

12.3.1 *A Same Method for Modeling Both Environment Objects and Human Bodies*

Our purpose was to improve the control of synthetic human behavior in a task-level animation system by providing information about the environment of a synthetic human comparatively to the sense of touch. We also state that the use of the same method for modeling both objects and human bodies improves the

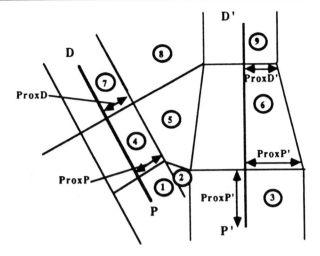

Figure 12.3 Areas for a palm mapping. *P*: proximal joint of the link to cover; *D*: distal joint of the link to cover; *P'*: proximal joint of the neighbor link; *D'*: distal joint of the neighbor link; *ProxP*: proximity parameter of *P*; *ProxD*: proximity parameter of *D*; *ProxP'*: proximity parameter of *P'*; *ProxD'*: proximity parameter of *D'*

Figure 12.4 Object Grasping

modeling of the contacts between them. We developed a finite-element method (Gourret et al., 1989) to model the deformations of human flesh due to flexion of members and/or contact with objects. The method is able to deal with penetrating impacts and true contacts. For this reason, we prefer to consider true contact forces with possibilities of sliding and sticking rather than only repulsive forces.

Figure 12.5 Round Deformations

The environment of characters is made up of rigid objects, key-frame deformable objects, mathematically deformable objects (Barr, 1984), soft objects represented by scalar combinations of fields around key points (Blinn, 1982; Wyvill et al., 1986), or physically deformable objects based on elasticity theory (Terzopoulos et al., 1987). With physical models, the objects act as if they have minds. They react to applied forces such as gravity, pressure and contact. Platt and Barr (1988) used finite element software and discuss constraint methods in terms of animator tools for physical model control. Moore and Wilhems (1988) treat collision response, developing two methods based on springs and analytical solutions. They state that spring solutions are applicable to the surface shapes of flexible bodies but do not explain how the shapes are obtained before initiation of contact calculations, nor how the shapes are modified as a result of a contact.

Our main objective was to model the world in a grasping task context by using a finite-element theory. The method allows simulation of both motion and shape of objects in accordance with physical laws, as well as the deformations of human flesh due to contact forces between flesh and objects. The following two arguments support the use of the same method for modeling deformation of objects and human flesh.

First, we want to develop a method that will deal with penetrating impacts and true contacts. For this reason, we prefer to consider true contact forces with possibilities of sliding and sticking rather than only repulsive forces. Our approach, based on volume properties of bodies, permits calculation of the shape of world constituents before contact, and to treat their shape during contact. When a contact is initiated we use a global resolution procedure that considers bodies in contact as a unique body. Simulation of impact with penetration can be used to model the grasping of ductile objects or to model ballistic problems. It requires decomposition of objects into small, geometrically simple objects.

Second, all the advantages of the physical modeling of objects can be transferred to human flesh. For example, we expect the hand grasping an object to lead to realistic flesh deformation as well as an exchange of information between the object and the hand, which will not only be geometrical. When a deformable object is grasped, the contact forces on it and on the fingertips will lead to deformation of both the object and of the fingertips, giving rise to reactive forces, which provide significant information about the object and more generally about the environment of the synthetic human body. It is important to note that even if the deformations of the object and of the fingers are not visible, or if the object is rigid, the exchange of information will exist because the fingers are always deformable. This exchange of information using active and reactive forces is significant for a good and realistic grip and can influence the behavior of the hand and of the arm skeleton. For grip, interacting information is as important as that provided by tactile sensors in a robot manipulator. This is a well-known problem of robotics called *compliant motion control*. It consists of taking into account external forces and commanding the joints and links of the fingers using inverse kinematic or dynamic controls. In the past, authors dealing with kinematic and dynamic animation models oriented toward automatic animation control (Armstrong and Green, 1985; Badler, 1986; Calvert et al., 1982; Wilhelms, 1987), have often referred to works of roboticians (Hollerbach, 1980; Lee et al., 1983; Paul, 1981). In the same way, we believe that methods used intensively in CAD systems may improve the control of synthetic human animation.

12.3.2 *Finite-Element Approach in Computer Animation*

Solid three-dimensional objects and human flesh are discretized using simple or complex volume elements, depending on the choice of the interpolation function. The finite-element approach (Bathe, 1982; Zienkiewicz, 1977) is compatible with requirements of visual realism because a body surface corresponds to an element face that lies on the body boundary.

Once the various kinds of elements are defined, the modeled shape is obtained by composition. Each element is linked to other elements at nodal points.

In continuum mechanics (see Figure 12.6), the equilibrium of a body presenting a shape can be expressed by using the stationary principle of the total potential or the principle of virtual displacements:

$$wR = wB + wS + wF \tag{1}$$

where wB represents the virtual work due to the body forces such as gravity, centrifugal loading, inertia and damping; wS represents virtual work of distributed surface forces such as pressure; wF represents the virtual work of concentrated forces; and wR represents the internal virtual work due to internal stresses.

In the finite-element method, the equilibrium relation (1) is applied to each element e

$$w_{Re} = w_{Be} + w_{Se} + w_{Fi} \tag{2}$$

and the whole body is obtained by composing all elements

$$\sum_{element=1}^{NBEL} W_{Re} = \sum_{element=1}^{NBEL} W_{Be} + \sum_{element=1}^{NBEL} W_{Se} + \sum_{i=1}^{NBP} W_{Fi} \tag{3}$$

Our three-dimensional model uses elements with eight nodes and $NBDOF = 3$ degrees of freedom per node. These elements are easily modified to prismatic or tetrahedral elements to approximate most existing 3-D shapes. The composition of $NBEL$ elements with eight points give NBP points and $NB = NBP*NBDOF$ equations. From the relation (3) we can write the following matrix equation between vectors of size $[NB*1]$ as follows:

$$R + RI = RB + RS + RF \tag{4}$$

where RB is the composition of body forces, RS is the composition of surface forces and RF represents the concentrated forces acting on the nodes. $R + RI$ is the composition of internal forces due to internal stresses. These stresses are initial stresses which give the RI term, and reactions to deformations created by RB, RS, and RF, which give the R term.

W uses the equilibrium relation (4) under the form (5)

$$K.U = R \tag{5}$$

where K is the $[NB*NB]$ stiffness matrix, a function of material and flesh constitution, R is the $[NB*1]$ load vector including the effects of the body forces, surface tractions, and initial stresses, and U is the $[NB*1]$ displacement vector from the unloaded configuration.

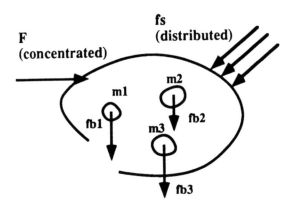

Figure 12.6 Continuum Mechanics

Relation (5) is valid in static equilibrium and also in pseudostatic equilibrium at instant t_i. Instants t_i are considered variables, which represent different load intensities. In this chapter, we do not deal with dynamics when loads are applied rapidly. In this case, true time inertia and damping, displacement velocity, and acceleration must be added to (5).

Under this form, the body can be viewed as a huge three-dimensional spring of stiffness K and return force R. The equilibrium relation (3) is a function of volume properties because each component is obtained by the summation of integrations over the volume and the area of each element (see Zienkiewicz, 1977 for more details).

Since the process consists of the composition of elements to create a global deformable object, we believe that this property, and its inverse, i.e., the decomposition of a global deformable object into two or multiple subobjects, should be used in computer animation.

The decomposition is very easy to implement because the constitutive properties of each element as well as interelement forces are memorized and are taken into account during numerical calculations. It is possible for example to create a global object made of different subobjects; each subobject would have its own constitutive properties and be composed of one or more elements.

There are several ways to exploit the intrinsic properties of the finite-element method:

- *The decomposition approach* can be exploited to model penetrating shocks between two or more deformable objects. Each object is subdivided into many deformable subobjects, which are able to interact with each other because each inherits its own properties. The decomposition approach may also be used in contact problems when contact is released.

- *The composition approach* can be used for modeling contacts without penetration between two or more objects. In this case, objects can be considered as subobjects evolving independently until contact is detected and a global object is composed following contact. In practice this means that relations $K_n.U_n = R_n$ are resolved independently before contact and a unique relation $K.U = R$ is resolved after contact of n bodies. This process works if we take into account the contact forces that prevent overlapping in equation (5). We use the composition approach for the grasping and pressing of a ball described in the following section. A survey of contact problems is given by Bohm (1987). Examples of 3-D treatments can be found in Chaudary and Bathe, 1986.

12.3.3 *A Case Study: Ball Grasping and Pressing*

To show how the physical modeling of deformable objects can contribute to human animation, we present an example of a contact problem dealing with the grasping and pressing of a ball. Details may be found in (Gourret et al., 1989).

Starting with the facet-based envelopes of ball and hand obtained from the image synthesis system SABRINA (Magnenat-Thalmann and Thalmann, 1987b), we mesh the volume of the objects to create full 3-D bodies, or shell bodies depending on the application. After calculations of the deformations using our method based on finite-element theory, the facet-based deformed envelopes are extracted from the database used in our calculations and restored to SABRINA for visualization. In this way, visual realism is always ensured by the image synthesis system.

Bones are connected to the segment and joint skeleton animated by the HUMAN FACTORY system. The hand envelope and segment-joint skeleton are sufficient for realistic hand animation without contact but are not able to reproduce skin deformations from contact. A mere bone segment is not sufficient to give realistically large deformation of skin under contact forces because, as in human fingers, skin deformations are restricted by bones. For this reason, we use the realistic bones shown in Figure 12.7. This has an impact on visual realism and behavior of the hand during grasping, because bone parts are flush against the skin in some regions and are more distant in others. Moreover, in the future, more complex modeling will probably take into account nerves and muscles tied to bones (Thomson et al., 1988).

We use a composition approach based on the resolution of relation (5) including contact forces between ball and finger. This relation works perfectly in a grasping problem because loads are applied slowly.

However, contact modeling is not easy because the equilibrium equation (5) is obtained on the assumption that the boundary conditions remain unchanged during each time t_i. Two kinds of boundary conditions exist: *geometric boundary conditions* corresponding to prescribed displacements, and *force boundary conditions* corresponding to prescribed boundary tractions. We cannot control a single degree of freedom in both position and force; consequently, the unknown

Figure 12.7 Hand and Bones at Rest

displacement will correspond to known prescribed force and conversely known prescribed displacement will correspond to unknown force.

In matrix notation, the problem can be stated in the following way: U_k are known prescribed displacements, U_u is unknown displacements, R_k is known prescribed forces and R_u is unknown forces. In this way, relationship (5) can be written

$$\begin{bmatrix} K_{11} & K_{12} \\ K_{22} & K_{22} \end{bmatrix} \cdot \begin{bmatrix} U_U \\ U_K \end{bmatrix} = \begin{bmatrix} R_K \\ R_U \end{bmatrix} \tag{6}$$

If NP degrees of freedom are displacement prescribed, $NBEQ = NB - NP$ equations are necessary to find the U_u unknown displacements. Matrix dimensions are $[NBEQ*NBEQ]$ for K_{11}, $[NBEQ*NP]$ for K_{12}, $[NP*NBEQ]$ for K_{21} and $[NP*NP]$ for K_{22}.

Equations for solving U_u are

$$K_{11}.U_u = R_k - K_{12}.U_k \tag{7}$$

Hence, in this solution for U_u, only the $[NBEQ*NBEQ]$ stiffness matrix K_{11} corresponding to the unknown degrees of freedom U_u need to be assembled. Once U_u is evaluated from (7) the nodal point forces corresponding to U_k can be obtained from (8)

$$R_u = K_{21}.U_u + K_{22}.U_k \tag{8}$$

Boundary conditions can change during grasping and pressing when prescribed forces or displacements are sufficient to strongly deform the ball and hand skin. This situation creates other contact points between ball and table, and between ball and fingers. Consequently the calculations are more complicated because the number of unknown displacements U_u, and reactive forces R_u, will vary depending upon the number of contact points which prescribe R_k and/or U_k.

In a first step, sight allows us to evaluate certain dimensions, mass, roughness, elasticity, etc.; i.e., to imagine our position in relation to the ball.

In the domain of animation, this information is contained in the ball database (e.g., volume point coordinates, and physical characteristics such as constitutive law, mass density, and texture, which can be related to roughness). The hand grasps or presses the ball applying a prescribed force, whose intensity is dictated by the knowledge acquired by the sense of sight. The prescribed contact force is created by muscular forces acting on bones and using flesh as an intermediary. Generally, the grip is as gentle as possible without letting go of the ball. This can be viewed as a "minimization of the power due to the muscles," as pointed out by Witkin and Kass (1988). A gentle grip not only prevents damage to a fragile object, but results in a grip that is more stable (Cutkosky, 1985; Slotine and Asada, 1986). In a second step, the sense of touch allows an exchange of information between the ball and the fingers, implying contact forces, sliding contacts, deformations, and internal stresses in the fingers. In

Figure 12.8 Grasping of a Ball Submitted to Internal Pressure

computer animation the first step is difficult to implement because the animator cannot resort to force transducers for forces applied directly to the bones. Consequently the first step based on given prescribed forces R_k on bones is not currently possible. For this reason our solution for the grasping problem is different from the robot or human solution. It is displacement-driven rather than force-driven.

In this way, the animator is not concerned with forces but with the hand key position required by the script. For ball grasping, shown in Figure 12.8, the ball is made of a rubber envelope and is submitted to internal pressure. The animator imposes prescribed displacements U_k on the hand bones using a "classical" method (parametric, kinematic, or dynamic) and places the ball between the fingers. During this process the animator can ignore the material of which the ball is built. It can be a very soft ball or a very stiff ball. The animator positions the fingers (skin and eventually bones) inside the ball. The purpose of calculations is to decide if the chosen finger position is or is not a realistic one and determine its consequences on skin and ball shapes. This is the reaction of the ball on the fingers which will decide the validity of grasping. Since finger position is prescribed by the animator, the ball must be repelled to prevent overlaps, ignoring, as a first approximation, whether it is stiff or soft.

Figure 12.9 shows an iterative procedure for obtaining both the contact forces and the displacements under contact.

Relation (7) is solved using a direct solution (Gauss-Seidel method). Convergence occurs when for all points the variation between two successive iterations is less than some fixed threshold. In this procedure, relations (7) and (8) represent the global system made up of ball and hand. The first step requires animator manipulation (e.g., parametric key-frame animation). In the second step all skin displacements, and those ball displacements resulting from overlap suppression are prescribed. Step 3 will give displacements U_u on ball and reacting forces on repelled ball nodes by solving equations (7) and (8). Step 4 ensures that

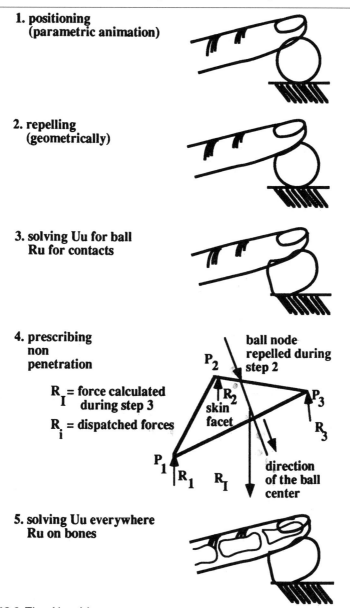

1. positioning
 (parametric animation)

2. repelling
 (geometrically)

3. solving Uu for ball
 Ru for contacts

4. prescribing
 non
 penetration

R_I = force calculated
 during step 3

R_i = dispatched forces

ball node
repelled during
step 2

P_2

R_2

skin
facet

P_3

R_3

P_1

R_1 R_I

direction
of the ball
center

5. solving Uu everywhere
 Ru on bones

Figure 12.9 The Algorithm

at equilibrium, contact forces between ball and skin will be equal and opposite to maintain compatible surface displacements. Because ball nodes are not repelled in coincidence with skin nodes, but on skin polygon surfaces, the reacting force calculated in step 4 is distributed among the three nodes constituting the skin facet, with weights depending on the position of the ball node on the facet. In

step 5, reacting forces are assumed to be known and all degrees of freedom of ball and skin are released. In other words, we rearrange matrix relation (6) because the number of equations is modified in comparison with step 3. The method can be interpreted as a Lagrangian multiplier method that forces the nonpenetration condition between the ball and the hand with additional equations. Steps 2 to 5 are repeated until convergence is reached. Otherwise they are stopped when the evaluation of the reacting force on bones overruns a force threshold allowable by the human musculature.

In a parametric computer animation system, the reacting force on bones can be used to suggest solutions to the animator as in an expert system. In a system with inverse dynamics, the position of bones is modified automatically using calculated reacting force. Calculation of finger deformations is necessary even if fingers and palm deformations are not visible. An exchange of information will take place since the fingers are always deformed. It is finger flexibility and frictional resistance that permit human grasp of rigid objects. This is the reason actual robot hands are made up of elastic extremities equipped with tactile sensors (Jacobsen et al., 1988; Pugh, 1986). Our actual simulation is based on prescribing and releasing the displacement of contact points during each iteration. This allows us to release dynamically the parts of the two bodies. A more sophisticated model, now being developed, must include an evaluation of frictional resistance. For example a Coulomb friction law may be used to simulate the adhesion of papillary ridges. In this law, a coefficient of friction u relates the normal force F_n to the tangential force F_t at contact points. Force $u.F_n$ represents the frictional resistance during contact, and sliding contact is initiated when $F_t \geq u.F_n$.

During the second step of grasping, if the initial prescribed force R_k has been poorly evaluated by the sense of sight, the ball and finger(s) will slide. This information can then be used to increase the prescribed force, or to modify the position of fingers on the ball. The evaluation of sliding and the increase in the prescribed force must be repeated until an equilibrium or an unstable condition is obtained.

Both the tactile sensor model and the command model must be included in a complete automatic motion control, because the stiffness of grip is a function of the stiffness of finger tissue and of the disposition of fingers around the ball. This compliant motion control scheme, which is made to sustain the environmental factors, might be made easier by the fact that kinematic and dynamic models dealing with articulated bodies can be looked upon as a displacement-based finite-element method applied on trusses and bars.

The global treatment of contact presented here can be applied to inter-deformation of fingers, deformation between fingers and palm, or, more generally, between two synthetic human parts following a compression or a stretching of skin. For this purpose, each part of the body must be considered as an entity able to interact with each other part. An entity cannot interpenetrate itself, and some entities cannot reach all others because of joint angle limits imposed on the

skeleton (Isaacs and Cohen, 1987). For example, during finger flexing, we consider the third phalanx unable to interpenetrate the second and first phalanges. In the same way we also consider that a foot cannot reach the face unless we are simulating a chubby baby or a gymnast or a yogi.

12.3.4 *Animation Control*

Animation of a physically deformable object can be simply supported in the HUMAN FACTORY system by defining prescribed displacements called U_k in the preceding sections as new state variables. When fewer than three degrees of freedom of some point are prescribed, state variables of VECTOR type are sufficient for defining the movement of prescribed points. When fewer than three degrees of freedom are displacement-prescribed, a new type of state variable has been defined. With this approach deformable bodies are processed as actors. Object points are not only submitted to translations and rotations, but automatically follow the prescribed degrees of freedom according to constitutive laws and other potential constraints such as body forces and surface forces. It should be noted that the use of state variables is not always required and can often be omitted. For example the problem of free-fall of a deformable object is implicitly defined and does not require an extra physical law and prescribed degrees of freedom.

12.4 *Conclusion*

Two methods for improving deformations of human bodies have been described. The JLD approach is convenient when there is no contact between the human being and the environment. A finite-element method in three dimensions has been introduced to model both object deformations and synthetic human flesh deformations. By doing this, the method gives information about the synthetic environment of the human. This environment is made up of physical objects, which should act as it would if the objects had minds. They should react to applied forces such as gravity, pressure, and contact. This approach provides a significant contribution to automatic motion control in 3-D character animation. We believe that it can be used to improve the behavior of human grasp and human gait and more generally to improve synthetic human behavior in the synthetic environment.

Acknowledgments

The authors are grateful to Dr. J.P. Gourret from Ecole Nationale Supérieure de Physique de Marseille for his work in the finite-element project and R. Laperrière from University of Montreal for his cooperation in the JLD project. The research was supported by le Fonds National Suisse pour la Recherche

Scientifique, the Natural Sciences and Engineering Council of Canada, the FCAR foundation and the Institut National de la Recherche en Informatique et Automatique (France).

References

Armstrong, W.W. and Green, M.W. 1985. Dynamics for animation of characters with deformable surfaces, in: N. Magnenat-Thalmann, D. Thalmann (Eds) *Computer-generated Images*, Springer, Heidelberg, pp. 209–229.

Badler, N.I. and Morris, M.A. 1982. Modeling flexible articulated objects. *Proc. Comp. Graphics '82*, Online conf., pp. 305–314.

Badler, N.I. and Smoliar, S.W. 1979. Digital representations of human movement. *Computing Surveys* 11(1):19–38.

Badler, N.I. 1986. Design of a human movement representation incorporating dynamics, in: Enderle, G., Grave, M., Lillehagen, F., *Advances in Computer Graphics I*, Springer, Heidelberg, pp. 499–512.

Barr, A.H. 1984. Global and local deformations of solid primitives, *Proc. SIGGRAPH '84, Computer Graphics* 18(3):21–30.

Bathe, K.J. 1982. *Finite Element Procedures in Engineering Analysis*. Prentice Hall, Englewood Cliffs, NJ.

Blinn, J.F. 1982. A generalization of algebraic surface drawing. *ACM Trans. on Graphics* 1(3):235–256.

Bohm, J. 1987. A comparison of different contact algorithms with applications. *Comp. Struc.* 26(1–2):207–221.

Calvert, T.W., Chapman, J., and Patla, A. 1982. Aspects of the kinematic simulation of human movement. *IEEE Computer Graphics and Applications*, November, pp. 41–52.

Catmull, E. 1972. A system for computer-generated movies. *Proc. ACM Annual Conference* 1:422–431.

Chadwick, J., Haumann, D.R., and Parent, R.E. 1989. Layered construction for deformable animated characters. *Proc. SIGGRAPH '89, Computer Graphics* 23(3):234–243.

Chadwick, J. and Parent, R. 1988. Critter construction: Developing characters for computer animation. *Proc. Pixim 88*, pp. 283–305.

Chaudary, A.B. and Bathe, K.J. 1986. A solution method for static and dynamic analysis of three dimensional contact problems with friction. *Comp. Struc.* 24(6):855–873.

Cutkosky, M.R. 1985. *Robotic Grasping and Fine Manipulation*. Kluwer Academic Publishers, Norwell, MA.

Gourret, J.P., Magnenat-Thalmann, N., and Thalmann, D. 1989. Simulation of object and human skin deformations in a grasping task. *Proc. SIGGRAPH '89, Computer Graphics* 23(3):21–30.

Hollerbach, J.M. 1980. A recursive Lagrangian formulation of manipulator dynamics and a comparative study of dynamics formulation. *IEEE Trans. on Systems, Man, and Cybernetics.* SMC-10(11):730–736.

Isaacs, P.M. and Cohen, M.F. 1987. Controling dynamic simulation with kinematic constraints, behavior functions and inverse dynamics. *Proc. SIGGRAPH '87, Computer Graphics* 21(4):215–224.

Jacobsen, S.C., McCammon, I.D., Biggers, K.B., and Phillips, R.P. 1988. Design of tactile sensing systems for dextrous manipulators. *IEEE Control Systems Magazine* 8(1):3–13.

Komatsu, K. 1988. Human skin model capable of natural shape variation. *The Visual Computer* 3:265–271.

Lee, C.S.G., Gonzales, R.C., and Fu, K.S. 1983. *Tutorial on Robotics.* IEEE Comp. Soc. Press, New York, NY.

Magnenat-Thalmann, N. and Thalmann, D. 1987. The direction of synthetic actors in the film *Rendez-vous à Montréal. IEEE Computer Graphics and Applications* 7(12):7–19.

Magnenat-Thalmann, N. and Thalmann, D. 1987b. *Image Synthesis: Theory and Practice.* Springer, Tokyo.

Magnenat-Thalmann N. and Thalmann, D. 1988. Construction and animation of a synthetic actress. *Proc. EUROGRAPHICS '88,* Nice, France, pp. 55–66.

Magnenat-Thalmann, N. and Thalmann, D. 1990. *Computer Animation: Theory and Practice.* Springer, Tokyo.

Magnenat-Thalmann, N., Laperriére, R., and Thalmann, D. 1988. Joint-dependent local deformations for hand animation and object grasping. *Proc. Graphics Interface '88,* Edmonton.

Moore, M. and Wilhelms, J. 1988. Collision detection and response for computer animation. *Proc. SIGGRAPH '88, Computer Graphics* 22(4):289–298.

Paul, R.P. 1981. *Robot Manipulators: Mathematics, Programming and Control.* MIT Press, Cambridge, MA.

Platt, J.C. and Barr, A.H. 1988. Constraint method for flexible models. *Proc. SIGGRAPH '88, Computer Graphics* 22(4):279–288.

Pugh, A. (ed.) 1986. *Robot Sensors. Vol 2. Tactile and Non-Vision.* IFS publications Ltd (Bedford) and Springer Verlag.

Slotine, J.J.E. and Asada, H. 1986. *Robot Analysis and Control.* John Wiley and Sons, New York. NY.

Terzopoulos, D., Platt, J., Barr, A., and Fleischer, K. 1987. Elastically deformable models. *Proc. SIGGRAPH '87, Computer Graphics* 21(4):205–214.

Thomson, D.E., Buford, W.L., Myers, L.M., Giurintano, D.J., and Brewer, J.A. 1988. A hand biomechanics workstation. *Proc. SIGGRAPH '88, Computer Graphics* 22(4):335–343.

Wilhelms, J. 1987. Toward automatic motion control. *IEEE Computer Graphics and Applications* 7(4):11–22.

Witkin, A. and Kass, M. 1988. Spacetime constraints. *Proc. SIGGRAPH '88, Computer Graphics* 22(4):159–168.

Wyvill, G., McPheeters, C., and Wyvill, B. 1986. Data structure for soft objects. *The Visual Computer* 2:227–234.

Zienkiewicz, O.C. 1977. *The Finite Element Method*, 3rd edition, McGraw-Hill, London.

IV

COMPUTING THE DYNAMICS OF MOTION

13

Dynamic Experiences

Jane Wilhelms

Computer and Information Sciences
University of California, Santa Cruz
Santa Cruz, California

ABSTRACT

This chapter reviews research during the past few years by the author and collaborators researching the use of physical simulation for animating rigid and flexible bodies. Physical simulation has been explored both as an interactive tool for object manipulation and as a means to automatically generate complex motion for animation. Most work has centered around manipulating articulated rigid bodies. This report provides some background on modeling with physical simulation, and discusses dynamics formulations, control methodologies, and implementation of constraints and collisions. There is a discussion of the use of physical simulation for interactive manipulation of articulated bodies and a brief description of systems developed with this in mind. Finally, the author provides some discussion of the state of physical simulation and what lies ahead.

13.1 *Introduction*

Physical simulation refers to the modeling of objects as masses that move under the influence of forces and torques. Given the mass properties of objects and the forces, torques, and constraints that are active in the environment, motion can be predicted using the dynamics equations of motion. By coupling this motion description to computer-generated graphical objects, a computer animation of the motion can be made. The more common alternative method for generating computer-animated motion is to specify positions taken over time, with no reference to physical laws. This is referred to as kinematically generated motion. Physical

simulation has potential for generating complex and realistic motion with relatively little user specification. Its main drawbacks are that it is computationally more expensive and that it involves some difficult control issues.

This chapter provides an overview of the research done on these issues by the author and collaborators during the past few years. Its purpose is to provide some insight into the advantages and disadvantages encountered in various aspects of the research. Detailed descriptions of the methods are not provided. It is hoped that the reader can find these details in the references, if desired.

Section 13.2 provides some basic background on the use of physical simulation. Section 13.3 deals with the types of dynamics formulations and integration methods that we used. Section 13.4 discusses some low-level control issues and the inclusion of constraints and collisions. Section 13.5 discusses the use of dynamics for interactive manipulation, and Section 13.6 offers some conclusions.

13.2 *Basic Dynamics*

Basic physical simulation can be implemented in a few relatively easy steps. A more detailed description of these steps can be found in a tutorial (Wilhelms, 1988). First, a physical description of the objects to be manipulated is found. Second, the dynamics equations of motion are set up, relating how masses move under the influence of forces and torques. Third, the equations are solved for accelerations, given known forces and torques. Fourth, an integration is performed to find new velocities and positions. Finally, these new positions (a kinematic description of motion) are used to animate graphical objects. This description will be for three-dimensional simulations. One- or two-dimensional simulations are simpler but less interesting.

13.2.1 *The Physical Object Description*

In the first step, a physical description of the objects is found. In the simplest case, objects may be represented as point masses, and the only physical description needed is their mass. A point mass has only three degrees of freedom of motion: It can translate in X, Y, and Z. More realism is gained by treating an object as a rigid body, which is made up of masses distributed in space. An articulated rigid body is one made up of rigid body segments, each of which has its own physical description but which is constrained in some way by its neighbors.

A rigid body can be described in terms of a coordinate frame attached to the body. A rigid body has six degrees of freedom of motion: It can translate in three directions (its position) and also rotate (its orientation). The mass information needed to simulate a rigid body includes its total mass, center of mass, and

moments and products of inertia. These latter describe how the mass is distributed about the body-fixed coordinate frame.

Often a rigid body can be approximated by a simple shape, in which case its moments and products of inertia can be found easily. For a simple rectangular box of homogeneous material and dimensions $2c$ in X, $2b$ in Y, and $2a$ in Z, the moments of inertia about the center of mass are (Wells, 1969)

$$I_x = \frac{1}{12} m \, (a^2 + b^2) \tag{1a}$$

$$I_y = \frac{1}{12} m \, (a^2 + c^2) \tag{1b}$$

$$I_z = \frac{1}{12} m \, (b^2 + c^2) \tag{1c}$$

If the body is symmetrical, the products of inertia about the center of mass are zero.

For purposes of calculation, the moments (I_x, and so on) and products (I_{xy}, and so on) of inertia are arranged in a 3 X 3 inertial tensor matrix.

$$J_k = \begin{bmatrix} I_x & -I_{xy} & -I_{xz} \\ -I_{xy} & I_y & -I_{yz} \\ -I_{xz} & -I_{yz} & I_z \end{bmatrix} \tag{2}$$

The inertial tensor matrix will change if it is expressed relative to a body-fixed frame not centered at the center of mass or arranged so that the mass is not symmetrically distributed. However, finding the new matrix is not hard and is described in Wilhelms (1988).

13.2.2 *Setting Up the Dynamics Equations*

There are a number of ways to formulate the dynamics equations, such as the Gibbs-Appell (Wilhelms, 1987), the Lagrangian (Wells, 1969), the D'Alembert (Isaacs and Cohen, 1987), the Euler (Wells, 1969), and the Armstrong recursive formulations (Armstrong and Green, 1985). Perhaps the most basic and intuitive formulation is that of Euler. In this case, two three-dimensional vector equations describe the translational and rotational motion of a single body as follows:

$$f = ma - mc \times \dot{\omega} + m \, \omega \times (\omega \times c) \tag{3}$$

$$\tau = J \, \dot{\omega} + mc \times a + \omega \times J\omega \tag{4}$$

Table 13.1 provides a succinct definition of terms found in equations.

In the case of articulated bodies, a constraint that prevents the bodies from moving completely freely of each other must somehow be specified. If the articulated body represents an animal, the joint can be assumed to be rotary, so that up to three degrees of rotational motion are possible but no translational movement between segments (a dislocation). In this case, the constraint may take the

Table 13.1 Meaning of Terms

Matrices	
J	Inertial tensor matrix
R^{s}	Rotation matrix segment relating one frame to another
M	Mass configuration matrix for Gibbs-Appell dynamics

3-D Vectors	
f	Force
f_{grv}	Force due to gravity
f_{ext}	External applied force
f_{son}	Force applied by child of a segment thru a joint
f_{topar}	Force applied onto parent of a segment thru a joint
τ	Torque
p	Position
v	Linear velocity
a	Linear acceleration
a_{grv}	Gravitational acceleration
ω	Angular velocity
$\dot{\omega}$	Angular acceleration
l	Vector to joint of child segment from parent frame
c	Vector to segment center of mass defined in segment frame
v	Velocity-dependent force vector for Gibbs-Appell dynamics
\ddot{e}	Generalized accelerations for Gibbs-Appell dynamics
q	generalized forces for Gibbs-Appell dynamics

Scalars	
m	Mass
δt	Time step between samples
I_x, I_y, I_z	Moments of inertia
I_{xy}, I_{xz}, I_{yz}	Products of inertia

form of an equation defining the acceleration of one rigid body at its joint as exactly the same as the acceleration of the neighboring body at that joint, or

$$a_{child} = a_{parent} - l_{child} \times \dot{\omega}_{parent} + \omega_{parent} \times (\omega_{parent} \times l_{child}) \tag{5}$$

The motion is being described in terms of the axes of the body-fixed frame of segment *parent*, but knowledge of the relative positions and orientations of the neighbor segments to each other make it simple to move descriptions from one frame to another.

13.2.3 *Solving the Dynamics Equations for Accelerations*

Looking at the two vector dynamics equations, one will note that some variables are known and others unknown. The mass information (mass, center of mass, and inertial tensor) is known and can be assumed constant. These quantities can also be altered (for example, if the body is a rocket and burning fuel), but, in general, they do not vary from moment to moment in any significant way. The angular velocity ω can be taken to be that calculated at the time step. This leaves net force f and net torque τ, as well as new linear acceleration a and new angular acceleration $\dot{\omega}$ as unknowns.

In robotics, it is often the case that the desired accelerations have been calculated, and one needs to find the forces and torques to move the robot (*inverse dynamics*). In a graphical simulation, it may be that one is applying known forces and torques to create a motion, in which case the accelerations are solved for (*forward dynamics*). In actual fact, depending on the method, a combination of both approaches may be used (Barzel and Barr, 1988; Isaacs and Cohen, 1987).

In the simple forward case, though, one can assume that forces and torques acting on the body are calculated, and the equations can be solved using a suitable technique. But how does one find the forces and torques?

13.2.3.1 *Applied Forces* An applied force (f) is specified by a 3-D vector describing its direction and magnitude and another 3-D vector describing the position on the body where it is acting (p). It may come from gravity (an applied force at the center of mass) or from pulls and pushes from ropes or rods or from reactive forces from neighbors if the body is articulated. In the case of an articulated body, the reactive forces between neighbors balance so that the push of the parent on the child is equal and opposite to that of the child on the parent. Thus, the net force on segment i can be described as

$$f_i = m_i \, a_{grv,i} + f_{ext,i} + \sum f_{son,i} - f_{topar,i} \tag{6}$$

13.2.3.2 *Applied Torque* A torque causes a rotational motion. It may be specified as a pure torque, which is added directly into the net torque vector, or

as due to a force applied away from the origin of the local frame. The torque caused by a force depends on where the force is applied, by the relation

$$\tau = p \times f \tag{7}$$

13.2.3.3 The System of Equations Given the information described above, one can now solve the equations of motion using a suitable equation solver, which could be a simple as Gaussian elimination or LU Decomposition (LUD). For an articulated body with only fully movable (spherical) rotary joints, each segment will have two three-dimensional vector equations, and each joint will have one three-dimensional constraint equation. As an example, here are the equations for a two-segment body. These specify the force and torque equations for each segment plus a constraint equation.

$$\begin{bmatrix} m_p & -m_p c_p\times & 0 & 0 & -1 \\ m_p c_p\times & J_p & 0 & 0 & 0 \\ 0 & 0 & m_s & -m_s c_s\times & R_s \\ 0 & 0 & m_s c_s\times & J_s & 0 \\ 1 & \times l_s & -R_s & 0 & 0 \end{bmatrix} \begin{bmatrix} a_p \\ \dot{\omega}_p \\ a_s \\ \dot{\omega}_s \\ f_{cons} \end{bmatrix} = \begin{bmatrix} f_p - m_p \omega_p \times (\omega_p \times c_p) \\ \tau_p - \omega_p \times J_p \omega_p \\ f_s - m_s \omega_s \times (\omega_s \times c_s) \\ \tau_s - \omega_s \times J_s \omega_s \\ \omega_p \times \omega_p \times l_s \end{bmatrix} \tag{8}$$

 f_{cons} is the constraint force acting to hold the segments together,

 l_s is a vector from the origin of frame p to the origin of frame s (the joint),

 R_s is a rotation matrix that takes the frame of object p into the frame of object s.

The other forces and torques include any external forces and torques being applied. The equations are solved for the linear and angular accelerations of each segment in terms of world-space (inertial) motion but relative to their own coordinate frame.

13.2.4 Integrating the Equations

The simplest integration method is the *Euler method*. It can be easily implemented but is likely to behave unsatisfactorily for large time steps, stiff situations, or rapid motion. The Euler method assumes that the acceleration will be constant during the time step (δt) used. The integration equations for linear motion are shown below. Those for rotational motion are comparable.

$$v_{i+1} = v_i + a_i \delta t \tag{9}$$

$$p_{i+1} = p_i + v_i \delta t + \frac{1}{2} a_i \delta t^2 \tag{10}$$

 There are better methods of numerical integration, such as the Runge-Kutta, which samples during the time period as well as at the beginning. Other integration methods devised for stiff situations will also help (Gear, 1971; Press et al., 1986).

Another important aspect of the integration problem is the size of the time steps used. During stiff situations, such as collisions, it may be necessary to take very small time steps. The method used by the author has been to adaptively alter the time step according to the situation. Both a fourth- and a fifth-order Runge-Kutta integration are done, and, if the results deviate by too much, the time step is halved and the process is repeated (Lapidus and Seinfeld, 1971; Wilhelms et al., 1988). If the deviation is very small, the time step is increased. There is a chance that the two integrations will both be erroneous in the same direction, and the error will not be caught. This has not caused problems in practice. This method also causes the speed of the simulation to vary, but, if this is a problem, the motion description can be stored as key-frames and replayed.

13.3 *Three Dynamics Formulations*

Two matrix and one recursive dynamics formulations have been implemented by the author and her collaborators. In temporal order, these were a Gibbs-Appell matrix formulation, the Armstrong recursive formulation, and a matrix Euler formulation.

13.3.1 *The Gibbs-Appell Matrix Formulation*

The initial work was done with a Gibbs-Appell matrix dynamics formulation (Wilhelms, 1985; 1987; Wilhelms and Barsky, 1985). This method has been found attractive because of its generality (Horowitz, 1983; Pars, 1979). The Gibbs-Appell formulation, like the Lagrangian, uses the concept of a generalized force, which can be thought of as a net force or torque (depending on whether the joint is sliding or revolute) acting on a particular degree of freedom. Only actual degrees of freedom of motion need to be considered; therefore, joint constraints that remove degrees of freedom need not be specified as separate equations. Thus, for example, only one equation is needed to specify the motion of a one degree-of-freedom hinge joint, rather than three equations with appropriate constraints. The Gibbs-Appell formulation also neatly partitions the complex force, torque, mass, configuration, and velocity information, producing a system of equations that can succinctly be expressed as

$$M^{-1}(q - V) = \ddot{e} \tag{11}$$

where M is an $n \times n$ inertial matrix describing the configuration of system masses, V is an n-length vector of velocity-dependent forces dependent on both the configuration of masses and their velocities, q is an n-length vector of the net generalized forces, and \ddot{e} is an n-length vector of local accelerations at each of n degrees of freedom of motion.

The Gibbs-Appell method was abandoned, however, because the matrices generated were not sparse and the cost of solving for accelerations was prohibi-

tively expensive. This often meant waiting overnight for several seconds of animation. The author learned of a linear time-recursive formulation that seemed to offer much superior performance.

13.3.2 *Armstrong's Recursive Formulation*

Armstrong and Green (1985) presented a recursive dynamics formulation (from Armstrong, 1979) for use in graphical simulation. The recursive method is based on the Euler dynamics equations but avoids having to set up a matrix. The advantage of the recursive formulation is that it is linear in the number of degrees of freedom, though the formulation in its present form assumes six degrees of freedom from the world to the root body segment and three rotary degrees of freedom between each body joint. Armstrong provided the author with the code for his formulation, which became the basis for much later work.

The derivation of the recursive equations from those of Euler is described in Armstrong and Green (1979) and in Wilhelms (1988), and the equations themselves are not intuitively obvious, so they are not described here. The author's experience has been that the method is indeed very fast and also robust (with suitable consideration of stiffness). Considering only the calculation of basic dynamics, without sophisticated control or environmental interactions, simulations can be done on a graphics workstation such as the Silicon Graphics IRIS at interactive speeds (Forsey and Wilhelms, 1988). That is, one can simulate pushing and pulling a body using applied forces and torques and see immediate animated responses. It is not real time, in the exact sense of the response appearing in the same time period as that internally calculated by the equations.

13.3.3 *The Euler Matrix Formulation*

For reasons having to do with control, explained below, Matthew Moore and the author decided to implement a Euler formulation for articulated bodies, such as described in Section 13.2. Considering only simple dynamics, not control, this involved setting up a system of $2n$ three-dimensional vector equations expressing the dynamics of each segment plus $n - 1$ three-dimensional constraint equations holding the joints together, for an n-segment body. Because these equations are expressed in terms of inertial motion, the matrix is sparse. It was thus possible to use sparse matrix techniques to solve them, making the method order n, comparable to the Armstrong formulation. In practice, it is somewhat slower, due to the work of setting up the sparse matrix method (Pissanetsky, 1984).

13.4 *Approaches to Control*

Initial work convincingly showed that the implementation of dynamics itself was expensive but not a major problem. The real problem was controlling the motion. Implementing physical simulation without fairly sophisticated control requires

the user to supply detailed dynamic control instructions (forces and torques) rather than detailed kinematic specifications (positions). The seeming advantages of physical simulation can indeed be mixed blessings. For example, one of the features of physical simulation is that reaction forces are naturally taken into account so that, as one segment of the body moves, segments attached to it will react appropriately. Without suitable constraints, such as joint limits, damping, or actual joint torques to resist motion, the whole body will flail about like a rag doll.

As it appeared that the complexities of high-level control and coordination using physical simulation must rest on a solid foundation of low-level control, desiderata of such control were explored. These included (1) realistic reaction to collisions with other objects; (2) friction and damping during such interactions; (3) joint limits to prevent unnatural configurations; (4) resistance to undesirable motion, such as the flailing mentioned above; (5) the ability to constrain designated segments to particular positions; and (6) the ability to specify and have the body move correctly toward goals.

The initial approach taken toward fulfilling these goals was a *preprocessing* approach. All desired constraints and control were converted into appropriate forces and torques and included in the dynamics equations in the normal manner. More recently, inspired by the work of other researchers (Isaacs and Cohen, 1987; Witkin et al., 1987; Witkin and Kass, 1988), a different approach was explored, which for lack of a better term is referred to here as *matrix control*. In this latter approach, much of the low-level control was specified in the form of constraint equations (similar to the constraint equations holding segments together in the Euler method described in Section 13.2). Because it appeared difficult to include such equations in the recursive approach, the Euler formulation was implemented.

13.4.1 *Preprocessing Control*

The initial approach was to convert all control suggestions to forces and torques (Wilhelms, 1987; Wilhelms and Barksy, 1985; Wilhelms et al., 1988). In most cases, these take the form of a simulated spring and damper, the spring applying a force proportional to its length, and the damper, a force proportional to the velocity of motion. This method can implement goals if the rest position of the spring occurs when the segment reaches its goal. It implements joint limits or collisions if the simulated spring is compressed when the joint limit is surpassed or a collision occurs. Because springs can be translational or rotary, they can implement external or internal (pseudomuscular) control. The user need not actually deal with the spring but can specify the goal or path of motion in kinematic terms.

This method has the problem common to spring control, in that the springs become stiff. Because of the nature of numerical methods, assumptions are made that calculated conditions occur for some future time step. During this time, the

rest position of the spring may be overshot. For example, during a collision, one body may extend into the other during the time step. The spring will recognize this and push back, proportional to its compression, possibly adding extra energy to the system and causing an unrealistic, overelastic collision. The same problem occurs in trying to hold a segment at a goal. Making the spring-and-damper coefficients a function of conditions and using small time steps during stiffness will largely solve the problem, but this can also make the simulation unacceptably slow. However, it has been the author's experience that this approach is far more robust and generally as fast as the next method for bodies and environments of any complexity.

13.4.2 *Matrix Control*

The alternative method used involved specifying constraints in the form of equations. In simple cases, the system of equations specified (including both the dynamics equations and constraint equations) is perfectly constrained, and the number of unknowns equals the number of constraints. In this case, ordinary sparse matrix methods can be used to find the solution quickly (Pissanetsky, 1984).

The situation becomes somewhat more complex in the case of an underconstrained system of equations. The matrix will have more columns than rows, and there may be an infinite number of solutions. For example, the hand may be given a goal to reach, but there are many different configurations of joints that will place the hand in the desired position. In this case, an extra constraint can be independently specified in the form of an objective function that should be minimized (Witkin et al., 1987). For example, in the above case, the objective function might ask that the total kinetic energy involved in the motion be minimized. Various numerical methods, such as the conjugate gradient technique, can be used to solve the equations (Witkin et al., 1987). Often these methods work by finding the gradient of the objective function and following it down to a position when the function is zero or at least acceptably small.

This more elegant approach to low-level control has been found to have some problems when simulations add more realism, such as automatic collision detection and response, joint limits, variable elasticity, and friction. The problem with gradient methods in general is that the gradient may lead the solution down to a local minimum in the state space. From a minimum position, all further changes appear to make the situation worse, though in actual fact a much better solution may exist in a different region of the state space. In simple cases, such as a single chain arm reaching a goal, this may not occur. In complex cases, it may occur regularly. Experience in the author's laboratory with several methods, including conjugate gradient, penalty functions, and simulated annealing, led to the admittedly preliminary opinion that these methods were no faster and were less robust than simple spring-based methods when simulating complex bodies and interactions.

13.4.3 *Automatic Environmental Interactions*

A major advantage to the use of physical simulation is its ability to automatically mimic interactions between bodies. This involves two problems: first, identifying when an interaction (such as a collision) occurs, and, second, responding to it. Joint limits can be treated as a kind of collision. Response may be simulated by addition of a spring and damper between bodies, insertion of a new constraint equation in the matrix, or an analytic approach that calculates the collision response between dynamics time steps (Moore and Wilhelms, 1988).

The spring-and-damper method causes a temporary force to be applied in an equal and opposite fashion between the two bodies. Appropriate adjustment of the direction and magnitude of the collision reaction force can simulate differential elasticity and friction. The force is used as an external force added into the physical simulation.

Though a temporary equality constraint may be used to simulate collision in the matrix approach, inequality constraints are more realistic. Penalty methods can be used for this, but somewhat limited exploration of this approach was not encouraging.

The analytic approach solves a set of equations that describe how momentum is conserved during the collision. This approach assumes that the collision is instantaneous and occurs between time steps for dynamic analysis; in fact, it can be used in a kinematic system (Moore and Wilhelms, 1988). The solution of these equations describes the new velocities and positions of the bodies after the collision, and these values are inserted into the appropriate kinematic state of the bodies to accomplish the collision. The analytic approach avoids the problem of stiff springs but has an unpleasant feature when one body is resting on another. Though the analytic solution ensures that one body does not enter into the one below, during the dynamics time-step gravity may cause penetration. The analytic solution must then undo this effect in the next interval. Combination of both spring and analytic collisions, one coming into effect after the other if necessary, helps avoid this.

Addition of collisions and joint limits greatly increases the cost of the simulation. For a moderately complex humanoid body, the resulting speeds are too slow for interaction.

13.5 *Dynamics for Interactive Manipulation*

Physical simulation may serve two related but different functions in the animation of articulated bodies. The first is as the lowest level of a hierarchical control structure for automatically generating complex coordinated motion from high-level commands (such as "walk out the door"). At present, such low-level simulation may be possible but is very expensive, and the higher level control is still an area of research (Bruderlin and Calvert, 1989; Zeltzer, 1982; 1985).

The second use of physical simulation is to interactively manipulate bodies into desired configurations. In this case, similar low-level routines are used, but the user provides the high-level control. Here, physical simulation may provide an alternative to inverse kinematics techniques. The author and collaborators have explored this approach in three systems.

13.5.1 *Force and Torque Functions: Virya*

Originally, user control was supplied using an interactive program called Virya (Wilhelms, 1986). Used with dynamic input, Virya allowed the user to design force or torque versus time functions for any degree of freedom of motion. This function was sampled during dynamic analysis to find the appropriate forces or torques at each joint. Environmental forces due to collisions and gravity were automatically added during dynamic analysis. Joint limits were automatically simulated using a strong spring and damper that came into effect when they were reached. It was also possible to hold a joint in a (relatively) stable position by using a spring and damper.

It was immediately obvious that controlling the motion by designing force functions was not intuitive. For example, if an appropriate force was found to raise and lower the shoulder, and then a force at the elbow was added, this would be enough to alter the shoulder motion in undesirable ways.

In hopes of improving the control, Virya was extended to allow the user-defined functions to represent position versus time for each degree of freedom. In this case, the system would check, before dynamic analysis, to see the desired final position of joints under this type of control. Using simple methods (considering the momentum of the body and distance to be moved), an appropriate torque was generated to satisfy this constraint at the end of the time step. This method was highly simplistic and would have benefitted by more sophisticated control and feedback. However, it worked fairly well in the initial system. The frequency of the dynamic analysis was sufficiently more rapid than that of the images used for animation (30 frames per second) that any jitter in the motion was evened out and was not visually obvious.

13.5.2 *Dynamics for Interactive Manipulation: Manikin*

At this point, a more interactive approach was explored where the user could interactively adjust motion at joints. Working with Dave Forsey, an interactive physical simulator, Manikin, was implemented (Forsey and Wilhelms, 1988; Hanrahan, 1986). Manikin did indeed run fast enough (on a VAX 8600 with an animation controller running in parallel) for interactive control. Some extra control methods were added for ease of use. For example, it was possible to limit dynamics to a subset of body segments. This provided stability to the rest of the body as well as speeding up interactivity by reducing the number of degrees of freedom. The user could manipulate the body either by applying forces and

torques or by specifying goal positions and having the system generate appropriate forces to accomplish the goals. A user-friendly interface was never completed, but Manikin strongly suggested that dynamics can be a desirable way to manipulate articulated bodies for modeling purposes.

13.5.3 *Kaya*

Kaya is a flexible physical simulation system for articulated bodies which runs on the Silicon Graphics IRIS (Wilhelms et al., 1988). Kaya can be used as an interactive system with most of the functionality of Manikin and a somewhat improved user interface. Goals and applied forces and torques can be interactively specified either numerically or using simulated sliders. Kaya has a variety of parameters to control the nature of the objects and their simulation. Both a matrix Euler dynamics formulation and the Armstrong recursive formulation are used. For greater realism, collisions and joint limits can be included. For greater speed, dynamics can be limited to subsets of the body. Constraints can be simulated using either preprocessing or constraint equations integrated into the dynamics. Euler, Runge-Kutta, or adaptive Runge-Kutta integration is possible. Motion generated dynamically can be stored as key-frames for fast replay.

13.6 *Summary and Discussion*

There are a number of interesting problems with using physical simulation for interactive modeling and for computer animation. One important one is the speed of the simulation; real-time simulation is not yet possible for humanlike articulated bodies with realistic constraints for joint limits, collisions, and other aspects of human motion. Comfortable manipulation of complex bodies for modeling is also still somewhat slow, though close to being usable. A second problem is solving underconstrained and overconstrained systems. Springs and dampers are fairly easy to implement and work consistently, though slowly. Constraint equations are more elegant and provide better possibilities of control but are less reliable.

Finally, control remains the major stumbling point, as indeed it is with kinematic control. Constraint equations can provide low-level control and the dynamic equivalent of solving the inverse kinematics problem. They do not help with problems of coordinated movement. Much work remains to be done in this area.

Acknowledgments

This work was supported by National Science Foundation grant number CCR-860519 and University of California at Santa Cruz faculty fellowships. Much of this work was done in collaboration, particularly with Matthew Moore at Univer-

sity of Califonria, Santa Cruz and Dave Forsey at the University of Waterloo. Robert Skinner at University of Califonria, Santa Cruz also contributed much to the coding and user interfaces of our simulation programs. Peter Valtin (now at Digital Equipment Corporation) also helped with the implementation. Brian Barsky at University of California, Berkeley provided initial inspiration and support.

References

Armstrong, W.W. 1979. Recursive solution to the equations of motion of an n-link manipulator. *Proceedings of the Fifth World Congress on the Theory of Machines and Mechanisms*, pp. 1343–1346.

Armstrong, W.W. and M.W. Green. 1985. The dynamics of articulated rigid bodies for purposes of animation. *Proceedings of Graphics Interface '85*, Canadian Information Processing Society Toronto, Ontario, Canada, pp. 407–415.

Barzel, R. and A.H. Barr. 1988. A modeling system based on dynamic constraints. *SIGGRAPH '88 Conference Proceedings, Computer Graphics* 22(4): 179–188.

Bruderlin, A. and T. Calvert. 1989. Goal-directed dynamic animation of human walking. *SIGGRAPH '89 Proceedings, Computer Graphics* 23(3):233–242.

Forsey, D. and J. Wilhelms. 1988. Manikin: Dynamic analysis for articulated body manipulation (also UCSC Tech. Report UCSC-CRL-87–2). *Proceedings of Graphics Interface '88*, Canadian Information Processing Society Toronto, Ontario, Canada.

William, C. 1971. *Gear Numerical Initial Value Problems in Ordinary Differential Equations*. Prentice Hall, Englewood Cliffs, NJ.

Hanrahan, P. 1986. Personal communication.

Horowitz, R. 1983. *Model Reference Adaptive Control of Mechanical Manipulators*. PhD Thesis, Mechanical Engineering, University of California, Berkeley.

Isaacs, P.M. and M.F. Cohen. 1987. Controlling dynamic simulation with kinematic constraints. *SIGGRAPH '87 Conference Proceedings, Computer Graphics*.

Lapidus, L. and J.H. Seinfeld. 1971. *Numerical Solution of Ordinary Differential Equations*. Academic Press, New York.

Moore, M. and J. Wilhelms. 1988. Collision detection and response for computer animation. *SIGGRAPH '88 Conference Proceedings, Computer Graphics* 22(4):289–298.

Pars, L.A. 1979. *A Treatise on Analytical Dynamics*. Ox Bow Press, Woodbridge, CT.

Pissanetsky, S. 1984. *Sparse Matrix Technology*. London, Academic Press.

Press, W.H., B.P. Flannery, S.A. Teukolsky, and William T. Vetterling. 1986. *Numerical Recipes*. Cambridge University Press, Cambridge, England.

Wells, D.A. 1969. Lagrangian dynamics. *Shaum's Outline Series*. McGraw-Hill, New York.

Wilhelms, J. 1985. *Graphical Simulation of the Motion of Articulated Bodies Such as Humans and Robots, with Particular Emphasis on the Use of Dynamic Analysis*. PhD Thesis, Computer Science Division, University of California, Berkeley.

Wilhelms, J. 1986. Virya—A motion control editor for kinematic and dynamic animation. *Proceedings of Graphics Interface '86*, Canadian Information Processing Society Toronto, Ontario, Canada, pp. 141–146.

Wilhelms, J. 1987. Using dynamic analysis for animation of articulated bodies. *IEEE Computer Graphics and Applications* 7(6).

Wilhelms, J. 1988. Dynamics for computer graphics: A tutorial. (Also UCSC Computer and Info. Sci., Tech. Report UCSC-CRL-87–5.) *Computing Systems*, Winter, pp. 63–93, 1988.

Wilhelms, J. and B.A. Barsky. 1985. Using dynamic analysis for the animation of articulated bodies such as humans and robots. *Proceedings of Graphics Interface '85*, Canadian Information Processing Society Toronto, Ontario, Canada, pp. 97–104.

Wilhelms, J., M. Moore, and R. Skinner. 1988. Dynamic animation: interaction and control. *The Visual Computer*.

Witkin, A., K. Fleischer, and A.H. Barr. 1987. Energy constraints on parameterized models. *SIGGRAPH '87 Conference Proceedings, Computer Graphics*.

Witkin, A., and M. Kass. 1988. Spacetime constraints. *SIGGRAPH '88 Conference Proceedings, Computer Graphics* 22(4):159–168.

Zeltzer, D. 1982. Motor control techniques for figure animation. *IEEE Computer Graphics and Applications* 2(9):53–60.

Zeltzer, D. 1985. Towards an integrated view of 3-D computer character animation. *Proceedings of Graphics Interface '85*, Canadian Information Processing Society Toronto, Ontario, Canada, pp. 105–115.

14

Using Dynamics in Computer Animation: Control and Solution Issues

Mark Green
Department of Computing Science
University of Alberta
Edmonton, Alberta

ABSTRACT

The use of dynamics is becoming a standard technique in computer animation. This technique has the advantages of producing realistic motion and requiring a modest amount of control input. There have been two main problems associated with the use of dynamics in computer animation. The first problem is controlling the motion produced by the dynamics simulations. Simple motions, from a physical point of view, are easy to produce, but complicated motions can be quite difficult. The dynamics simulations are driven by forces and torques, which are not a natural way of specifying motion for most animators. In order to profitably use dynamics, control techniques that can automatically produce these forces and torques are required. The other main problem is the development of numerical techniques for solving the equations of motion. We would like these techniques to be efficient, so interactive control of the motion is possible, and at the same time they must be very stable. The differential equations used in articulated figure animation tend to be quite stiff, and this leads to stability problems in their solution. At first these two problems appear to be unrelated, but there is a strong relationship between them. The control techniques are the main contributors to the stiffness of the equations and the problems involved in their numerical solution. Similarly, the available solution techniques dictate the control techniques that can be used. For example, if the solution techniques are too slow, interactive

control is not possible. In this chapter, we investigate control techniques and solution techniques for the equations of motion. We also investigate the relationships between them.

14.1 *Introduction*

The use of dynamics and other types of physical simulations is rapidly becoming a standard technique in computer animation. This can be seen from the number of papers at recent SIGGRAPH conferences related to this topic. At first it appears that applying physics (and other mathematical models from the physical and biological sciences) is a straightforward application of the relevant theory. We need only to find the appropriate equations in a physics book and program them. Programming the equations can be quite easy (given that the appropriate set of equations can be found, which is not always the case), but this is only a small part of the problem. The main reason for using physical models is to produce realistic motion for animation. This implies that the animator has some motion that he or she wants the objects to perform, and thus the animator must provide some input to the physical model that causes the objects to perform this motion. This is where the real problems start.

In the case of dynamics, forces and torques are used to control the motions of the objects. The average animator, and indeed the average physicist, has no intuitive feel for the appropriate forces and torques required to produce a given motion. In many of the early implementations of physical models, the animators spent vast amounts of time guessing the forces and torques required to produce even simple motions. This is the main reason why most animations produced using these techniques feature falling objects—the force of gravity is obvious. In order to make physical models generally useful in computer animation, control techniques that do not involve the detailed specification of forces and torques are required. Some of the possible solutions to this problem are outlined in this chapter.

Another major problem with the use of physical models is solving the equations that are used in them. In most if not all cases, a closed analytical solution to the equations are not available, forcing us to use numerical techniques for their solution. There are many techniques available for the numerical solution of differential equations. Again, it seems relatively easy to find an appropriate technique (from your favorite numerical analysis textbook) and implement it. Computer animation places two major restrictions on the techniques that can be used. First, an animation lasts for a significant length of time. Thus the solution interval for the differential equation will be quite long (over 10,000 time steps), and we need a technique that is quite stable and not strongly influenced by round-off error. Second, we would like to have interactive control over the animation. This facilitates the development of motion sequences, which is largely a creative, as opposed to an algorithmic, activity. This implies that the solution

technique that we use must also be time efficient (space efficiency is not a major problem).

If these two problems were independent, they could be tackled individually. Unfortunately, there seems to be a strong relationship between the two problems. A number of the control schemes that we would like to use tend to introduce nonlinearity and stiffness into the differential equations. This greatly complicates their solution and forces us to use more sophisticated techniques. Also, the solution techniques that are available influence the control techniques that can be effectively used. If the equations can be solved in close to real time (within one or two orders of magnitude), then interactive control techniques are possible. If the solutions require overnight batch runs, we are forced to look at automatic techniques that rely on feedback or learning. In our early work, we had trouble debugging one control technique due to the fact that it caused the solution technique to become unstable.

In the next section, we present our approach to the control of dynamic simulations. This approach relieves the animator from working with forces and torques. The third section contains an overview of the equations of motion. This section is not a complete treatment of dynamics for computer animation, it merely serves as the background for the remaining sections of this chapter. The fourth section is a brief survey of some of the numerical techniques that can be used for solving differential equations. Some of these techniques have been used extensively in computer animation, whereas others are fairly new to this area (but, not new in general). The following section discusses the stability of these numerical techniques and how it can be affected by the structure of the equations and the control techniques that are used. Most of these sections contain examples motivated by the work that we have done or by other researchers in the field. We have not attempted to provide a complete survey of each of these topics but instead have provided the basic techniques and ideas required to get started. Hopefully, by discussing our results and experiences, we can save future researchers from following the many blind alleys and problems that we encountered.

14.2 *Control*

As previously mentioned, controlling animations based on physical models is one of the main problems that we face. The animator does not want to work at the level of forces and torques, he wants to use more natural units of control. In this section, we present a theory of how motion can be effectively controlled. This theory is based on our own experience with using dynamics and other forms of procedural models in computer animation. This theory is by no means complete and draws heavily on the work of others. In the presentation of the main structure of the theory, we will attempt to credit those researchers that have been the major influences on our thinking.

Before presenting the theory itself, we briefly outline the aspects of motion control that it must account for. At its lowest level, the theory must be capable of generating the forces and torques that are required in physical simulations, and it should do this in a way that does not directly involve the animator. The animator should be able to control the motion in terms, or vocabulary, that he or she is familiar with. The theory must be able to account for the normal behavior of the objects that we are modeling (for the purposes of this discussion, we assume that all the objects are animate). In the case of fish, it must be able to account for their normal schooling behavior, and in the case of people, the way they normally walk across a room. On top of this, the theory must be able to express the differences between individuals of the same type. For example, all people walk basically the same way, but there are certain characteristics of each person's walk that are particular to him. These individual characteristics we call the character or personality of the person.

We also need to be able to deal with the interactions between objects. A good example of this is two people dancing together. Each person is not in complete control of his or her own motion—the dancers must be anticipating the motion of their partners. The animator also needs the ability to control the objects in the animation at different levels of detail. In some cases, the animator will want detailed control of the motion of an object, and he or she will want to be able to specify positions and orientations at particular points in time. In other cases, the animator is interested only in the general motion of an object. The animator may want a crowd of people walking down a busy street. In this case, he or she is not interested in the motion of an individual person but in the general direction of their motion.

The basic structure of our theory of motion control is presented in Figure 14.1. From this figure, it can be seen that this theory is basically hierarchical in nature. The main difference between this model and more traditional hierarchies is that each level is viewed as a separate process that is executing in parallel. The time scales for the different layers of the hierarchy may be quite different, depending on the time scales of the phenomena being modeled. For example, the physical model will execute at least 30 times per second, and the character model may execute once every few seconds. The various levels in the model communicate by passing messages back and forth. Each level is also viewed as a collection of processes, each responsible for one small aspect of the object's motion. In this way, our theory is similar to Minsky's *The Society of Mind* (1985), though it was developed separately.

The bottom three levels of this model are essentially the same as the corresponding levels in the model presented by Alan Barr (1988). The lowest level contains the graphical primitives that are rendered by the graphics system. The next level consists of the three-dimensional modeling primitives that are used to represent the shape of the object. These primitives could be polygons, surface meshes, or surface patches. The third level of the model represents that basic physics or biology that produces the motion of the object. We can assume that

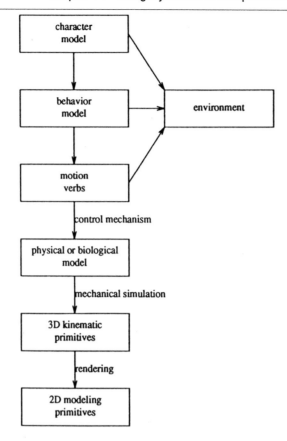

Figure 14.1 Basic Structure of Our Control Model

these are the standard equations of motion, as presented in the next section. These three levels are fairly standard in current physically based modeling systems and contain nothing that is particularly interesting from the control point of view.

The remaining levels of the model are examined in more detail. We present a common example showing how the different levels interact, along with descriptions of the levels. The example selected for this purpose is ballroom dancing. This example was chosen for the following five reasons. First, ballroom dancing has a small, well-defined repertoire of motions, which are rich enough to provide interesting motion. Second, ballroom dances consist of the repetition of a number of standard patterns. This easily fits into our hierarchical theory of motion (we may be accused of cheating on this point). Third, ballroom dancing requires the cooperation of two individuals, thus it provides us with some interesting synchronization problems. Fourth, this is one of the original problems that we considered when we started applying dynamics to human motion five years

ago (it would be nice to come up with a solution to indicate that we have made some progress over the years). Fifth, highly detailed descriptions of ballroom dances are available in a form that can potentially be computerized (Thornhill-Geiger, 1981). More details on the ballroom dancing system can be found in Green and Lake (1989).

The motion verb level of the model represents the basic motion vocabulary of the object. Each motion verb represents one type of motion that the object is capable of performing. In the case of human motion, the motion verbs could be reaches, walking, or dance steps. The motion verbs produce the forces and torques that are required to drive the physical model and produce the desired motion. Each type of object will have its own set of motion verbs that represent its motion vocabulary. For example, the set of motion verbs for fish is radically different from the set for humans. The motion verbs can be used as the basis for an animation system that is reasonably easy to use, thus providing the animator with a convenient interface to the physical model. Such a system is described by Green and Sun (1988).

For the ballroom dancing example, there are two ways in which the motion verbs could be developed. One approach is to produce a motion verb for each of the possible dance steps. This approach provides a high level interface to the human model, but each of the motion verbs will need to perform a significant amount of computation to convert the dance step into the appropriate forces and torques. The other approach is to break the individual dance steps down into a number of more primitive movements. These movements correspond to the motions of the feet and arms. In the case of ballroom dancing, there are a small number of motions that feet and arms perform, thus this is a reasonable approach. These motions are called positions, but they really correspond to moving a limb from its current position to a new position. Once we have the positions defined, we can build the dance steps on top of them. This approach introduces an extra level into the problem, but it has two major advantages. First, a number of the dance steps involve the same positions; therefore, the production of motion verbs for the positions removes a large amount of redundancy in the development of the dance steps. Second, the individual motion verbs are responsible for smaller amounts of motion, which facilitates their development and debugging. The dance steps could be either at the motion verb level or at the behavior model level. Since the individual dance steps do not involve goal setting (just the sequencing of positions), the motion verb level is the appropriate place for them.

The motion verbs can be implemented by a set of virtual processes that operate on the modeling primitives in the physical model. Each motion verb has its own set of processes, which are responsible for producing the forces and torques required by the motion verb. When a motion verb is active, its motion processes are executing. When the motion verb is inactive, its processes are suspended. The definition of the motion processes can be based on the types of the modeling primitives used in the physical model. This approach is described

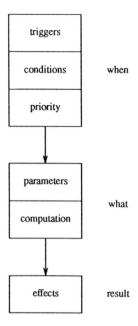

Figure 14.2 Structure of a Behavior Process

in more detail by Green and Sun (1988), along with a special purpose animation language based on these ideas.

The behavior model is used to control the set of motion verbs that are active at any point in time. The behavior level of the model represents the short-term goals of the object. The motion verbs provide the vocabulary of motion, but they are not responsible for achieving any particular goal. The behavior level is responsible for setting short-term goals and then using the motion verbs to achieve these goals. This level of the model can also be viewed as a collection of processes, each of which is responsible for one aspect of the object's motion. For example, there could be behavior processes for avoiding collisions, exploring the current environment, finding food, or dancing.

There are many ways of modeling the behavior processes. They could be left as arbitrary processes that can freely interact with each other. This approach imposes essentially no structure on the behavior model and therefore makes it difficult to produce tools that facilitate the production of the behavior model. In order to produce powerful tools, we need to impose some structure on the behavior processes. The model of behavior processes that we use is shown in Figure 14.2. This model can be divided into three main sections—when, what, and result.

The *when* section of the behavior determines when the behavior will be active. This section consists of a set of triggers, a set of conditions, and a priority. The triggers are used to activate the behavior process. They are based on conditions in the environment and the other processes in the behavior model. When one of the triggers for a behavior process fires, the process checks to see if it can do anything useful. The conditions are used for this purpose. They are logical expressions based on the state of the environment, the object, and the other active behavior processes. Both the conditions and triggers look like logical expressions on the environment and the object. The main difference is that the triggers are usually quite simple. They form a quick test of whether the process should be active at the current point in time. The conditions are a more thorough examination of the environment and object, to determine whether the process can contribute to the current situation. Also, another behavior process can cause one of the triggers in another process to fire. This allows for the sequencing of processes and the cooperative action of groups of processes. The priority is used as a higher level control over the activation of the process. If the character model decides that it does not want a particular process to be active, it can set its priority to zero. If the character model strongly prefers a particular behavior, it can assign it a high priority value. At each time step, only a limited number of behavior processes will be executed. Those with the highest priority will be executed first.

The *what* section of the behavior performs the computations for the behavior process. This section is divided into two parts, called parameters and computations. The parameters are accessible to the character model and can be used to modify the action of the behavior process. The computation part consists of a sequence of statements that are executed by the behavior process in each time step that it is active.

The final section of the behavior process produces the *results* of the behavior. This consists mainly of calls to motion verbs and sending triggers to other processes in the behavior model.

In the ballroom dancing example, the main function of the behavior model is to determine the sequence of dance steps to be performed. In ballroom dancing, the exact sequence of steps is usually left up to the individual dancers. There are several things that must be taken into consideration when deciding upon the next dance step to perform. One factor is the current state of the dance floor. If we are close to other dancers or the edge of the dance floor, certain steps are not appropriate, and others will help move us to better locations. Another factor is the current dance step that we are performing. Certain sequences of dance steps are awkward or hard to perform; thus the current dance step will influence the choices for the next dance step. A third factor is the current state of our partner. If our partner is a good dancer, we can be more aggressive in our choice of dance steps. If our partner is tired or not a good dancer, we are restricted to the more basic steps. The behavior processes must take all these factors into consideration when it is choosing the next step. Choosing the next dance step is the responsi-

bility of the male dancer. The female dancer must follow the lead provided by her partner. If the partner is a good dancer, this is not very difficult since he will provide the signals that indicate the dance steps that he is about to perform. If the partner is not a good dancer, the female dancer must be able to anticipate his moves, which is not always possible.

The character level of the model is responsible for the long-term goals of the objects and its personality traits. The character processes influence the way the behavior processes operate. This influence could take the form of activating and deactivating particular behavior processes, depending on the object's current mood. It can also take the form of modifying parameters in the behavior processes or their priority.

In the ballroom dancing example, if there is no character model, all the dancers would perform in the same way, which is not what would normally be expected. Some dancers have a better feel for the music and flow from one step to the next, and others are more awkward and tend to have definite discontinuities between the steps. The current mood of the dancer can also influence his or her motions, such as the depth of a dip in the tango. Also, dance performance could depend on the physical properties of the dance partner or on the conditions under which the dance is performed (for example, in a competition the dance may not be as smooth due to nervousness).

14.3 *Equations of Motion*

In this section, we briefly present the equations of motion that can be used for animating different types of objects. The main purpose of presenting this material is to provide the background required for the remaining sections of the chapter. The properties of these equations are needed when we discuss various solution techniques and their properties. We start by presenting the equations of motion for a particle. This is followed by the equations of motion for rigid bodies. Finally, the equations of motion for articulated bodies (such as people and animals) are briefly discussed. A much more complete treatment of these equations can be found in the standard textbooks on dynamics (Goldstein, 1959; D'Souza and Garg, 1984; Wittenburg, 1977).

14.3.1 *Particles*

The simplest object that we will consider is the particle. A particle can be viewed as a point with a mass. Only the translational motion of a particle is significant, any rotation of the particle is ignored. The position of the particle is represented by the vector x, its velocity is represented by the vector v, and its acceleration is represented by the vector a. The mass of the particle is represented by the scalar m, and the forces acting on the particle are represented by the vectors F_i. The equations of motion for a particle are:

$$ma = m\frac{dv}{dt} = \sum_i F_i$$
$$\frac{dx}{dt} = v$$

We have written these equations in a particular way that suggests the approach that will be used in their solution. The equations of motion are second order ordinary differential equations, and the motion for a particle could be solved as a single differential equation. A second order differential equation can always be written as two first order differential equations and then solved as a system of equations. Since we know more about numerical techniques for solving first order equations, this approach is normally taken. This issue will be explored further in Section 14.4. We can write the above equations as a second order differential equation in the following way:

$$m\frac{d^2x}{dt^2} + d\frac{dx}{dt} + sx = \sum_i F_i$$

In this equation, the terms involving

$$\frac{dx}{dt}$$

and x have been removed from the F_i and placed directly into the differential equation. The terms involving these quantities are called the damping and stiffness terms of the differential equation.

14.3.2 *Rigid Bodies*

For rigid bodies, the equations are slightly more complicated, and there are many ways they can be written. In the case of a rigid body, all the mass is not concentrated at one point, and the rotation of the body is significant.

Two types of coordinate systems are used in rigid body dynamics. The first type of coordinate system, called an inertial system, is fixed in space. This is similar to the world coordinates that are used in computer graphics. The second type of coordinate system, called a body coordinate system, is attached to one of the bodies and moves and rotates with the body. The origin of the body coordinate system is usually the center of mass of the body, though this is not always the case. The basis vectors for this coordinate system are usually the principal axes of the object (to be described below). Each body in the system has its own body coordinate system. The body coordinates can be transformed into inertial coordinates by the use of a rotation and a translation. Note that this transformation will change over time as the body moves through space. For body i, the center of mass is represented by the vector c_i, and its orientation is represented by the 3 x 3 matrix R_i. Then the inertial coordinates, p, corresponding to the body coordinates, p', are:

$$p = c_i + R_i p'$$

For graphics, this is a convenient way of dividing up the motion of the object. In the display part of the animation system, the geometry of the object can be described once, and then in each frame of the animation the rotation matrix R_i and the translation c_i can be applied to this model to obtain its image in that frame.

Since we have divided the position of a point on the object into two parts (a translation and a rotation), it seems natural to describe its motion in the same way. The center of mass behaves in the same way as a particle, therefore, we can use the equations of motion from the previous section to describe its motion. Thus, for the center of gravity c_i, of body i we have the following equations:

$$m\frac{dv_i}{dt} = \sum_j F_j$$

$$\frac{dc_i}{dt} = v_i$$

where F_j are the forces acting on the body.

The rotational part of the motion is more complicated, and there are many ways it can be expressed. These differences are based on the coordinate system that is used for expressing the rotational part of the motion and the scheme that is used for representing the orientation of the body.

In order to formulate the rotational part of the equations of motion, we need to know the distribution of mass through the body. A long slender body has a different rotational motion from a cube or sphere. The distribution of mass is represented by the inertial tensor, which is a 3 x 3 matrix, I, with the following components:

$$I = \begin{bmatrix} \int (y^2 + z^2)dm & -\int xy\,dm & -\int xz\,dm \\ -\int xy\,dm & \int (x^2 + z^2)dm & -\int yz\,dm \\ -\int xz\,dm & -\int yz\,dm & \int (x^2 + y^2)dm \end{bmatrix}$$

All the above integrations are performed over the volume of the body. In an inertial coordinate system, I will change over time since in general the body will be rotating. In a body coordinate system that rotates with the body, I will be a constant. For this reason, we compute I in the body coordinate system and then transform it to any other system in which it is required.

There exists a coordinate system in which I is a diagonal matrix. The basis vectors for this coordinate system are called the principal axes of the body, and the diagonal elements of I are called the principal moments of inertia. As we shall see shortly, it is often convenient to choose the principal axes of an object as the basis of the body coordinate system.

The main equation for the rotational part of the motion is:

$$\frac{dH_i}{dt} = \sum_j T_j$$

In this equation, H_i, is the angular momentum of the body, which is given by $I\omega$, where ω is the angular velocity of the body. In this case, both I and ω must be expressed in the inertial coordinate system. The T_j are the torques acting on the body. The torques can be divided into two components, the pure torques applied at the center of mass and the torques resulting from forces applied at a point other than the center of mass. If a force F_i is applied at a point p_i (with respect to the center of mass), then the generated torque T_i will be:

$$T_i = p_i \times F_i$$

If the principal axes are used as the basis for the body coordinate system, then the equations for the rotational part of the motion reduce to Euler's equations, which are:

$$I_x\dot{\omega}_x + (I_z - I_y)\omega_y\omega_z = T_x$$
$$I\dot{\omega}_y + (I_x - I_z)\omega_x\omega_z = T_y$$
$$I_z\dot{\omega}_z + (I_y - I_x)\omega_x\omega_y = T_z$$

In these equations, ω is expressed in the local coordinate system of the object (the body coordinate system).

In order to render the bodies in the animation, the matrix R is quite useful. This matrix can be obtained from the following equation:

$$dR/dt = \omega^*R$$

In this equation, ω^* is the dual of ω, which is defined in the following way:

$$\omega^* = \begin{bmatrix} 0 & \omega_z & -\omega_y \\ -\omega_z & 0 & \omega_x \\ \omega_y & -\omega_x & 0 \end{bmatrix}$$

Usually the motion of the object is controlled by supplying values for the forces and torques that act on the object. In this case, the control scheme easily integrates with the equations of motion. One case where this is not the best approach is collisions between objects. In this case, the velocities of the objects are modified to reflect the effects of the collision (Hahn, 1988; Moore and Wilhelms, 1988). This can cause some problems in the numerical techniques that are used to solve the equations of motion (these problems are discussed in Section 14.5.3).

14.3.3 *Articulated Figures*

The equations of motion for articulated figures are much more complicated than the equations for particles and rigid bodies. The complications arise from the interactions between the different parts of the body. Numerous formulations of the equations of motion for articulated bodies have appeared in the literature. Researchers in robotics have produced formulations motivated by the structure of common robots (see Paul, 1981, for an introduction to these approaches).

These techniques work well for robots, but they are not ideally suited to human and other animal bodies. This is largely because these bodies can have several degrees of freedom at each joint, and there are a large number of joints in each body.

The Gibbs-Appell approach has been used successfully in the animation of human figures (Wilhelms, 1987; Wilhelms and Barsky, 1985). This approach is quite general but tends to be expensive since it involves the inversion of a large matrix (usually sparse) on each time step of the animation.

A number of recursive schemes have been developed for articulated figures. These approaches have the advantage of efficiency. They are usually linear in the number of joints in the figure. Their main disadvantages are they are not as well behaved numerically and are not as easy to manipulate (mathematically) as the Gibbs-Appell formulation. Recursive techniques have been used by Armstrong and Green for the animation of human figures (Armstrong and Green, 1985; Armstrong, Green, and Lake, 1987).

Wittenburg (1977) presents an extensive discussion of the dynamics of tree-structured objects. This approach has been used by Isaacs and Cohen (1987) for human figure animation.

All the formulations of dynamics for articulated figures produce large systems of second order differential equations. There will be one second order differential equation for each degree of freedom in the body. Even simple models of the human body have 40 to 50 degrees of freedom. Therefore, the size of this system of equations is an important consideration when choosing a solution technique. Also, each of the equations tends to be fairly complicated, involving terms from adjacent limbs and the control techniques. Thus, the evaluation of each equation may take a considerable amount of time.

14.3.4 *Initial Value Problems Versus Boundary Value Problems*

In general, a differential equation will have a family of solutions. In animation, we are interested in one particular member of this family of solutions. A unique solution to a differential equation can be determined by applying a set of constraints to its solution. This is usually done by specifying the initial value of the solution (the value at the start of the animation). The combination of the differential equation and the initial values is called an initial value problem. In the case of second order differential equations, two initial values must be specified, which are the initial value of the solution and its derivative. In the case of dynamics, for an initial value problem we must specify the position and velocity for each degree of freedom in the body. For many animations, this is a natural way of specifying the problem to be solved. That is, the animator knows the situation at the start of the animation and wishes to know how the motion evolves, given the control schemes that have been specified.

Another way of constraining the solution of a differential equation is to specify its values at both the beginning and the end of the animation. This type

of constraint is called a boundary value constraint since it specifies that value of the solution at its end points or boundaries. The combination of the differential equation and the boundary value constraints is called a boundary value problem. In the case of dynamics, two boundary values are needed for each degree of freedom in the body. These boundary values could be the position of the object at the beginning and end of the animation. The object's velocities, or a combination of positions and velocities, could also be used, as long as there are two independent constraints for each degree of freedom. Boundary value problems are potentially useful in computer animation. In some ways they resemble key-frames—positions can be specified at the end of intervals in the same way that keyframes specify the positions of objects at key points in time. The ballroom dancing example from Section 14.2 is a good example of this approach. The position of the body is known at key points in each of the dance steps. These positions could be used as the boundary values in a dynamic animation of the dance step. This approach is similar to the spacetime constraints of Witkin and Kass (1988). Boundary value problems will not be discussed further in this chapter. Numerical solution techniques for boundary value problems are discussed in Conte and Boor (1972) and Press et al. (1986).

14.4 *Numerical Methods for Ordinary Differential Equations*

A large number of methods have been developed for the numerical solution of ordinary differential equations. Given the importance of this problem and the length of time it has been worked on, one would expect that good solutions would be well established and that there would be few open research problems. Unfortunately, this is not the case. The numerical solution of well-behaved differential equations is well understood, but the equations encountered in dynamics are usually not well behaved (the notion of well behaved is defined in Section 14.5). A good survey of the open problems in the numerical solution of ordinary differential equations has been presented by Gear (1981).

In this section, some of the methods that can be used to solve the differential equations that arise in dynamics are presented. This is not a complete survey of all the methods that have been used to solve these equations. Our emphasis is on the main techniques that have been extensively used and some of the new techniques that offer some promise. Some of these methods are experimentally evaluated in Section 14.5. The presentation of the numerical methods is divided into two parts. The first part deals with the methods that can be used for systems of first order differential equations. As noted in the previous section, we can always write the dynamics equations as a system of first order equations. The second part deals with the methods that can be directly applied to second order differential equations. Since these methods are tuned to the types of equations we encounter in dynamics, they offer some promise of being more efficient. Good introductions to the numerical methods used to solve ordinary differential equa-

tions can be found in Conte and Boor (1972), Gear (1971), Fatunla (1988), and Butcher (1987).

14.4.1 *Systems of First Order Equations*

In this section, we survey some of the standard methods that have been used to solve systems of first order differential equations. In order to simplify the presentation, the methods will be described in terms of a single equation. All these methods can be generalized to systems of equations by applying the method to each of the equations in parallel.

Each of the methods solves the following initial value problem:

$$\frac{dx}{dt} = f(x,t)$$

$$x(t_0) = x_0$$

The exact solution of this initial value problem is represented by the function $g(t)$. We are interested in producing an approximation to $g(t)$ on the interval $[t_0, t_n]$. This interval is divided into n subintervals (in the presentation of the techniques, we assume that all the subintervals are the same size, but this is not the case in practice). Each of these subintervals is called a time step. The size of each time step, h, is given by

$$h = \frac{(t_n - t_0)}{n.}$$

The techniques start with the known value of x at $t = t_0$ and then produce an approximation, x_1, to the solution of the equation at $t = t_0 + h$. The value of x_1 is then used to produce the estimate x_2 at $t = t_0 + 2h$. This process continues until the value of x_n is produced. The techniques are sequential, producing the solution values in the order $x_0, x_1, x_2, ..., x_n$. Note that this is a discrete approximation to the solution $g(t)$. We have produced solutions only at the ends of the time steps— we do not have approximations to $g(t)$ on the interior of the time steps. This can lead to the standard aliasing problems found in other areas of computer graphics.

If a method uses only the values of f that are known at the beginning of the time step, it is called an explicit method. If a method uses the value of f at the end of the current time step, it is called an implicit method. At the beginning of the time step, there is no way of directly computing the value of f at the end of the time step. As a result, implicit methods must use some iterative scheme or solve a system of equations that involves both the values of x and f at the end of the time step.

14.4.1.1 *Euler's Method* The oldest and best known numerical method for ordinary differential equations is Euler's method. This method is based on the Taylor series expansion of the solution, $g(t)$, about the approximate solution x_i at the left end of the time step. This expansion is:

$$g(t_i + h) = g(t_i) + h\, f(g(t_i),t_i) + O(h^2);$$

The solution value $g(t_i)$ is approximated by x_i, thus this expansion can be approximated by:

$$x_{i+1} = x_i + h\, f(x_i,t_i) + O(h^2)$$

By considering only the first two terms in this expansion, a first order solution method is produced.

Euler's method has two main advantages. It is easy to program; f is evaluated once, multiplied by the step size, and added to the current approximation. It can also be very efficient (on a certain set of problems) since it evaluates $f(x,t)$ once for each step of the solution. The main disadvantages of this technique result from the assumption that $f(x,t)$ varies slowly over a time step. That is, in going from t to $t + h$, $f(x,t)$ can be viewed as constant. Thus, for slowly varying equations, Euler's method is a reasonable choice, but, for equations that vary rapidly or have discontinuities, Euler's method should be avoided.

One of the most important techniques in numerical methods for ordinary differential equartions (ODE) is automatic step size control. This technique can be nicely illustrated by considering Euler's method. The third term in the Taylor series is:

$$\frac{h^2}{2} f' (g(t_i),t_i)$$

This term can be used as a measure of the error in the approximation to the solution. We can approximate f' numerically based on the solution values that have been produced (using numerical differencing). This estimate of the error can be compared with the maximum error that is acceptable for each time step. The difference between these values can be used to compute the maximum step size, h, that will produce an acceptable error. Obviously, the step size will be inversely proportional to the value of f'. If the desired maximum error for a time step is *toler*, then the step size, h, is given by:

$$h = \sqrt{\frac{2 \cdot toler}{f'}}$$

On each step of the algorithm, this expression is evaluated to determine the size of the next time step. If the error on the current step is larger than the maximum allowed error, the step is repeated with the smaller step size. When increasing the step size, it is a good idea to be on the conservative side. If too large a step is made, then it must be repeated with a smaller step size, which is a waste of computer time.

14.4.1.2 *Runge-Kutta Method* The Runge-Kutta method is one of the most popular methods for solving ordinary differential equations. This method can solve most ordinary differential equations, but in most cases it is not the most efficient algorithm. Thus, its popularity and power come from its general

applicability and not its efficiency. Runge-Kutta is a family of methods, all of which share the same basic solution technique. The approach used in these methods is to evaluate f at a number of points within each time step. In Euler's method, f was evaluated only at the beginning of the time step, whereas in Runge-Kutta methods f is evaluated at least twice in each time step.

The most common Runge-Kutta method consists of the following computations, which are performed in each time step:

$$k_1 = hf(x_i, t_i)$$
$$k_2 = hf(x_i + \frac{k_1}{2}, t_i + \frac{h}{2})$$
$$k_3 = hf(x_i + \frac{k_2}{2}, t_i + \frac{h}{2})$$
$$k_4 = hf(x_i + k_3, t_i + h)$$
$$x_{i+1} = x_i + \frac{1}{6}(k_1 + 2k_2 + 2k_3 + k_4)$$

For this method, the error is $O(h^5)$, so we would expect to be able to take larger step sizes with this method than with Euler's method. However, we must evaluate f four times in each step, which is four times the amount of work. Automatic step size control is not as easy with Runge-Kutta techniques. One of the standard ways of doing it is to use two different step sizes to produce two approximations to the solution over a short interval. Typically, the main part of the algorithm uses a step size of h, and the error estimation part uses a step size of $2h$. Every two time steps, the difference between the two solutions is used as an estimate of the error in the solution. This error is proportional to h^5, which can be used to compute a new step size. Again, if the error is too large, the previous two time steps must be repeated with a smaller step size.

In general, an explicit Runge-Kutta method will perform the following computations on each time step:

$$k_0 = hf(x_i, t_i)$$
$$k_q = hf(x_i + \sum_{j=0}^{q-1} \beta_{qj}k_j, t) \qquad q = 1, \ldots, r-1$$
$$x_{i+1} = x_i + \sum_{q=0}^{r-1} \gamma_q k_q$$

This is called an r stage method since f must be evaluated at r points within the interval. The constants β_{qj} and γ_q are chosen in a way that gives the method some desired set of properties, such as accuracy. Some of the ways this can be done are described in Gear (1971) and Butcher (1987).

14.4.1.3 _Multistep Methods_ In the Runge-Kutta methods, the accuracy of the solution was improved by using several values of f within each solution interval. The problem with this is, it involves a large amount of computation in

each time step (which can be a major problem if computing f requires a considerable amount of time). The multistep methods increase the accuracy of the solution by using multiple values of f, but only one f value per time step is used. That is, in each step of the algorithm, one new value of f is computed. This value of f, along with previous values of f, are used to compute the new value of x. In some multistep methods, previous values of x are also used. These methods essentially fit a polynomial to the f values and then compute the area under this polynomial and add the result to x_i.

The general explicit multistep method can be written in the following way:

$$\sum_{i=0}^{k} \alpha_i x_{n-i} = \sum_{i=1}^{k} \beta_i f(x_{n-i}, t_{n-i})$$

with the condition that $\alpha_0 \neq 0$.

The main difference between the different multistep methods is the choice of k, α_i, and β_i. In order to simplify the notation in this and subsequent sections, we use the following abbreviation for the values of f.

$$f_i = f(x_i, t_i)$$

One of the more popular multistep methods is the Adams-Bashforth method. This method has the following form:

$$x_{i+1} = x_i + \frac{h}{24}(55f_i - 59f_{i-1} + 37f_{i-2} - 9f_{i-3})$$

In order to use this method, we must save three past values of f. At each step of the algorithm, one new value of f is computed, and the oldest value of f is discarded. One drawback of this approach is the space required for storing past values of f. Another problem is that three past values of f are required before we can start using this method. Typically, some other method, such as Runge-Kutta, is used to generate the values of x and f for the first three time steps, and then Adams-Bashforth is used for the remaining time steps. As a result, we say that multistep methods are not self-starting.

Automatic step size selection is more complicated in multistep methods. When the step size changes, the saved values of f are no longer usable. There are two common solutions to this problem. One solution is to restart the computation using another method, such as Runge-Kutta. The other approach is always to halve or double the step size. In this approach, some of the saved values of f can still be used. Consider the Adams-Bashforth method, which requires three saved f values. If the step size increases, the next step will use the current f_n and f_{n-2} and will need the value of f_{n-4}. If we always save one extra f, doubling the step size will not be a problem. If the step size decreases, we can still use the current values of f_n and f_{n-1} in the next step. But, we will also need the value of f between these two values. This could be computed using one step of Runge-Kutta.

Another problem with multistep methods is determining when to increase or decrease the step size. In the Adams-Bashforth method, the error is of order

$O(h^5)$. This means that we must estimate the fifth derivative of f. This can be done, but estimates of higher order derivatives are subject to numerical error, therefore, basing step size calculations on a fifth derivative may not be ideal.

14.4.1.4 Predictor-Corrector Methods

The predictor-corrector methods are the easiest class of implicit methods to program, and they can be quite efficient. The basic approach used in these methods is essentially the same as in the multistep methods. Values of f are used to produce a polynomial, which is then integrated to give the change in the solution over the current time interval. In the multistep methods, the value of f at the beginning of the current time interval and past values of f were used to construct in the polynomial. In the predictor-corrector methods, the value of f at the end of the current time interval is also used. Thus, in the general predictor-corrector method, we have the following formula:

$$\sum_{i=0}^{k} \alpha_i x_{n-i} = \sum_{i=0}^{k} \beta_i f(x_{n-i}, t_{n-i})$$

Note that this formula is similar to the multistep formula, except that the value of f at the end of the time interval is also used. This produces a solution method that is both more accurate and more stable.

The main problem with implicit methods is that the value of f at the end of the time interval is unknown. In predictor-corrector methods this, problem is solved by first estimating the value of f_{i+1} using a standard multistep method and then using this estimate in the implicit formula. This will result in a more accurate estimate of x_{i+1}, which can in turn be used to produce a more accurate estimate of f_{i+1}. In principle, we could iterate the corrector until convergence is reached. In practice, this is not done since each iteration requires the evaluation of f, and we are usually better off if we decrease the step size rather than iterating multiple times.

One of the standard corrector formulas is the Adams-Moulton formula, which has the following form:

$$x_{i+1} = x_i + \frac{h}{24}(9f_{n+1} + 19f_n - 5f_{n-1} + f_{n-2})$$

The Adams-Moulton formula is often used with the Adam-Bashforth formula as a predictor. Many more predictor-corrector formulas can be found in Gear (1971), along with a detailed discussion of their properties. Gear also describes a particular predictor-corrector method called Gear's method, which for many years was the standard technique for solving stiff differential equations (it is still quite popular).

Predictor-corrector methods have the same problems with automatic step size control that multistep methods have, except the error is easier to estimate. When changing step size, we still need to recompute some of the past values of f or use another method to restart the computation. The error can be estimated by numerically computing the derivative associated with the error value of the

method and then using the value to compute the step size. Gear (1971) contains an extensive discussion of how this can be done. The error can also be estimated by taking the difference between the predicted value of x_{i+1} and its corrected value. The error in the corrected value should be less than this difference.

14.4.1.5 *Other Methods* A large number of numerical methods have been developed for the solution of ordinary differential equations. Most of the methods that have been developed recently are intended for stiff differential equations (stiff differential equations are described in Section 14.5.1). The methods described in the previous section are typical of the techniques that have been used to develop other methods. This section briefly discusses some of the other methods that could be useful in the solution of the differential equations found in dynamics.

There are several factors that should be considered when a new method is investigated. The first is the complexity of the method. A highly complex method may take a considerable amount of time to program and debug and may not result in large improvements in performance. Some methods use parameters whose values must be determined before the method can be used. Parameter determination can be a time consuming and frustrating process. A second important consideration is the number of times the method evaluates the differential equation. In the case of articulated figures, each evaluation can be quite expensive. Therefore, a method that requires several evaluations per time step may not be very efficient. A third consideration is the amount of experience with the method. New methods have typically been used on a few problems when they are published. Quite often there is not enough experience with the method to indicate how well it will work with dynamics problems. It is usually a good idea to gain some experience with the method on a few simple test cases (the test suite described in Section 14.5.4 could be used for this purpose). This provides some experience with the method and a controlled environment for tuning its parameters (such as the step size algorithm).

Most of the methods that have been developed for stiff differential equations are implicit. This implies that iteration must be used on each time step. For stiff differential equations, simple iteration of the corrector formula may not converge. In most cases, a form of Newton iteration must be used to guarantee convergence and decrease the number of iterations required. Shampine (1979) discusses some of the problems associated with this iteration process. For articulated figures, implicit techniques are not very attractive due to the need for iteration. Each iteration requires an evaluation of the differential equation, which is an expensive operation. A slowly converging method would be very expensive in this case. Implicit techniques are more useful when the differential equation can be easily evaluated.

An attractive class of methods are the cyclic multistep methods (Tischer and Gupta, 1985). These methods make use of several multistep methods, such as those described in Section 14.4.1.3. The multistep methods are applied cyclically

to the differential equation. If M methods are used, the resulting cyclic method is called an M-stage method. In this case, a given multistep method is used every M time steps. Cyclic methods have better stability properties than the individual multistep methods that are used in them. The main advantages of this type of method are that the differential equation is evaluated once in each time step and the multistep methods are fairly easy to program. This fits in quite well with the types of problems encountered in dynamics.

Another interesting class of methods is contractive methods (Nevanlinna and Liniger, 1978; 1979). These methods are both stable and able to handle a range of discontinuous and nonsmooth equations. The contractive methods are implicit and require iteration, but since they solve two of the major problems in the differential equations in dynamics they may be worth investigating.

14.4.2 *Systems of Second Order Equations*

A number of numerical methods have been developed for directly solving systems of second order differential equations. In this case, we are interested in differential equations of the following form:

$$M\ddot{X} + C\dot{X} + K = F(t)$$

where X is a vector of the positions of the objects, or parts of objects, in the system, and the dot over X indicates a time derivative, M is the mass matrix for the system, C is the damping matrix, and K is the stiffness matrix. The vector $F(t)$ is the forces applied to the system. In this formulation, M is a constant, but C and K can vary over time. For a complete initial value problem, the initial values of X and \dot{X} must be specified.

Most of the techniques for directly solving second order differential equations are based on forming difference expressions for \ddot{X} and \dot{X} in terms of X. These difference expressions are then substituted into the original differential equation, which is solved for X. In this section, an explicit and an implicit method based on this approach are presented. Other techniques for directly solving second order equations are discussed in Brusa and Nigro (1980), D'Souza and Garg (1984), and Thomas and Gladwell (1988).

14.4.2.1 *Central Difference Predictor* The central difference method is an explicit method. In this method, the following central difference expressions are used:

$$\dot{X}_i = \frac{1}{2h}(X_{i+1} - X_{i-1})$$

$$\ddot{X}_i = \frac{1}{h^2}(X_{i+1} - 2X_i + X_{i-1})$$

When these difference expressions are substituted into the differential equation, the following difference expression results:

$$(\frac{1}{h^2}M + \frac{1}{2h}C)X_{i+1} = F(t_i) - (K - \frac{2}{h^2}M)X_i - (\frac{1}{h^2}M - \frac{1}{2h}C)X_{i-1}$$

This can be written in the following way:

$$mX_{i+1} = q$$

where

$$m = \frac{1}{h^2}M + \frac{1}{2h}C$$

$$q = F(t_i) - (K - \frac{2}{h^2}M)X_i - (\frac{1}{h^2}M - \frac{1}{2h}C)X_{i-1}$$

This is a system of linear equations that can be solved by inverting m and multiplying it into q. On each step of the algorithm, the m and q matrices must be evaluated, m inverted, and the inverse multiplied into q. For small systems of equations, this is not an extensive computation, but for large systems of equations the inversion of m can be quite time consuming. The central difference method has an accuracy of $O(h^2)$, so standard step size control algorithms can be used with it. Since X_{i-1} is used in the evaluation of q, this method is not self-starting.

14.4.2.2 _Park Stiffly Stable Method_ The Park method is an implicit method that makes use of some of the stiff methods developed by Gear (1971). It uses a combination of Gear's two-step and three-step methods, which results in good response to both the low and high frequency components of the solution.

In this method, the following difference formulas are used:

$$\dot{X}_{i+1} = \frac{1}{6h}(10X_{i+1} - 15X_i + 6X_{i-1} - X_{i-2})$$

$$\ddot{X}_{i+1} = \frac{1}{6h}(10\dot{X}_{i+1} - 15\dot{X}_i + 6\dot{X}_{i-1} - \dot{X}_{i-2})$$

When these difference formulas are substituted into the differential equation, the following difference equation results:

$$(\frac{100}{36h^2}M + \frac{10}{6h}C + K)X_{i+1} = F(t_{i+1}) + \frac{15}{6h}M\dot{X}_i - \frac{1}{h}M\dot{X}_{i-1} + \frac{1}{6h}M\dot{X}_{i-2}$$

$$+ (\frac{150}{36h^2}M + \frac{15}{6h}C)X_i - (\frac{10}{6h^2}M + \frac{1}{h}C)X_{i-1} + (\frac{1}{36h^2}M + \frac{1}{6h}C)X_{i-2}$$

This difference equation can be written in the following form:

$$mX_{i+1} = q$$

where

$$m = \frac{100}{36h^2} M + \frac{10}{6h} C + K$$

$$q = F(t_{i+1}) + \frac{15}{6h} M\dot{X}_i - \frac{1}{h} M\dot{X}_{i-1} + \frac{1}{6h} M\dot{X}_{i-2}$$

$$+ (\frac{150}{36h^2} M + \frac{15}{6h} C)X_i - (\frac{10}{6h^2} M + \frac{1}{h} C)X_{i-1} + (\frac{1}{36h^2} M + \frac{1}{6h} C)X_{i-2}$$

Since q depends on quantities evaluated at $i + 1$, solving this difference equation involves iteration. If we can assume that C and K stay constant within a time step, m needs to be inverted only once per time step. Otherwise it must be inverted for each iteration within the time step. Obviously, for large systems of equations, this can be quite expensive. Also note that this method is not self-starting, and past values of X and \dot{X} must be saved.

14.5 *Stability and Control Issues*

Any numerical method for solving ODEs will work on well-behaved linear differential equations. Problems arise when the differential equations are nonlinear or stiff or have discontinuities. In these cases, the numerical method may fail to find the correct solution. In most cases (if you are lucky), this failure is indicated by an instability in the method on that particular equation. Basically, an instability occurs when the numerical method behaves in an inconsistent manner for a particular differential equation. This inconsistency may show up as radically different solutions for different step sizes or, more likely, in high frequency perturbations of the solution. An example of an instability is shown in Figure 14.3. In this figure, the top curve is the correct solution to the differential equation, and the bottom curve is the result of a numerical method that is not stable for this particular problem. Note in the unstable solution how the small perturbations quickly grow to dominate the correct solution. Instabilities can be caused by the differential equation (some differential equations are unstable), the numerical method, or a combination of the two. The most common situation is the combination of a stiff differential equation (which is stable) and a numerical method that cannot handle stiffness. This situation is addressed in the next subsection. The following two subsections deal with the related issues of conservation properties and discontinuities in the equations.

The basic theme of this section is how accurately the numerical methods solve the differential equations and the factors that affect this accuracy. After all, any numerical method is only approximating the solution to the differential equation. This approximation is influenced by the properties of the equation that we are trying to solve. In solving a differential equation, we can encounter the same type of aliasing problems that we are familiar with in rendering. We approximate the solution at discrete points in time. As we move from one time point to the next, we sample the value of the differential equation in order to produce the next solution value. The sampling of the differential equation

(a)

(b)

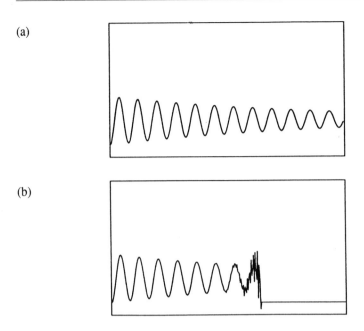

Figure 14.3 (a) A Stable Solution; (b) An Unstable Solution

depends on the current value of the solution, which is only approximate. Thus, in this sampling process, any errors will cause us to sample a different differential equation than the one we are trying to solve. This can result in the solution to an equation we are not interested in. The main aim of the more sophisticated numerical methods is to keep these errors small and ensure that we stay close enough to the intended equation and its solution.

14.5.1 *Stiffness*

Stiffness in ordinary differential equations has been studied for approximately thirty years, and there is an extensive formal literature on this topic. However, our understanding of this problem is not as great as it may seem at first. There is a technical definition of stiffness (which is presented below) and an extensive body of results. But, most researchers will agree that the technical definition does not cover all aspects of the problem, and most of the results are limited to particular classes of problems (those characterized by the differential equation $\dot{x} = \lambda x$). Also, the stability of a numerical method is often tied to stiffness. Stiffness was the first known cause of instability in numerical methods, but we now know that there are other causes (such as discontinuities), which may require a different set of techniques. These factors tend to make the literature on stiffness and stability hard to apply in practice. It is not unusual for methods that have been

shown to be stable to turn out to be unstable when applied in practice. This is usually due to the fact that stability was shown for a particular class of problem, and the current problem is not in that class.

The technical definition of stiffness can be approached in the following way. Consider the following system of ordinary differential equations.

$$x_1 = f_1([x_i],t)$$
$$x_2 = f_2([x_i],t)$$
$$. . .$$
$$x_n = f_n([x_i],t)$$

where $[x_i]$ is a vector of the values x_1, x_2, ..., x_n. The Jacobian of this system of equations is defined in the following way:

$$J = [\frac{\partial f_i}{\partial x_j}] = \begin{bmatrix} \dfrac{\partial f_1}{\partial x_1} & \dfrac{\partial f_1}{\partial x_2} & \cdots & \dfrac{\partial f_1}{\partial x_n} \\ \dfrac{\partial f_2}{\partial x_1} & \dfrac{\partial f_2}{\partial x_2} & \cdots & \dfrac{\partial f_2}{\partial x_n} \\ \cdots & \cdots & \cdots & \cdots \\ \dfrac{\partial f_n}{\partial x_1} & \dfrac{\partial f_n}{\partial x_2} & \cdots & \dfrac{\partial f_n}{\partial x_n} \end{bmatrix}$$

The matrix J will have a set of eigenvalues, λ_i, $i = 1,..., n$. A set of differential equations is called stiff if one or more of the λ_i have large negative real parts while the others are close to zero or positive. Basically, what this means is that some components of the solution will be slowly varying, while others, corresponding to the λ_i with large negative real parts, will have a very high frequency but will quickly decay to zero. Since we are sampling the differential equation at discrete points in time, these two components could become mixed, even after the high frequency parts have been reduced to zero. This is what causes the rapidly varying perturbations in a solution that has become unstable. Usually, the stability of a numerical method is studied in the context of the following system of equations:

$$\dot{x}_i = \lambda_i x_i$$

The eigenvalues of this system are easy to determine, and it is fairly easy to manipulate mathematically.

The obvious solution to stiffness problems is to use a small step size, in the numerical method. With a small enough step size, the differential equation will be sampled often enough to correctly handle the high frequency components. There are two problems with this approach. First, the step size directly determines the time required to solve the equation. The smaller the step size, the more computer time required. Second, when the step size is decreased, the rounding errors in the computations increase. Eventually a point will be reached where the rounding errors dominate the solution of the equation. If a differential equation

requires a step size smaller than this limit, that particular numerical method cannot be used to solve the differential equation. The special numerical methods that have been developed for stiff differential equations allow reasonably large step sizes to be used so that the solution can be produce economically.

In the case of dynamics, where does the stiffness come from? The Jacobian is based on partial derivatives with respect to the position and velocities (both linear and angular) of all the components of the system. Any quantity that is not a function of position or velocity does not appear in the Jacobian and thus cannot affect the stiffness of the equations. For example, any force or torque that is not a function of position or velocity will not influence the stiffness of the system. A frictional force that is a function of velocity will influence the stiffness of the equations. Typically, the stiffness will be a function of the coefficient of friction. Similarly, a force or torque that is used to produce some body orientation or enforce a constraint will enter into the Jacobian and influence the stiffness. These are standard techniques that are used to control the motion of articulated figures, and in general a control technique will influence the stiffness of the equations. Without the control forces and torques, the equations of motion for articulated figures are not very stiff: it is just when we want to control them that the stiffness occurs.

14.5.2 *Conservation Properties*

One area of numerical methods for ordinary differential equations that has received little attention is conservation properties, even though this is a very active area in partial differential equations. The numerical methods that we apply to the dynamics equations should respect the conservation laws that have been developed in physics. One of the main problems is the conservation of energy. We would not like the numerical method to remove or add significant amounts of energy to the system. A number of the standard numerical methods do not conserve energy (Sanz-Serna, 1988). One example of such a numerical method is the standard Runge-Kutta method. It has been observed in practice that the Runge-Kutta method has a damping effect on the solution (D'Souza and Garg, 1984). The explicit Runge-Kutta schemes do not conserve energy, but there exist implicit Runge-Kutta schemes that do (Sanz-Serna, 1988).

This is one area where further investigation is required. Is it important that energy be conserved in the solution of dynamics equations? Can we approximately conserve energy and still have good solutions—in other words, how much can we get away with?

14.5.3 *Discontinuities*

Some of the control techniques that are used in computer animation introduce discontinuities into the equations of motion. The most obvious example of this are the collision techniques that use conservation of momentum results. Dis-

continuities, or apparent discontinuities, can arise in control schemes that rapidly change the forces and torques applied to an object. Any control mechanism that is state based and does not smoothly change forces and torques between states will produce discontinuities in the equations. The problem of discontinuities has been studied recently. An introduction to some of the problems and the literature can be found in Gear and Osterby (1984). In general, discontinuities are not good as they can cause the numerical methods to become unstable in the neighborhood of the discontinuity.

There are two problems associated with discontinuities in differential equations. The first problem is detecting where the discontinuities are. In our case this is not a problem since the discontinuities are caused by the control techniques, and thus we know where they are. The second problem is getting around the discontinuity. The standard approach to this problem is to integrate up to the discontinuity and then restart the integration on the other side of the discontinuity. Essentially, this divides the original initial value problem into two initial value problems, with the second problem starting after the discontinuity. This will cause some loss of efficiency in multistep methods since they need to be restarted after the discontinuity. Some of the methods are capable of handling some discontinuities. For example, the Adams methods can handle some types of discontinuities (Nevanlinna, 1979).

14.5.4 *An Experimental Comparison of Some ODE Solution Techniques*

One of the main questions that faces us is how well the numerical methods for solving ODEs work in practice. One way of answering this question is to apply each of the methods to a test suite of problems that are similar to the problems we encounter in practice. We use a test suite, instead of the real problems, for the following reasons. In the test suite, we can use problems that are easy to manipulate analytically. In this way, we can produce analytical solutions to the equations and derive properties of the equations that are important in the evaluation, such as the eigenvalues of the Jacobian. Real problems are typically too complicated to be manipulated analytically. Second, each of the problems in the test suite can evaluate one aspect of the performance of the methods. For example, we can have one problem for nonlinear equations and another for stiff equations. This allows us to identify the particular set or range of problems that individual numerical methods are capable of handling. Real problems often contain a mixture of these features, making it difficult to determine why a particular method fails on a given problem. Third, the problems in the test suite are often smaller and easier to set up than real problems. This facilitates the automatic evaluation of a reasonable number of numerical methods.

The test suite presented here addresses two questions. The first question is whether the direct methods for solving second order equations are better than the methods for solving systems of first order equations, in the case of the differen-

Figure 14.4 Mechanical System for Test Suite

tial equations that arise in dynamics. By "better" we mean that they are more efficient and cover as wide a range of problems. The second question is determining the range of problems that can be efficiently handled by the different solution methods. In particular, we are interested in linear, nonlinear, and discontinuous problems. For each of these types of problems, both stiff and non-stiff versions are considered.

The test suite is based on two sets of second order differential equations. The first set consists of linear differential equations, and the second set consists of nonlinear differential equations. The first set of equations is:

$$m_1\ddot{q}_1 + c_1\dot{q}_1 + c_2(\dot{q}_1 - \dot{q}_2) + k_1q_1 + k_2(q_1 - q_2) = F_1$$
$$m_2\ddot{q}_2 + c_2(\dot{q}_2 - \dot{q}_1) + k_2(q_2 - q_1) = F_2$$

The second set of equations is:

$$m_1\ddot{q}_1 + c_1\dot{q}_1 + c_2(\dot{q}_1 - \dot{q}_2) + k_1q_1 - k_2[(q_2 - q_1) + 0.5(q_2 - q_1)^3] = F_1$$
$$m_2\ddot{q}_2 + c_2(\dot{q}_2 - \dot{q}_1) + k_2[(q_2 - q_1) + 0.5(q_2 - q_1)^3] = F_2$$

These sets of equations were used by D'Souza and Garg (1984) to evaluate some of the numerical techniques for solving second order differential equations. They are based on the physical situation shown in Figure 14.4.

The first problem in the test suite is the linear set of equations with the following parameter values:

$m_1 = 1$	$m_2 = 10$
$c_1 = 0.1$	$c_2 = 0.1$
$k_1 = 20$	$k_2 = 1$
$F_1 = 0$	$F_2 = 4$

With these parameter values, the eigenvalues of the Jacobian are:

0	-0.1111
$-0.0495 + 0.2959i$	$-0.495 - 0.2959i$

Obviously this set of equations is not stiff. This test problem forms the base case that all the methods should be able to handle.

The second problem in the test suite is based on the nonlinear set of equations. This test uses the same parameter values as used in the first test. The eigenvalues of the Jacobian for this set of equations are much harder to determine. The eigenvalues are complicated functions of q_1 and q_2 (the printed value of one of these eigenvalues is 31 pages long). At $q_1 = 0$ and $q_2 = 0$, the approximate values of the eigenvalues are:

$-0.0045 + 0.3086i$	$-0.0045 - 0.3086i$
$-0.1004 + 4.5819i$	$-0.1004 - 4.5819i$

At $q_1 = 0.4$ and $q_2 = 4.2$, the approximate eigenvalues are:

$-0.0024 + 1.0161i$	$-0.0024 - 1.0161i$
$-0.1026 + 6.6244i$	$-0.1026 - 6.6244i$

From these values, it appears that this problem is not stiff.

The third problem is based on the linear set of equations, except that a discontinuity is introduced into the equations at $t = 50$. At this point the value of F_2 is changed from 4 to 5. The eigenvalues for this problem are the same as for the first problem.

The fourth problem is based on the linear set of equations, with different values for c_1 and c_2. These values are:

$$c_1 = 1000.0 \qquad\qquad c_2 = 1.0$$

With these parameter values, the eigenvalues of the Jacobian are:

0	-1001.0
$-0.0499 + 0.3121i$	$-0.0499 - 0.3121i$

This set of equations is moderately stiff. Most of the eigenvalues are small, except for the one at -1001.0, which causes this set of equations to be stiff. This set of equations is not as stiff as the ones that can occur in human animation, but it is stiff enough to form a good test of the methods.

The fifth problem is based on the nonlinear set of equations with the same parameter values as the fourth problem. With these parameter values, the eigenvalues of the Jacobian at $q_1 = 0$ and $q_2 = 0$ are:

-0.0200	-1000.9791
$-0.0504 + 0.34i$	$-0.0504 - 0.34i$

This test problem is approximately as stiff as the fourth test problem.

The sixth problem is based on the linear set of equations with the same parameter values as the fourth problem. This problem has the same discontinuity at $t = 50$ as the third problem. This problem is an example of a stiff discontinuous system of equations.

Plots of the six test problems are shown in Figure 14.5. These plots were produced using the Adams predictor-corrector method described in Section 14.4.1.4.

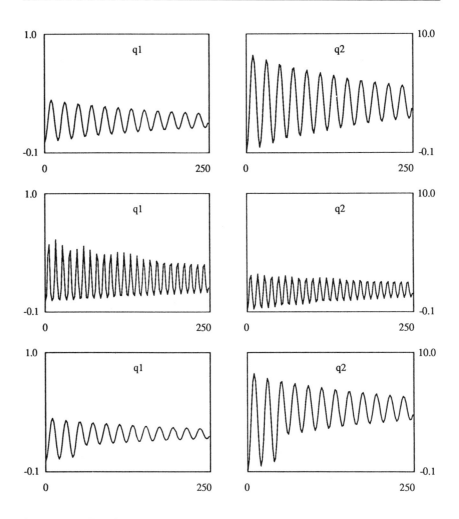

Figure 14.5 The Six Problems in the Test Suite

The results of running the test suite on four of the numerical methods is shown in Table 14.1. Each test case was run from $t = 0$ to $t = 250$ seconds. This table shows the CPU time and number of steps required to compute the solution for four different accuracy values. These tests were run on a SUN 3/50 workstation with a 68881 floating point coprocessor. A '–' in the Steps column indicates that the method was unstable for that problem. In this case, the Time column indicates the simulation time where the instability was detected (instability was detected by checking to see if q_1 and q_2 stay within a reasonable range).

Table 14.1 Test Suite Results

	Euler		Runge-Kutta		Adams		Central Difference	
Accuracy	Time	Steps	Time	Steps	Time	Steps	Time	Steps
Linear system								
0.001000	1.32	2371	1.30	525	2.22	1490	7.46	4404
0.000100	3.94	6854	1.52	613	2.64	1758	21.06	12818
0.000010	12.34	20938	2.64	1002	4.00	2686	60.10	36625
0.000001	36.36	65397	3.84	1555	5.14	3440	195.52	119724
Nonlinear system								
0.001000	3.20	3403	5.20	1103	4.22	1753	14.54	6174
0.000100	8.56	9302	7.58	1585	5.36	2152	39.86	17279
0.000010	25.62	27767	10.66	2295	7.74	3059	117.24	51057
0.000001	80.08	86479	15.52	3372	7.50	3084	362.26	158433
Discontinuous system								
0.001000	1.24	2212	1.40	542	2.28	1499	6.30	3999
0.000100	3.52	6183	1.68	664	2.70	1763	18.24	11540
0.000010	10.50	18592	2.80	108	4.02	2628	53.50	33935
0.000001	32.62	57789	4.56	1783	5.22	3439	165.48	105108
Stiff linear system								
0.001000	62.44	–	62.37	–	183.78	124388	0.17	–
0.000100	79.34	143771	315.72	126619	180.06	124374	315.78	179968
0.000010	80.02	145253	306.26	126997	179.66	124361	271.62	155450
0.000001	80.78	146389	304.88	126854	179.70	124342	238.28	138263
Stiff nonlinear system								
0.001000	57.64	–	191.62	–	292.64	124392	0.17	–
0.000100	122.50	143657	547.20	126829	292.56	124379	2.77	–
0.000010	122.12	144989	546.76	126856	292.64	124368	424.94	156433
0.000001	109.84	129331	545.68	126635	292.52	124334	391.22	147903
Stiff discontinuous system								
0.001000	61.90	–	314.80	126878	184.18	124388	0.17	–
0.000100	77.02	143771	314.06	126679	184.32	124374	315.92	177503
0.000010	77.82	145282	315.30	127097	184.16	124361	274.48	155170
0.000001	79.20	147625	314.52	126774	184.60	124354	230.68	133094

The following numerical methods were used in this evaluation. The first set of results is for Euler's method as described in Section 14.4.1.1 with automatic step size control. The second set of results is for the standard Runge-Kutta method described in Section 14.4.1.2 with automatic step size control. The third set of results is for the Adams predictor-corrector method. The Adams-Bashforth

method is used as the predictor, and the Adams-Moulton method is used as the corrector. Again automatic step size control is used. The fourth method tested is the central difference method described in Section 14.4.2.1 with automatic step size control.

There are several conclusions that we can draw from the results presented in Table 14.1. Euler's method is the most efficient method, but it suffers from stability problems. This method can be used when solution speed is the main criterion and the user is willing to accept some surprises due to instability on some problems. In the case of nonlinear and stiff systems, the Adams predictor-corrector methods are faster than Runge-Kutta and do not have stability problems. This suggests that the Adams methods are in general the methods of choice. Numerical techniques for second order equations do not seem to compete with the methods for systems of first order equations. This is a rather tentative conclusion since only one method was tried—the other methods could be better.

14.6 *Conclusions*

This chapter has discussed two issues related to the use of dynamics in computer animation, motion control and numerical solution of the dynamics equations. A hierarchical scheme for motion control has been used in several of our animation systems and is currently being used as the basis for a ballroom dancing animation system. After reviewing a number of popular numerical techniques for solving differential equations, we showed how motion control schemes can contribute to the instability of the numerical techniques used to solve the differential equations. Finally, a set of test problems for evaluating the different numerical techniques for solving differential equations was presented. This test suite was based on the problems encountered in the numerical solution of dynamics problems. Some of the popular numerical techniques were evaluated using this test suite, with the conclusion that the Adams predictor-corrector methods are probably the best choice for this type of problem.

Acknowledgments

I would like to thank Bill Armstrong, Rob Lake, and Hanqiu Sun for their assistance with this work. I would also like to acknowledge the support of the Natural Science and Engineering Research Council of Canada and the University of Alberta.

References

Armstrong, W. and M. Green. 1985. The dynamics of articulated rigid bodies for the purposes of animation. *Graphics Interface '85 Proceedings*, pp. 407–415.

Armstrong, W., M. Green, and R. Lake. 1987. Near-real-time control of human figure models. *IEEE Computer Graphics and Applications* 7(6):52–61.

Barr, A. 1988. Teleological modeling. *SIGGRAPH '88 Course Notes on Developments in Physically-based Modeling* (see also, Chapter 15, this volume).

Brusa, L. and L. Nigro. 1980. A one-step method for direct integration of structural dynamic equations. *International Journal for Numerical Methods in Engineering* 15(5):685–699.

Butcher, J.C. 1987. *The Numerical Analysis of Ordinary Differential Equations.* John Wiley & Sons, New York, NY.

Conte, S.D. and C. de Boor. 1972. *Elementary Numerical Analysis*, second edition. McGraw-Hill, New York, NY.

D'Souza, A.F. and V.K. Garg. 1984. *Advanced Dynamics.* Prentice Hall, Englewood Cliffs, NJ.

Fatunla, S.O. 1988. *Numerical Methods for Initial Value Problems in Ordinary Differential Equations.* Academic Press, Boston.

Gear, C.W. 1971. *Numerical Initial Value Problems in Ordinary Differential Equations.* Prentice Hall, Englewood Cliffs, NJ.

Gear, C.W. 1981. Numerical solution of ordinary differential equations: Is there anything left to do? *SIAM Review* 23(1):10–24.

Gear, C.W. and O. Osterby. 1984. Solving ordinary differential equations with discontinuities. *ACM Transactions on Mathematical Software* 10(1):23–44.

Goldstein, H. 1959. *Classical Mechanics.* Addison-Wesley, Reading, MA.

Green, M. and R. Lake. 1989. Ballroom dancing by computer. Forthcoming technical report, University of Alberta, Edmonton.

Green, M. and H. Sun. 1988. A language and system for procedural modeling and motion. *IEEE Computer Graphics and Applications* 8(6):52–64.

Hahn, J. 1988. Realistic animation of rigid bodies. *SIGGRAPH '88 Proceedings*, pp. 299–308.

Isaacs, P. and M. Cohen. 1987. Controlling dynamic simulation with kinematic constraints, behavior functions, and inverse dynamics. *SIGGRAPH '87 Proceedings*, pp. 215–224.

Minsky, M. 1985. *The Society of Mind.* Simon and Schuster, New York.

Moore, M. and J. Wilhelms. 1988. Collision detection and response for computer animation. *SIGGRAPH '88 Proceedings*, pp. 289–298.

Nevanlinna, O. and W. Liniger. 1978. Contractive methods for stiff differential equations, Part I. *BIT 18*, pp. 457–474.

Nevanlinna, O. and W. Liniger. 1979. Contractive methods for stiff differential equations, Part II. *BIT 19*, pp. 53–72.

Paul, R. 1981. *Robot Manipulators*, MIT Press, Cambridge, MA.

Press, W., B. Flannery, S. Teukolsky, and W. Vetterling. 1986. *Numerical Recipes*, Cambridge University Press, Cambridge.

Sanz-Serna, J.M. 1988. Runge-Kutta schemes for hamiltonian systems. *BIT 28*, pp. 877–883.

Shampine, L. 1979. Evaluation of implicit formulas for the solution of ODEs. *BIT 19*, pp. 495–502.

Shampine, L.F. and C.W. Gear. 1979. A user's view of solving stiff ordinary differential equations. *SIAM Review* 21(1):1–24.

Thomas, R. and I. Gladwell. 1988. Variable-order variable-step algorithms for second order systems. Part 1: The methods. *International Journal for Numerical Methods in Engineering* 26(1):39–53.

Thornhill-Geiger, R. 1981. *Thirteen Ballroom Dances, N.C.D.T.O. Revised Bronze Standard*. The National Council of Dance Teacher Organizations, Inc., Richmond Hill, NY.

Tischer, P.E and G.K. Gupta. 1985. An evaluation of some new cyclic linear multistep formulas for stiff ODEs. *ACM Transactions on Mathematical Software* 11(3): 263–270.

Wilhelms, J. 1987. Using dynamic analysis for realistic animation of articulated bodies. *IEEE Computer Graphics and Applications* 7(6):12–27.

Wilhelms, J. and B. Barsky. 1985. Using dynamics analysis for the animation of articulated bodies such as humans and robots. *Graphic Interface'85 Proceedings*, pp. 97–104.

Witkin, A. and M. Kass. 1988. Spacetime constraints, *SIGGRAPH '88 Proceedings*, pp. 159–168.

Wittenburg. J. 1977. *Dynamics of Systems of Rigid Bodies*. B.G. Teubner, Stuttgart.

Teleological Modeling

Alan H. Barr

Computer Science Department
California Institute of Technology
Los Angeles, California

ABSTRACT

A new approach to modeling is developing, for creating abstractions and mathematical representations of physically realistic and time-dependent objects. In this approach, geometric constraint properties, mechanical properties of objects, the parameters representing an object, and the control of the object are incorporated into a single conceptual framework. *Teleological modeling* techniques provide an extension of the current notions about how to make mathematical models of objects; the approach utilizes forces, torques, internal stress, energy, and other physically derivable quantities that allow us to simulate many of the fundamental properties of the shapes, combining operations, and constraints that govern the formation and motion of objects. The techniques have the potential to extend the scientific foundation for computer graphics.

15.1 *An Object Is More than Its Shape*

Intuitively, a teleological model is "goal-oriented" modeling. It is a mathematical representation that calculates the object's behavior from what the object is "supposed" to do. Each modeling element within this context is called a "teleological" modeling element (from the Greek word *teleos*, meaning end, or goal), because its character is directed toward an end or shaped by a purpose. The teleological methods can create mechanistic mathematical models with predictive capability and produce compact formal descriptions of complex physical objects and systems. As such they have the potential to vastly extend the state of the art for computer graphics modeling.

Unlike conventional kinematic modeling, in which an object is represented through its instantaneous shape, a teleological model incorporates time-dependent *goals of behavior* as the fundamental representation of what the object is. The teleological representation of a static or dynamic physical object takes

1. a set of motion and position goals for the parts of the object to satisfy, i.e., a subset of its shape and behavior, and produces

2. a description of the object's shape and behavior as a function of time.

The mathematical and physical techniques that achieve this end include *inverse dynamics, simulated annealing, Hamiltonian physics*, and *constrained optimization* (see Barzel and Barr, 1988; Platt and Barr, 1988; Witkin et al., 1987).

For instance, if we wish to model the behavior of a set of chain links to be hooked together, we need to make the links react to external forces such as gravity, yet still cause the links to hold themselves together. Using this set of approaches, we are able to more fundamentally represent the "chain-ness" and reactivity of the chain, beyond its momentary shape. Such methods have many potential applications beyond computer graphics, as in mechanical CAD, robotics, goal-oriented motion, self-assembling mechanical systems, computer vision, and whenever time-dependent, three-dimensional objects are being designed and modeled. The teleological approach involves a wide variety of techniques that have not yet been fully consolidated into one self-consistent, conceptual framework.

In contrast, the kinematic modeling techniques used in traditional interactive computer graphics have been well established for several years. The primary modeling scheme, as described in (Foley and Van Dam, 1982), creates objects as an N-level hierarchical tree of transformations and objects. The transformations consist of user-specified rotations, translations, and scalings; while the objects consist of other objects and geometric modeling primitives.

The kinematic modeling system is relatively easy to create and learn to use. The user controls the motion of objects by specifying the numerical values of the positions and orientations of the objects as a function of time, and by modifying the modeling hierarchy as needed.

However, as anyone who has used almost any of the kinematic systems is aware, the forementioned modeling techniques are far from perfect. In the context of the contemporary modeling paradigms, we are hard pressed to create the numerical values of the positions and orientations that maintain geometric constraints between moving objects.

15.2 *Teleological Models Are Composed of a Collection of Motion Goals*

Central to the teleological approach is that shape and time-varying motions of objects are represented by a collection of goals involving position, force, veloc-

ity, and other *physically based quantities* that constrain the behavior of the objects. The goals can be ordered in time, producing a "time-line" of behavior. In addition, there is usually much less distinction between "modeling" and "animation" with the teleological approach than with customary techniques, because the time parameter is explicitly involved in the model. Mathematically, a teleological "energy" is constructed to measure the deviation of the object from the desired (time-dependent) state. The solution techniques generally minimize the energy in order to achieve the motion goals.

15.3 *Hierarchy of Abstractions for What an Object Is*

Perhaps the simplest abstraction of an object is its graphical appearance. The "object-as-image" is represented by two-dimensional primitives, primarily consisting of pixel images and vector line drawings.

The next abstraction is that of shape. The Greeks created the polyhedra and the conic sections; for many years, graphics has not progressed significantly beyond this modeling approach. (Certainly there has been some progress—the Greeks did not invent bicubic patches!) The "object-as-shape" is represented with polygons, patches, and the like.

The next abstraction is that an object is represented through its physical behavior. Isaac Newton's physics was founded very much on the shape principles derived by the Greeks, although it was derived nearly two millennia afterwards. "Objects-as-behavior" are represented as rigid and flexible physical bodies.

The final abstraction is teleological. A teleological model incorporates time-dependent *goals of behavior* or *"purpose"* as the fundamental representation of what the object is. Just as physics incorporates "geometry" as an integral part of its worldview, the teleological approach incorporates physics. Examples of teleological objects are "objects-as-time-line" or "objects-as-set-of-goals."

Abstractions for Objects

An object is a timeline of "goals": *Teleological Modeling Primitives*
An object is Newtonian Behavior: 3^+D *Physical Modeling Primitives*
An Object is its Shape: *3-D Kinematic Primitives*
An Object is an Image: *2-D Modeling Primitives*

15.4 *A New Graphics Pipeline*

The teleological approach makes a new graphics pipeline possible. The user gives the teleological system a time-line of motion and position goals; inverse dynamics and other teleological techniques are used to produce a physics of interaction of the objects; physical stimulation then produces the positions and orientations of the objects, via polygons, bicubic patches, and other kinematic modeling elements. Finally, rendering techniques such as ray-tracing and depth-buffering techniques are used to convert the shape of the object into an image.

Conversions between Representations

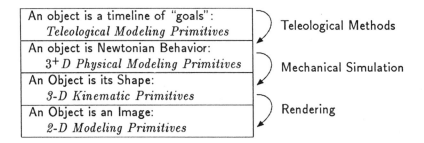

15.5 *Summary*

The teleological approach involves four representational layers, in which an object can be:

1. a time-line of teleological "event" primitives (position and orientation constraints, force constraints),

2. a set of 3-D Newtonian primitives (time-dependent 3-D rigid bodies, flexible bodies),

3. a set of 3-D geometric primitives (such as polygons, bicubic patches), and

4. a set of 2-D primitives (such as pixel values and screen-vectors).

Thus, objects are modeled at different levels of abstraction.

We depict the object's time-dependent *constraint properties* with a "teleological" model, its *physical behavior* with a dynamic model, its *instantaneous shape* with a kinematic model, or its *pictorial appearance* with an image model.

We convert teleological "event" primitives into 3-D Newtonian primitives via *inverse dynamics* or related techniques; we convert 3-D kinematic primitives by solving the equations of motion of the *physical simulation*; finally, we convert to 2-D primitives by *rendering* the kinematic model.

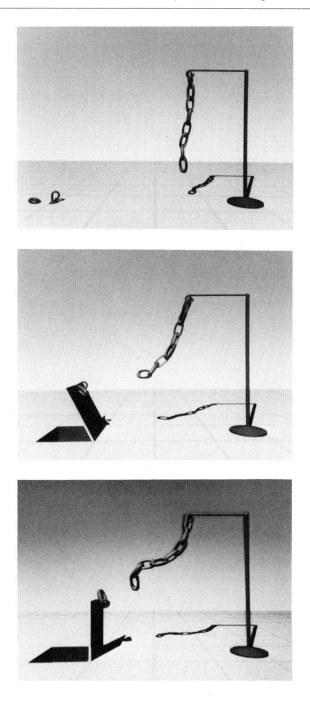

Figure 15.1 Chain Links Assembling and Animating

References

Barr, A.H., B. Von Herzen, R. Barzel, and J. Snyder. 1987. Computational techniques for the self assembly of large space structures, *Proceedings of the 8th Princeton/Space Studies Institute Conference on Space Manufacturing*, Princeton, NJ, May 6–9 1987, to be published by the American Institute of Aeronautics and Astronautics.

Barzel, R. and Barr, A. 1988. A modeling system based on dynamic constraints, *ACM SIGGRAPH Proceedings*.

Caltech studies in modeling and motion (videotape). 1987. SIGGRAPH video Review #28, *Visualization in Scientific Computing Computer Graphics* 21(6).

Foley, J.D. and A. Van Dam, 1982. *Fundamentals of Interactive Computer Graphics*, Addison-Wesley Publishing Company, Reading, MA.

Fox, E.A. 1967. *Mechanics*, Harper and Row, New York.

Gear, C. William. 1971. *Numerical Initial Value Problems in Ordinary Differential Equations*, Prentice Hall, Englewood Cliffs, NJ.

Gerard, M. and A.A. Maciejewski. 1985. Computational modeling for the computer animation of legged figures, *Computer Graphics* 19(3):263–270.

Goldstein, H. 1983. *Classical Mechanics*, 2nd Edition, Addision-Wesley, Reading, MA.

Golub, G. and C. Van Loan. 1983. *Matrix Computations*, Johns Hopkins University Press, Baltimore, MD.

Isaacs, P.M. and M.F. Cohen. 1987. Controlling dynamic simulation with kinematic constraints, behavior functions, and inverse dynamics, *Proc. SIGGRAPH*, pp. 215–224.

Kajiya, J.T. 1986. The rendering equation, *SIGGRAPH '86 Computer Graphics* 20(4):143–150.

Nelson, G. 1985. Juno, a constraint-based graphics system, *Computer Graphics*, 19(3):235–243.

Platt, J. and A.H. Barr. 1988. Constraint methods for flexible models, *SIGGRAPH Proceedings*.

Platt, J., D. Terzopoulos, K. Fleischer, and A.H. Barr. 1987. Elastically deformable models, *Topics in Physically Based Modeling*, ACM SIGGRAPH '87, Anaheim, CA.

Terzopoulos, D., J. Platt, A. Barr, and K. Fleischer. 1987. Elastically deformable models, *Proc. SIGGRAPH*, pp. 205–214.

Wilhelms, J. and B. Barsky. 1985. Using dynamic analysis to animate articulated bodies such as humans and robots, *Proceedings Graphics Interface '85*.

Witkin, A., K. Fleischer, and A.H. Barr. 1987. Energy constraints on parametrized models, *SIGGRAPH* '87 21(4).

Zeltzer, D.L. 1984. *Representation and Control of Three Dimensional Computer-Animated Figures*, PhD Dissertation, The Ohio State University, Columbus Ohio.

Appendix

A

Video Notes

The following are notes and commentary on some of the segments in the video *Making Them Move: Mechanics, Control, and Animation of Articulated Figures*. This video is available for purchase from Morgan Kaufmann Publishers. For ordering information, see page opposite Contents.

Order of Commentaries

- *The BOLIO Virtual Environment System*, David Zeltzer and others
- *Strength-guided Motion*, Philip Lee, Susanna Wei, Jianmin Zhao, and Norman I. Badler
- *Task Animation from Natural Language*, Jeffrey Esakov, Moon Jung, and Norman I. Badler
- *Genghis: A Six-Legged Walking Robot*, Rodney A. Brooks and others
- *Eurhythmy*, Michael Girard and Susan Amkraut
- *Her Majesty's Secret Serpent*, Gavin Miller and Michael Kass
- *Interactive Dynamics*, Jane Wilhelms
- *COMPOSE*, Tom Calvert and others
- *Goal-directed Dynamic Animation of Human Walking: GESTURE— A System for the High-level Control of Human Gestures*, C. Morawetz, and *KLAW—A Hybrid Approach to the Animation of Human Gait*, A. Bruderlin
- *Galaxy Sweetheart*, Nadia Magnenat-Thalmann and Daniel Magnenat-Thalmann

The BOLIO Virtual Environment System

David Zeltzer and others

The Media Laboratory
Massachusetts Institute of Technology
Cambridge, Massachusetts

Research at the Computer Graphics and Animation Group of the MIT Media Lab focuses on issues of dynamic, kinematic, and goal-directed graphical simulation. The virtual environments in our demonstrations contain solids that obey the laws of Newtonian dynamics—a robot arm and a six-legged insect that walks around on its own, controlled by biologically based motor programs. You can interact with any of these objects directly using the VPL DataGlove, a Spaceball, or, more conventionally, by tablet and dial input.

BOLIO is a developmental testbed for experimenting with various graphical simulation techniques, and provides a framework for developing virtual environments. It provides our programmers and researchers with a substantial library of graphics routines, as well as a set of standard interfaces for communicating with other embedded applications. To bind applications in a common environment, the BOLIO system builds a network of constraints through which embedded applications can communicate with other applications and objects. The applications define the physical laws of a virtual world, and the constraint network is the means by which the laws, agents, objects and users interact. Constraints propagate through the system so that one event may trigger a causal chain of events, such as using the DataGlove to pick up and throw a set of objects connected by springs, or using the Spaceball to move the synthetic camera interactively.

The DataGlove (VPL Research, Inc., Redwood City, CA) uses specially treated optical fibers attached along the fingers of the glove. When a fiber is bent near a finger joint, the light signal transmitted through that fiber is attenuated. By measuring the amount of attenuation, we can compute how much the fiber—and thus, the finger it is attached to—has been bent. Attached to the back of the DataGlove is a Polhemus tracker that transmits the 3-D location and orientation of the hand. This information is combined with the finger joint angles and inserted into the BOLIO constraint network by the BOLIO glove application. A graphical representation of a hand is linked (through a set of constraints) to display a stylized representation of the user's hand in the microworld. This hand object triggers other constraints including positioning objects, cameras, and lights, and directing the path of the insect. The glove application includes software lookup tables for posture recognition so that particular hand postures can be used to trigger events. Postures are used to activate and pick items from pop-up menus, and for grabbing objects or directing the insect. The DataGlove provides the user with a very real and immediate presence in the microworld.

The Spaceball (Spatial Systems, Inc., Billerica, MA) is a 6-degree-of-freedom force input device—a hand-sized ball mounted on a shaft that measures the

forces and torques applied to it. The Spaceball supplies decoupled forces—linear *x*, *y*, *z* forces; and yaw, pitch and roll torques. The Spaceball interface to BOLIO is similar to that of the DataGlove, and it can interact with other objects. The displayed Spaceball "object" is a gray sphere with a hole in the middle.

The software is coded entirely in C under UNIX. BOLIO runs on the 300 and 800 series of HP 9000 workstations with TurboSRX graphics processors.

Dynamic BOLIO Environment with DataGlove and Spaceball

One of the applications within BOLIO is the dynamics handler. This utility tracks the motions of objects and maintains their momenta. It provides various kinds of object interactions, including spring and damper constraints, collision detection, gravity, and inertial forces. The dynamics currently handled are deliberately simple so as to operate in real- (or nearly real-) time. Collision detection is based on bounding spheres, and integration uses a modified second-order Euler method. In our demonstration the user can pick up objects with the Data-Glove and Spaceball, and throw them against springy walls or against other objects. Either or both of these devices can also be used to interactively position and point the synthetic camera.

Inverse Kinematic Arm

The inverse kinematics application allows the simulation of jointed mechanisms such as robot arms. Given a desired 3-D location for the end of an arm (i.e., the *end-effector*), the inverse kinematic procedure calculates the necessary joint angles to position the end-effector at the desired goal. Here, we demonstrate this by "grabbing" and moving the end-effector with the DataGlove. Since the robot arm is a physical object, when the end-effector is released, the arm slowly drops to the ground plane under the influence of gravity.

Real-Time Hexapod Locomotion in a Dynamic Virtual World

The walking insect is another application that was developed independently, and later added to the BOLIO simulation repertoire. As part of our continuing investigation of behavioral modeling—in this case, locomotion—we use a set of coupled oscillators to control the stepping rhythm of the insect's legs. Together with a few reflexes, and empirically derived rules that describe vertebrate and invertebrate gaits, our simulated insect is capable of making its way around our microworld quite on its own. Using some of the other simulation tools in BOLIO—such as the path planner (described below)—the user can modify the speed and direction of the insect. If the insect should happen to run into an object—no problem—with automatic collision detection and dynamic simulation, the insect simply pushes it out of the way!

Gait Patterns Generated by Coupled Oscillators

Two sequences illustrate the operation of the coupled oscillators. In the upper right quadrant of the screen is shown a schematic view of six oscillators. When

an oscillator box turns white, that indicates that a stepping motion has been triggered. In the lower left and and lower right quadrants you can see a side view and a top view, respectively, of the simulated insect stepping according to the rhythm and frequency set by the oscillators. The stepping trace in the upper left quadrant shows that the footfalls of the synthetic insect are very similar to the footfall patterns of real insects.

Smooth Gait Change Using Coupled Oscillators with Varying Leg Count

The coupled oscillator model has two nice properties—the number of legs is just a parameter to the gait controller, and smooth gait changes can be accomplished by adjusting the overall frequency of the oscillators. This sequence shows a biped, a quadruped, and a hexapod, each controlled by the same gait oscillator program, and all smoothly varying their gait from a slow walk (quadruped "crawl" or hexapod "wave gait") to a fast walk (quadruped "trot" or hexapod "tripod gait").

Increasing Oscillator Frequency Creates Smooth Gait Change

In this sequence the walking insect is shown smoothly increasing its gait from a wave gait to a tripod gait, as it moves through the virtual world.

Path Planning and Path Following

Since we are not simulating sensory behavior for the insect, we need to compute collision-free paths for it as it moves through the virtual world. The path planner does this in a two-stage process using a version of the *visibility graph* algorithm developed by Lozano-Perez of MIT AI Lab. Briefly, in a preprocessing step, the algorithm finds all unobstructed lines-of-sight among the vertices of the objects in the microworld. Now, to find a path through the world, we merely find the minimum-cost traversal through this visibility graph, from the start point to the desired ending location. In our demonstration, after the visibility graph has been created, the user can gesture with the DataGlove, and the insect will walk along a safe path to the point specified by the hand position.

Avoidance

The insect demonstrates a very simple behavior—if it detects that something is trying to "grab" it, it scurries off to its "safe house"—the wireframe cube in the distance. Here, the Spaceball is being used to grab the insect—grab mode is indicated by the red line from the Spaceball to the nearest object. Grab mode is triggered by a posture when wearing the DataGlove, and by a button-push for the Spaceball

A Telerobotic Application: BOLIO and the Whole Arm Manipulator (WAM)

BOLIO is also being used to assist in the development of teleoperative systems. One example of this is a simulation that duplicates the motions of the *whole arm*

manipulator (or WAM), a robot developed by Ken Salisbury's group at the MIT AI Lab. Our simulation is connected via ethernet to the actual robot arm, so that when the user grabs the end of the simulated arm and moves it around, the real robot arm will move to mimic the motions of the user. The robot arm echoes its position and orientation, and we display a copy of the WAM using this information.

The Virtual Erector Set

The *virtual erector set* is a system for simulating the dynamics of mechanical assemblies. In the first sequence, a number of rigid links has been connected by springs to form a "tensegrity" structure—a notion invented by R. Buckminster Fuller. Starting from an initial configuration, the simulated tensegrity toy eventually comes to rest in the correct configuration.

Training for Police Car Scene

The "vehicle" consists of a rigid body, and four wheels, each of which is connected to the body by a spring and damper. Each wheel is driven by a motor, and there are brakes on each of the front wheels. The task is to accelerate the vehicle to speed, and then "slam on the brakes," so that the car comes to a skidding halt. In the first try, we apparently applied too much brake and rolled the car—seen from the driver's view as well as from the distance. The second try looks a little better. These scenes were videotaped directly from the workstation.

Police Car Final Motion

This sequence was single-framed, so that we could see the simulation at normal speed, and verify that no temporal artifacts were introduced. It looks right. Finally, the fully rendered scene.

Scenes from Grinning Evil Death

The animation *Grinning Evil Death* tells a tale of breakfast, blood, super heroes, and roaches—and in the process, displays a variety of simulation programs under development in our research group. A kid munching cereal and watching TV learns that an alien space pod is bound for Earth. The pod crashes into the city, and a giant, cybernetic roach emerges. The roach proceeds to wreak havoc in the city, breaking power lines and kicking cars. Donning the powerful "Ring of Sarcasm" from his cereal box, the kid leaps from his window to do battle with the roach.

Shown here is an excerpt, in which the cybernetic cockroach first emerges from his space pod. In order to support and propel the body, the roach's legs must supply forces, much as a muscle does. To create the structure of the roach, the physiology of the cockroach was studied and modeled. To create the control mechanisms involved in walking, the nervous system of the cockroach was modeled as coupled oscillators and reflexes. The computer generates all of the motions of the cockroach, and the other moving objects in this scene, using physical simulation techniques.

Acknowledgments

This work was supported in part by NHK (Japan Broadcasting Corp.), National Science Foundation Grant IRI-8712772, and equipment grants from Hewlett Packard Co., Gould Electronics, Inc., and Apple Computer, Inc. Thanks to the members of the Computer Graphics and Animation Group, all of whom have contributed to the work shown here.

Strength-guided Motion

Philip Lee, Susanna Wei
Jianmin Zhao, Norman I. Badler
University of Pennsylvania
Philadelphia, Pennsylvania

In this video, several examples of the application of strength-guided motion are given: a human figure standing up, a series of single-armed lifts, and a two-armed lift. In each of the examples, inverse kinematics is used to move a set of serially connected segments to an initial configuration. Then (excluding the standing example) tasks defined with increasingly heavier objects are performed.

To define a task the user has to specify the segments that will perform the action; the goal of the task, which is currently specified by a point in space, and an end-effector (i.e., hand), which is specified by a point on the end of the segment chain. The idea is that the end-effector is to reach for the goal. Also included in our system are strength data for each joint and the external force applied on the end-effector. The external force may represent the weight of an object that is to be translated.

In the first segment of the video, the figure is kinematically guided to a sitting position. Then an arbitrarily selected weight is used so that the motion uses the moment reduction strategy. This strategy balances the need of having the body's center of mass positioned over its feet with the need of reaching a standing position, which is described by specifying a point in space that will be reached by a corresponding point on the body when it is standing.

The next video segment shows the path of the arm when lifting a heavy object from the bottom shelf to a corner of the green box that is above the figure's head. The path of the end-effector is traced. The objects are 10, 15, and 20 pounds. When the object is light, the action is governed by the available torque strategy, and a wide path is taken. As the weight of the object increases, the arm is drawn closer to the body. If the motion of the end-effector is near the boundary of the body's desired comfort level, it may switch between the available torque and minimum-moment strategies. Switching between two strategies causes the motion to be jagged. (A finer time sampling interval would reduce this jerkiness.)

The next video segment shows the arm lift from the middle shelf. The object weights are 20, 25, and 30 pounds. In this segment, the weight of the objects has increased to the point where the arm does not have enough strength to lift the object directly toward the goal. As a result, the arm follows the pull-back strategy, which avoids adding any additional stress to the weakest joint. To avoid overexertion, the end-effector may have to pursue a path that deviates from the goal—when a more comfortable region is found, the arm can again pursue a path continuously moving toward the goal.

The final video segment depicts the arm lifting from the top shelf. In these cases, the pull-back strategy is required. A single-arm lift with a 30-pound object and a two-armed lift with a 45-pound object are shown. The motion of the block through the head demonstrates that the task is likely to be unsafe for an agent with this strength in this posture.

Task Animation from Natural Language

Jeffrey Esakov, Moon Jung,
and Norman I. Badler

University of Pennsylvania
Philadelphia, Pennsylvania

This tape demonstrates a unidirectional flow of information from a natural language understanding module to a computer animation generation module. The natural language parser, along with a knowledge base, enables the system to develop a "deep understanding" of the natural language input and generate the appropriate directives to the animation generation module.

For this tape, input consists of "looking" and "reaching" tasks. Natural language directives, such as "Turn switch-1 on," generate animation directives to extend an agent's arm so that the hand touches the switch, depresses the switch, and returns the arm to a resting position. The directives are generated only if switch-1 is not already in the "on" position. Explicit locations and geometric values are avoided by using symbolic references.

The animation generator uses inverse kinematics to determine goal positions for an end-effector. The duration of an action is determined through the use of human performance models; for this tape, Fitts's Law was used. (Fitts's Law is a regression equation that relates movement time to the distance to be moved and the size of the target.)

The two figures in the tape were "generated" from a database containing anthropometric data from a group of NASA trainees. The instrument panel is a bit-mapped representation of the NASA space shuttle remote manipulator system panel.

Genghis: A Six-Legged Walking Robot

Rodney A. Brooks and others

Artificial Intelligence Laboratory
Massachusetts Institute of Technology
Cambridge, Massachusetts

Sponsor This video shows research done at the Artificial Intelligence Laboratory of the Massachusetts Institute of Technology. Support for the research is provided in part by the University Research Initiative under the Office of Naval Research contract N00014-86-K-0685 and in part by the Advanced Research Projects Agency under Office of Naval Research contract N00014-85-K-0124.

Description of Video

- Walking along completely autonomously, showing some simple rough terrain scrambling without sensing.

- Soda can scene: Simple standup behavior.

- Series of obstacle runs from a rear view:

 1. No sensing. Notice the pitching and rolling as it goes over the obstacle.

 2. Added beta balancing; i.e., leg tries to keep the force on it (in the downward direction) below some threshold. Roll of the vehicle is now much reduced. Note however the bug where the back legs fall out as the body is pitched upward—likewise when the nose is down as it comes off the obstacle.

 3. Alpha collide is added. Left-front leg hits the obstacle. Force is sensed. On its next step that leg is raised higher, and it gets right up onto the obstacle. This sequence is cut before the robot comes down from the obstacle.

 4. Beta balancing is selectively suppressed on some legs based on pitch inclinometer readings. Now the rear-dropping and nose-dropping are much less pronounced. The robot climbs over the obstacle much better now.

- Side view of the robot and some obstacles:
 1. Green book. Shows the alpha collide reflex.
 2. Two reams of paper (higher). This time the left-front whisker is triggered and the leg lifts higher in anticipation of the obstacle.

- Static demonstration. As a leg is pushed upward by hand the walking reflexes are triggered. The leg swings forward and then down, while all other legs swing back slightly to maintain a zero alpha sum.

- Demonstration of all behaviors combined as it clambers over a pile of books.
- Pyroelectric passive infrared sensors and the person-following behavior.
- Comic version of predation.
- Comic version of undesirable evolutionary adaptations—heat seeking in the presence of blow torches.

Eurhythmy

Michael Girard
Susan Amkraut

Stichting Computeranimatie
Groningen Polytechnic
Groningen, The Netherlands

The animation depicts animals, humans, and a flock of birds joining together in a ritualistic dance in a deserted temple courtyard. The human and animal motion in this video was choreographed by Girard using his PODA animation system. PODA implements Girard's research on modeling legged animal motion, incorporating many robotics techniques for limb kinematics, dynamics, and legged locomotion. Susan Amkraut designed the bird motion in *Eurhythmy* using her FLOCK animation system. FLOCK controls the motion of groups with vector force fields that act to define environmental flow patterns and prevent collisions. *Eurhythmy* was rendered using Scott Dyer's TROUT program, a scanline z-buffer display program used at the Ohio State University.

Her Majesty's Secret Serpent

Gavin Miller
Michael Kass

Apple Computer, Inc.
Cupertino, California

Her Majesty's Secret Serpent is a video produced by the Media Technologies Group, which is part of the Advanced Technology Group at Apple Computer, Inc. in Cupertino, California. One of the aims of the Media Technologies Group is to develop new and user-friendly ways of creating realistic animations. One key element of this process is to simulate the physical properties of mechanical objects so that the computer can synthesize their movements. For living creatures, the simulation includes the behavior of the animals.

In *Her Majesty's Secret Serpent*, the character called "Frank the Snake" descends on a parachute, slithers across the sand, and then bites a film canister, and finally dives off a cliff. The snake was modeled as a collection of masses and

springs, which were used to compute the dynamics of snake locomotion. The mass points were then used as control points for cubic splines, which formed a smoothly curved surface including the modeling of the head. Finally, the snake was rendered using surface bump mapping and color mapping to produce the appearance of scales. The snake begins with the animation attached to a parachute, which opens as the snake descends. The simulated air pressure puffs up the canopy of the parachute and slows the descent of the snake until a critical altitude is reached. At this point the ropes become detached from the snake, and it falls freely to the ground. The snake has a homing behavior that adjusts its muscle contractions so that it is directed toward the film canister lying on the sand some distance away. Once close enough to the canister, the grab behavior is triggered so that the snake opens its jaw and lunges its head forward. When the target is in the jaw it is joined kinematically to the head, and the snake starts to flee from an unseen enemy behind it, finally diving off a cliff into an abyss.

The animation is 1 minute, 40 seconds long, and the animated segments took 10 minutes a frame on an SGI 120 using a single processor. The animation was rendered on fields that required 60 frames per second of animation. Rendering on fields is essential for showing subtleties of motion as well as eliminating strobing problems for fast-moving objects. The finished frames were copied over Ethernet to an Abekas A60 and were edited from there to a Sony D1 digital video recorder.

How Snakes Play Golf was a previous dynamic simulation using Silicon Graphics IRIS Graphic Library, which led to the development of software used in *Her Majesty's Secret Serpent*.

Interactive Dynamics

Jane Wilhelms

University of California, Santa Cruz
Santa Cruz, California

David Forsey

University of Waterloo
Waterloo, Ontario

Interactive Dynamics shows the use of physical simulation for interactively manipulating three-dimensional models. Physical simulation can provide a fast and realistic alternative to inverse kinematic approaches for goal-directed manipulation. This video shows articulated models being manipulated by the use of applied forces and torques and by specification of goals. Forces and torques are specified by the location of application and the magnitude of the force or torque. Goals are specified by a point on the body and a goal position in world space; the program automatically calculates a reasonable force to bring the two together. Once reached, goals can act as constraint points. Constraint points can also be

simulated by extra heavy masses. A limited subset of joints can be chosen for physical simulation in order to local the motion.

COMPOSE

Tom Calvert and others

Graphics Research Group
Simon Fraser University
Burnaby, British Columbia

After some years experience working with computer-based movement notation systems to edit and interpret Labanotation, in 1984 we began to develop a set of tools to support the choreographer and the animator in the compositional process. These have now evolved to the COMPOSE system, which exists in slightly different forms on Silicon Graphics IRIS and Apple Macintosh workstations. Our implementation has evolved in the context of our developing understanding of composition in relation to hierarchical process, alternate views, use of knowledge, and visualization of motion from concept to final realization. For example, in composing a dance or animation on the computer, at any point in time the spatial interrelationships of the figures can be studied and refined. Alternatively, a representation analogous to a musical score allows the composer to review and edit developments over time. A third view allows movement paths of the figures on the stage to be specified. All of these are components of the final physical realization.

The choreographer or animator can visually compose the key scenes for the piece in space and time. A key scene consists of a number of figures of various colors placed appropriately on a stage, each having a posture chosen from a menu. Key scenes are stored as they are composed and additional, intermediate scenes are created as the composition is further developed. This process can be seen as being analogous to the development of a storyboard for a movie. Once the key scenes have been sketched out, the choreography or animation can be refined to a more detailed level, and an animation of the resulting motion can be realized.

Composition in Space—The Stage

The screen is made up of a number of display areas or windows. On the right-hand side there is a menu of figures (currently up to 18) in standing, lunging, sitting, kneeling, or lying positions (additional figures are available in other named menus—our current library has a total of about 500 stances). On the left of this there is a larger display area providing a view of the stage, which the choreographer can continuously adjust by using the mouse (rotate, translate, zoom in or zoom out). A number of menus and potentiometers for the various controls allow a dancer or groups of dancers to be selected, moved, rotated, jumped, etc.

The composer starts by setting up an initial scene. Figure stances are created from the menu of postures and are placed on the floorplan using the mouse. Their facings are then individually adjusted. Figures are identified by colors or a simple name. When the initial scene is complete, it is stored, and a second scene is created—this is repeated for as many scenes as are needed to define this segment of the dance or animation. As noted above, these scenes are similar to the series of storyboard sketches used in planning a film, but the interactive 3-D workstation allows the choreographer to zoom-in or zoom-out from the stage and to view it from all angles.

Composition in Time—The Timeline

The timeline display provides the composer with a score-like display showing how each figure's position changes over time. Each figure on the timeline display corresponds to the equivalent figure in one frame of the stage display. Compositions can be created spatially on the stage or temporally on the timeline. The timeline provides editing functions analogous to those available in a word processor (select, cut, paste, etc). Movement sequences can be copied to other figures at any point in time, and the time course can be selectively edited with squeeze and stretch functions.

Editing Bodies

Body postures or positions can be created on the "body screen." A three-dimensional human body is first displayed in a natural neutral, standing position. Limb segments may be selected with the mouse and adjusted interactively using both spherical and directional potentiometers or by directly picking and moving the selected limb segment. The body is a complex structure—definition of a posture can require the specification of 44 individual joint angles. Complexity has been reduced by

- treating the neck and back as single entities even though they consist of multiple joints—a spline assures a smooth distribution of bend across these joints;
- the mirror image of any posture can be produced by selecting a button;
- existing postures can be copied fully or in part from the menus. A pair of hemispherical sliders that display the movement ranges about the selected joint provide a particularly convenient way to select a 3-D orientation on a 2-D display. When the posture is satisfactory to the composer, it can be added to a specified posture menu or copied directly onto the spatial display.

Editing Sequences

Movement sequences can be built up with successive postures. These must be chosen carefully to ensure that there is sufficient detail to fully specify the desired movement patterns. In addition, movement sequences can be generated procedurally (e.g., by simulation) or by capturing live action. Whatever the source, the completed sequence is added to the menu of sequences.

A movement sequence allows the composer to work at a higher level with "movement" rather than with stationary "postures." This greatly extends the power of the system, both conceptually, by allowing the composer to think in larger "chunks," and at a practical level by allowing quite long pieces to be put together very quickly.

Hardcopy Printout

In order to provide a means of communication between the composition being worked out on the computer system and the rehearsal by live dancers in the studio, a hardcopy printout has been developed. This summarizes the changing positions with a timeline-like display as well as giving a view of the movement path for each figure.

Goal-directed Dynamic Animation of Human Walking

GESTURE—A System for the High-level Control of Human Gestures

C. Morawetz

Graphics Research Group
Simon Fraser University
Burnaby, British Columbia

Overview Movement is not perceived as being realistic unless it includes those subtle secondary gestures that humans add to their primary movement. Secondary movement involves much of the body language so crucial to subconscious, nonverbal communication. GESTURE allows the animator to define the specific personality of the individual actor (extrovert vs. introvert, cheerful vs. gloomy, assertive vs. passive, domineering vs. submissive) as well as the moods that affect the actor from time to time (boredom, nervousness, fatigue, impatience, and fear). As implemented, the GESTURE system generates secondary movement for two characters walking toward each other.

This system uses a graph to represent gestures; the execution of a sequence of movements is equivalent to traversing the graph. Nodes in the graph contain joint angle values for a collection of joints. These can be viewed as key positions for a set of joints in the body model. Arcs are labeled with the names of different movements, and a number indicating the number of frames between key positions. This representation is very flexible, since a graph can encode results from arbitrary motion algorithms, such as from a dynamic simulation, as easily as from key-frame movement. This can be done by enhancing the graph with nodes representing the motion data, and creating appropriate arcs connecting these nodes.

Illustration of GESTURE in the Video The video first shows how simple gestures are realized by a walking human figure. Following this there are examples of how one gesture interrupts another. Finally, it is shown how parameters can be adjusted to give the animated character a particular personality and mood and how this affects the gestures of the walking figure.

KLAW—A Hybrid Approach to the Animation of Human Gait

A. Bruderlin

Graphics Research Group
Simon Fraser University
Burnaby, British Columbia

Overview This video introduces a method to animate human locomotion based on thigh-level control, dynamic simulation, and kinematic constraints. A generic locomotion cycle is derived from a simple dynamic model. The forces and torques that control this model are internally generated from knowledge about human gait. The mechanical and robot-like appearance of the simulated motion is visually enhanced and humanized through kinematic algorithms; a human leg is superimposed onto the simplified dynamic pendulum leg, a pelvis is induced, and the arm swing and shoulder rotation during locomotion are expressed as functions of the lower body movements.

The system that has been implemented can produce quite realistic looking human walks under a fairly wide range of conditions on specification of only a few parameters, such as desired walking speed and step length. This will be extended in a straightforward way to running and locomotion over uneven terrain, up and down stairs, etc. Studies are also underway to determine how this approach can be applied to nonlocomotory movement.

A specific instance of a gait can be defined with two independent parameters (expressed in terms of the step unit): step length (sl) and step frequency (sf). Together with their product, which is the speed of the locomotion (v), they form the three locomotion parameters that specify a desired locomotion as a high-level task. For example, "walk at speed x" or "walk with step length s." Thus, these parameters are the high-level input into the animation system for human locomotion described in the sections below. If only one parameter is specified, the system completes the parameters using a normalization formula. At the same time a check is made of whether the gait is possible at all.

Illustration of KLAW in the Video

The video first shows how the underlying gate is generated. The stance leg is simulated as a single pendulum with a spring and damper at the "knee." The swing leg is a two-segment compound pendulum. The video next shows the superposition of upper leg, lower leg, and foot segments onto these simple

dynamic models. This is followed by an illustration of how the the simulated leg movements kinematically drive the movements of the hips, torso, head, and arms.

Following the demonstration of the fundamentals, the video illustrates a normal walk (normal step-length and normal speed), walks with short step-length and long step-length, and walks that are fast and slow. Finally there is a demonstration of how the locomotion parameters can be used to customize a walk pattern to the natural style of an individual. The parameter illustrated controls pelvic list, and the video shows walks with no list, normal list, and exaggerated list. Gait is customized by controlling five major determinants of gait; this is achieved by adjusting up to 35 locomotion attributes.

An Application Thecla Schiphorst has created a short animation for eight figures using COMPOSE. The piece uses the simulated walk generated by Armin Bruderlin's KLAW program as the basis for a simple but elegant animation. The animation is accompanied by a Walking Commentary inspired by some words of ee cummings on the nature of making—in this case making an animation.

Galaxy Sweetheart

Nadia Magnenat-Thalmann

MIRALab, CUI
University of Geneva
Geneva, Switzerland

Daniel Thalmann

Computer Graphics Lab
Swiss Federal Institute of Technology
Lausanne, Switzerland

Galaxy Sweetheart is a demo reel to show the creation and dynamic transformation of synthetic actors. An extraterrestrial tries to create a woman using a computer. The several methods of transforming and building characters involved are described below. After many interactive trials, our 3-D character living in a galaxy finally succeeds in creating the woman he likes.

Creation of a Synthetic Actor by Composition of Different Parts

This approach (Magnenat-Thalmann and Thalmann, 1988) is based on the composition of irregular surfaces stored in a database in one coherent figure. This implies the use of elements common to both figures to allow them to be assembled.

Modification of an Existing Synthetic Actor Using Local Transformations

A local transformation (Magnenat-Thalmann et al., 1988b; 1989) is a transformation applied to a part of a figure and not the whole as a global transformation is. Generally, a local transformation consists of two steps. First, a region is determined by a selection operation; examples of selections are selection by vertices, selection inside a volume, selection using color, selection based on set-theory operations applied to selected regions. Then, transformations are applied to regions, e.g., attraction by a vertex, general translation, scale according to a plane.

Generation of New Synthetic Actors Obtained by Interpolation Between Two Existing Actors

This method (Magnenat-Thalmann et al., 1989) consists of generating an in-between human face from two given human faces. The technique consists of extracting profiles of a digitized object from selected planes and generating a grid that corresponds to the original object. A correspondence is established between the profiles, then a correspondence between the parallel sections is found using a similar method; the correspondence between points is straightforward. Finally, an in-between human face is just obtained by linear interpolation.

References

Magnenat-Thalmann, N. and Thalmann, D. 1988. Construction and animation of a synthetic actress, *Proc. Eurographics '88*, North Holland, pp. 55–66.

Magnenat-Thalmann, N., Minh, T.M., de Angelis, M., Thalmann, D. 1988b. Human prototyping. *New Trends in Computer Graphics*, N. Magnenat-Thalmann and D. Thalmann (eds.). Springer, Heidelberg, pp. 74–82.

Magnenat-Thalmann, N., Thalmann, D., Hong, M.T., de Angelis, M. 1989. Design, transofrmation, and animation of human faces. *The Visual Computer* 5(1–2):32–39.

B

About the Authors

The Editors

Norman I. Badler is the Cecilia Fitler Moore Professor and Chair of computer and information science at the University of Pennsylvania and has been on that faculty since 1974. Active in computer graphics since 1968 with more than 80 technical papers published, his research focuses on human figure modeling, manipulation, and animation. Badler received the BA degree in creative studies mathematics from the University of California at Santa Barbara in 1970, the MSc in mathematics in 1971, and the PhD in computer science in 1975, both from the University of Toronto. He is a senior editor of *Computer Vision, Graphics, and Image Processing*, and coeditor of the new journal *Graphical Models and Image Processing*. He also directs the Computer Graphics Research Facility with two full-time staff members and about 40 students.

Brian A. Barsky is associate professor of computer science at the University of California, Berkeley and adjunct associate professor of computer science at the University of Waterloo. He was an Attaché de Recherche Invité at the Laboratoire Image of École Nationale Supérieure des Télécommunications in Paris and a visiting researcher with the Computer-aided Design and Manufacturing Group at the Sentralinstitutt for Industriell Forksning (Central Institute for Industrial Research) in Oslo. His research interests include computer-aided geometric design and modeling, interactive three-dimensional computer graphics, and visualization in scientific computing. He attended McGill University where he received a DCS in engineering and a BSc in mathematics and computer science. He studied computer graphics and computer science at Cornell University where he earned an MS degree. His PhD degree is in computer science from the University of Utah. Professor Barsky is author of *Computer Graphics and Geometric Modeling Using Beta-splines* (Springer-Verlag, Heidelberg, Ger-

many) and coauthor of *An Introduction to Splines for Use in Computer Graphics and Geometric Modeling* (Morgan Kaufmann Publishers, San Mateo, California). He is an area editor for the new journal *CVGIP: Graphical Models and Image Processing*. He was the technical program committee chair for the Association for Computing Machinery SIGGRAPH '85 conference.

David Zeltzer is associate professor of computer graphics in the media arts and sciences section at the Massachusetts Institute of Technology. He joined the faculty at MIT in 1984, after receiving his MS and PhD degrees in computer and information science from Ohio State University in 1979 and 1984, respectively. He was awarded the BS in mathematics, magna cum laude, from Southern Oregon State College in June 1978. While at Ohio State, Dr. Zeltzer was a research assistant at the Computer Graphics Research Group. His work there centered on modeling the kinematics of the human figure and investigating goal-directed animation of human movement. He has produced animated sequences portraying a human skeleton walking over level and uneven terrain that have been shown at numerous computer graphics conferences and widely published. He is a frequent speaker at computer graphics symposia and workshops. Since September 1984, Dr. Zeltzer has been the director of the Computer Graphics and Animation Group at the MIT Media Laboratory. The efforts of this group are aimed at developing a graphical simulation environment that integrates robotics, artificial intelligence, and computer graphics technologies to provide a powerful visualization tool for learning, simulation, and design. In addition to work in computer animation, his research interests include biological and artificial motor control systems, robotics, and human interface design.

The Contributors

Alan H. Barr received his PhD in mathematics from Rensselaer Polytechnic Institute in 1983. In 1988 he received the SIGGRAPH Computer Graphics Achievement Award for computer graphics modeling. Currently, he is an associate professor of computer science at the California Institute of Technology, and is a member of Caltech's Computation and Neural Systems option.

Rodney A. Brooks received a BSc and MSc in mathematics from the Flinders University of South Australia. He received the PhD in computer science from Stanford University in 1981. His doctoral research, at the Stanford Artificial Intelligence Laboratory, was in model-based computer vision. In June 1981 Dr. Brooks moved to Carnegie Mellon University as a research associate in the computer science department where he worked on the definition of Common LISP and its first implementation for the S-1 supercomputer at Lawrence Livermore National Laboratories. Later that same year he took up an appointment as a research scientist at MIT's Artificial Intelligence Laboratory. There he worked on many aspects of automating robot programming; in particular colli-

sion avoidance, error analysis and task decomposition. In 1983 he became an assistant professor of computer science at Stanford University, and in 1984 took a similar position at MIT. He is now an associate professor in the department of electrical engineering and computer science and a member of the Artificial Intelligence Laboratory. Since rejoining MIT his work has been concerned with autonomous robots; in particular decomposition of control systems, vision for navigation, and micro-robots. He is a cofounder of Lucid, Inc., of California. He is a cofounding editor (with Takeo Kanade) of the *International Journal of Computer Vision*.

Tom Calvert is a professor of computing science, engineering science and kinesiology at Simon Fraser University in British Columbia, Canada. He has degrees from University College London (BSc), Wayne State University (MSEE), and Carnegie Mellon University (PhD). Following industrial appointments with ICI Ltd. and Canadair Ltd., he has held faculty appointments at Carnegie Mellon University (1967–1972) and Simon Fraser University (1972–present). He is currently the president of the Science Council of British Columbia and is on leave from Simon Fraser University. His research interests include human figure animation, intelligent CAD, and computer vision.

Jeffrey Esakov is a PhD candidate at the University of Pennsylvania. His areas of interest include computer graphics and animation, object-oriented languages, and software engineering. He is coauthor of the book *Data Structures: An Advanced Approach Using C*. Esakov received the BS degree in computer science from Union College in 1982 and the MS degree in computer science from the University of Illinois, Urbana-Champaign in 1983. Prior to returning for his PhD, he worked at AT&T Bell Laboratories in Holmdel, New Jersey.

Michael Girard received his PhD in computer and information science from Ohio State University as a member of the Computer Graphics Research Group, after taking his BSc in mathematics from the University of California, Santa Cruz. Currently, Girard acts as the head of education and research in the computer graphics and animation department of the Groningen Polytechnic and Stichting Computeranimatie (SCAN), the National Institute for Computer Animation in The Netherlands. Aside from his focus on the problem of attaining expressive motion qualities with regard to the computer animation and simulation of articulated animal movement, Girard is interested in robotics, geometric modeling, image synthesis, nonphotorealistic rendering, and the development of computer-based multimedia composition and production systems.

Mark Green is an associate professor in the computing science department at the University of Alberta. His principal research interests are user interfaces, computer animation, software engineering, and databases for design applications. Green received his MSc and PhD in computer science from the University of Toronto in 1979 and 1985, respectively.

Peter Greene has combined his training in mathematical biology at the University of Chicago with his abiding interest in emergent processes, in particular early sensorimotor development, to study how the brain controls movement without being overwhelmed by the need to control all the muscles at once. His early papers on neural networks and his popularization of the work of the Soviet school of N. Bernstein on movement have anticipated or influenced a number of developments in these areas. He is currently associate professor of computer science at Illinois Institute of Technology.

Jugal Kalita is a doctoral candidate in the department of computer and information science at the University of Pennsylvania. His research interests include natural language processing and artificial intelligence; his dissertation probes the interface between language and graphics. He will be an assistant professor at the University of Colorado, Colorado Springs beginning Fall 1990.

J. A. S. Kelso holds the Glenwood and Martha Creech Chair in science and is director of the Center for Complex Systems at Florida Atlantic University since August 1985. Before that he was on the research staff of Haskins Laboratories, New Haven, Connecticut and professor of psychology and biobehavioral sciences at the University of Connecticut. Kelso obtained the PhD degree from the University of Wisconsin, Madison in 1975.

Nadia Magnenat-Thalmann is full professor of communication and computer science at the Graduate School of Business, University of Montreal. Her research interests include 3-D computer animation, image synthesis, and knowledge-based graphical systems. She has written and edited several books and research papers in various application areas of computer science, and she was producer and codirector of the computer-generated films: *Dream Flight*, *Eglantine*, and *Rendez-vous à Montréal*. Magnenat-Thalmann received a BS in psychology, and MS in biochemistry, and a PhD in quantum physics and computer graphics at the University of Geneva.

Gavin Miller received his PhD degree in computer graphics and computer-aided manufacture from Cambridge University in 1986 and is currently a senior research scientist with Apple Computer, Inc. His research interests include the rendering and animation of natural phenomena, the simulation of elastic and fluid materials, and the animation of characters using dynamics.

A. S. Pandya is an assistant professor (joint) at Florida Atlantic University's Center for Complex Systems and the department of computer engineering. He obtained the PhD in computer science from Syracuse University in 1988.

K. G. Pearson is currently a professor in physiology at the University of Alberta, Canada. His main research interest is the neuronal basis for animal locomotion. Dr. Pearson graduated in electrical engineering from the University of Tasmania and completed his PhD in physiology at Oxford University.

Elliot Saltzman received an AB degree in psychology from Harvard College in 1970, and a PhD degree in developmental psychology from the Institute of Child Development and the Center for Research in Human Learning at the University of Minnesota in 1979. He was a NICHHD postdoctoral fellow at the department of kinesiology, University of Washington (1979–1980) and at Haskins Laboratories (1981). His research is focused on the dynamics of control and coordination in skilled activities of the limbs and speech articulators. He is currently a research staff member at Haskins Laboratories, and a research affiliate in the psychology department and the Center for the Ecological Study of Perception and Action at the University of Connecticut.

Richard A. Schmidt is a professor in the department of psychology at the University of California, Los Angeles. His research interests are in human cognition, learning, and movement control.

R. C. Schmidt received a BA degree in psychology from the University of Connecticut in 1982 and a PhD from the University of Connecticut in 1988. His research interests are in the perceptual control of movement and the coordination of movements between people. He is currently a postdoctoral associate at the Center for the Ecological Study of Perception and Action at the University of Connecticut.

Daniel Soloman recently completed his PhD in the computer science department of the Illinois Institute of Technology. His dissertation is entitled *An Object-Oriented Representation for Motor Schemas*. His research interests include the dynamics of human movement.

Daniel Thalmann is full professor and director of MIRALab, the computer graphics laboratory at the University of Montreal. He has taught at the Swiss Federal Institute of Technology and at the University of Nebraska, and has been a research member of the Computer Graphics Group at CERN. His research interests are computer animation, image synthesis, and artificial intelligence. He has published over 60 papers in these areas and is coauthor of 10 books, including *Computer Animation: Theory and Practice* and *Image Synthesis: Theory and Practice*. He was codirector of three computer-generated films: *Dream Flight*, *Eglantine*, and *Rendez-vous à Montréal*. Thalmann received his diploma in nuclear physics and PhD in computer science from the University of Geneva.

Michael T. Turvey received a DLC degree from Loughborough College in 1963, an MA from Ohio State University in 1964, and a PhD from Ohio State University in 1967. His research interests are in the ecological approach to perception and action and in the processes underlying language and reading. He is currently a professor in the psychology department and at the Center for the Ecological Study of Perception and Action at the University of Connecticut, and is a research associate at Haskins Laboratories.

Bonnie Lynn Webber is an associate professor in the department of computer and information science at the University of Pennsylvania, where she has been a member of the faculty since 1978. She received her BSc from MIT, and her MSc and PhD from Harvard University. Her main areas of research are natural language processing and AI applications in medicine. She is on the editorial board of the ACL/MIT Press series in natural language processing and has served on the Board of Scientific Counselors of the National Library of Medicine.

Jane Wilhelms has been an assistant professor of computer and information sciences at the University of California, Santa Cruz, since 1985. She received an MA in biology from Stanford University and an MS and PhD in computer science from the University of California, Berkeley. She is a member of the editorial board of *IEEE Computer Graphics and Applications* and is on the SIGGRAPH technical committee for 1989, 1990, and 1991. Her main interests are computer animation, physical simulation, and scientific visualization.

Douglas E. Young is an assistant professor in the department of physical education at California State University, Long Beach. His research interests are in the control and acquisition of complex human movements encountered in activities such as sport, music, industry, and dance.

Index